THE COMPLETE BOOK OF

PHOTOGRAPHY

THE ESSENTIAL GUIDE TO TAKING BETTER PHOTOS

THE COMPLETE BOOK OF
PHOTOGRAPHY

THE ESSENTIAL GUIDE TO TAKING BETTER PHOTOS

CONSULTANT EDITOR CHRIS GATCUM

AMMONITE
PRESS

First published 2015 by
Ammonite Press
an imprint of AE Publications Ltd
166 High Street, Lewes, East Sussex, BN7 1XU,
United Kingdom

ISBN 978-1-78145-105-2

A catalog record for this book is available from the
British Library.

Consultant Editor: Chris Gatcum
Managing Editor: Richard Wiles
Art Editor: Robin Shields
Design: Richard Dewing Associates
Contributing Authors: Tracy Hallett, Robert Harrington,
Ross Hoddinott, Andy Stansfield, David Taylor,
Steve Watkins.

Typeset in Berthold Akzidenz Grotesk
Color reproduction by GMC Reprographics
Printed in China

Contents

Introduction 6

Chapter 1
Cameras 8

Chapter 2
Lenses 30

Chapter 3
Filters & Accessories 86

Chapter 4
Exposure 110

Chapter 5
Light & Lighting 168

Chapter 6
Flash 210

Chapter 7
Composition 242

Chapter 8
Color 292

Chapter 9
Workflow 320

Chapter 10
Retouching 344

Chapter 11
Black & White 372

Chapter 12
Printing 408

Glossary 438

Web Sites 442

Index 443

Acknowledgments 448

Introduction

Photography is a vast subject, comprised of countless genres and sub-genres for you to explore. Yet regardless of whether you want to photograph the landscape in its many and varied forms, or you would prefer to concentrate on photographing people, or wildlife, or sports (or any other subject you desire), the core photographic skills that you will need are common to all areas.

In the past, relatively few skills were needed to get you started, because cameras were relatively straightforward. Consequently, some of the simplest SLRs required little more than a working understanding of aperture, shutter speed, and film speed and you were "good to go."

Today, however, that has all changed, as digital sensors have (largely) replaced film. This has meant that technology now needs to be mastered in addition to traditional camera skills, making the photographer part technician, part scientist, and part artist. Where once there might only have been manual focus, we now find multiple automatic focusing modes, with a bewildering array of focusing points, zone options, and "dynamic" performance.

While an old film SLR might have had a single exposure metering mode, we now have multiple options—some of which can be customized—to drive numerous shooting modes of varying levels of sophistication. If you throw in the potential to adjust the sensitivity of a digital camera's sensor on a shot-by-shot basis, and the ability (and often necessity) to tweak the color, in-camera, before you shoot things suddenly start to get more complex. And this is before we even begin to look at the less essential creative options that every modern camera is bristling with, or the art of composition, or what to do after we've taken a photograph.

With so much to get to grips with, it's hardly surprising that many people starting out on their photographic journey can feel overwhelmed. However, help is at hand. This book is the work of a team of highly experienced

photographers and authors who, between them, have written dozens of books on the subject, taking tens of thousands of photographs along the way. These experts will guide you through every stage of your new-found passion, from choosing your first camera and lens, to producing pixel-perfect prints with your inkjet printer. Along the way you will learn how to make the "perfect" exposure; how to focus your camera precisely where you want it; how to control light; how to frame your shots for maximum impact—everything, in fact, that you need to know to take great pictures and get the best from your camera.

Chris Gatcum

CHAPTER 1
CAMERAS

Introduction to Cameras

It should go without saying that a camera is the most important part of taking photographs, but the other equipment you choose will also have a bearing on how easy or frustrating your life as a photographer will be. There are superb cameras on the market to suit everybody's needs, tastes, and budget—you just have to decide what you want.

It's often said that the camera doesn't matter and it's the person behind it that's important. To a certain extent this is true, because all cameras are essentially boxes that control how much light reaches a light-sensitive surface so that an image can be formed. They are tools, and they can be used well or they can be used badly. A good photographer will be able to create interesting images no matter how basic the equipment they use, but your choice of camera is still important. If you don't like the ergonomics of a camera, for example, you're unlikely to want to use it, just as you are less likely to take pictures if you aren't happy with the image quality.

The good news is that if you are in the market to buy any type of digital camera, you are going to be completely spoilt for choice. Fierce and increasing competition across all the sectors has led to a glut of highly specified cameras being available for pretty much bargain prices. But how do you go about choosing the one that best suits your needs? Following the steps that follow should help you narrow things down.

Decide Your Budget

To some degree this will govern both the type and the quality of the camera that you can get, although it is hard to buy a truly bad camera these days. The key to getting the most value for your money is to be very specific about the features that you really need on the camera. If you have a clear idea of which ones are the most important for your type of photography, then you can focus on the quality of those.

Decide On Camera Type

As you will see on the following pages, there are numerous camera types available, from professional system cameras, through to point-and-shoot compact cameras, and even the camera in your cell phone.

The camera type most associated with "proper" photography—and the primary focus of this book—is the interchangeable lens camera. This encompasses both digital single-lens reflex cameras (or DSLRs) based on classic 35mm film SLR camera design, and mirrorless interchangeable lens cameras (compact system cameras or CSCs) that have eschewed the traditional mirror for a pure "live view" approach to viewing and composing images. The biggest manufacturers in the DSLR arena are Canon, Nikon, Pentax, and Sony, while Fuji, Olympus, Panasonic, Samsung, and Sony (again) have strong offerings in the CSC market.

Regardless of the camera type you settle on, an interchangeable lens camera is just one part of a much larger "system." Which brand (or system) you choose will determine the range of lenses and other accessories available to you, including battery grips, flashes, and remote releases.

Digital cameras also differ in the range of options offered, how robustly they are made, and how large the sensor is (which ultimately affects the size of the camera and other factors such as depth of field). Therefore, it is worth considering not just the specifications of your interchangeable lens camera of choice, but also whether its capabilities will keep pace with your growing needs as a photographer.

> **TOY CAMERA**
This was shot on a plastic "Holga" film camera that costs less than $32 (£20). There are many limitations, such as a fixed shutter speed and two aperture settings, but it shows that cameras don't need to be expensive (or sophisticated) for you to have fun and make creative photographs.

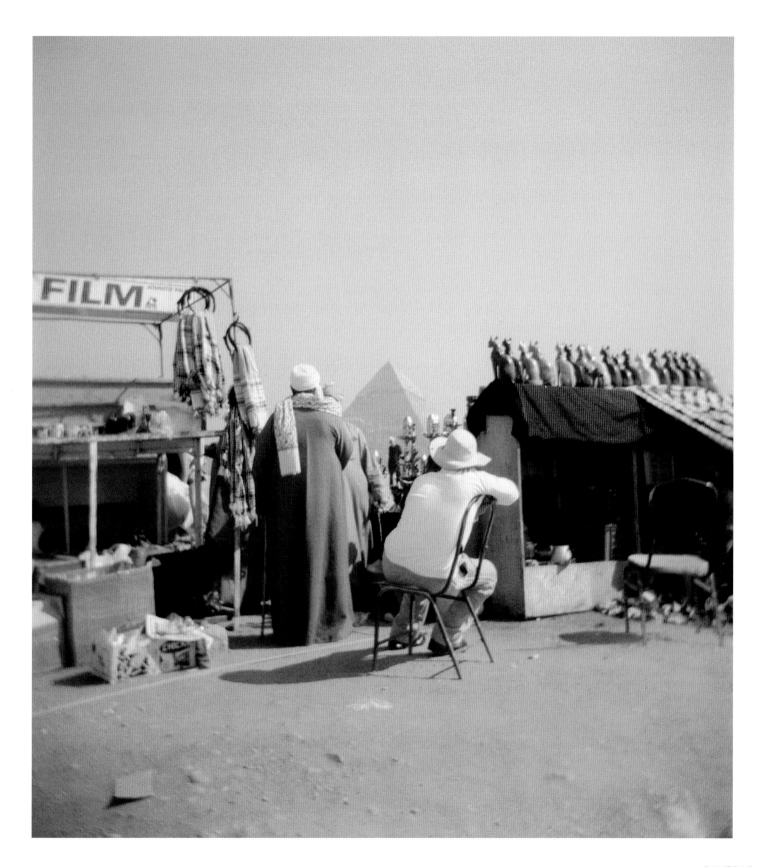

Fixed-Lens Cameras

A fixed-lens camera offers an all-in-one photographic solution: you just need to add a memory card and a battery, and you're ready to shoot.

Cell Phones

The ubiquity of the cell phone has had a marked effect on photography, with sales of compact cameras falling as people use their phones instead to take pictures. This is partly because a cell phone is often carried around all day, every day, and there's a saying that the best camera in the world is the one you have with you when you need it. In fact, cell phones have led to the rise of "citizen journalism," in which events that once would have been missed are immediately recorded for posterity.

However, the digital sensor in cell phones is generally smaller than those found in any other type of camera, and the photos captured are stored as heavily compressed JPEG files. Both of these things mean that image quality is often compromised, and low-light performance is especially poor compared to "dedicated" cameras. Cell phones also tend to have fixed focal length lenses, which means that the only way to "zoom" is to physically move the camera closer or further away from the subject.

Compact Cameras

Compact cameras have several defining features. The first is that they're... well, compact. This makes them easy to carry around, either in a pocket or small camera bag. They're not quite as portable as a cell phone, but some slimline models are not far off.

The size is achieved through the use of a relatively small digital sensor, which is typically larger than the sensor in a cell phone, but smaller than the sensor in a system camera. In terms of image quality, this means that compact cameras are somewhere in the middle ground between two. A few high-end models break this rule, and use a sensor that's the same size as those found in some system cameras (delivering comparable image quality), but these compacts are few and far between, and tend to be comparatively expensive.

The range of features on a compact camera depends largely on price. Low-cost compact cameras are often quite feature-poor, shooting only JPEGs and offering little more than rudimentary exposure control. At the opposite end of the scale, high-end compacts are often

∧ **CANON POWERSHOT G1X MKII**
Some high-end compacts, such as Canon's G1X MkII, have sensors and features that are comparable to system cameras.

∧ **PANASONIC LUMIX LF1**
Panasonic's LF1 may be small, but it packs a 28–200mm zoom lens into its diminutive frame, which is ideal for a "carry anywhere" camera.

< **SAMSUNG GALAXY K ZOOM**
Samsung's Galaxy K Zoom is something of a rarity among smartphones—it features a 10x optical zoom lens that extends its photographic capabilities.

CELL PHONE >
Having a camera with you at all times will encourage experimentation and spontaneity. Most people carry a cell phone that can be used in this way.

the equal of system cameras when it comes to features (and price), offering a high level of control over the picture-making process and Raw files.

What all compacts have in common, though, is a fixed lens. Although many compacts have a zoom lens (usually covering moderate wide-angle to moderate telephoto focal lengths), the lens cannot be removed. This makes compact cameras far less expandable than system cameras, so you may quickly outgrow a compact camera as your photography develops. However, one way in which a compact camera is very useful is as a "walkabout" camera. The size and weight means it is easy to keep in a jacket pocket or bag, which is ideal for a more spontaneous approach to photography, or for use as a "visual notebook."

Bridge Cameras

Bridge cameras are so called because they "bridge" the gap between compact and system cameras. They tend to be bigger and better specified than compact cameras and some use sensors that are the same size as those found in system cameras (many also look like DSLRs to emphasize their more "serious" aspirations).

Bridge cameras also offer a system camera level of control over your shots, allowing you to change the ISO,

aperture, shutter speed, file size, white balance, and metering systems with ease. Many also shoot Raw files and most bridge cameras are able to take an external flash and have a filter thread on the lens that enables you to use filters.

As with compact cameras, the zoom lens on a bridge camera is fixed, so it can't be removed and swapped. This is compensated for with an enormous optical zoom range (often referred to as a "superzoom"), which is an attractive option if you want a camera that can be used for just about any shooting situation you can think of. However, to create such an impressive zoom lens means that compromises have to be made in its design, and image quality usually suffers as a result.

∧ PANASONIC LUMIX FZ70
A true superzoom bridge camera, Panasonic's FZ70 boasts a 60x optical zoom lens with a focal length range of 20–1200mm.

NOTEBOOK >
Photographers often use a compact camera as a visual "notebook" to record compositional ideas that can be repeated later with their larger "work" camera.

MURAL

A compact camera is very useful as a "visual notebook." It can be taken easily with you when you are out and about, allowing you to explore ideas for future compositions without the need to constantly carry around bulkier equipment.

System Cameras

A system camera is just one component in a much broader range of photographic equipment. Lenses, flash units, and countless other accessories can be added to widen your photographic repertoire, allowing your camera kit to grow with your experience.

System cameras are those that allow you to swap lenses and add additional equipment such as flashes, battery packs, and other accessories to expand their capabilities. Because of this, they are far more versatile than bridge, compact, and cell phone cameras. The sensor in a system camera is often far larger as well, which means it will have a wider dynamic range and offer higher ISO settings than a compact model, without compromising image quality to the same extent. System cameras also tend to allow you to use a greater range of aperture and shutter speed settings, as well as supporting Raw files, which means you can tweak factors such as white balance in post-processing, without a loss of image quality. There are two main types of system camera: digital single lens reflex cameras (DSLRs) and compact system cameras (CSCs).

Digital Single Lens Reflex Cameras

DSLRs are the type of camera used by just about every professional photographer and the majority of enthusiasts. The main camera manufacturers have also been doing their utmost to tempt beginners to this type of camera, by manufacturing DSLRs with built-in help guides and a host of technological advances that significantly increase the likelihood of taking flawless photographs in almost any situation.

∧ **NIKON D3300**
Modern "entry-level" DSLRs, such as the Nikon D3300, are extremely well specified given their (relatively) low cost.

∧ **CANON EOS 7D MKII**
Mid-range DSLRs, such as the Canon EOS 7D MkII, appeal as much to professionals as they do to advanced amateurs, thanks to superb performance and great handling.

∧ **NIKON D4S**
Top-end DSLRs, such as Nikon's full-frame D4s, combine outstanding image quality with the robust build needed to match the rigors of everyday professional use.

WHAT IS A SINGLE LENS REFLEX CAMERA?

A single lens reflex camera (SLR) is a camera type in which the photographer looks through the actual taking lens when they peer through the viewfinder. It employs a mechanical mirror system and pentaprism to direct light from the lens to an optical viewfinder at the back of the camera. When you take a picture, the mirror assembly swings upward, the aperture narrows—if set smaller than wide open—and a shutter opens to allow the lens to project light onto the digital sensor positioned behind. All of this occurs so quickly that some SLRs are able to capture up to a staggeringly quick 10 frames per second. SLR cameras are popular with all types of photographer, of any ability. They allow photographers to accurately preview framing immediately before the moment of exposure and, being compatible with a vast range of different, interchangeable lenses, their capabilities are virtually endless.

Although DSLRs are generally heavier and more expensive than compact and bridge cameras, they pack a whole host of incredible features into a robust, contoured body. Thanks to some clever engineering, photographers can manually control every aspect of the picture-taking process, from ISO sensitivity to metering, focusing, and drive modes. These functions can be accessed easily, while the less commonly used features are hidden away in electronic menus.

The main advantage of a DSLR is the ability to change lenses, offering the maximum level of flexibility and potential for the system to grow with you as your photography improves. From 14mm super wide angle, to 105mm macro, and 600mm super telephoto, the choice of optics and accessories is extensive—not only from the camera maker itself, but from third-party manufacturers as well. However, the accessories for one camera system will rarely be compatible with those from another. This makes it easy to get "locked in" to a particular camera system and expensive to change if you wish to switch to a different brand later on.

In general, DSLRs fall into three broad categories. Top-end, or "pro spec" DSLRs are often heavy and rugged, as they're designed for daily professional use (and abuse). They will typically feature weatherproofing seals on the camera body and around the lens mount to prevent the ingress of water and dust, and many use a high resolution full-frame sensor for optimum image quality.

At the opposite end of the DSLR spectrum are entry-level DSLRs. These tend to be smaller and lighter than their professional counterparts, and often feature a host of user-friendly automated shooting modes, such as "Full Auto" and Portrait, Landscape, and Sports scene modes. However, this doesn't mean that an entry-level camera is limited—many of them match their more expensive stablemates in terms of the features they offer, whether that's sophisticated exposure metering or fast, multi-point autofocus (AF) systems.

Between these extremes are mid-range DSLRs, which tend to be more solid than the entry-level offerings, with slightly more advanced features—a higher frame rate or faster AF, for example—to satisfy advanced amateurs and some professionals as well.

∧ ILLUMINATING
The larger sensor found in a system camera is particularly beneficial when shooting low-light subjects, as it will allow you to increase the ISO without introducing heavy levels of detail-destroying noise.

Compact System Cameras

Compact System Cameras—or CSCs—are the latest innovation in terms of interchangeable lens system cameras. They eschew the mirror used in a DSLR camera in favor of a "live view" that lets you use the rear LCD screen to frame your shots, in a similar fashion to a compact camera. Some CSCs also have an electronic viewfinder (or EVF), which acts like the optical viewfinder on a DSLR (you hold the camera to your eye and peer through a small "window" in the camera), However, instead of looking through the lens, you are looking at a small screen.

Because a CSC doesn't need a mirror and prism, the cameras can be made much smaller and lighter than DSLRs. This has led to two distinct design styles: CSCs that look like miniaturized DSLRs, and CSCs that look more like compact cameras. Although they differ on the outside, internally they are often very similar, with both types using sensors that are the same size as those found in some DSLRs, giving comparable quality results.

One of the primary advantages of a CSC system is size and weight: as the cameras and lenses are typically much lighter than those used by a DSLR system, it is less effort to carry. Another (arguable) benefit of CSCs is that they are less daunting than a DSLR camera, especially the compact-styled models. For someone graduating from a compact camera or a cell phone they will feel immediately more familiar.

∧ PANASONIC LUMIX DMC-GM5
Panasonic's GM5 is a super-small system camera based on the Micro Four Thirds standard.

∧ OLYMPUS PEN E-PL7
Olympus' PEN range of CSCs has a retro style based on the company's 35mm PEN cameras from the 1960s.

∧ SAMSUNG NX1
Samsung's NX1 houses a 28.2MP sensor in its sleek-looking mirrorless body.

∨ PANASONIC LUMIX DMC-G5
Panasonic's G5 looks and acts like a DSLR, but is noticeably smaller and lighter, thanks to its mirrorless design.

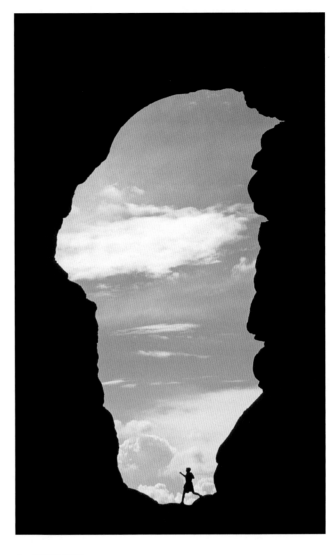

∧ CONTROL
System cameras have all the tools you need to control the appearance of your pictures, so from focus to exposure you have the option to call the shots and create them in the way that you want.

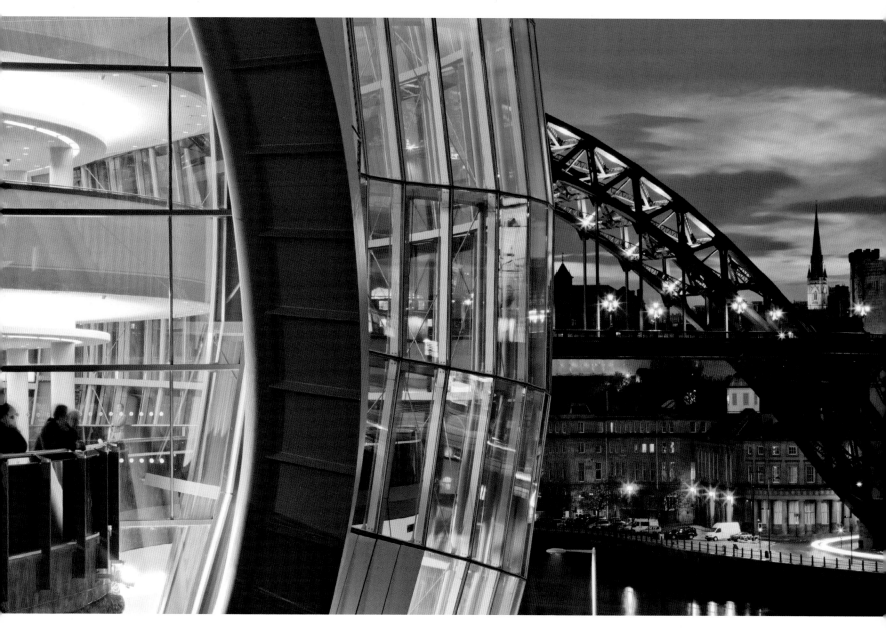

∧ DYNAMIC RANGE

Extremes of light and dark can prove challenging to cell phone and compact cameras because of their sensor's limited dynamic range. The larger sensor in a system camera—especially a full-frame model—will do a much better job at recording challenging scenes like this.

Sensors

Although system cameras are alike in theory, there are important differences between individual models. The greatest difference is arguably in the size of the sensor inside the camera, but its shape and resolution also play a part in how your images are formed.

Digital imaging sensors are produced in a variety of sizes and fabricated on discs of silicon, so the smaller the sensor, the greater the number that can be fitted onto one disc. This makes small sensors less expensive to manufacturer than larger ones, so in an ideal world we would all be using inexpensive cameras with tiny sensors. However, reducing the size of a sensor has unavoidable consequences when it comes to image quality.

Photons of light are essentially units of information to a digital sensor. The greater the number of photons a digital sensor can sample during an exposure, the more information it will have to enable it to create an accurate image afterward. A smaller sensor will always struggle to achieve this aim compared to a larger sensor,

so smaller sensors are more prone to image noise, suffer from a restricted ISO range, and often have a compromised dynamic range too. In many respects, using a camera with a smaller sensor is more difficult than using a camera with a larger sensor. More care has to be taken with exposure as there is generally less scope for adjustment in postproduction without image quality deteriorating unacceptably. There are three different types of sensor commonly employed in system cameras: full frame, APS-C, and Micro Four Thirds.

Full Frame

The term "full frame" refers to a sensor that matches the size of an old frame of 35mm film (36 x 24mm). Because of its size, a full-frame sensor doesn't need to pack in the pixels, so image quality is often—but not always—better than smaller sensor formats, with lower noise levels at high ISO ratings and a wider dynamic range. Using a full-frame camera means that your lenses will operate at their stated angle of view and won't need a crop factor applied (more on this later), as they do with smaller-format sensor cameras. Full-frame sensors are, however, more expensive to manufacture, and the camera prices reflect that—full-frame sensors are typically reserved for pro-spec camera bodies.

APS-C

This sensor format—which stands for Advanced Photo System, Type C—uses a sensor sized at approximately 25.1 x 16.7mm (different manufacturers use slightly different measurements), which significantly reduces manufacturing costs compared to full-frame sensors.

Notes

The most common types of sensor design found in system cameras are Charge Coupled Device (CCD) and Complementary Metal Oxide Semiconductor (CMOS). Both types accomplish the same task of capturing light and converting it into electrical signals.

In the early days of DSLRs, CCD sensors were the superior option, but today neither technology has an advantage in terms of image quality. However, a CMOS design can be implemented with fewer components, employs less power, and provides data faster than a CCD, which is why it is by far the most prevalent sensor type in modern system cameras.

IMAGE SENSOR

At the heart of a digital camera is its sensor. It is this technology that dictates the image's resolution and whether or not there is a focal length multiplication factor. This is the 24.6 megapixel, full-frame CMOS sensor found in the Sony Alpha 900. Full-frame DSLRs do not have a "crop factor," so the focal length of the lens attached to the camera is unaltered.

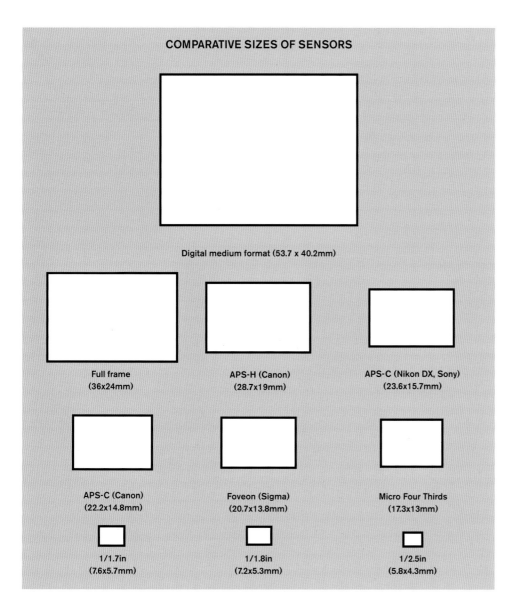

COMPARATIVE SIZES OF SENSORS

Digital medium format (53.7 x 40.2mm)

Full frame
(36x24mm)

APS-H (Canon)
(28.7x19mm)

APS-C (Nikon DX, Sony)
(23.6x15.7mm)

APS-C (Canon)
(22.2x14.8mm)

Foveon (Sigma)
(20.7x13.8mm)

Micro Four Thirds
(17.3x13mm)

1/1.7in
(7.6x5.7mm)

1/1.8in
(7.2x5.3mm)

1/2.5in
(5.8x4.3mm)

Common sensor sizes

Sensor size (inches)	Height (mm)	Width (mm)	Diagonal (mm)	Crop factor factor*
1/4 (iPhone 3)	2.4	3.2	4	10.8x
1/3.2 (iPhone 5)	3.4	4.5	5.7	7.6x
1/3	3.6	4.8	6	7.2x
1/2.7	4	5.4	6.7	6.4x
1/2.5	4.3	5.8	7.1	6x
1/2.3 (Pentax Q)	4.5	6.2	7.7	5.6x
1/2	4.8	6.4	8	5.4x
1/1.8	5.3	7.2	8.9	4.8x
1/1.7 (Canon G15)	5.7	7.6	9.5	4.5x
1/1.6	6	8	10	4.3x
2/3 (FujiFilm X20)	6.6	8.8	11	3.9x
1/1.2	8	10.7	13.3	3.2x
Nikon CX standard	8.8	13.2	15.9	2.7x
1	9.6	12.8	16	2.7x
Four Thirds/Micro Four Thirds	13	17.3	21.6	2x
1.5	14	18.7	23.4	1.8x
Foveon X3 (Sigma)	13.8	20.7	24.9	1.7x
APS-C (Canon)	14.8	22.2	26.7	1.6x
APS-C (Nikon DX, Sony etc.)	15.6	23.6	28.3	1.5x
APS-H (Canon)	18.6	27.9	33.5	1.3x
35mm / full-frame	24	36	43.2	1x
Pentax 645D	33	44	55	0.8x
Digital medium format	40.2	53.7	67	0.6x
Phase One digital backs	40.4	53.9	67.4	0.6x

* Compared to a full-frame sensor

Cameras featuring APS-C sensors are immensely popular, as they offer very good image quality at a lower price. A downside is that the smaller sensor introduces a crop factor, because it reduces the angle of view of any lens attached to the camera. For example, a camera with a 1.6x crop factor effectively turns a 24mm lens into a 38mm lens (in terms of an old 35mm film or full-frame digital camera). To get the equivalent angle of view of a 24mm lens in APS-C format, you will therefore need to use a 15mm lens, which is more technically challenging and expensive to produce.

Micro Four Thirds

Micro Four Thirds sensors are based on the Four Thirds system developed by Panasonic and Olympus. The sensor is smaller than APS-C, measuring just 17.3mm x 13mm. All Micro Four Thirds cameras are CSCs, so do not include a mirror or pentaprism. Combined with the small sensor size this allows the manufacturers to make far smaller and lighter cameras. All Micro Four Thirds cameras apply a 2x crop factor to lenses, so the effective focal length of a lens is doubled (a 24mm lens behaves like a 50mm lens, for example).

∧ **SENSOR SIZE**
Although there are only three main sensor sizes used in system cameras, there are numerous subtle variations (especially when it comes to APS-C sized sensors), as well as a bewildering range of compact and cell phone sensor sizes. This grid shows the range of sizes used in imaging devices, while the graphic opposite shows the physical size differences.

Aspect Ratio

The aspect ratio of a sensor determines the shape of the images it will capture. Aspect ratio defines the proportional relationship of the horizontal length of a rectangle to its vertical length, so a rectangle with an aspect ratio of 1:1 has horizontal and vertical dimensions that are proportionally equal (in other words, square), while an aspect ratio of 3:2 is a relatively long rectangle. There are no digital sensors that are currently made with an aspect ratio of 1:1, although it was once a popular shape for medium-format film cameras, most notably those produced by Hasselblad.

Instead, digital system cameras typically use sensors with an aspect ratio of 3:2 (full frame and APS-C) or 4:3 (Micro Four Thirds, although the aspect ratio has nothing to do with the name). A 4:3 ratio is a far squarer rectangle than 3:2 (4:3 is the same aspect ratio as an analog television) and this can change the way in which you compose your shots—some subjects suit a squarer format better than others.

Learning to work within a particular image shape is one of the keys to successful composition, but you don't have to be tied to the aspect ratio of your camera's sensor.

Many cameras offer a crop facility (typically in JPEG file format only) that will allow you to choose from a range of alternative settings. So you can shoot 3:2 format images on a 4:3 sensor, for example, or vice versa. Most cameras will also allow you to shoot images with an aspect ratio of 16:9, which is the standard aspect ratio of an HD TV. To achieve this, the camera simply uses a smaller area of the sensor to record the image. As this process effectively crops the full sensor area, the same result can be achieved by cropping during postproduction.

< ASPECT RATIO
This 3:2 image could be cropped to a 1:1 aspect ratio (the red box), 4:3 (green box), or 16:9 (blue box). Get into the habit of visualizing how an image should be cropped at the time of shooting, rather than seeing it as a way of later "rescuing" an image that you feel hasn't worked.

< > CHANGING ASPECTS
This coastal landscape (right) works well with an almost square, 4:3 aspect ratio, which gives added width for the rocks in the foreground. However, the mountainscape (left) benefits from a more elongated frame shape: if it were more square, there would have to be more sky or foreground in the frame, which would detract from the snow-capped peaks. In both instances, the aspect ratio can be changed in-camera, or images can be cropped during postproduction.

Catching Light

A digital imaging chip, or sensor, consists of millions of tiny, light-sensitive photosites, which gather the light coming through the lens. On their own, these photosites record the brightness of the light, but not color. To create color images, almost all sensors used in digital cameras today employ what is known as a Bayer filter.

In a Bayer sensor, the photosites are filtered, so that in a group of four photosites, one is filtered so it is sensitive to red light, one is filtered for blue, and two are filtered for green. In a process known as "demosaicing," groups of these filtered photosites are assessed to produce a full-color pixel in the final photograph.

The most common analogy used to describe how each photosite works is that it is like a bucket catching rain, with the rain in this analogy being photons of light passing through the lens. If each photon is thought of as a unit of information, the more you can capture during the exposure, the more information you have to build up an image.

As a general rule, this means that a sensor with bigger photosites should be better able to record detail than a sensor with smaller photosites. For example, compact digital cameras have smaller sensors than those found in system cameras, which means that the physical size of the photosites must be reduced in order to squeeze the same number of photosites onto the sensor. This reduces their ability to capture light, affecting the final image. Typically, images from compact digital cameras display more noise, have less dynamic range, and cannot use as high an ISO as a system camera. Modern compact digital cameras can still produce astonishingly good images, but there will always be a disparity.

Units Of Information

After exposure, the amount and quality of light captured is processed by the camera to produce the image information, which is stored as digital data. In computing, a "bit" is the smallest possible unit of data and like a switch, it can be set off or on: when a bit is "off" it is set to 0 and when it is "on" it is set to 1.

The next unit up from a bit is a "byte," which is a string of eight bits. Computers use binary notation, so eight

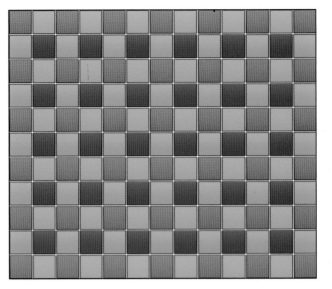

<< **BAYER SENSORS**
This diagram shows the typical arrangement of photosites in a Bayer sensor. There are more green photosites because the human eye is more sensitive to green light than it is to red or blue. By having two green-filtered photosites a digital camera mimics this sensitivity. As a result, the green channel of an image is often far less noisy than the red and the blue channels because more "green" has been captured and more information gathered in this channel.

bits can be used to store numbers from 0 to 255 (or from 00000000 to 11111111 in binary). This means that to store image data you could use one byte to create 256 different tones, from no tone (black) when the byte is set to 0, to maximum (white) when the byte is set to 255.

However, this only refers to grayscale brightness. To display a full-color pixel on a monitor, three bytes are used: one byte is used to represent red, one for blue, and a third for green (hence the initials RGB). This results in 16.7 million different possible color combinations when red, blue, and green are mixed in different proportions (256 red values x 256 green values x 256 blue values).

Bit-depth

Sixteen million colors may seem like a large number, but in reality using one byte (or 8 bits) per color is very limiting. If you make a color adjustment that generates a color value that is a fraction (such as 130.7), that number will need to be rounded up (or down). If you perform lots of these adjustments then any rounding errors are compounded, which can result in a visual error known as "posterization." This is seen as sudden jumps or gaps between colors in an image.

The solution is to use 12, 14, or 16 bits (or two bytes) of information to record the color value in a digital image.

∧ 8-BIT EDITING
The gaps in this histogram show where the data in an 8-bit photo has been stretched too far. This would result in a posterized image that might not be good enough to print.

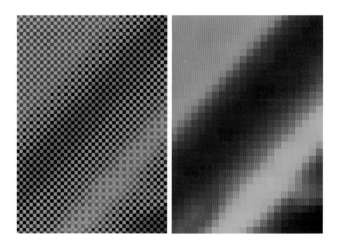

In a 16-bit image there are 65,536 levels of color per pixel, as opposed to 256, resulting in 281 trillion different color combinations! While computer monitors and printers can't display this range of colors (and we'd also struggle to perceive them all), software such as Adobe Photoshop and Lightroom can make use of this extra information "behind the scenes," making rounding errors far less likely and maintaining image quality.

∧ POSTERIZED
The top image was adjusted in 16 bit and the colors have remained true. The lower image was edited in 8 bit, resulting in strange color shifts and far less subtle color transitions.

∧ DEMOSAICING
Full-color pixels in your images are created through a "demosaicing" process, which processes the color information based on groups of filtered photosites.

File Formats

There are three photo file formats commonly used by photographers: JPEG, TIFF, and Raw. Each has strengths and weaknesses, and which you choose will depend on how you use your photographs after capture and how much time you are prepared to devote to postproduction.

The JPEG Option

All digital cameras have the ability to record a type of image file called a JPEG. The name derives from the Joint Photographic Experts Group who formulated the standard in 1992. Most people start their photographic career shooting JPEGs, which is understandable, as a JPEG is the digital equivalent of a film transparency or slide. What this means is that when a JPEG file is saved by your camera, the photo has generally been processed according to a series of user-defined options. These options typically include settings such as contrast, color saturation, and sharpness. A saved JPEG is therefore "baked" and ready to use immediately with a wide range of software packages, including image-editing software such as Adobe Photoshop and Photoshop Elements, web browsers, and word processors.

JPEG files are typically smaller than TIFF and Raw files and so use less space on a memory card or hard drive. This is because a JPEG is compressed to reduce its file size. This may sound like a good thing (you can fit more images onto your memory card or hard drive), but there is a price to pay: a JPEG is compressed by discarding fine image detail, and the greater the level of compression, the greater the loss of detail will be. More importantly, once this detail has been lost it is gone for good.

< **COMPRESSION**
This is a JPEG image with maximum compression applied. The result is a mess of hard color bands and there is a loss of fine detail.

Another drawback of shooting JPEG is that the file format only supports 8-bit color, so making adjustments to a JPEG can quickly result in a loss of image quality. Any subsequent alteration you make to your photograph will degrade the quality more quickly than if you were editing a Raw file. If you opt to shoot in JPEG, then inspect your camera menu and ensure that the Image Quality is set to its highest setting, often referred to as "Fine" or "Super Fine" in the menu.

TIFF Files

TIFF is the acronym for Tagged Image File Format, identified by the extension .TIF or .TIFF. The TIFF file format is widely used by graphic artists and the publishing industry as TIFFs can be opened, adjusted, and resaved without sacrificing image quality.

A few cameras have the ability to shoot TIFF files, but it is generally not a popular choice. Files recorded in this way are typically 8-bit (as JPEG), but are uncompressed so take up a large amount of memory card space and take a while to save to the card to start with.

Instead, TIFFs are usually employed at the postproduction stage. If you are shooting JPEGs, for example, you might convert them to TIFFs to avoid any further degradation to the image.

Photographers who shoot Raw will also often save the file as a TIFF after converting it with image-editing software. When saving a TIFF in this way you are usually faced with the option of saving it as an 8-bit or 16-bit image (if you plan on carrying out more adjustments to the file you should save it as 16 bit) and the ability to apply lossless compression that creates smaller file sizes without any loss of quality.

> **RAW OR JPEG?**
If you get everything right in camera, there's little need to shoot Raw. However, if you want or need to make extensive edits during postproduction, JPEG is not the best option.

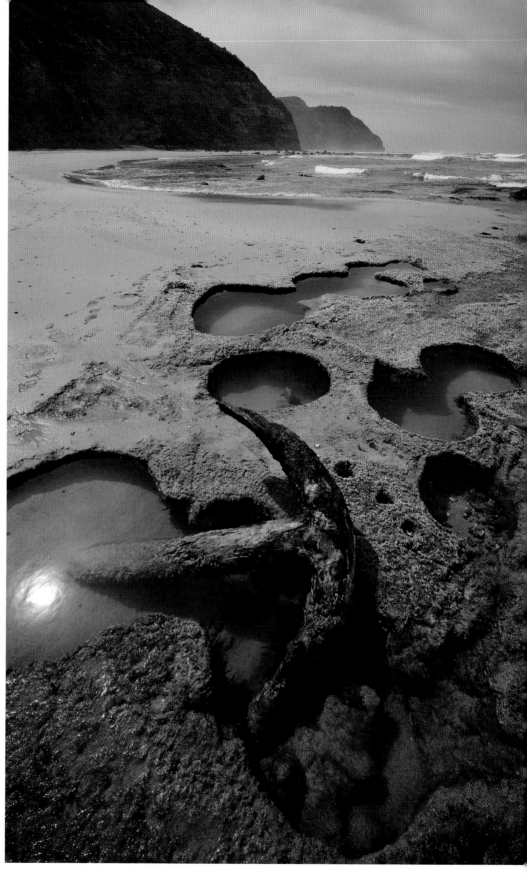

Raw Choice

In normal usage, the word "raw" is a synonym of uncooked, unrefined, and unprepared. This is a very apt description of what camera Raw files are and is the reason for this name. A Raw file is a package of the image data captured by the camera sensor when you press the shutter-release button to make an exposure. The camera does not process this image in any way so, unlike a JPEG file, it has not been "baked." This makes viewing Raw images initially disappointing, as they often appear flat and washed out compared to a JPEG, which can look perfect straight from the camera. What the Raw image has, however, is potential: if a JPEG is a finished meal, a Raw file is the ingredients you need to make your own.

The big advantage of shooting in Raw format is that there is far more scope for adjusting the image later using Raw processing software—the recorded file is just the starting point. The alterations you can make to a Raw file are far in excess of the options that are available on the menu of your camera. Also, the color data in a Raw file is saved using 12- or 14-bit values, so there is more leeway for postproduction alteration than is found with JPEG files. This makes Raw the format of choice for serious amateur and professional photographers.

One disadvantage to the Raw format is that because the camera captures more data, fewer images fit onto the memory card. Although Raw files are often compressed, they use "lossless" compression that doesn't throw anything away, so the compression is less efficient. It does mean that every detail is there when you process the Raw file, but you will need a larger memory card than if you shot JPEGs, and more storage space on your computer's hard drive as well—although this is less of an issue with the large-capacity cards and hard drives available today.

It is also important to appreciate that Raw files need to be processed and converted to a more usable file type, such as TIFF or JPEG before you can do anything with them. This is not a quick process, so you must be prepared to allocate time for postproduction—it is all too easy to spend more time optimizing and converting Raw files on your computer than taking new photographs. However, this is arguably a small price to pay for getting the optimum image quality from your camera.

< CAMERA RAW
The dialog box shown when importing Raw files directly into Adobe Photoshop.

∧ RED POPPY
Red is a color that is easy to oversaturate, especially when shooting JPEG images with the camera set to "Vivid" or a similar color-enhancing picture setting. In this instance, shooting Raw will give you the option to refine your images post-capture.

< **CHOICES**
A Raw file is a "digital negative" and how you process it to create the final image is entirely your decision. You can alter the look of the image as little or as much as you like. This image was always intended to be black and white. Shooting Raw gave the flexibility to refine the image until it matched the original idea.

Notes

There is also no universally used Raw standard—a Raw file from one model of camera is not necessarily the same as that produced by a different model, even when both cameras are made by the same manufacturer!

You can convert Raw files to the DNG format. DNG is an open raw format developed by Adobe Systems. Because it is not tied to one particular camera system, it is more widely recognized by image-editing software and operating systems than proprietary Raw formats.

Some cameras offer the option of shooting Raw and JPEG formats at the same time, which is useful if you immediately need to use some images from a shoot, but also want the maximum level of manipulation available. This option increases the demand on memory space on your storage cards, though, as every image you shoot is saved twice.

< **THE DNG ADVANTAGE**
Shot in 2004, this digital image was shot in Raw. Because it was converted from the original Raw file format to DNG it can still be opened and reworked, and is likely to remain that way into the future.

Color Space

The color space on a camera dictates the range of colors that can be captured in a photograph at the point of pressing the shutter-release button.

A color space is a mathematical model that describes the range of colors an imaging device such as a monitor, printer, and so on, can capture, display, or print. These color spaces are device-specific, as different imaging devices have different color spaces. For instance, printers generally have a smaller color space than monitors. In a properly calibrated system, each imaging device attached to a computer would have a profile, which is a file stored on the computer that describes how each device handles color.

There are two common color spaces used by digital cameras: sRGB and Adobe RGB. Almost all digital cameras are sold with the default color space set to sRGB (or "Super Red Green Blue") and although this sounds like a good option from its name, it is in fact very limited as it was developed to represent the limited color palette that can be displayed on the monitors of most computers.

Adobe RGB (which is also referred to as Adobe RGB 1998) is a wider color space than sRGB, which means it is capable of capturing more color tones, especially in the blue and green regions. It is also Photoshop's default working color space, although its color range (or "gamut") is often larger than the color space of most monitors and printers. However, by using profiles for the monitor and printer, Photoshop can translate between the devices using Adobe RGB as a bridge. Theoretically, this means that the colors you record will be the colors you see on your screen, which will in turn closely match the colors in a print.

When you shoot JPEG images, the color space you have set on your camera will be tagged to the file. It is

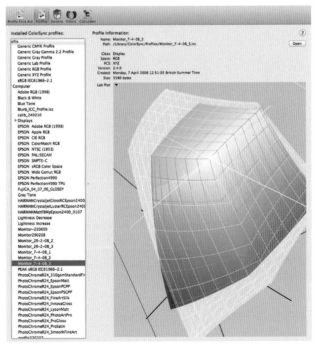

< < sRGB VERSUS ADOBE RGB
As this illustration shows, the sRGB color space records less data than Adobe RGB, although the difference is mainly in the green-blue areas.

< GRAPHS
Running ColorSync on a Mac allows you to compare the color spaces installed on the system. This is a monitor color space—the gray wireframe box around it is the Adobe RGB space, which is clearly much larger.

easy to convert an Adobe RGB image to sRGB (as the sRGB color space is smaller), but you cannot convert an image that was originally captured in sRGB to Adobe RGB and recover the missing colors.

Raw files do not have an embedded color space, which gives you the flexibility to choose which one to use when you process your images.

∧ **GET THE BLUES**
Adobe RGB's color gamut encompasses more blue/green hues than sRGB, making it the preferred choice for landscape images, or photographs such as this cool-colored seascape.

CHAPTER 2
LENSES

Introduction to Lenses

If you have recently bought your first system camera, choosing, buying, and using interchangeable lenses will be a new experience, but lens choice has a massive impact on the way you will be able to capture a scene or subject.

Regardless of whether you are a beginner, amateur, keen enthusiast, or professional, an understanding of lenses is important if you wish to realize their full potential. When you buy a system camera, you are not simply purchasing a camera, but investing in a whole "system." One of the biggest advantages of a system camera, compared with a digital compact, is the ability to change lenses. This allows photographers to select the lens and focal length best suited to the subject or situation.

With the exception of the Micro Four Thirds system, lenses can't be swapped from one make of camera to another, due to the different mounts employed by the various manufacturers. However, this is not necessarily a problem, as each brand offers a wide range of optics designed to fit its dedicated lens mount. In addition to this, third-party lens makers, such as Sigma, Tamron, and Tokina, produce lens ranges in different camera mounts to fit all the popular brands. As a result, you will not be short of options.

Many cameras come with a kit lens, which is typically a wide-angle to short telephoto zoom. These lenses are a good starting point when you begin your photographic journey, but they are generally not the best of their kind. One of the problems with a kit lens is its relatively small maximum aperture—it is difficult to produce a zoom with a large maximum aperture economically. Small maximum apertures result in darker viewfinders and less efficient autofocus, and—in terms of technique—it is more difficult to achieve selective focus effects. However, zoom lenses with large maximum apertures tend to be very expensive and also very heavy as more glass is used in their construction. As with most aspects of photography there are always compromises to be made when buying lenses.

With so much choice, buying a new lens can prove daunting. It is a big decision and a substantial investment. Despite this, many photographers still deliberate far longer over which camera to buy than they do when choosing a lens. But before parting with your cash, it is important you understand how lenses work, the benefits and drawbacks of different focal lengths, and which subjects they suit best. For instance, do you opt for a prime or zoom lens; one with image stabilizing technology or not; and how do you best clean and care for lenses? These are the type of questions we will answer here.

∧ **LENS MOUNT**
With a single half-turn of the lens, a bayonet mount allows photographers to attach and detach optics quickly and easily. Each camera brand employs its own mount, so lenses are not generally interchangeable or compatible with other systems.

BASIC THEORY OF LENS OPERATION

Light strikes the front surface of the lens and passes through the glass element. Since light rays bend when they enter glass at any angle other than 90 degrees, they change direction. This effect is known as refraction. By employing various glass shapes in their design, lenses are able to channel the light in a specific direction. Focusing occurs because the adjustable elements of the lens are able to precisely control the light's direction so that the rays converge at one point—on the camera's light-sensitive array.

< MARBLED WHITE BUTTERFLY
Lenses are available in a wide variety of focal lengths, from circular fisheyes, to long, powerful telephotos of 1000mm or more. There are hundreds of lenses currently available to buy, made by various camera and third-party manufacturers. There are many more—both existing and discontinued models—available secondhand, which are perfect for photographers on a budget. Your lens choice will have a huge influence on the look of the final image. In this instance, a macro lens was the right choice for this close-up.

∨ ON REFLECTION
Only by having a good understanding of lenses can you expect to make good decisions when buying and using them. Focal length has a huge impact on composition and the look of the final image. This chapter will help you make the most of your system—both your existing lenses and those you intend to buy in the future.

∧ EVENING LIGHT
Selecting the most appropriate lens is an intuitive skill. At first, new photographers might need to make a conscious decision regarding focal length. However, with just a little time and experience, you instinctively grow to know which focal length will suit which subject. This Cornish beach scene is ideally suited to an extreme wide-angle lens, for example.

More importantly, a good understanding of a system camera's lenses will also help you realize the full, creative potential of your optics once you have them, regardless of whether they are new or part of your existing system. This will allow you to be more creative, and enable you to take more control over your photography. After all, a camera is effectively just a light-tight box—it is the focal length, speed, and quality of the lens that is attached to it that is of arguably greater importance.

Lens Anatomy

Despite the sophistication of modern optics—and the technology incorporated within them—camera lenses remain relatively basic on the outside with few controls. However, it is still important to be familiar with the features of a lens in order to get the most out of your system.

1 Filter thread

The vast majority of optics are designed with a thread, of a certain diameter, at the end of the lens barrel. This allows the attachment of screw-in filters or a filter holder.

2 Focusing ring

This is the manual focus ring. While many photographers prefer using automatic focusing (AF), this ring allows you to override AF and focus manually.

3 Zoom ring

Naturally, this is a function only found on zooms and not prime lenses. This ring allows the focal length of the lens to be altered. Rotating the ring on the lens barrel causes the optical elements within the lens to move accordingly.

4 Aperture ring

The aperture ring is linked mechanically to the lens diaphragm to allow the aperture to be set manually. Few lenses today still feature an aperture ring, as aperture selection is typically made via the camera itself.

5 Lens mount/contacts

This enables the lens to be mounted to a compatible camera body with fully automatic coupling. A lens-mount index—normally a red or white dot—is included on both the camera and lens to indicate how the lens should be fitted.

6 Distance scale

This is a scale on the lens barrel—in units of meters and feet—that indicates the distance between the subject and the camera. On some models, the depth of field at a given aperture is also marked.

7 AF/MF switch

This switch allows the photographer to select either auto focus (AF) or manual focus (MF) mode. Some lenses have the additional feature of allowing manual focusing override while in AF mode.

> **DARTMOOR PONY**
Long focal lengths will allow
you to photograph your subject
(or specific details) in isolation.

Lens Technology

If you are relatively new to photography you will find talk about lenses is littered with jargon, which can seem daunting or confusing at first. Here are brief descriptions of some of the most relevant and frequently employed lens terms.

Angle of view

This is a measurement—stated in degrees—of the amount of a scene that can be recorded by any given lens. It is directly related to the lens' focal length and is usually provided as a diagonal measurement across the image area. The size of the digital sensor has an effect on the angle of view.

Aperture

The lens aperture is the adjustable opening through which light passes to expose the digital sensor. The lens diaphragm governs the aperture stop, controlling the effective diameter of the lens opening—functioning like the iris of an eye. The aperture also affects depth of field.

Elements

An element is an individual piece of glass that makes up one component of a lens. Camera lenses are constructed from multiple individual elements assembled together inside a cylindrical barrel. Elements are often assembled closely together to form a "group."

Field of view

The term field of view is often used interchangeably with angle of view. However—technically speaking—it shouldn't be, as the field of view is a linear measurement that is also dependent on the subject distance.

Focal length

In basic terms, the focal length of a lens is the numerical value in millimeters that indicates its power and angle of view. The smaller the number, the wider

the field of view; the larger the number, the narrower the angle of view. For example, a 28mm lens has an angle of view of 84 degrees, while a 300mm lens has an angle of view of eight degrees. Quite simply, focal length indicates the lens' power. A zoom lens has an adjustable focal range.

For the more technically minded, the focal length is given as the distance between the focal plane and the rear nodal point of the lens, given infinity focus.

Focal plane

This plane is perpendicular to the axis of the lens and results in the sharpest point of focus. The focal plane represents the area in a camera where the light is focused. The digital sensor is positioned on the focal plane.

Focus

This is the point at which an image, projected onto the sensor by the attached lens, is properly defined and details appear clearly. When an image is sharply defined it is said to be in focus; if it is not, then it is out of focus. A lens needs to be focused, either automatically or manually, to obtain focus.

Lens mount

This is the attachment system used to couple a lens to an interchangeable lens camera. Most cameras employ a bayonet mount system, enabling interchangeable lenses to be attached and removed quickly and easily. Typically, lens mounts are incompatible between camera systems—for example, a Nikon lens will not fit a Canon camera or a Sony camera.

∧ **THE FRONT ELEMENT**
A lens is constructed from multiple pieces of optical glass, which are known as "elements." The complexity of a lens—the number of elements and their degree of asphericity—depends upon its angle of view and maximum aperture (speed). Because the front element is exposed, it is important to care for it—avoid touching the glass and try to keep it protected from dirt, dust, or moisture.

∧ MINIMUM FOCUSING DISTANCE
Every lens has a minimum focusing distance. This indicates
how close the lens can be to the subject and still achieve sharp
focus. By shooting at a lens' minimum focusing distance, you also
effectively magnify the subject more.

Minimum focusing distance

This indicates how close the lens can be placed from
the object while still being able to achieve sharp focus.
The distance is measured from the vertex of the front
glass of the lens. A lens' minimum focusing distance
varies from one lens to the next and can range from
just a few centimeters to several meters. Shorter focal
lengths generally have a smaller minimum focusing
distance than longer telephotos.

Prime lens

A prime lens has a fixed focal length—for example a
28mm, 50mm, or 135mm lens. The term "prime" has
come to be used as the opposite of zoom.

Standard lens

A standard—or normal—lens is one that delivers an
angle of view that is roughly equivalent to our own eyes.
This equates to a focal length of 50mm on a full-frame
or 35mm camera. A zoom lens that includes 50mm in
its range is normally considered to be a standard zoom.

Telephoto lens

A telephoto lens is a lens with a narrower angle of view
than the human eye, so technically speaking, any lens
upward of 50mm is a telephoto. However, we typically
think of telephotos as being longer and more powerful
—for example, 200mm, 300mm, and 400mm are all
popular telephoto lengths.

Wide-angle lens

The human eye has an angle of view of approximately
46 degrees; a wide-angle lens has a larger angle of
view than this. Typically they have a focal length of
35mm or less and an angle of view of 60–108 degrees.

Zoom lens

Zoom refers to a type of lens with a mechanical assembly
of lens elements that has the ability to vary focal length—
and therefore the angle of view—as opposed to being a
fixed focal length (prime) lens.

∧ STANDARD LENS
A 50mm "standard lens"
makes a great walk-around
lens, thanks to its combination
of light weight and a fast
maximum aperture.

Choosing a Lens

It is difficult to offer advice on choosing a lens, since much will depend on your own personal budget, demands, and the type of subjects you want to photograph.

The best general advice is to buy the best lenses you can afford. This might seem obvious, but it is surprising just how many people will blow their budget on a camera and then have to scrimp on what they spend on accompanying lenses. Doing so is false economy, as without good-quality glass, you cannot realize your camera's full potential.

The first question to ask yourself is which focal lengths you need? Your answer will largely depend on your requirements and the subjects you intend shooting. One of the great advantages of photography with a system camera is that you are not restricted to just one focal range—you can add different focal lengths and expand your system whenever you wish to. Ultimately, most photographers will build a system of several different lenses, covering a wide range of focal lengths. Unfortunately, the majority of us can't afford or justify buying three or four lenses at once, so you may well have to build your system over several years, prioritizing in the first instance.

If you are new to photography, it is best to start with a standard lens. Most new cameras are sold with a short, standard zoom, but as already mentioned, these tend to be fairly basic. Therefore, in the long term, you may wish to replace your kit lens with a higher-quality version.

Unless you intend to photograph sports or action, there is no need to invest in a long, fast telephoto lens, which can prove very costly. However, most photographers will

want to shoot distant subjects or capture frame-filling images. Therefore, some sort of telephoto is a good lens to invest in next. An excellent option is a telephoto zoom covering a range of around 70–300mm. This is a versatile focal length range that will prove useful for photographing a wide range of subjects.

If you can only justify buying two lenses, a standard zoom and telephoto zoom are the most practical, useful options. Together they will cover a broad range from 35mm to 300mm, enabling you to capture most subjects. However, a wider lens is a great addition to any photographer's kit bag—particularly if you like shooting landscapes—so make this your next priority. Once you own these core focal lengths, you might want to expand your camera's capabilities further by investing in a more specialist lens, such as a macro lens.

Independent Lens Brands

Each camera manufacturer produces a wide range of dedicated lenses to fit its system camera bodies. Manufacturers will naturally recommend you invest in their lens range, but they can prove more costly than third-party brands. Therefore, if budget is an issue, don't overlook independent makers, such as Sigma, Tamron, and Tokina. Today, the build and optical quality of their lenses can often rival that of the camera manufacturer, yet they typically cost less. The majority of independently made lenses boast full compatibility with the camera's automatic functions (although it is always wise to check before buying) and all the leading brands produce them in the most popular camera mounts, including the Micro Four Thirds system.

Digital-Specific Lenses

The way in which a digital sensor records light is different to film. In film photography, light falling on the film is recorded accurately across the frame irrespective of the angle of incidence. However, the imaging sensor employed in a digital camera is a microchip with photodiodes laid out at regular intervals on a grid. These light-sensitive photodiodes sit in depressions, meaning that light can only reach them effectively if it comes through the lens from straight ahead. As a result, should

you attach an older—non-digital-specific—lens to your camera, insufficient light may reach the periphery of the sensor and this can degrade image quality. The wider the angle of view of the lens, the worse the effect is likely to be. To combat this effect, the latest models are designed specifically for use with digital cameras. Often they are of a "telecentric" design, which means light falls on the sensor as close to 90 degrees as possible.

Lenses For Cropped Sensors

The majority of consumer system cameras are designed with a sensor that is smaller than a traditional, standard 35mm frame (typically APS-C). Manufacturers have produced a new breed of optics designed specifically for these cropped-type sensors. Typically, they are ultra wide-angles of 10mm upward, designed so that the lens' image circle matches the smaller size of the image sensor. Their specialized design gives these lenses the ideal properties for the cameras they are made for, and their construction is more compact and lightweight. However, this type of lens isn't fully compatible with a full-frame camera, which could make a lens redundant if you were to later switch from an APS-C camera to a full-frame model.

∧ **COMPATIBILITY**
Many of today's lenses are designed for use with digital cameras. This wide-angle portrait was taken using a Tamron 18–270mm ultra-high-power zoom lens, which boasts a remarkable 15x zoom ratio. It is one of Tamron's Di II—Digitally Integrated—range, which are only compatible with cameras housing an APS-C-sized chip.

Prime Vs. Zoom

There are two types of lens: prime and zoom. Prime—or "fixed"—lenses have a specific focal length that cannot be altered, while a zoom lens has an adjustable focal length, allowing photographers to choose from a range of lengths without having to physically change lenses.

< PRIME LENSES
If a camera comes with a kit lens, it is usually a zoom. For most photographers the biggest advantage of a zoom—the ability to precisely frame a shot by changing the focal length—outweigh the disadvantage of a (usually) relatively small maximum aperture. Prime lenses—lenses with a fixed focal length—generally have wider maximum apertures. In certain conditions, a prime lens set close to maximum aperture will allow you to handhold your camera without resorting to an unnecessarily high ISO setting.

∧ PRIME LENS
Fixed focal lengths might seem outdated, but they still have much to offer. Their high optical quality and fast, fixed aperture make them appealing to enthusiasts. They are available in short focal lengths—such as this prime 35mm lens—up to long telephotos exceeding 1000mm.

Prime

When zoom lenses were first introduced, their optical quality was undeniably poor. This meant prime focal lengths remained the only practical choice for serious photography. However, today's zooms offer such high image quality that many amateurs overlook fixed optics altogether, citing their lack of flexibility as the reason. At first glance, having a fixed range—28mm, 50mm, 100mm, 135mm, 200mm, and 300mm are all popular fixed focal lengths—might seem limiting, but prime optics continue to offer much to today's photographer.

Most significantly, prime lenses still just have the edge over zooms in terms of optical quality—particularly at wide apertures, giving them an advantage in low light. This is because fewer compromises have to be made in their optical design. Fixed lenses also tend to have a faster—and fixed—maximum aperture, creating a brighter viewfinder image, and are generally more compact, too. However, on the downside, photographers need to carry more lenses in order to cover a wide range of focal lengths. This can prove expensive and—if walking far—impractical due to the added weight and bulk of lugging around so much equipment.

It is often presumed that a fixed lens' biggest drawback is its lack of flexibility. However, this is also one of its greatest benefits. Using a fixed focal length can make you a more creative photographer, as it forces you to physically adjust your shooting position to frame the image precisely. As a result, it could be argued that prime lenses help ensure you don't grow lazy or complacent.

∧ SIZE
An advantage of prime lenses is their weight. Some, such as Panasonic's 20mm "pancake" lens, weigh almost nothing compared to a zoom lens.

18mm

270mm

∧ **FISHEYE ZOOM**
Canon's 8–15mm f/4 fisheye zoom lens is a unique optic.

∧ **ZOOM RANGE**
Zooms are wonderfully versatile and useful in a wide variety of shooting situations. You can create very different results by simply adjusting the focal length. These two images help illustrate the contrasting results possible using a zoom—in this instance, images were taken from the same position using both the short and long end of an 18–270mm zoom lens.

Zoom

A zoom lens covers a range of focal lengths in a single lens, so its biggest advantage is flexibility and convenience—by simply twisting or sliding the zoom collar you can precisely select any focal length within the lens' range. Consequently, a zoom lens can replace several prime optics, meaning you don't have to buy (or carry) extra lenses. Nor do you incur so many delays caused by having to change lens, which minimizes the amount of dust and dirt entering the camera body and settling on the sensor or low-pass filter.

Zooms are available in a wide variety of lengths, from ultra wide-angle 10–20mm zooms to powerful 300–800mm telezooms. Some of the most popular ranges are 17–50mm, 18–70mm, 55–200mm, and 70–300mm, but every brand offers a wide variety of zooms within its lens range to cater for the needs of different photographers.

Zoom lenses are often described using the ratio of their shortest-to-longest focal lengths. For example, a lens with a range from 100mm to 300mm will often be retailed as a "3x zoom." The term "superzoom" or "hyperzoom" is used to describe zooms boasting large focal length factors—up to 10x or greater. For example, an 18–200mm zoom has an 11.1x zoom range.

In the past, photographers chose primes over zooms due to their superior optical quality, but thanks to modern

lens technology this is no longer the case. However, zoom lenses tend to have smaller apertures than prime lenses within the same focal length range, forcing slower shutter speeds, increased depth of field, and the need for a tripod or other firm support. In addition, these lenses can make photographers lazy—to get closer to a subject move your feet first and then the zoom ring.

∧ **TELEPHOTO ZOOM**
Today, zooms are available in almost every imaginable length. This is a 150–500mm telephoto zoom made by Sigma. While large and expensive, it maintains high image quality throughout its focal length range. Its maximum aperture of f/5.6–6.3 makes it well suited to wildlife, sports, and action photography.

Tip

If you opt for zoom lenses, buy two or three lenses covering shorter focal length ranges, rather than a single all-purpose superzoom that covers them all. This is because compromises have to be made in the construction of a zoom lens boasting a large focal length range of 10x or more.

∧ **STANDARD ZOOM**
This Carl Zeiss 16–70mm standard zoom is designed for Sony's E-mount cameras, offering a 24–105mm focal length equivalent.

Focal Length

The focal length of a lens determines not only its angle of view, but also how much the subject will be magnified.

The focal length of a lens is the distance in millimeters from the optical center of the lens to the focal plane when a subject at infinity is in focus. The focal plane is where the sensor in your camera is located.

The angle of view of a lens is the angular extent of the image projected by the lens and recorded by the sensor in your camera. The angle of view is dependent on the focal length of a lens and on the size of the sensor.

As its name suggests, a wide-angle lens captures a wide angle of view. This results in elements of the picture appearing spatially farther apart. The longer the focal length, the smaller the angle of view, but the more the image is magnified, bringing your subject "closer" to you. Longer lenses are referred to as telephotos.

Ultra Wide-angle (14–20mm)

These lenses have a huge angle of coverage, although the resulting images can look decidedly unnatural. This is because straight lines become curved and the spatial relationships between elements of the scene are distorted. It's not recommended to use an extreme wide-angle lens as a portrait lens unless for effect.

Wide-angle (24–35mm)

Perspective is less distorted than with an extreme wide-angle lens, but can still look unnatural, particularly for portraits. Landscape photographers commonly use wide-angle lenses to create a sense of space.

Standard (50–70mm)

A standard lens is one that is generally thought to produce an image that most closely resembles how we perceive the world. Perspective looks natural and spatial relationships are normal.

Telephoto (85–200mm)

Perspective appears more compressed due to the increased working distance, resulting in objects in a scene appearing closer together. Telephoto lenses are useful when single objects at a distance need to be isolated from their surroundings.

Extreme Telephoto (300mm–greater)

Perspective becomes very compressed and objects that aren't necessarily close spatially can look "stacked" together. A very narrow angle of view means that objects are isolated from their background and become the most important (and often the only) element in the image.

∧ **FOCAL PLANE**
The symbol used on a camera body to show the position of the sensor or film plane.

Horizontal lens angle of view and sensor size

Focal length	Sensor size							
	1/2.5in.	1/1.7in.	2/3in.	Nikon CX	Four Thirds	APS-C (1.5x)	APS-H	Full frame
6mm	51°	65°	72°	96°	110°	126°	135°	143°
10mm	32°	42°	48°	67°	82°	99°	110°	122°
14mm	23°	30°	35°	51°	64°	80°	91°	105°
18mm	18°	24°	28°	41°	51°	66°	77°	90°
24mm	14°	18°	21°	31°	40°	52°	62°	74°
28mm	12°	16°	18°	27°	34°	46°	54°	65°
35mm	9°	12°	14°	22°	28°	37°	45°	54°
50mm	7°	9°	10°	15°	20°	27°	32°	40°
80mm	4°	5°	6°	10°	12°	17°	20°	25°
100mm	3°	4°	5°	8°	10°	13°	16°	20°
150mm	2.2°	3°	3.4°	5°	7°	9°	11°	14°
200mm	1.7°	2.2°	2.5°	4°	5°	7°	8°	10°
250mm	1.3°	1.7°	2°	3°	4°	5°	7°	8°
300mm	1.1°	1.5°	1.7°	2.5°	3.3°	4.5°	6°	7°
400mm	0.8°	1.1°	1.3°	2°	2.5°	3.4°	4°	5°
600mm	0.6°	0.7°	0.8°	1.3°	1.7°	2.3°	2.7°	3°

Highlighted numbers indicate the approximate focal length for a standard lens for the sensor.

> FOCAL LENGTH

This simple focal length comparison sequence helps illustrate the effect that focal length can have. The images were all taken from the same shooting position—only the focal length changed.

Tip

Focal length can have an impact on how easy it is to achieve a sharp, handheld photograph. Longer focal lengths require faster shutter speeds in order to minimize any blurring caused by the photographer's natural movement.

Note

The focal length of a lens affects the depth of field achievable at a given aperture: longer focal lengths produce less depth of field.

10mm

20mm

35mm

50mm

70mm

110mm

200mm

300mm

Λ ULTRA-WIDE ANGLE
As this photograph demonstrates clearly, distant objects recede
dramatically when using an ultra wide-angle lens.

⋀ TELEPHOTO

The longer the focal length, the more "stacked" the elements of your photo will look. The buildings in this photo appear to be almost on top of each other, although in reality they are spatially distant.

Crop Factor

The vast majority of entry-level and consumer DSLRs employ an APS-C size sensor, which is smaller than the 35mm standard. Micro Four Thirds cameras have a smaller sensor size as well. In each case, this creates what is known as a "crop factor."

As mentioned earlier there is a wide range of sensor sizes employed by camera manufacturers. The largest sensor commonly used (excluding medium-format digital cameras) is the full-frame sensor, which is the same size as the 35mm film format. 35mm film cameras first made an appearance in the 1920s and became the standard for small, handheld cameras until the arrival of digital. Photographers familiar with the particular angle of view of lenses fitted to 35mm film cameras therefore tend to prefer to use full-frame cameras.

However, if you use a camera with a smaller sensor (such as an APS-C sensor), the angle of view of the lens is reduced—an APS-C sensor has a crop factor of 1.5x (1.6x for Canon), while Micro Four Thirds cameras have a 2x crop factor. Therefore, if you fit an 18–55mm lens onto an APS-C camera, it will have the equivalent angle of view to a 27–82mm lens on a full-frame camera, while the same lens on a Micro Four Thirds camera would have a 36–110mm equivalent focal length.

In practical terms, this means that a wide-angle lens will be less wide when used with a cropped sensor camera than when used with a full-frame camera. However, a telephoto lens will have greater apparent magnification as compensation. Depending on the subject you are photographing, this can prove either advantageous or disadvantageous. For example, traditional wide-angle lenses lose their characteristic effect, meaning an even shorter focal length has to be employed to retain the same field of view. However, when photographing distant subjects, such as sport, wildlife, and action, the multiplication factor can be hugely beneficial and desirable.

It's important to note, though, that the focal length of lenses doesn't change—just the angle of view. Depth of field at a particular focal length and aperture is the same regardless of what camera a lens is fitted to.

Note

The crop factors of the different sensor sizes can be seen in the grid on page 19.

< **CROPPED**
This image was shot with a full-frame camera and a lens set at a 30mm focal length. If the same lens were fitted to an APS-C camera the angle of view would be restricted to the red box. The blue box shows the angle of view of a 30mm lens on a camera with a 1/1.7-inch sensor.

> CROP FACTOR

Cropped-type sensors have a significant impact on focal length, effectively increasing the power of your interchangeable lenses. This is advantageous when photographing timid wildlife and distant subjects. The effect of using an APS-C size sensor (top right), compared with a full-frame model (bottom right), is obvious.

Perspective

The world is three dimensional, yet photographs only represent two dimensions. Despite this, our brain recognizes the elements within an image to determine scale, distance, and depth.

The appearance of perspective is dictated by the camera-to-subject distance and, to some extent, focal length. An understanding of perspective is important, enabling you to create, control, and manipulate it in order to produce striking compositions.

Perspective refers to the appearance of depth or spatial relationships between objects within an image. The human eye judges distance through the way elements within a scene diminish in size, and the angle at which lines and planes converge—if we look down a railroad track, for example, our eyes perceive the tracks to meet at a distant point on the horizon. Perspective is a powerful compositional and visual tool, which you can utilize to create the impression of volume, space, depth, and distance.

The more a photographer is able to control the transition from 3D to 2D, the more control they have over the look of the final image. Strictly speaking, perspective is controlled solely by the camera-to-subject distance. Moving farther away will compress the appearance of foreground-to-background space (between given points), making subjects that are apart look closer together. Moving closer will exaggerate the foreground-to-background distance between certain elements; stretching the appearance of perspective and making foreground subjects look far larger and more dominant than those behind.

The reason why many photographers falsely believe that perspective is altered simply through focal length (wide-angles are generally thought to exaggerate perspective, while telephotos flatten it) is simple to explain. It is due to the fact that, in order to render a given subject exactly the same size in the frame using both short and long focal lengths, the photographer would be forced to move closer or further away from the subject, resulting in a shift in perspective.

However, lens choice clearly has a huge impact on the way perspective is recorded. For example, when using a short focal length to photograph a nearby subject, background objects appear farther away from the main subject. This is because, when we focus closer, the distance between the lens and foreground and background objects changes proportionally. The closer object will appear bigger and more dominant in the frame, while the object farther away will seem smaller—thus creating the effect of exaggerated perspective. In fact, using a short focal length, together with a close approach, is a popular technique—drawing attention to the main subject or creating a "distorted" view of the scene. Similarly, using a telephoto lens doesn't actually compress perspective; it just creates that impression.

By using the right combination of camera-to-subject distance and lens focal length, a photographer can create a picture that looks deep or shallow. While the feeling of depth or shallowness may only be an illusion, it is an important visual tool.

Tip

Shoot your own comparison sequence. Maintain the subject's size in the frame, but vary the camera-to-subject distance (and focal length) with each subsequent frame. Doing so will help you to appreciate the affect of perspective and how it can be used in your photography.

Note

Although perspective appears to change with focal length, this is not the case. If you cropped an image taken using a wide-angle focal length so that it matched an image taken from the same position with a much longer focal length, you would discover that the two are, in fact, identical.

18mm

28mm

35mm

50mm

75mm

100mm

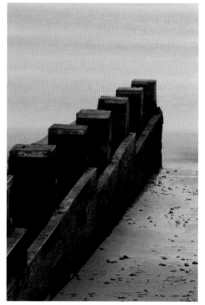

200mm

∧ < **PERSPECTIVE AND FOCAL LENGTH**

Perspective is determined by the camera-to-subject distance and relates to the size and depth of subjects within the image space. Look at this sequence of images and you will notice that although the size of the principal subject remains largely unchanged, its appearance and relationship to its surroundings alters considerably.

Ultra Wide Angle

Any focal length of less than 35mm is deemed to be a wide-angle, but thanks to modern lens design, wide-angle lenses are getting even wider.

Ultra Wide-Angle Lenses

Full-frame sensor range: 14–20mm (fisheye 8–15mm)

Cropped sensor range: 8–15mm (fisheye 4.5–10mm)

Ultra wide-angle lenses have an enormous angle of coverage. At the most extreme end of this scale are fisheye lenses, which are lenses with an angle of view not less than 180 degrees. Often, this is measured diagonally, but there are fisheyes available that have a 180-degree angle of view in all directions, creating a circular image space within the center of the viewfinder. This means there are two types of fisheye—circular and "full frame."

When using a circular fisheye lens, the 180-degree angle of view is projected onto the sensor as a circle within the rectangular image space (as seen in the oxeye daisy image on page 52). However, when the popularity of using fisheye lenses grew for general, everyday photography, manufacturers began producing them with an enlarged image circle, circumscribed around the entire frame so they give a rectangular image. This type of fisheye lens means less of the image space is wasted. By their nature, fisheyes display progressive distortion toward the periphery of the image.

Ultra wide-angle lenses are less extreme than fisheyes, but still deliver a very wide angle of view—Sigma's 12–24mm zoom offers a 122 degree angle of view at its widest focal length setting, for example. With most lenses of this type, this results in severe levels of distortion within the image: straight lines are rendered as curves and the spatial relationships between elements of the scene are highly exaggerated. Ultra wide-angle lenses are often used for effect to create an extreme sense of space, but compositionally they can be difficult to use, as a scene can look very empty unless care is taken to get close to your subject. This type of focal length is rarely used as a portrait lens, as the spatial distortion is very unflattering.

∧ **FISHEYE**
A variety of fisheye lenses is available to buy. Sigma's 4.5mm circular fisheye is the first circular fisheye lens designed exclusively for DSLRs with an APS-C-sized image sensor.

∧ **ULTRA WIDE ANGLE**
Sigma's 12–24mm ultra wide-angle zoom will work on both full-frame and cropped-sensor cameras. On a full-frame camera the angle of view is an ultra-wide 122–84.1 degrees.

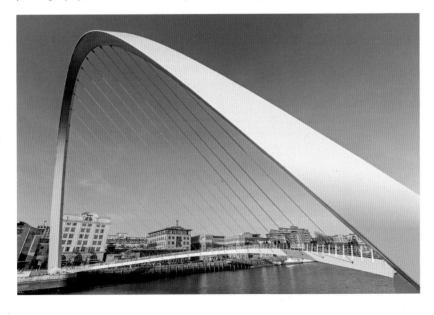

< **ULTRA WIDE**
Very wide-angle lenses are useful when large subjects need to be squeezed into the image space. However, distortion at the extreme corners can be a problem.

< NATURAL ENVIRONMENT
Ultra wide-angle lenses can be used to exaggerate foreground elements, while giving context to natural subjects such as plants and fungi. For this shot a 10–20mm ultra wide-angle zoom was used.

∧ DISTORTION
Looking up with a 20mm ultra wide-angle focal length clearly shows the extreme distortion this type of lens possesses, but here it adds a dramatic perspective to the shot.

< LOW DOWN
If you really want to emphasize lines in a landscape, shooting low down with an ultra wide-angle focal length (here 17mm) is one of the most dramatic ways to achieve this. Getting down low also helps you fill the foreground.

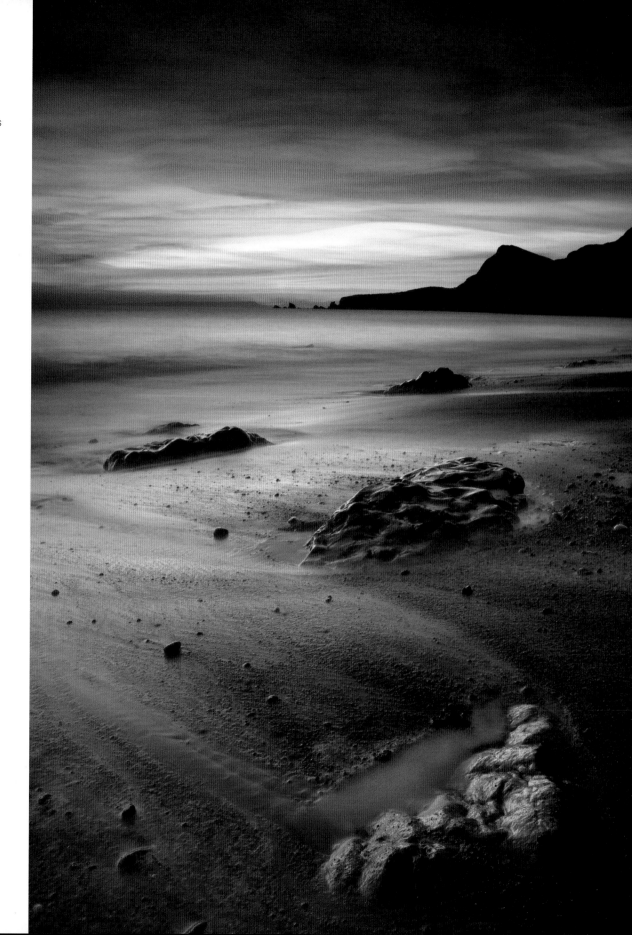

< OXEYE DAISIES

You can achieve some stunning effects using a fisheye lens. In this instance, lying prone on the ground and angling the camera upward to photograph these oxeye daisies gave a "worm's eye" perspective against the blue summer sky.

> KEEP COMPOSITION SIMPLE

Wide-angle lenses are well suited to shooting sweeping views and "big landscapes," but it is normally best to keep images simple and arrange the key elements in a logical, visually pleasing order.

Wide Angle

Wide-angle lenses are one of the most popular and useful lens types—no kit bag should be without one, as their unique characteristics can suit practically any subject.

Wide-Angle Lenses

Full-frame sensor range: 22–35mm
Cropped sensor range: 17–24mm

As the name suggests, wide-angle lenses have a wide angle of view. Another defining characteristic is that spatial relationships between elements of a scene are extended and exaggerated: distant objects will seem smaller and further away than with the naked eye.

Wide-angle lenses create images that are arguably more involving for the viewer. It's easier to create a sense of depth with a wide-angle lens than with a telephoto lens, as images created with a wide-angle lens will likely contain foreground, mid-ground, and background details.

The more restricted angle of view of a telephoto makes this harder to achieve. Wide-angle lenses also have inherently greater depth of field at a given aperture, so front-to-back sharpness is less of a problem with a wide-angle lens than it is with a telephoto. The exaggeration of space can add drama to an image shot with a wide-angle lens. Any lines in an image, real or implied, will appear to recede more quickly than when shot with a longer lens.

However, getting the exposure right with wide-angle lenses can be tricky, as the intensity of light across a scene can vary considerably, especially when photographing landscapes. This will be reflected by uneven exposures in your image.

∧ WIDE ANGLE
This 24mm Nikon wide-angle prime lens combines a wide angle of view with a fast maximum aperture of f/1.4.

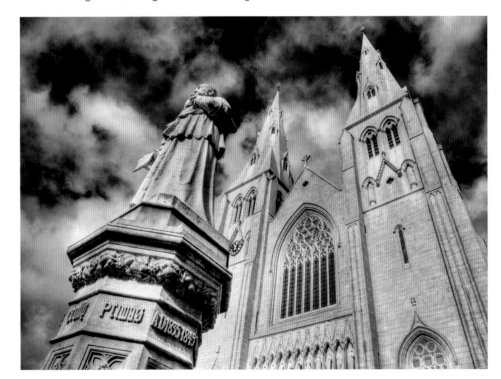

< WIDE ANGLE
Pointing your camera upward, with a wide-angle lens can create a dramatic perspective.

> ### Tip
>
> When using short focal lengths, camera-mounted flash may not spread widely enough to evenly illuminate the full coverage of the lens. To alleviate the problem, attach a diffuser or wide-angle adapter over the flash.

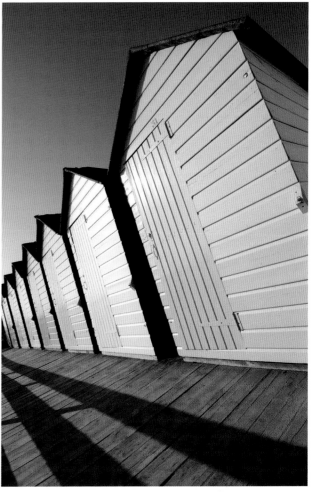

∧ CONVERGING VERTICALS

Converging angles can create striking, dynamic results. However, equally, it can be undesirable and degrade photographs of buildings. The effect is most likely, and pronounced, when using a wide-angle lens near to the subject—whether you try to minimize the effect or emphasize it creatively is down to personal taste.

∧ DISTANT

Wide-angle lenses have the effect of making distant objects appear farther away than would be the case if you were looking at the scene with your own eyes. This is ideal for creating a sense of space, particularly when shooting landscapes, but it is usually important to include subject matter in the foreground to create interest, depth, and help lead the viewer's eye into the image.

Standard

A "standard" lens has a similar angle of view to the human eye, with a focal length approximately equal to the diagonal measurement of the sensor.

Standard Lenses

Full-frame sensor range: 35–50mm

Cropped sensor range: 25–35mm

On 35mm film and full-frame digital cameras the diagonal measurement of the film/sensor is 43mm, although 50mm became the default "standard" lens for 35mm SLRs (on APS-C cameras the standard focal length is closer to 28mm). Not so long ago, almost every new (35mm) SLR would be sold with a fixed 50mm lens, which would prove the cornerstone of a photographer's lens system.

A standard lens is compact and lightweight—so suited to being used handheld—and its focal length is useful on a day-to-day basis for general photography. They are also relatively inexpensive and normally boast a fast maximum aperture of f/1.4 or f/1.8, so gather more light than most other lenses. This not only provides a bright viewfinder image, but allows photographers to shoot in low light. Also, prime standard lenses are often superb optically, offering excellent sharpness and image quality.

However, in recent years the rise of good-quality, affordable zooms has meant that the prime "standard" has been greatly superseded, with consumers preferring the flexibility of a standard zoom. Small "standard" zooms typically have a range of 35–70mm (2x), 28–85mm (3x), or 24–105mm (4x) and today their optical quality is almost comparable. A prime standard lens shouldn't be overlooked, though—no other lens of this quality, speed, and sharpness is available for so little money.

While a standard lens might not have the dynamic, wide view of a wide-angle, or the magnification and power of a telephoto, this focal length shouldn't be considered boring. A standard lens remains an essential lens type for practically every photographer. Thanks

to the minimal distortion they display and the "natural" perspective they provide, a standard lens is suitable for a wide range of subjects, such as still life, landscape, and street photography. Indeed, some of the world's greatest photographers have relied extensively on the capabilities of a standard lens. For example, Henri Cartier-Bresson—one of the world's most celebrated photographers—employed a standard lens for more than half the images he took.

Tips

Due to the simple construction of a prime 50mm lens they are cheap to produce. They feature highly corrected optics and offer corner-to-corner sharpness, which a zoom is unable to match. They also have a fast maximum aperture. Their simplicity is suited to beginners and, as they have largely fallen out of favor with consumers, can often be bought at a bargain price.

Due to the multiplication factor of smaller APS-C-sized sensors, you will require a shorter focal length to achieve the same angle of view as a 50mm lens. There is a wide range of high-quality, inexpensive 35mm lenses that will provide a similar perspective to a traditional standard lens when attached to a cropped-type DSLR.

Attach a standard 50mm lens to a DSLR with a cropped-type sensor and the crop factor will mean that its effective focal length will be approximately 75–80mm. This is ideal for shooting flattering portraits.

∧ STANDARD ZOOM
The flexibility of using a standard zoom has greatly superseded the traditional prime 50mm lens. Most kit lenses supplied with new system cameras are standard zooms. Their versatile range makes them useful for general day-to-day photography.

∧ STANDARD PRIME
The traditional 50mm standard prime lens may seem outdated, but it is still a highly useful lens type. Its "natural" looking perspective is similar to what the human eye sees, and it is ideally suited to recording subjects faithfully. Standard lenses are normally fast, compact, and optically superb.

> SUNSET AND SILHOUETTE

A standard focal length is ideally suited to photographing all number of subjects. In this instance, the natural-looking perspective created by a normal lens suited this silhouetted folly against a colorful sunset.

∧ DOCUMENTARY

A standard lens is ideal for documentary-style images, as the angle of view closely matches that of the human eye. Because of this, photographs appear "natural."

∧ GET CLOSER

Standard lenses can be teamed with extension tubes and/or reversing rings to reduce the minimum focusing distance.

> DEPTH OF FIELD

The large maximum aperture of a prime standard lens means you can easily create a very shallow depth of field to concentrate attention on the important areas of a scene.

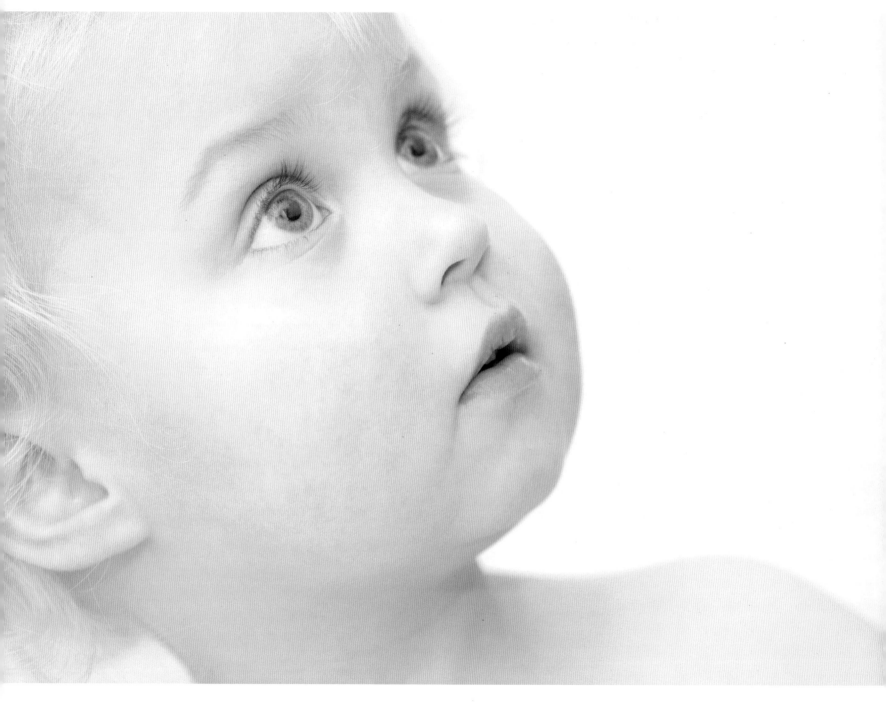

∧ PORTRAIT LENS
The crop factor on a camera with an APS-C-sized sensor means
that a 50mm prime lens will effectively behave like a 75mm or
80mm focal length, which is perfect for portraits.

> STILL LIFE

Not all still-life images have to be set up. "Found still life" refers to photographs of subjects that the photographer has chanced upon, rather than objects that have been prearranged. A standard lens is ideal for such studies.

Telephoto

Telephoto lenses get you closer to your subject, allowing you to shoot frame-filling shots of nearby objects, or to achieve intimate portraits of distant wildlife that would be otherwise impossible with a shorter lens.

Telephoto Lenses

Full-frame sensor range: 60–200mm
Cropped sensor range: 50–150mm

Telephoto lenses have a narrow angle of view, making them appear to magnify objects in the frame—much like a telescope. As a result, frame-filling pictures can be obtained at greater working distances than standard lenses, which is great for capturing sensitive subjects such as damselflies and reptiles. In 35mm terms, any lens with a focal length greater than 50mm is classed as a telephoto, but due to the crop factor on APS-C sensors, shorter, more affordable lenses can be used to achieve similar results.

Telephotos are available in a wide range of strengths, up to and exceeding 1000mm—although this type of specialist lens is not in the price range of the majority of photographers. Telephotos can be divided into two broad categories: short telephotos and long, or "extreme" telephotos. Short telephotos fall within a focal range of 60–200mm on a full-frame camera, or 50–150mm (APS-C). While not particularly powerful, this is still a useful and versatile range, which makes them suitable for shooting subjects from farther away, or in situations

when you can't get closer to your subject—sports events or public displays, for example.

A short telephoto produces a flattering perspective that is well suited to portraiture and isolating detail or interest within the landscape or urban environment. Telephotos create the impression of bringing foreground and background objects closer together—the opposite effect to using a wide-angle lens. This is known as "perspective compression" or "foreshortening" and the greater the focal length, the more the effect is exaggerated. However, this type of compression is purely an illusion—it is the camera's position that determines perspective.

Telephoto lenses also provide a relatively shallow depth of field—especially at wide apertures such as f/4 and f/5.6. Due to this limited zone of sharpness, telephotos are ideal for isolating a subject against a soft, blurry background or foreground. On the flip side, shallow depth of field increases the need for accurate focusing, so handholding a telephoto lens is rarely an option. In addition, these lenses tend to be rather large and heavy, confirming the need for a tripod or other firm support. Thankfully, many telephotos come with image stabilization (IS), although this is usually matched by a hefty price tag.

< ∧ **CANON 200MM PRIME AND SIGMA 70–200MM ZOOM**
Prime telephotos tend to offer the best image quality, and will normally have a faster maximum aperture than the equivalent telezoom. However, zooms are typically cheaper, more versatile, and physically smaller and lighter. Which type of telephoto you opt for will be dictated by your needs and budget.

TIP

The unique perspective of a telephoto lens allows photographers to capture striking and unusual compositions. However, one drawback of the foreshortening effect is that the results can appear quite flat—they often lack the three-dimensional feel of images taken with a wide-angle lens.

> STACKED

One of the most distinctive effects of using a telephoto lens is the "stacked" appearance of elements in an image. This spatial compression is useful if you want to pull the image elements together to suggest a relationship of some kind. In this image the photographer wanted to create an impression that—although the architecture is varied—the neighborhood is still close-knit.

> > BEECH AVENUE

Telephotos appear to compress perspective—making foreground and background objects seem much nearer to one another. This unusual perspective can prove a great compositional tool.

> BLURRY BACKGROUND

Due to the shallow depth of field, telephoto lenses are ideal for isolating a subject against a soft, out-of-focus background.

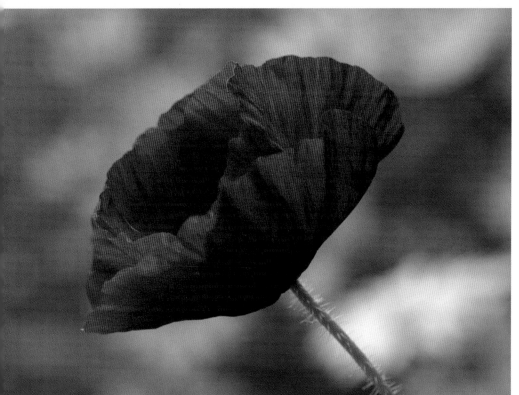

Extreme Telephoto

When photographing sports, action, or wildlife, a long telephoto lens is the principal tool, allowing you to capture frame-filling images from a distance.

Extreme Telephoto Lenses

Full-frame sensor range: 300mm+
Cropped sensor range: 200mm+

Extreme telephoto lenses are simply those with a longer focal length that have an even narrower angle of view and therefore greater magnification. The perspective of an extreme telephoto is very compressed and objects that aren't necessarily close spatially can appear even more "stacked" together.

Nature photographers and photojournalists most often use extreme telephotos as they allow them to fill the frame with the subject, without needing to get physically close to them. Extreme telephotos have a very narrow angle of view, which means that objects are often isolated from their background and thus become the dominant element in the image. The narrow depth of field of an extreme telephoto enhances this sense of isolation.

Sports photography is another genre where extreme telephoto lenses are used. The exact focal length you require will depend on the sport, any restrictions that may apply, and the style of image you wish to take, but focal lengths of 300mm and upward are commonly used. Their level of magnification is sufficient to take images brimming with impact and which make the viewer feel like they are among the action. However, when shooting sport, lens speed is also a critical factor. Lens speed refers to the maximum (largest) aperture of the lens: the quicker the lens, the faster the shutter speed you can select. The speed of the lens grows more important the longer the focal length is.

Teleconverters

Teleconverters (or extenders/multipliers) fit between the lens and the camera body, effectively increasing the focal length of the lens. The most common strengths are 1.4x (which increases the focal length by 40%) and 2x (which increases focal length by 100%). These extenders are popular with wildlife and sports photographers as they are lighter and more compact than extreme telephoto lenses, and relatively inexpensive.

However, as these accessories contain optical elements, there will always be slight degradation in image quality. In addition, teleconverters cause a certain amount of light loss—a 1.4x converter results in a 1-stop reduction in light, while a 2x converter causes a 2-stop reduction. If you're using a camera with TTL (through-the-lens) metering this loss will be catered for automatically, but it may lead to slower shutter speeds, and consequently the need for a tripod.

This loss of light can also create problems for autofocus systems, so it's best to switch to manual focus (MF) if the lens appears to be struggling. Some teleconverters are incompatible with certain lenses, so it's best to check before you buy.

∧ TELECONVERTER
By far the most common teleconverter strengths are 1.4x and 2x. This is Canon's EF 1.4x III Extender.

∨ EXTREME TELEPHOTO
Sigma's 800mm f/5.6 telephoto is the longest focal length lens the company makes, weighing in at a hefty 172.8 oz. (4900g).

∧ SERVING
An extreme telephoto allows you to get intimate action pictures at sporting events. Color will add impact to your shots, so try and position yourself carefully in order to achieve a complementary backdrop that is also free from distraction.

∧ ROBIN
Stalking is often the only practical way to get closer to wildlife. At parks and reserves, nature is much more accustomed to human activity and therefore more tolerant of you stalking them. They can prove good places to hone your skills.

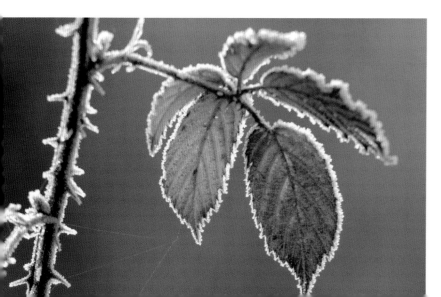

< BRAMBLE LEAF AND FROST
A clean, diffused backdrop is a characteristic of a long focal length. Use it to your advantage by isolating your subject from its surroundings. In this instance, a focal length of 300mm was intentionally selected in order to create a complementary out-of-focus background.

Macro

Close-up—or "macro"—photography requires specialist equipment, which can range from special adapters that will enable you to expand the capabilities of your existing lenses, through to a dedicated lens.

If your budget allows, a macro lens is the best option for close-up photography. These lenses are designed to focus much closer than standard optics, resulting in frame-filling pictures at reproduction ratios of between 1:2 (half life-size) and 5:1 (five times life size), without the need for extension tubes or other close-up accessories. As they are specially designed for close focusing, the optical quality of these lenses is second to none. In addition, many of them can be used for portrait photography.

Macro lenses come in a range of focal lengths, but can generally be described as standard (50–60mm), short telephoto (90–105mm), or long telephoto (200mm). The standard focal lengths are lightweight and offer the possibility of handholding. However, these lenses have a wider angle of view than short telephotos, which means they show more of the surrounding environment—

something that can be distracting. Furthermore, standard macro lenses have a short working distance, forcing you to move closer to your subject. This proximity is fine for static objects, such as fruit and fungi, but flighty creatures, such as butterflies and damselflies, are easily disturbed by movement in the vegetation, and will not take kindly to this intrusion.

A short-telephoto offers a greater working distance than a standard macro lens, making it ideal for capturing insects, reptiles, and other sensitive creatures. It is by far the most popular type of macro lens, with many close-up photographers opting for focal lengths in the region of 90–105mm. Short telephoto macro lenses have a narrower angle of view than those in the "standard" bracket, and show less of the surrounding environment, which is great for isolating subjects against busy backgrounds. Lenses in this group work well with extension tubes, allowing greater magnifications without reducing image quality. In general, they can achieve reproduction ratios of up to 1:1 (life size).

Finally, long telephoto macro lenses are the optic of choice for photographers looking to dramatically increase working distance, while achieving large magnifications. These lenses have an extremely narrow angle of view, which is ideal for reducing the amount of background in your shot and transforming what is there into a soft, attractive blur.

On the downside, long telephoto macro lenses are heavy and should be used with a tripod—some even come with a special collar to support the extra weight. In addition, these lenses are expensive and less widely available. In general, they can achieve reproduction ratios of up to 5:1 (five times life size).

Notes

Reproduction ratio is a term used to describe the actual size of the subject in relation to the size it appears on the sensor—not the size at which the image is subsequently enlarged on screen or when printed.

For example, if an object 40mm wide appears 10mm on the sensor, it has a reproduction ratio of 1:4 (quarter life-size). If the same object appears 20mm in size, it has a ratio of 1:2 (half life size), while if it appears the same size on the sensor as it is in reality, it has a reproduction ratio of 1:1 (life size).

A "true" macro lens is capable of projecting a life size image (1:1) on the sensor without the aid of extensions or adapters.

∨ **MACRO LENSES**
Macro lenses are available in a variety of focal lengths, but most photographers find a lens in the region of 90–105mm is their preferred choice.

CANON 100MM F/2.8

NIKON 105MM F/2.8

> PURE HUE
Close-up equipment needn't be expensive. To give the appearance of rain on the petals of this sweet pea, the plant was given a quick squirt with a cheap plant mister.

V GET CLOSER
Dedicated macro lenses are designed to focus much closer than standard optics.

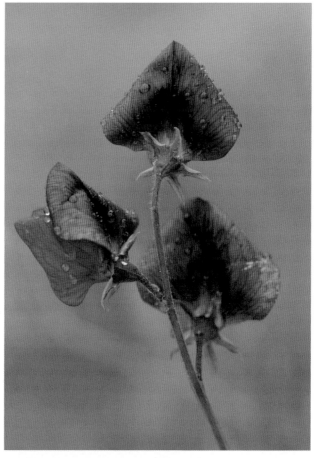

Tip

Although some standard zooms feature the word "macro" in their name, this is just an indication that the lens has close-focusing ability. While such optics might offer a handy reproduction ratio of around 1:4 (quarter life size), they should not be mistaken for a true macro lens.

V CHILD'S PLAY
Although macro lenses are optimized for close focusing, they work like any other lens, which means they can be utilized to photograph a wide range of subjects. A medium-length macro lens—in the region of 70–100mm—is perfectly suited to capturing flattering portraits.

Extension Tubes

Typically sold in sets of three, extension tubes fit between the lens and the camera body, and can be used individually or combined to produce different reproduction ratios. These hollow tubes usually come in three lengths (12mm, 25mm, and 36mm) and physically increase the distance between the focal plane (sensor/film) and the rear of the lens, reducing the minimum focusing distance and increasing magnification as a result. The amount of magnification can be determined by dividing the length of the extension tube by the focal length of the lens—using a 50mm extension tube on a 100mm lens, for example, will result in a reproduction ratio of 1:2 (half size).

As they contain no optical elements, extension tubes have no effect on image quality, but they do cause a certain degree of light loss—the longer the tube, the greater the loss. Also, as only a few (more expensive) extension tubes retain the electronic connection between your camera and lens, you may need to determine your exposures manually (and focus manually as well, as any loss of light can create problems for autofocus systems).

Close-Up Lenses

Close-up lenses (also known as supplementary lenses) screw to the front of the lens like a filter. They work by reducing the minimum focusing distance, allowing you to focus closer to your subject. These lenses act like magnifying glasses and are available in different powers (or diopters). The most common diopters are +1, +2, +3, and +4. The higher the number, the greater the magnification. Two or more close-up lenses may be used together, but it's worth remembering that the more glass you put in front of your lens, the higher the chance that the image will suffer from some degradation.

Single-element close-up attachment lenses can cause both chromatic and spherical aberration. The effects of spherical aberration can be reduced by using mid-range apertures (such as f/8 and f/11), but to counteract both of these problems, camera manufacturers such as Canon, Nikon, and Pentax produce double-element close-up attachment lenses—these reduce flare, improve contrast, and correct aberrations.

While close-up lenses may not offer the sharpness and clarity of dedicated macro lenses, they are lightweight, portable, and excellent value for money. In addition, they do not reduce the amount of light reaching the sensor, or affect metering and focusing systems. On the downside, unless these lenses are paired with a short telephoto lens (such as those in the 150–200mm range) they do not provide enough working distance to photograph sensitive subjects such as insects or reptiles.

∧ CLOSE-UP LENS
Although inexpensive, close-up lenses are an excellent introduction to the world of macro photography. They are available in a range of strengths and can be purchased individually or in a set.

< DRAGONFLY
Close-up lenses are available in a variety of filter thread diameters and simply screw onto the front of the lens. They do not reduce the amount of light entering the lens, so shutter speed remains unaltered, making them ideal for situations where you need to shoot handheld.

Reversing Rings

Reversing rings enable you to mount a lens back to front—one end of the ring attaches to the camera body, while the other fits to the filter thread of the front of the lens (which now becomes the back). As a result of being reversed, the lens will focus much closer to the subject. These rings contain no glass elements, so image quality is unaffected, and there is also no light loss for the camera to contend with.

However, the electronic contacts will now be at the front of the lens, which can mean there is no communication between the lens and camera, leading to a loss of automatic exposure metering and aperture control, as well as automatic focusing. Some reversing rings enable you to retain full lens functions, but these are very expensive.

Despite the technical drawbacks, reversing rings are a light and relatively inexpensive way to experiment with large magnifications. These adapters come in various sizes to fit a multitude of lenses (usually with the help of stepping rings) but are most effective on short prime lenses (such as 50mm). Using a reversing ring on a wide-angle lens is inadvisable, as light may become blocked at the edges of the frame, causing vignetting.

Bellows

Bellows fit between the lens and the camera body, and work in much the same way as extension tubes—they move the lens physically further away from the focal plane (the sensor/film) to reduce the minimum focusing distance and increase magnification. However, unlike extension tubes, bellows are flexible and allow precise control over the results.

As they do not contain any glass elements, bellows do not affect image quality, but they do create a significant light loss. For the best results, bellows should be used in conjunction with a tripod and focusing rail.

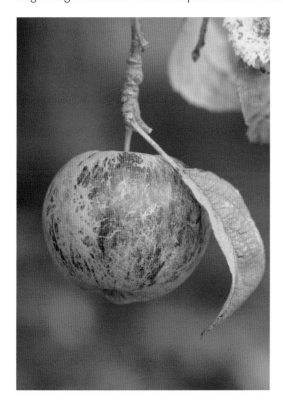

∧ USE MANUAL FOCUS
As extension tubes lead to a loss of light, it's a good idea to switch to manual focus.

∧ REDUCE THE DISTANCE
Extension tubes reduce the minimum focusing distance of the lens, which is great for static subjects.

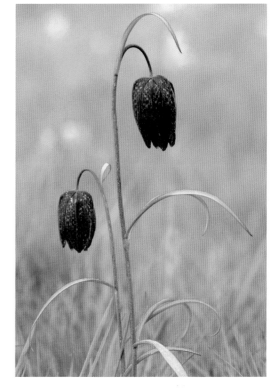

∧ SCREW IT ON
Close-up attachment lenses are lightweight, inexpensive, and useful for capturing non-sensitive subjects such as flowers and fungi.

> COMMON BLUE BUTTERFLY

In order to achieve frame-filling images of miniature subjects—such as this small butterfly—the high image quality and ease of use of a macro lens makes them an unrivaled choice for close-up enthusiasts.

∧ DEPTH OF FIELD
The closer your subject is to the lens, the less depth of field is available, even at the smallest aperture settings. This makes it essential that you focus accurately.

Tilt and Shift

With conventional optics, the axis of the lens is fixed at right angles to the sensor plane. As a result, if you point your camera up or down, subject distortion will occur. Tilt-and-shift lenses correct this problem.

Some manufacturers offer at least one tilt-and-shift, or "perspective control" lens within their range. These lenses are designed to mimic the front rise and fall movements of a view camera, allowing photographers to alter the plane of focus, control depth of field, and correct converging verticals when shooting buildings. While subject distortion isn't always undesirable, it is a common problem that architectural photographers often want to correct if they are to portray a subject authentically. However, product and scenic photography can also benefit from the elimination of this type of distortion.

The tilt-and-shift principle involves two different types of movement—rotation of the lens (tilt) and movement of the lens parallel to the image plane (shift). Tilt controls the orientation of the plane of focus and, as a result, the area of the final image that appears sharp. Shift is used to control perspective, eliminating the convergence of parallel lines.

Tilt

The tilt movement on a perspective control lens enables you to tilt the plane of sharpest focus so that it no longer lies perpendicular to the lens axis. In effect, this creates a wedge-shaped depth of field—its width increases further from the camera. Therefore, the tilt movement doesn't actually increase depth of field—it simply allows you to customize its location to suit the subject better. The plane of focus can be oriented so that the depth of field is as extensive as possible (useful for landscape photography) or so that only a small part passes through the subject, giving an ultra-shallow zone of sharpness that is not dissimilar to using a macro lens to photograph miniature objects.

Shift

When the subject plane is parallel to the sensor plane, any parallel lines of the subject will remain parallel in the final image. However, if the sensor plane is not parallel to the subject—when pointing the camera upward to photograph a tall building, for example—parallel lines converge and the subject appears less natural.

Shift is a movement of the lens that allows the line of sight to be adjusted, while the image plane—and focus—remains parallel to the subject. Typically, this type of design is used to keep the sides of tall buildings parallel in architectural photography.

∧ TILT AND SHIFT
Nikon's 45mm PC-E perspective control lens showing tilt (top) and shift (bottom) movements.

< ARCHITECTURALLY ACCURATE
This type of distortion (top) is known as convergence. It is most apparent when photographing rectilinear subjects, such as buildings, and is a product of the camera's sensor plane not being parallel to the plane of the subject. Tilt-and-shift—or perspective control—lenses correct this problem (bottom). They are an essential tool for architectural photographers, but have other uses too.

Mirror

Mirror lenses are aimed at photographers who require the function of a long focal length, but cannot justify or afford the high price tag usually associated with prime telephotos.

Mirror—or "reflex"— lenses employ both glass elements and mirrors in their design. This type of construction is known as a catadioptric optical system and the technology utilized in photographic lenses is similar to that used for astronomy. Incoming light is reflected by a main mirror—located at the rear of the lens—toward a small secondary mirror at the front. This reflects the light back toward the sensor via a corrective glass element. The lack of glass elements within its design has certain advantages over refractive lenses. For example, chromatic aberrations are virtually nonexistent, and due to the way the light path is "folded" by the mirrors, reflex lenses are much more compact.

However, while they are physically shorter in size and comparatively lightweight—making them easier to store or transport—the main mirror at the rear of the lens is quite large, so their width is increased. The design also precludes the use of an adjustable diaphragm, meaning the aperture is fixed—normally at f/8—which severely impedes exposure control. It is only possible to adjust the incoming light levels using shutter speed, neutral density filters, or via the ISO setting. Also, with the fixed aperture being relatively slow, it is difficult to capture moving subjects, such as wildlife or sports, unless the conditions are bright and sunny.

One of the main characteristics of catadioptric lenses is the donut-shaped bokeh—the quality of the out-of-focus areas of a picture—that they create. This is due to the position of the secondary mirror mounted at the front of the lens, which blocks part of the light path and transforms out-of-focus areas—particularly highlights—into little rings. Although this type of background blur can prove quite attractive, more often it is distracting and undesirable. Optically, image sharpness is normally no

better than average and contrast is also quite flat. So, while "reflex" lenses are a cheap introduction to telephoto photography and fun to play with, the lack of control over depth of field and poor image quality severely limits their usefulness and appeal.

∧ **MIRROR LENS**
10–15 years ago, practically all lens manufacturers had at least one mirror lens within their range, but today they are far less popular. However, they are still available from some independent brands. You can also find them secondhand and through auction web sites.

< **BOKEH**
One of the main characteristics of a mirror lens is the way it renders out-of-focus highlights—known as "bokeh"—as a donut shape. This type of blur betrays the use of a catadioptric lens design.

Focusing

In order to capture sharp images, a camera lens has to be precisely focused. This is the point at which the image of an object, cast onto the sensor by an optical system, is properly defined so that subject detail appears clearly.

Achieving focus can be obtained in two ways; either by using autofocus, which relies on sensors to determine the correct focus, or manually, by the photographer turning the lens' focusing ring to focus the lens at a specific distance. Both forms of focusing are useful, being suited to different situations.

Autofocus (AF)

Autofocus systems rely on electronics, sensors, and motors to determine the correct focus. Most modern digital cameras utilize through-the-lens optical AF sensors, which also perform as lightmeters. Autofocusing is generally fast, accurate, and quiet, and achieved by simply depressing the shutter-release button halfway. It is hardly surprising that this is the preferred method of focusing for the majority of photographers.

Phase Detection

Phase-detection AF is the most common system in digital SLRs. It is achieved by dividing incoming light into pairs of images and then comparing them. Secondary Image Registration (SIR) TTL passive phase detection is a common technology in DSLRs. This system utilizes a beam splitter—implemented as a small semi-transparent area of the main reflex mirror, coupled with a small secondary mirror that directs light to an autofocus sensor. Optical prisms capture the light rays and divert it to the AF sensor. The two images are then analyzed for similar light intensity patterns and the phase difference is calculated in order to find if the object is in front- or back-focus position. This provides the exact direction of focusing and amount the focus ring needs moving.

Although AF sensors are typically one-dimensional photosensitive strips—only a few pixels high and a few dozen wide—some modern cameras feature area SIR sensors that are rectangular, providing two-dimensional intensity patterns. Cross-type focus points have a pair of sensors oriented at 90 degrees to one another.

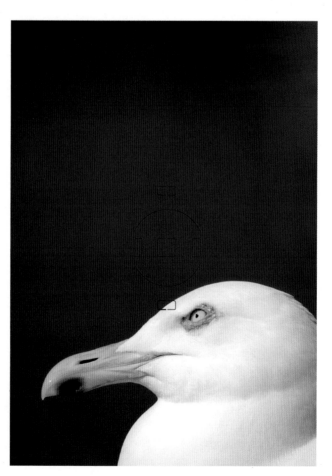

< **FOCUS POINTS**
Modern DSLRs have multipoint autofocusing systems boasting a number of AF sensors that give extended coverage across the frame. Most multipoint focusing systems allow the photographer to choose between leaving all the AF sensors active or selecting individual points. This enables sharp autofocusing, even when the subject is off-center.

Contrast Measurement

Contrast measurement is achieved by measuring contrast within a sensor field through the lens. In simple terms, the AF sensors provide input to algorithms that calculate the contrast of the actual picture elements. The microprocessor in the camera then looks at the difference in intensity among adjacent pixels. If the scene is out of focus, adjacent pixels have similar intensities. The microprocessor moves the lens, repeating the process to see if the difference in intensity between adjacent pixels improves or worsens. The difference in intensity naturally increases with correct image focus. The optical system can thereby be adjusted until the maximum contrast is detected. This is the point of best focus.

In this form of passive focusing, AF does not involve actual distance measurement and is generally slower than phase detection systems—particularly when operating in low light. However, being implemented in software (it doesn't employ a dedicated sensor), contrast-detect autofocus can be more flexible and potentially more accurate.

∧ ACTION
Achieving pin-sharp images of moving subjects can prove difficult when focusing manually. The speed and reliability of autofocusing can prove the difference between success and failure when shooting fast action.

In either guise, autofocusing is an essential aid for photographers who have less-than-perfect eyesight. Also, many press, sports, and wildlife photographers rely heavily on the accuracy of modern AF systems to help them achieve sharp images of moving subjects.

AF is an integral part of modern lens design and autofocusing is growing increasingly more sophisticated. Many systems use a multipoint system, with a number of selectable AF sensors. The increased area of coverage makes it easier for AF to lock onto the main subject and also enables photographers to focus on off-center subjects. Many AF systems allow you to choose between leaving all the sensors active or selecting just individual points. There are also different AF-area modes and AF-focus modes—for example Single-shot AF, which focuses just once, and Continuous AF, which continues to track moving subjects.

Notes

By default, a camera presumes the subject you wish to focus on will be central in the frame. Therefore, when you wish to take pictures of subjects that are off-center you will either need to adjust your active focus point accordingly or lock focus. Locking focus can often prove the fastest method and is simple to do.

In some AF modes, you can lock focus by keeping the shutter-release button half pressed after focusing on your subject.

Many DSLRs also feature a dedicated autofocus lock (AF-L) button. Simply focus on your subject and, by pressing and holding the AF-L button, focus will remain locked. This allows you to adjust the composition without the camera refocusing.

Do not alter the distance between camera and subject while focus lock is activated. If you or the subject moves during focus lock, you will need to focus again at the new distance.

Manual Focus (MF)

Manual focus overrides the camera's built-in automatic system, enabling photographers to focus the lens by physically rotating the focusing ring—moving the lens elements in order to obtain a sharp image. Normally, it can be selected via a small lever near the lens barrel, via one of the camera's menus and/or via an MF/AF switch on the side of the lens itself.

If you are still new to photography, you may be wondering why you would ever utilize manual focusing when your camera boasts a sophisticated autofocus system to do the hard work for you, but while the latest AF systems are often reliable and fast, they are not infallible. For example, in low light or when the subject is very close or far away, your camera may struggle to focus accurately—searching back and forth for the subject and wasting valuable time.

Also, if you are taking pictures through glass—from an airplane window, for instance—or shooting captive animals through fencing, your camera may get confused where to focus. In instances like this, manual focusing is a more reliable option.

Your camera cannot predict your desired point of focus either. To utilize the full extent of the depth of field available—for a given aperture—you may need to focus slightly in front or behind your subject. This is best carried out manually.

Manual gives you far greater control and pinpoint accuracy over focusing and, for certain subjects—such as landscape and macro—it is preferable to focus manually if your eyesight will allow you to do so. With practice, it's possible to focus by hand with remarkable speed and precision, and some photographers prefer to work manually at all times, even if the subject is moving.

However, with the latest automatic systems boasting increased speed, versatility, and accuracy, AF is normally the preferred focusing method when tracking fast movement, such as sports, moving animals, and flight.

∨ MANUAL
Modern AF systems are incredibly sophisticated, but sometimes focusing manually might be preferable. Here, for example, the subject wasn't under any of the camera's focus points, making manual focus a viable option.

∧ HYPERFOCAL DISTANCE

For this shot, full front-to-back sharpness was required, which
meant focusing at the hyperfocal distance (see next page).
Sometimes this is more easily achieved by focusing manually.

Hyperfocal Distance

Although a lens can only precisely focus at one distance, sharpness decreases gradually on either side of the point of focus. As a result, any reduction in sharpness within the available depth of field is imperceptible under normal viewing conditions.

Depth of field (the zone of acceptable sharpness within an image) extends approximately one-third in front of the point of focus and two-thirds beyond it. The hyperfocal distance is the point where you can achieve maximum depth of field for any given aperture. Identifying and focusing on this point is important when you require extensive depth of field—when photographing landscapes, for example. When a lens is focused on the hyperfocal point, depth of field extends from half this point to infinity.

The hyperfocal distance depends on the focal length and lens aperture that you are using. Calculating this point is made far easier if your lens has a depth of field scale—simply align the infinity mark against the selected aperture. Unfortunately, manufacturers of many modern optics have disposed of this useful scale, meaning photographers have to calculate or estimate the distance.

To achieve this there is a variety of depth of field calculators and hyperfocal distance charts, tables, and equations available to download from the internet. The charts opposite give the hyperfocal distance for a range of popular focal lengths at various apertures, for both full-frame and cropped-type DSLRs. Once you've focused at the hyperfocal distance do not adjust focal length or aperture—otherwise you will need to recalculate.

Frustratingly, it can prove difficult focusing your lens at a specific distance, as many lenses have rather perfunctory distance scales—for example, a lens may only have 0.3m, 0.5m, 1m, and infinity marked on its scale. As a result, a degree of guesswork may be required. However, it is not essential that hyperfocal focusing is exact—it just needs to be close to it.

If necessary, just make your best estimate of where the hyperfocal distance is from the camera position.

Allow a margin for error by focusing a little beyond the hyperfocal distance, then everything from at least half the focal point to infinity will be acceptably sharp in the final image. Many photographers don't bother calculating the distance at all, and simply focus approximately a third into the image. This is a rough, but quick method that is far from exact, but is still an improvement on simply focusing at infinity.

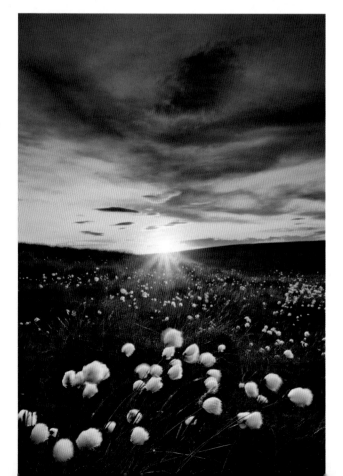

< **MAXIMUM SHARPNESS**
When you have both foreground detail and distant elements that you want to appear sharp, setting the correct aperture— and the hyperfocal distance— becomes important. Your choice of focal length will also play a part, as wide-angle lenses provide a greater depth of field at any given aperture than telephoto lenses.

Depth of field (m): 18mm on APS-C sensor

Focused at	Aperture	2.8	4	5.6	8	11	16	22
1m	Near	0.66	0.58	0.49	0.41	0.33	0.25	0.20
	Far	2.05	3.74	inf	inf	inf	inf	inf
2m	Near	0.98	0.81	0.65	0.51	0.40	0.29	0.22
	Far	inf	inf	inf	inf	inf	inf	inf
3m	Near	1.18	0.93	0.73	0.55	0.42	0.30	0.23
	Far	inf	inf	inf	inf	inf	inf	inf
5m	Near	1.39	1.06	0.81	0.55	0.45	0.32	0.23
	Far	inf	inf	inf	inf	inf	inf	inf
Infinity	Near	1.93	1.35	0.96	0.67	0.49	0.34	0.25
	Far	inf	inf	inf	inf	inf	inf	inf

Depth of field (m): 28mm on APS-C sensor

Focused at	Aperture	2.8	4	5.6	8	11	16	22
1m	Near	0.83	0.77	0.70	0.62	0.55	0.45	0.38
	Far	1.27	1.43	1.73	2.51	5.80	inf	inf
2m	Near	1.40	1.24	1.08	0.90	0.75	0.58	0.46
	Far	3.48	5.09	13.4	inf	inf	inf	inf
3m	Near	1.83	1.57	1.32	1.06	0.85	0.64	0.50
	Far	8.33	34.8	inf	inf	inf	inf	inf
5m	Near	2.42	1.98	1.59	1.23	0.96	0.70	0.53
	Far	inf	inf	inf	inf	inf	inf	inf
Infinity	Near	4.66	3.26	2.33	1.63	1.19	0.82	0.59
	Far	inf	inf	inf	inf	inf	inf	inf

Depth of field (m): 50mm on APS-C sensor

Focused at	Aperture	2.8	4	5.6	8	11	16	22
1m	Near	0.94	0.91	0.88	0.84	0.80	0.73	0.66
	Far	1.07	1.10	1.15	1.23	1.34	1.59	2.05
2m	Near	1.77	1.68	1.58	1.45	1.32	1.14	0.98
	Far	2.31	2.47	2.72	3.22	4.17	8.21	inf
3m	Near	2.50	2.33	2.14	1.91	1.68	1.40	1.17
	Far	3.75	4.20	4.99	6.98	13.9	inf	inf
5m	Near	3.75	3.38	3.00	2.56	2.16	1.72	1.38
	Far	7.51	9.57	15.1	111	inf	inf	inf
Infinity	Near	14.9	10.4	7.43	5.20	3.78	2.60	1.89
	Far	inf	inf	inf	inf	inf	inf	inf

Depth of field (m): 90mm on APS-C sensor

Focused at	Aperture	2.8	4	5.6	8	11	16	22
1m	Near	0.98	0.97	0.96	0.95	0.93	0.90	0.87
	Far	1.02	1.03	1.04	1.06	1.08	1.13	1.18
2m	Near	1.92	1.89	1.85	1.79	1.73	1.63	1.52
	Far	2.08	2.12	2.18	2.26	2.38	2.60	2.93
3m	Near	2.83	2.76	2.67	2.55	2.42	2.22	2.03
	Far	3.20	3.29	3.42	3.63	3.95	4.61	5.77
5m	Near	4.53	4.36	4.15	3.87	3.56	3.15	2.77
	Far	5.57	5.86	6.29	7.07	8.38	12.1	25.8
Infinity	Near	48.2	33.7	24.1	16.9	12.3	8.43	6.13
	Far	inf	inf	inf	inf	inf	inf	inf

Depth of field (m): 28mm on full-frame sensor

Focused at	Aperture	2.8	4	5.6	8	11	16	22
1m	Near	0.90	0.86	0.81	0.75	0.69	0.60	0.53
	Far	1.13	1.20	1.30	1.49	1.82	2.90	10.0
2m	Near	1.62	1.50	1.37	1.20	1.05	0.86	0.71
	Far	2.61	2.99	3.74	5.95	23.0	inf	inf
3m	Near	2.22	2.00	1.76	1.50	1.26	1.00	0.80
	Far	4.62	6.00	10.0	inf	Inf	inf	inf
5m	Near	3.15	2.72	2.30	1.87	1.51	1.15	0.89
	Far	12.1	30.7	inf	inf	inf	inf	inf
Infinity	Near	8.48	5.94	4.24	2.97	2.16	1.48	1.08
	Far	inf	inf	inf	inf	inf	inf	inf

Depth of field (m): 50mm on full-frame sensor

Focused at	Aperture	2.8	4	5.6	8	11	16	22
1m	Near	0.97	0.95	0.93	0.91	0.88	0.83	0.78
	Far	1.04	1.05	1.08	1.11	1.16	1.25	1.38
2m	Near	1.87	1.81	1.75	1.66	1.56	1.42	1.28
	Far	2.16	2.23	2.34	2.52	2.79	3.40	4.61
3m	Near	2.71	2.60	2.46	2.29	2.10	1.85	1.62
	Far	3.37	3.55	3.84	4.36	5.25	7.96	20.9
5m	Near	4.23	3.96	3.66	3.28	2.91	2.44	2.05
	Far	6.12	6.77	7.89	10.5	17.8	inf	inf
Infinity	Near	27.1	18.9	13.53	9.47	6.89	4.73	3.44
	Far	inf	inf	inf	inf	inf	inf	inf

Depth of field (m): 90mm on full-frame sensor

Focused at	Aperture	2.8	4	5.6	8	11	16	22
0.4m	Near	0.399	0.399	0.398	0.398	0.397	0.395	0.394
	Far	0.401	0.401	0.402	0.402	0.403	0.405	0.407
0.6m	Near	0.597	0.596	0.595	0.593	0.590	0.585	0.580
	Far	0.603	0.604	0.605	0.608	0.611	0.616	0.622
0.8m	Near	0.794	0.792	0.789	0.785	0.779	0.770	0.760
	Far	0.806	0.808	0.811	0.816	0.822	0.832	0.845
1m	Near	0.99	0.99	0.98	0.97	0.96	0.94	0.92
	Far	1.01	1.02	1.02	1.03	1.04	1.06	1.09
2m	Near	1.96	1.94	1.92	1.88	1.84	1.78	1.71
	Far	2.04	2.06	2.09	2.13	2.19	2.28	2.41
3m	Near	2.90	2.86	2.81	2.74	2.65	2.52	2.38
	Far	3.10	3.15	3.21	3.31	3.45	3.70	4.06
5m	Near	4.73	4.63	4.50	4.31	4.10	3.79	3.47
	Far	5.30	5.43	5.63	5.95	6.41	7.35	8.93
Infinity	Near	87.6	61.4	45.8	30.7	22.3	15.3	11.2
	Far	inf	inf	inf	inf	inf	inf	inf

Depth of field (m): 200mm on full-frame sensor

Focused at	Aperture	4	5.6	8	11	16	22	32
3m	Near	2.97	2.96	2.95	2.93	2.89	2.85	2.79
	Far	3.03	3.04	3.06	3.08	3.12	3.16	3.24
5m	Near	4.92	4.89	4.85	4.79	4.70	4.60	4.43
	Far	5.08	5.11	5.17	5.23	5.34	5.48	5.73
7m	Near	6.85	6.79	6.70	6.59	6.42	6.23	5.93
	Far	7.16	7.23	7.33	7.47	7.70	8.00	8.55
10m	Near	9.69	9.56	9.39	9.18	8.85	8.48	7.93
	Far	10.3	10.5	10.7	11.0	11.5	12.2	13.5
20m	Near	18.8	18.3	17.7	16.9	15.8	14.7	13.1
	Far	21.4	22.0	23.0	24.4	27.2	31.4	42.4
Infinity	Near	303	150	116	89.8	65.4	49.4	35.0
	Far	inf	inf	inf	inf	inf	inf	inf

∧> **HYPERFOCAL DISTANCE TABLES**
These hyperfocal distance tables can be used to determine the optimum focus distance for a range of popular focal lengths.

Lens Problems

There is no such thing as a perfect lens and all lenses suffer from one fault or another. When shooting film, there was very little that could be done to correct these problems, but software allows us to reduce—or even eliminate—some of these faults.

Distortion

The effects of lens distortion are seen most readily when there are lines that should be straight in an image. The horizon when looking out to sea is a good example: if the horizon is curved in an image, this is due to lens distortion. Distortion can either be "barrel" or "pincushion." The first refers to a distortion that causes straight lines to bow out from the center, toward the edge of the image, while the second refers to distortion that causes straight lines to bow inward, toward the center of the frame.

Typically a zoom lens will display one type of distortion at one end of the zoom range and the second type at the opposite end of the range. You are also more likely to see distortion in an image shot with a wide-angle lens than a telephoto. Fortunately, unless you are regularly shooting straight lines, distortion is often not noticeable, unless it is extreme. In this case, you can correct distortion in most editing programs.

Chromatic Aberration

Visible light is a spectrum of wavelengths of electromagnetic radiation that our eyes can see and interpret. The longest wavelength in this spectrum corresponds to the color we see as red, the shortest to blue/violet. A lens that suffers from chromatic aberration (often shortened to CA) is not able to focus these different wavelengths of light at the same point (on the sensor). This results in colored fringing around the boundaries of light and dark areas of an image, especially toward the edges of the frame. Chromatic aberration is usually either green-red or yellow-blue.

There are two types of chromatic aberration: axial and transverse. Axial CA is seen across the whole of

< **PINCUSHION DISTORTION**
This is an example of "pincushion" distortion. The straight red line shows where the horizon should ideally be.

<A **CHROMATIC ABERRATION**

Chromatic aberration is a common lens flaw, particularly in cheaper lenses. Normally, color fringing isn't immediately obvious, but the larger the image is reproduced, the more noticeable it becomes—as you can see from the enlarged section of this photograph.

the image when the lens is set at its maximum aperture, but is reduced as the lens is stopped down. Transverse CA is seen in the corners of images and is visible at all aperture settings.

Of the two types, transverse chromatic aberration is easiest to correct for, and most editing software has functions to reduce it. Unfortunately, axial CA is more difficult to correct, so without a lot of retouching work, the only way to avoid its effects is to avoid using aperture settings close to maximum.

Vignetting

An image suffering from vignetting has edges that are noticeably darker than the center of the frame. Vignetting occurs most often when a lens has been set at its maximum aperture: stop the aperture down from maximum and the problem is usually resolved. Wide-angle lenses are generally more prone to vignetting than telephoto lenses are.

Diffraction

Diffraction softens overall image quality, although it is not related to optical quality. As you stop down the aperture—making it smaller by selecting a larger f-number—the light passing through the hole tends to "diffract" (scatter). The reason for this is that the edges of the diaphragm blades disperse the light passing through: the smaller the hole, the greater the effect. As a result, even if depth of field is increased, image sharpness can deteriorate. This can create a conflict of interests for photographers, particularly when shooting landscapes. For example, traditionally, a small aperture is a priority when shooting scenics to ensure that everything from the foreground right up to infinity is in acceptable focus.

However, while an f-stop in the region of f/22 or f/32 will maximize back-to-front sharpness, it also exaggerates the effect of diffraction. At the smallest aperture of a lens, the gain in depth of field may not be sufficient to offset the increased level of diffraction. As a guide, f/11 is generally considered to be the smallest aperture that remains greatly unaffected—or is "diffraction limited"—on cropped-type cameras. If you are using a full-frame camera, this "guideline" limit tends to be f/16.

∧ VIGNETTING
This image was taken using the short end of a 10–24mm lens. A polarizing filter was used to saturate the blue sky, but the thickness of the filter mount has blocked the light path at the corners of the frame—resulting in a common lens problem known as vignetting.

f/22

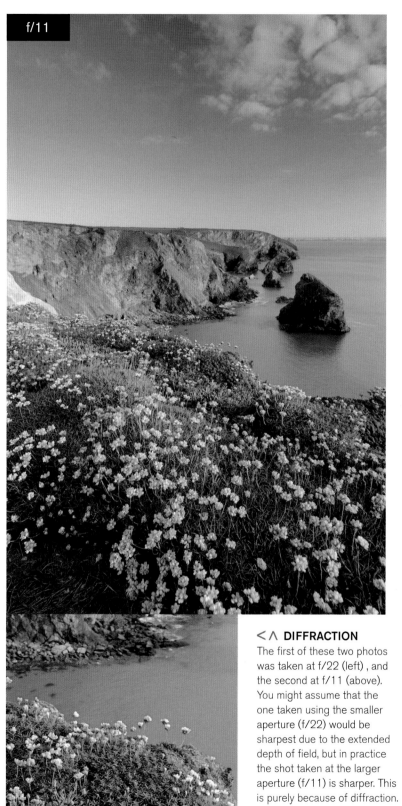

f/11

＜∧ DIFFRACTION

The first of these two photos was taken at f/22 (left), and the second at f/11 (above). You might assume that the one taken using the smaller aperture (f/22) would be sharpest due to the extended depth of field, but in practice the shot taken at the larger aperture (f/11) is sharper. This is purely because of diffraction.

Shake Reduction

Image stabilization is designed to increase the stability of the image and minimize or eliminate camera shake—counteracting vibrations that can, potentially, rob a photograph of its sharpness.

Camera shake is a common problem that occurs when the shutter speed isn't fast enough to eliminate the photographer's natural movement. The result is a soft or blurred image that can ruin the shot. The problem is exaggerated when using a long focal length lens or employing a high degree of magnification. The most effective way to eliminate shake is to use a support, such as a monopod, beanbag, or—best of all—a tripod, but this is not always practical.

Image stabilization systems work by compensating for any slight movement of a camera during an exposure. In practical terms, this enables you to handhold a camera at slower shutter speeds than normal without camera shake. The results vary from system to system (and from person to person), but 2–4 stops difference is usually possible.

There are two approaches to image stabilization. The first is lens based, which is known as optical image stabilization. Inside a stabilized lens, tiny gyroscopic sensors detect movement, which is canceled out by the shifting of a floating lens element. The main adherents to this approach are Canon, Nikon, Sigma, and Tamron, with image stabilized lenses bearing the code IS (Canon's Image Stabilization), VR (Nikon's Vibration Reduction), OS (Sigma's Optical Stabilization), and VC (Tamron's Vibration Compensation). The main advantage with this option is that the stabilization system can be tailored to each individual lens and it is possible to see the effect when looking through the viewfinder. A disadvantage is that stabilized lenses are expensive compared to equivalent non-stabilized versions.

The second approach to combating camera shake is to move the sensor inside the camera. Unsurprisingly, this is known as sensor-shift stabilization. The main adherents of this technology are Olympus, Pentax, Samsung, and Sony. The big advantage of sensor-based stabilization is that it works with any lens that is attached to the camera. The main drawback is that the effect isn't visible when looking through a viewfinder (although it can be seen when using Live View).

∧ IMAGE STABILIZATION
Lens-based image stabilization goes by a variety of names, but they all work to allow photographers to shoot at shutter speeds of up to 3 or 4 stops slower than normal. This is particularly useful when you are shooting in low or limited light and/or when you are using longer focal lengths.

CAMERA SHAKE

If the situation dictates that you have to shoot handheld, a good basic rule is to always employ a shutter speed equivalent to the focal length of the lens you are using. For example, if you are using the long end of a 70–300mm zoom, select a minimum shutter speed of 1/300 sec. To help generate a faster shutter speed, employ a larger aperture, or increase the camera's ISO sensitivity. However, this will reduce depth of field, or increase noise levels, respectively.

If your lens is designed with image stabilizing technology, use it; sharp images can be produced at speeds up to four stops slower than normal.

It is also possible to limit the effects of shake through the way you support your camera. For example, a kneeling position is more stable than standing. Hold your elbows in toward your chest and hold the camera in both hands, firmly to your face (assuming it has an eye-level viewfinder).

∧ STABILIZATION

In many situations, image stabilization can prove the difference between success and failure. In this instance, it was impossible to keep an 80–400mm lens still enough in overcast conditions to eliminate shake. However, with stabilization activated this was no longer a problem.

< TELEPHOTO

Camera shake is exaggerated by long focal lengths, so if you are buying a telephoto lens it is a good idea to invest in a stabilized version if your budget allows it (and such a lens is available).

Lens Care

Carefully mounting, cleaning, and storing your lenses will help ensure the optimum performance and long life of your investment.

Mounting

In order to alter focal length and lens type, system camera users are regularly required to change lenses. Doing so is simple and straightforward. Even if you are new to using a DSLR or CSC it won't be long before you can change lenses quickly and instinctively.

However, it is worth remembering that the electronic contacts on the lens and the bayonet mount of the camera are delicate components, and that careful alignment is important to ensure they are not damaged. Whenever you attach a lens, check that the camera is switched off first and keep the mounting mark on the lens aligned with the mounting mark on the camera body. Position the lens in the camera's bayonet mount and rotate until it clicks securely into place. Whether you need to rotate the lens clockwise or counterclockwise to attach it will depend on the make of the camera—if you are unsure, check your user's manual first.

By mounting your lenses with care, you will minimize wear and eliminate the risk of damage. However, it is inevitable that both camera and lens mounts will grow dirty over time. If the contacts are dirty, automatic features such as autofocusing may be affected. To clean them, gently wipe the mount using a soft, dry lens cloth.

Cleaning

The lens is the "eye" of your camera, so if it is dirty, marked, or scratched, image quality will be degraded. Dust and dirt settling on the front element of the lens is an ongoing challenge for photographers. While you shouldn't clean optics more than is necessary, it is important to keep them clean, otherwise image quality will be affected and the risk of lens flare enhanced.

In the first instance, use a "blower," or soft photographic brush to remove any loose particles of dust and dirt—using a cloth, you can unwittingly rub grit or tiny, hard particles across the lens. To remove smears or fingerprints, use a dedicated microfiber lens cloth, using a gentle, circular motion to clean the lens. Photographic wipes and lint-free tissues are also available.

For stubborn marks, you might require a cleaning fluid, but only buy solutions that are intended for photographic lenses and—unless the instructions say otherwise—apply it to the cleaning cloth, rather than directly to the lens itself. Never attempt to clean a lens using ammonia or other household cleaning solutions—permanent damage may result. When cleaning, don't overlook brushing the rear of the lens—dust on the rear element can fall into the camera body and settle on the sensor, causing marks on the final image.

∧ LENS STORAGE
Most lenses are supplied with a fitted, protective case, which is ideal for safely storing the lens should it not be required for a prolonged period. Alternatively, there is a wide range of lens pouches available to buy.

LENS COATINGS

The type and purpose of a lens' coatings will be listed among its specification. However, you can normally tell if it is coated by simply looking at it. Today, practically all camera lenses benefit from multiple coatings, but an uncoated lens would have a white reflection, similar to a window or drinking glass. A single-coated lens typically has a blue and amber reflection from its glass. However, the reflection from a modern, multi-coated lens will typically be green and magenta.

< **CAMERA EYE**
Your lens is your camera's "eye," so should be kept clean if you want to maximize image quality and reduce the risk of lens flare.

∧ **LENSPEN**
Dedicated accessories, such as the Lenspen, are intended to help you care for your optics. It features a retractable soft bristle brush, designed to remove dust and dirt. Then, using its unique tip, which flexes in order to follow the contours of the lens, you apply a cleaning compound. By applying gentle pressure on the lens and using smooth circular motions, smudges are safely removed.

One of the best ways to protect your delicate optics is to keep a clear filter, such as a UV or skylight filter, attached to the front element at all times. A scratched or damaged lens is irreparable and costly, but a filter is comparatively cheap to replace. Remember to keep the rear and front lens caps on whenever the lens isn't in use, to protect the optics.

Storage
If you do not intend using a lens—or lenses—for an extended period of time, it is important to store them well. If the lens was supplied together with a fitted, protective carry case, this will prove one of the safest places. Store the lens along with a sachet of silica gel, to keep moisture at bay. Alternatively, store optics in airtight plastic or aluminum containers, protected in a lens wrap, pouch, or sleeve. Again, silica is a cheap way to ensure your lenses stay free of moisture. Keep optics in a dry, cool environment—humidity can prove damaging, enhancing the risk of fungus and mould. Lastly, keep equipment stored above ground level—this will prevent the risk of water damage in the event of a leak or flood.

CHAPTER 3
FILTERS & ACCESSORIES

Filters

In general, filters are less essential for digital photography than they are for film, but certain types are still highly recommended if you want to improve your pictures.

Filter Types

A filter is a piece of glass, gelatin, or optical resin that affects the light passing through it in some way. They were once widely used for film photography, with colored filters being particularly important when it came to balancing the color temperature of light sources to the film being used. Today, white balance performs that role, and many other filter effects now have in-camera or software-based equivalents as well. However, just because a particular filter isn't strictly necessary, that doesn't mean that it's not fun to use, and there may be one that fits your particular photographic style. Star filters are a good example: these filters were in vogue during the 1980s, but now their use is less common. Furthermore, there are certain effects that are much better created using a filter in front of the lens.

Filters are available either in a screw-in form that attaches to the filter thread on the front of a lens, or as part of a holder system. Screw-in filters are usually relatively inexpensive, but as there is no standard filter thread size you may find that you need to buy multiple filters of the same type if you have a collection of lenses with different filter thread diameters. A more elegant solution is to buy a filter for the largest thread size and then buy step-up rings so you can use the same filter on your smaller lenses.

The alternative is a filter holder, which is a slotted plastic device that clips to an adapter ring screwed to the front of a lens. The filters that fit into a holder are usually either square or rectangular, and there are currently three different sized systems on the market: 67mm (Cokin A); 84/85mm (Cokin P); and 100mm (produced by a number of manufacturers including Cokin, Lee Filters, and Hitech). If you own a number of lenses you can use the same filters on each of them—all you need to buy is an appropriate (and inexpensive) adapter ring for each lens. Be careful to get the right size filter holder to start with, though—the smaller systems are the least expensive, but they are also less compatible with wide-angle lenses as they can cause noticeable cut-off at the corners of the frame.

∧ **LEE FILTERS**
The Lee Filters Foundation Kit filter holder allows you to stack up to three different filters at any one time.

∧ **FILTERS**
A 100mm square filter and 77mm screw-in filter.

Notes

Some filters, such as neutral density graduated filters, are only really useful when used with a filter holder.

All filters degrade image quality slightly, so while it is possible to stack multiple filters in front of a lens, this is not advisable.

Keep your filters clean using a dedicated soft cloth.

∧ SUNSET
Smoothing the sea in this shot required two filters: a polarizing filter to reduce reflections, enhance color, and extend the exposure time, and a graduated ND filter to balance the brightness of sea and sky.

Polarizing Filters

When light rays strike a non-metallic surface they bounce off and are scattered in all directions. Technically, the light has become polarized, which has the effect of decreasing the color saturation of the surface. In the case of glass and water this will also reduce the apparent transparency. A polarizing filter cuts out all polarized light perpendicular to the axis of the filter, restoring color saturation and the transparency of glass and water. Because of the way this happens, the effect of a polarizing filter cannot be reproduced in postproduction.

Polarizing filters can be bought to screw directly onto your camera lens, or to fit onto a filter system holder. With a screw-fit filter, the front element of a polarizing filter is designed to rotate through 360°, while a system filter can be rotated within the filter holder—rotating the filter allows you to vary the strength of its polarizing effect.

There are two types of polarizers: circular and linear. This does not refer to the shape, but rather to the properties of the filter. Linear polarizers are only suitable for manual focus cameras, as they adversely affect both the TTL metering and autofocus systems of AF camera, so digital cameras should use a circular polarizer.

Polarizing filters are commonly used to deepen the blue of the sky. This works best at a specific angle, in this instance when the filter is used at 90° to the sun.

The effect is visibly reduced when the polarizer is used at a greater or lesser angle. It is worth noting that the polarizing effect can be problematic when using ultra-wide angle lenses: as more sky is included, it's often possible to see an unnatural deep blue band running across the sky. At maximum polarization, you will find that skies can begin to turn almost black. If you were shooting in color, this effect can look decidedly unnatural, but it is a useful way to add a touch of drama to a sky in a black-and-white photograph.

Polarizing filters aren't just for sunny days—they also cut out reflections from wet surfaces and help to increase color saturation. This is useful with woodland scenes and wet foliage. In this instance, polarizing filters work best when they are at approximately 35° to a non-metallic surface, and not at all when they are at 90° (polarizing filters have no effect on the light reflected from a metallic surface).

It is also worth noting that a polarizing filter will reduce the amount of light reaching the sensor in your camera, so it can be used in a similar way to a neutral density filter. Your camera should compensate automatically for this light loss, but if you are shooting in manual exposure mode you will need to increase the exposure by 1½ to 2 stops.

∧ FILTER HOLDER
A slot-in filter holder with a polarizing filter fitted.

∨ BLUE, BLUE SKY
A polarizing filter helps to saturate the sky in an image and reduce glare. This can add contrast to a scene, as seen here with the clouds: in the unfiltered shot (left) the scene is slightly "flat," but this is fixed with a polarizing filter (right).

∧ VIEWPOINT

Strong sunlight with a scattering of clouds made this an ideal scene to use a polarizing filter on. The polarizer was set to maximum strength to deepen the tones in the sky, boosting the contrast dramatically.

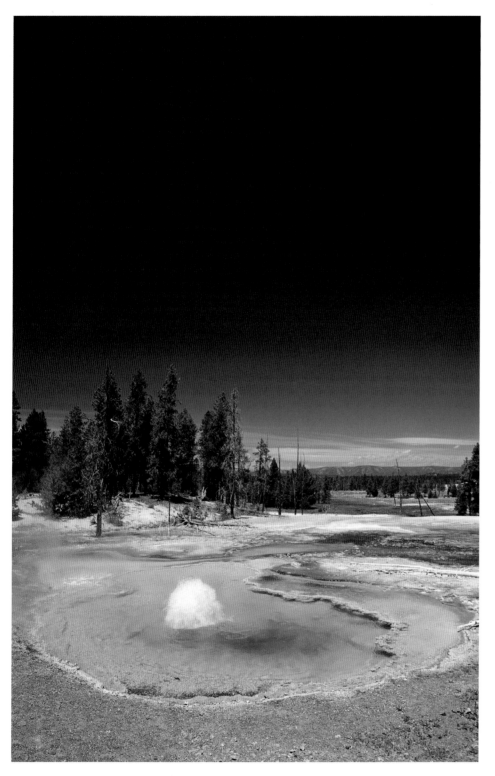

∧ SATURATED COLORS

A polarizing filter helps to saturate colors and reduce reflections in water. Used at full strength, the sky is unnaturally dark in this shot, but in this context it works.

<SMOOTHING OVER**
ND filters are closely
associated with photographs
of flowing water. They allow
exposure times to be extended
significantly, which can have
a "smoothing" effect, even on
crashing waves. For this shot,
a 3-stop ND filter was used.

Neutral Density Filters

There may be times when the intensity of the light you
are working in stops you from using a particular shutter
speed and aperture combination. Digital cameras often
have ISO 100 as a base ISO, and some use ISO 200.
This can be restrictive if you want to use a long shutter
speed without setting a very small aperture.

Neutral density (ND) filters are essentially "sunglasses"
for your camera, in that they reduce the amount of light
entering the lens, enabling you to use longer shutter
speeds or larger apertures as desired. Neutral density
filters are neutral in color (hence the name) and are
available either as a circular screw-in type or sized
to fit into a filter holder. There are different strengths
available, which are measured in stops: a 1-stop ND filter
has the same effect on the shutter speed and aperture
combination as if you changed from ISO 100 to ISO

50, a 2-stop filter is equivalent to changing from ISO
100 to ISO 25, and so on. However, ND filters are often
sold using an optical density figure, rather than stops: a
1-stop ND filter has an optical density of 0.3, a 2-stop
filter has a density of 0.6, a 3-stop filter is 0.9, and so on.

Extreme Neutral Density Filters

A recent development is the general availability of very
dense ND filters that reduce light by up to 12 stops.
These filters are so dense that to the naked eye they
appear opaque, and shutter speeds can be increased
from fractions of a second to several seconds or minutes,
even in very bright light. Because shutter speeds
lengthen so dramatically, extreme ND filters invariably
require the camera to be mounted on a tripod.

As with standard ND filters, extreme ND filters are
available in different strengths in either circular form,

∧ **TOO MUCH LIGHT!**
A neutral-density filter allows
you to use slower shutter
speeds to introduce motion
into daytime landscape images.

to fit directly onto a lens, or square for use in a filter holder. A good quality square filter should have a baffle around its circumference to stop light leakage around the edges during use.

One problem common to all extreme ND filters is that they are never entirely neutral. They either display a warm, almost sepia, cast or a noticeable coolness. This varies from manufacturer to manufacturer and the information about individual filters can usually be found very quickly in online reviews and forums. If you are shooting with the intention of converting your images to black and white, the color cast won't be an issue. To counteract the color cast when shooting color you should either create a custom white balance for the filter and the current shooting situation, or be prepared to adjust the color later in post-processing.

Because extreme ND filters are so opaque you will need to compose, determine exposure, and set the focus before fitting the filter. The exposure should be based on the settings taken without the filter attached and then altered depending on the strength of the filter: use the grid below as guidance. As an example, if the shutter speed with no filter attached is 1/15 sec., you would need to change it to 2 seconds if a 5-stop ND filter is used, or 1 minute with a 10-stop ND filter. Using manual exposure will allow you to make the necessary changes more easily, as exposure compensation usually only covers a 3–5 stop range.

The effect of using an extreme ND filter is very pronounced if there is any movement in the scene you are photographing. When used to shoot landscapes, moving clouds will lose definition and become more ethereal. Water—particularly tidal seawater washing back and forth—will cease to look like water, and take on a misty appearance. In many ways, it is a look that suits black-and-white imagery better than color, as black and white offers an inherently less literal representation of the world.

Because shutter speeds are potentially so long when using an extreme ND filter it's best to use fresh batteries in your camera whenever possible. If shooting digitally, Long Exposure Noise Reduction should be activated.

∧ WAVES
The use of a 1 minute exposure makes this coastal scene appear very tranquil. In reality, the waves were pounding against the rocks in the foreground.

Extreme ND filter exposure compensation

Shutter speed	5-stop filter	8-stop filter	10-stop filter
1/8000 sec.	1/250 sec.	1/30 sec.	1/8 sec.
1/4000 sec.	1/125 sec.	1/15 sec.	1/4 sec.
1/2000 sec.	1/60 sec.	1/8 sec.	1/2 sec.
1/1000 sec.	1/30 sec.	1/4 sec.	1 sec.
1/500 sec.	1/15 sec.	1/2 sec.	2 sec.
1/250 sec.	1/8 sec.	1 sec.	4 sec.
1/125 sec.	1/4 sec.	2 sec.	8 sec.
1/60 sec.	1/2 sec.	4 sec.	15 sec.
1/30 sec.	1 sec.	8 sec.	30 sec.
1/15 sec.	2 sec.	15 sec.	1 min.
1/8 sec.	4 sec.	30 sec.	2 min.
1/4 sec.	8 sec.	1 min.	4 min.
1/2 sec.	15 sec.	2 min.	8 min.
1 sec.	30 sec.	4 min.	16 min.
2 sec.	1 min.	8 min.	32 min.
4 sec.	2 min.	16 min.	64 min.
8 sec.	4 min.	32 min.	128 min.
15 sec.	8 min.	64 min.	256 min.
30 sec.	16 min.	128 min.	512 min.
1 min.	32 min.	256 min.	1024 min.

∧ BLUE
A Hitech 10-stop filter, which has a cool color cast, was used to shoot this picture. This could be corrected easily in postproduction or by using a custom white balance setting.

∧ DENSITY
Even with a low ISO and small aperture setting, the shutter speed was shorter than desired for this daylight shot. However, fitting a 3-stop ND filter extended the exposure time to a blur-inducing 5 seconds.

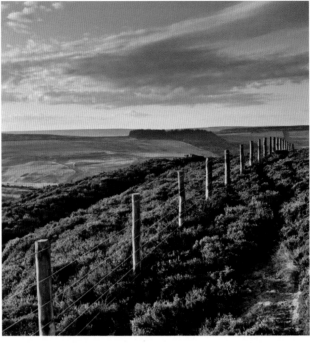

< **BALANCE**

ND grads are commonly used in landscape photography. For this shot, a 2-stop ND grad was needed to balance the sky and the foreground (left). Without a filter, the sky would have been washed out (far left).

Graduated Neutral Density Filters

ND graduated filters (or "ND grads") are related to neutral density filters, with the main difference being that an ND grad has a transparent bottom half and a filtered top half. Graduated ND filters are used to balance the exposure of a scene when one half is far brighter than the other half, and a "straight" exposure is impossible—the main users of ND grads are landscape photographers, who often use them to balance the exposure of a bright sky with a darker landscape. As with plain ND filters, ND grads come in a variety of strengths, as well as different types: soft, hard, or very hard. This refers to how abrupt the transition from the transparent to filtered area is.

One of the big problems with ND grads is that the exposure of everything covered by the filtered area is affected, so unless your horizon is perfectly straight this can mean elements of your landscape above the horizon will be unnaturally darkened. Using a soft ND grad can minimize this, but because the transition is less well defined it can often be difficult to place a soft graduated filter precisely where it is needed. Hard ND grad filters are easier to position, but it's best to use high dynamic range (HDR) or software-blending

techniques when this approach is problematic. While it is possible to buy ND grads as screw-in filters, they work best when used with a filter holder, as this allows them to be moved up and down (or rotated) so they can be positioned precisely where needed.

HARD OR SOFT?

ND grad filters come with either hard or soft transitions and in varying strengths. Hard filters are good for clean horizons; soft are best for busy horizons.

Metering with ND Grads

A very quick and crude method to assess whether an ND grad is necessary is to squint at the scene in front of you. If the foreground and sky appear equally bright then you probably don't need a filter. However, if the foreground looks far darker than the sky, you will need to use one.

Metering method #1

1. Switch your camera to manual exposure and select center-weighted metering.

2. Meter from the foreground and set the correct aperture and shutter speed combination.

3. Point the camera at the sky and meter again. Note the difference in the exposure between the foreground and sky, and select a graduated ND filter that reduces the difference to 1 stop.

4. Compose your shot and fit the filter, leaving the exposure set for the foreground.

Metering method #2

1. Switch your camera to manual exposure and select spot metering.

2. Take a reading from a midtone area, such as grass or rock. Note the suggested exposure.

3. Take spot meter readings of the midtones in the sky. These are typically areas of blue sky or the undersides of darker clouds. Again, note the suggested exposure.

4. Calculate the difference in stops between your two readings and use a graduated ND filter that is equivalent to the difference.

∧ OVER-COMPENSATED

The key to using ND grads is to use the right strength for the scene you are photographing. In this image, a 3-stop ND graduate was used, but the bottom half is unnaturally light compared to the sky. A 2-stop filter would have been a better choice.

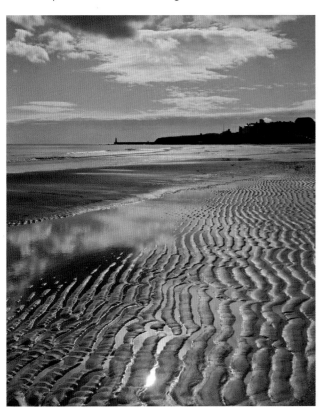

< EXTREME CONTRAST

Shooting toward the sun means coping with extreme levels of contrast. As this image was shot handheld, a 3-stop ND grad filter was used to deal with the contrast.

UV & Skylight Filters

Atmospheric haze will visibly reduce the sharpness of distant objects in your images. Both UV (ultraviolet) and skylight filters will help to reduce the effects of haze, as well as correcting for the over-blueness caused by ultraviolet light. Generally, the exposure is not affected by these filters, but a skylight filter is slightly pink, so it will also subtly "warm" an image (they are available in two strengths, 1A and 1B, with 1B being warmer). This color cast will likely be neutralized if you have the white balance set to Auto.

While UV and skylight filters are useful at high altitude where there is a greater concentration of UV light, the sensor in a digital camera already has a UV-blocking filter in front of it, which will filter out less extreme levels of UV light, making a filter on the lens non-essential.

However, many photographers still choose to leave a UV or skylight filter permanently attached to their lenses to protect the front element of the lens from damage. There are also clear "protective" filters available for this very purpose.

Starburst Filters

Starburst (or "cross-screen") filters are covered in a grid of finely etched lines that refract the light from point light sources. This produces distinctive colored lines radiating out from the light source: the number of lines is determined by the filter's grid pattern. There was a vogue for using starburst filters during the 1980s, but they are now seen as a touch passé. However, fashions come and go, and their day may yet come again.

Soft-Focus Filters

As with starburst filters, the effects of soft-focus filters have waned in popularity. The effect is also easily recreated digitally, so although fun to use, there is little need to invest in a dedicated filter.

Color Filters

For anyone shooting black-and-white film, a set of color filters—red, orange, yellow, green, and blue—is almost essential. Plain color filters work by blocking certain

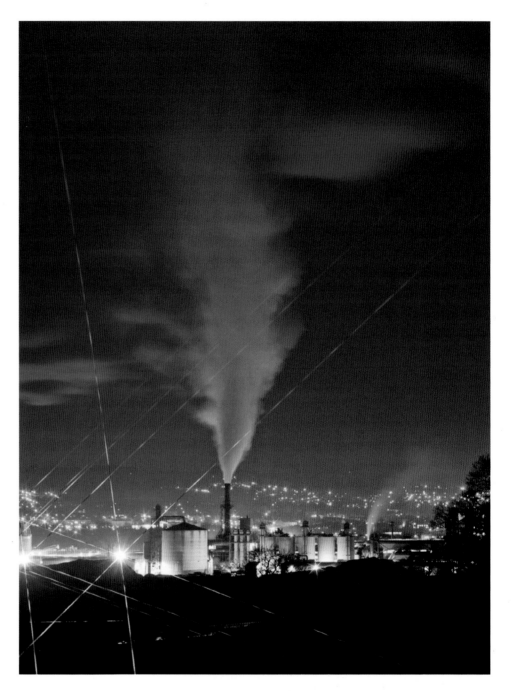

∧ STARBURST
The effect of a starburst filter (here, a six-point filter) was once popular, but it now looks a little dated.

wavelengths of light from reaching the film (or digital sensor). The blocked color will darken considerably, while colors similar to the filter color will lighten in tone. Red, orange, and yellow are useful for landscape photographers, as they will darken blue skies and help define the shape of clouds (red most dramatically, followed by orange, then yellow). Green filters are often used in portraiture to help produce pleasing skin tones as well as for lightening foliage.

Because colored filters block certain wavelengths of light, there will inevitably be a certain amount of light loss: your camera's automatic and semi-automatic exposure modes will compensate for this, but you will need to be aware of these changes if you set your exposure manually. The compensation factor required should be provided with the filter when you buy it, or it will be available as a fact sheet from the filter manufacturer's web site.

Colored filters are not essential for digital photography, as the effects are usually built into the camera and available as a menu option when you shoot in black and white. Alternatively, you can shoot in color and use your image-editing software to convert your images to monochrome—most good editing programs include a sophisticated range of "color filters" that not only includes more colors than the in-camera options, but also enables them to be applied more precisely.

∧ RED FILTER

Shot on film, a red filter was used over the lens to make sure that the clouds in this picture stood out against the hazy blue sky. With a digital camera a red "filter effect" could be used instead, either at the time of capture, or during postproduction.

Camera Supports

A key requirement for a lot of photographs is keeping the camera steady. Sometimes this is easy to do when you're handholding your camera, but at other times you may need additional support.

Tripods

Using a tripod is the traditional method of supporting a camera, and it's something that has been used since the dawn of photography. Originally, tripods were essential, as early photographic emulsions were very insensitive to light and exposures of minutes or hours were often required. Digital cameras have such high ISO settings that images can be captured handheld, even when light levels are extremely low. As a result, modern cameras—especially when coupled with a stabilized lens—can reduce the risk of camera shake to almost zero. The biggest problem with a tripod is that it can restrict spontaneity—setting up is time consuming. But this

is also a strength. By forcing you to slow down, a tripod will make you consider your photography more carefully. It will also open up new creative avenues by allowing you to shoot with longer shutter speeds for effect.

Weight & Rigidity

There is compromise to be made when choosing a tripod: you want one that will not be a burden to carry, but that is robust enough to support your camera successfully. The heavier your camera equipment, the weightier your tripod will need to be.

The cheapest tripods are made of materials such as plastic, which makes them light to carry, but less robust, and more liable to be blown over.

Metal tripods are a little more expensive, but stronger, and aluminum tripods offer a reasonable compromise between weight and cost.

However, the best weight-to-strength material used to make tripods is carbon fiber, an astonishingly rigid material given its weight. On the downside, carbon fiber tripods are often two to three times more expensive than an equivalent metal model.

Maximum Working Height

The working height of the tripod (without the tripod's center column being extended) is crucial. You don't want to be bent over double to look through the viewfinder, and extending the center column results in a loss of stability.

< INVALUABLE
A tripod is vital for low-light photography, and there are numerous techniques—such as "painting with light"—that would be impossible without one.

∨ TRIPOD CHOICES
A sturdy tripod is essential, but your choice will probably involve a compromise or two unless budget is not an option.

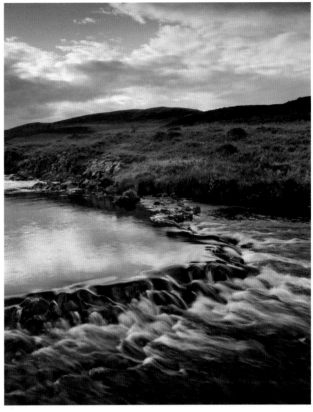

∧ MOVEMENT
Using an ND filter to blur the movement of water means using a slow shutter speed. That, in turn, means using a tripod.

< TOADSTOOLS
To get down to the level of these toadstools the camera was mounted upside down on the tripod.

Minimum Working Height

Changing the height you shoot from can add variety to your shots. Seeking out a "worm's eye" view of the world can not only result in some striking images, but also it can enable you to shoot a wider variety of subjects, such as ground-level plants. Some tripods allow you to open the legs to shoot from a low level, while others enable you to invert the central column, although this means working with your camera upside down.

Leg Lock Mechanism

There are two methods of locking tripod legs: lever locks or twist locks. There is no right or wrong choice with these; it purely comes down to personal preference. Whichever

system you go for, make sure that the locks can be easily operated while wearing gloves—assuming you plan on shooting outdoors in the cold, that is!

Tripod Heads

A tripod will either have a built-in head—typically this will be a three-way type—or you will need to buy and fit a separate head. A tripod that requires a separate head is the more flexible (and more expensive) option, but it means that you don't need to use a combination made by the same manufacturer—as long as the thread on the screw that joins the head to the tripod legs is compatible, you can mix and match as required. There is a number of different types of tripod head. As already

mentioned, the most common is the three-way head. As the name suggests, this type of head allows you to move your camera in one or all of three directions (horizontal, vertical, and tilt sideways). When the camera is in position, the head is locked to prevent any additional movement.

Ball-heads allow you to move the camera in any direction, thanks to the ball joint that gives them their name. They have a good weight-to-strength ratio, and even small ball-heads can generally hold a relatively heavy camera steady. The one drawback with ball-heads is that they can be tricky to use, and making fine adjustments is sometimes difficult as the head is free to move in any direction when it isn't locked down.

∧ **BEANBAGS**
The Pandoras Box is ideal for shooting low-level subjects, as it will cushion and support your camera and lens.

Finally, there are geared heads, which are by far the most precise and easily adjustable tripod head you can buy. However, this ease of use comes at a cost: most geared heads are far heavier than three-way or ball-heads, which tends to limit them to studio use, rather than outdoor photography.

Regardless of the type of tripod head you prefer, a useful feature to look out for is a quick-release mechanism. This allows a plate to be screwed into the tripod socket on the base of your camera, which can be clipped quickly onto the tripod head. This makes using a tripod a less frustrating and time-consuming business.

Good Technique

Using a tripod is usually about one thing: making sure that your camera is rock steady so that your images are as sharp as they can possibly be. However, care still needs to be taken, even when the camera is on a tripod. No matter how gently you press the shutter-release button, the internal actions of the camera —and the external actions of the photographer—can still cause vibrations, resulting in out-of-focus images. Thankfully, there are numerous ways that you can reduce this movement.

Setting Up

A tripod can wobble slightly if the legs are not extended evenly, so try to make sure that it isn't leaning before you attach your camera.

Many tripods also have a center column that can be raised or lowered. In theory, center columns are a good idea, as they enable the camera to be positioned at a greater height without having to make the tripod legs longer (saving on both weight and bulk). However, using a center column raises the center of gravity of your tripod, with the result that it becomes top heavy. To avoid this, make sure that you have extended the tripod legs to their maximum height before you consider using the center column.

It is also good practice not to move around during long exposures, particularly if the ground is soft: this may cause the tripod to move or, in very low light, you could accidentally walk into or trip over the tripod.

∧ **STAYING STILL**
Once your tripod is set up, try to minimize your movements: nothing is worse than knocking the tripod and ruining a carefully composed shot.

∧ **THREE-WAY HEAD**
The Benro HD1 is a traditionally styled three-way tripod head.

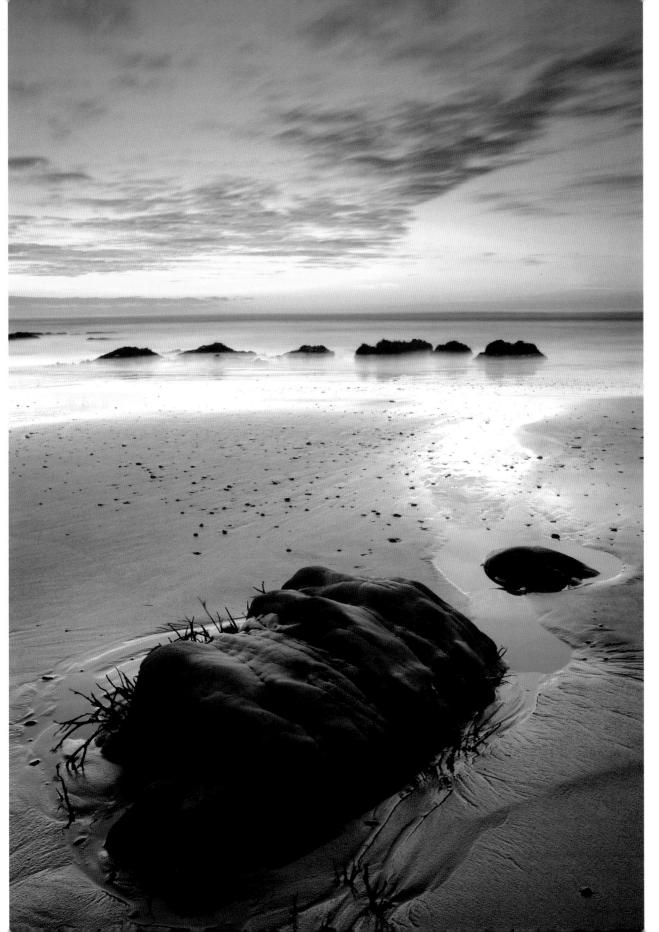

< **LONG EXPOSURE**
With an exposure time of several seconds or more, this image would have been impossible to achieve without the use of a sturdy tripod.

Remote Release

Pressing the shutter-release button by hand can cause the camera to shake slightly, leading to soft, blurry pictures. To eliminate the problem, trigger the shutter from a distance using a remote release. Cable releases (usually electronic) plug directly into the camera body and are activated via a button at the end of a lead. By contrast, wireless releases use an infrared beam to trigger the shutter. Either of these devices should be used with a tripod-mounted camera.

Self-Timer

Most cameras, whether system, bridge, or compact, feature a self-timer facility. This feature is most often associated with family portraits, where the photographer also appears in the picture. However, the self-timer facility can also be used in place of a remote release. By asking the camera to delay firing the shutter, any internal vibration caused by pressing the shutter-release button will have died down before the shutter opens to begin the exposure. For the best results, this feature should be used with a tripod-mounted camera and only with subjects that are stationary—it is hard to guess where a moving subject might be at the end of a 5- or 10-second countdown!

Mirror Lockup

Every SLR, whether digital or film, contains a reflex mirror that flips up to allow light to reach the sensor or film. During this process the mirror "slaps" the top of the mirror box, causing a slight vibration. This vibration dissipates quickly, but the movement is exaggerated when using telephoto lenses. To solve the problem, the majority of SLRs offer a mirror lockup facility (MLU).

When this feature is activated, pressing the shutter-release button once will raise the mirror, holding it in the "up" position. After waiting a few moments for the vibration to die down, the shutter-release button can then be pressed a second time to expose the sensor or film to light. When the exposure has been made, and the shutter closed, the mirror will return to the viewing position. By locking the mirror in the "up" position, any internal vibration is significantly reduced, although for the best results, mirror lockup should be used in conjunction with a tripod, and a cable or remote release.

Needless to say, "mirror slap" is not an issue with mirrorless cameras. Nor is it a problem if you are using Live View on a DSLR, as the mirror has to be raised to enable you to view the image on the rear LCD screen.

< SOFT
This image (far left) has been marred by noticeable camera shake (left): good technique would have prevented this.

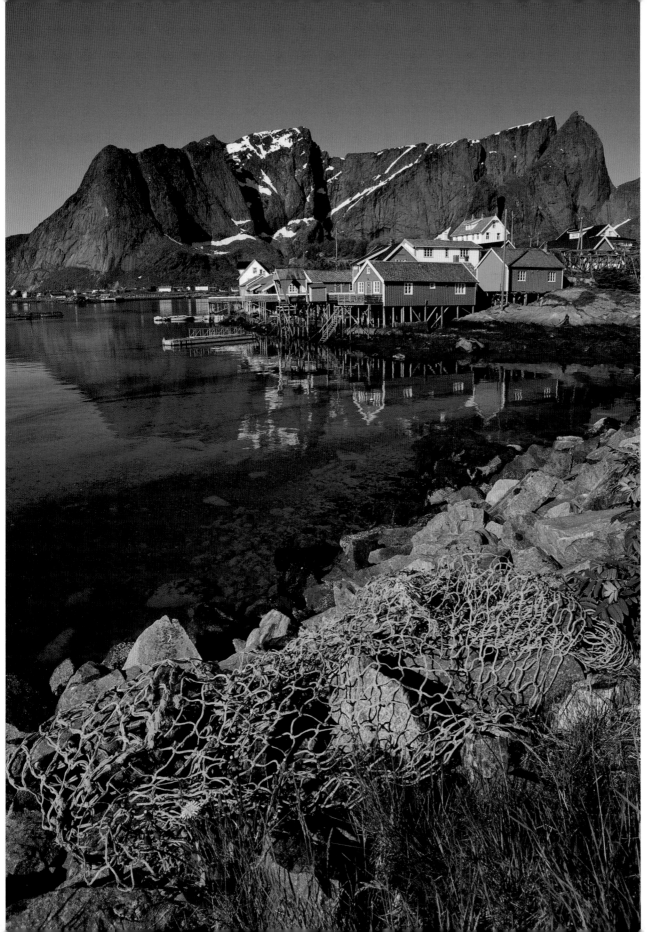

< IN THE FRAME
A good tripod will enable you
to frame your shots quickly
and precisely, but you also
need good technique to get
the full benefit of your support.

Other Accessories

In addition to cameras, lenses, filters, and tripods, there are countless gadgets and tools that will make your life easier, both practically and photographically. Some are essential; others less so.

Memory Cards

Memory cards definitely fall into the "essential" accessory category—leave home without one and your photo shoot will be incredibly short-lived. There are generally two considerations here: capacity and speed.

Your memory card's capacity—usually measured in Gigabytes (GB)—determines how many photographs you can shoot and record to it. There is no "magic number" here, as Raw files take up far more space than an equivalent JPEG file. Shooting both simultaneously requires more storage space still, so only you can decide how much space you need.

Once you have decided how much storage space you need, there are two approaches. The first is to have a single high-capacity memory card that is used throughout a photography session and then emptied when convenient. The other approach is to use a number of smaller-capacity cards and swap them out frequently as they are filled.

In many respects the latter approach is the safer of the two, as the loss of one card with a small selection of images is less disastrous than losing a card that contains all of your images, regardless of whether this is a physical loss, or a corruption of the data stored on the card. Buying numerous smaller-capacity cards is slightly more expensive, though, and it does require a disciplined approach to your photography—you don't want to format a card accidentally before you have had a chance to empty it!

The other consideration is speed, which refers to how fast a card can write data to the card and read data from it. Whether speed is important or not will really depend on two things: your style of shooting (a fast card is less important for a landscape photographer than a sports photographer, for instance) and the files you shoot (Raw files are larger, so take longer to write than JPEGs).

It is also worth noting that some of the fastest cards currently available might exceed the capabilities of your camera, in which case spending more money on the fastest memory card may not bring any benefit.

Camera bags

Unless you're going to walk around with your camera on a strap round your neck all the time, you will need a bag to put it in, along with all your accessories.

Bags typically fall into two categories: those that have a single strap and are worn over the shoulder, and those that have two straps and are worn backpack style.

V MEMORY CARDS
For most photography sessions a 16GB memory card would usually be more than sufficient, although some people would prefer to use two 8GB cards for security. You might also need a card reader (bottom) for your computer if it doesn't already have one built in.

∧ FULLY LOADED
Before you buy a camera bag, you'd be wise to load it with your gear and try it on. Bear in mind how comfortable it would be to carry around all day.

There are advantages and disadvantages to both, so it is a good idea to load a prospective bag with all your gear, and try it on before you buy it. As a general rule, backpacks are easier to carry over long distances and/or with heavier loads, while a shoulder bag allows you to access your kit more easily.

You should look at practical features, such as space and the number of internal pockets, and whether there's room for your kit to grow—if the bag is going to be full to bursting point when you buy it, what will happen if you purchase another lens in six months time?

Look for reinforcement where you need it most: the base and back—remember that your lenses may well be pointing toward the bottom of the bag, so it needs to be well protected. Also consider whether or not you need extra space to carry non-photographic equipment such as car keys, a wallet, or snack. If so, look for clear compartment divisions that will protect your camera gear from any spillages or knocks. Check also that the straps and fasteners are strong and easy to secure.

Batteries

A system camera will almost certainly come with a battery (it's not much use without one!) and while it is extremely efficient for its size, it will inevitably deplete as you use it. This is particularly true if you are constantly using the camera's Live View and image review functions, built-in flash, and when setting lengthy shutter speeds with Long Exposure Noise Reduction activated.

To prevent your photography session coming to a premature end, it's worth investing in a spare battery or two and keeping these charged up ready for use. Also be aware that batteries are depleted more quickly when conditions are cold, so store your spares inside your jacket to keep them warm until you need them.

Remote Releases

The humble remote release is an often-overlooked item of equipment. The simplest variety is a cable-release that screws directly into the shutter-release button. There is no electronic signal and it's the mechanical act of pushing down the plunger on the cable release that fires the shutter. Most modern camera manufacturers

< BATTERY
A spare battery (or two) might not be essential for short shooting excursions, but for longer photo sessions, or times when you might not be able to recharge your battery regularly, it can be beneficial.

no longer support this type of cable release, with the exception of Fuji and Leica.

Instead, most cameras today use proprietary electronic remote releases that are incompatible with rival systems. These remote releases are electronic devices that control the shutter by wire connection or infrared. Using a remote release means you can avoid touching your camera when it's mounted on a tripod. This all helps to reduce the risk of camera shake and knocking the camera. A vital feature to look out for when choosing a remote release is a shutter lock facility. This is used when employing Bulb mode and avoids the necessity of keeping a finger on the shutter button during the exposure.

The most sophisticated remote releases are those with programmable functions such as timer, timed Bulb, and an intervalometer. Intervalometers allow the shooting of multiple images over a regular period. This facility is particularly useful when shooting images for time-lapse movies or for star-trail stacking.

Lens Hood

A lens hood is a plastic, metal, or rubber ring that attaches to the end of the lens via a bayonet fitting. Its role is to block non-image-forming light from striking the lens from the sides—reducing contrast and causing unwanted lens flare. They are particularly useful when working outdoors, taking pictures in the general direction of the light, and for backlit subjects. The majority of new lenses are supplied with a dedicated hood, but some are not. Hoods are made in a variety of shapes and sizes, depending on the lens' focal length. The most common types are slightly flared, conical shaped, and 8–20cm

∧ THIRD-PARTY REMOTES
There is a number of third-party alternatives to an official camera manufacturer's remote control, offering varying levels of control.

∧ LENS HOOD
Not all lenses come with a hood, but it can be useful for reducing flare and maximizing image quality.

long. Lens hoods for telephoto lenses tend to be longer as, due to their limited field of view, the hood can extend further from the end of the lens.

Short focal lengths—prime or zoom—require a smaller and more complex hood. A standard cylindrical hood would block the lens' wide field of view and create vignetting. Instead, a "flower" or "petal" shape is more popular—basically a short hood with notches to ensure that, when fitted, it offers the lens optimum protection from stray light, without causing darkening at the corners of the frame.

Hoods are often designed so that they can fit onto the compatible lens facing either forward—when in use—or backward, so that it can be stored with the lens without taking up extra space. A lens hood also offers a certain degree of physical protection to the front of the lens from rain, snow, and accidental damage.

Spirit Level

If you photograph landscapes or seascapes, then the horizon should be horizontal, but it's not always easy to tell if that's the case when you're peering through the viewfinder or looking at a small image on your camera's screen. Some tripods and tripod heads come with a built-in spirit level, and an increasing number of cameras have an electronic level built into them, but an alternative option is a spirit level that clips into the hotshoe of your camera. This will tell you at a glance if your camera is level or not.

Right-Angle Finder

Looking at an object through the viewfinder can sometimes cause you to adopt a series of uncomfortable poses, especially when the object is situated at ground level. This discomfort can be alleviated by using a right-angle finder. These L-shaped accessories fit to the viewfinder eyepiece and allow the scene to be viewed from above. While they tend to be expensive, some models feature 1x or 2x magnification options, enabling you to check and adjust focus with relative ease. In addition, advanced versions can be rotated 180° or 360°, and occasionally feature dioptric adjustment, allowing spectacle wearers to use the device without glasses. Right-angle finders produced by the main camera brands tend to be the most expensive, so it's worth looking at options from independents. For the best results, this feature should be used with a tripod-mounted camera.

Articulated LCD Screen

This is not an accessory as such, but some cameras feature articulated (or tilt and swivel) LCD screens, which is great for close-up photography and shooting from low angles. When the subject is low to the ground, for example, the screen can be flipped out and rotated to allow more comfortable viewing (the camera will need to be displaying "live" images for this to be of use). In addition, an articulated screen is ideal for playing back digital images in bright sunlight, as it can be adjusted to reduce glare and reflections.

∧ **VIEWFINDER**
A right-angle viewfinder attaches over the eye-level viewfinder of a DSLR, allowing you to look through the camera from above.

∨ **TWIST AND TURN**
Some system cameras, such as the Nikon D5300, feature an articulated LCD screen, which is ideal for close-up work.

∧ **ON THE LEVEL**
Hotshoe-mounted spirit level.

Reflectors

A reflector is a surface—usually white—that is used to direct light into the shadow areas of your subject to reduce contrast. It's possible to buy reflectors in all sorts of shapes and sizes, although often a piece of card or paper is more than adequate, particularly when shooting macro subjects.

Commercial reflectors are also available in metallic finishes, either colored silver or gold. Metallic reflectors bounce more light back toward the subject and increase contrast compared to a pure white reflector. If you use a silver reflector outdoors this can have the effect of making the reflected light cooler, particularly when ambient light from the (blue) sky above is reflected. A gold reflector counteracts this and adds warmth to the light reflected back to your subject. Gold reflectors are often used in portraiture for this very reason—the warmer light adds a healthy glow to your subject.

< SHADOWS
The low, raking light of morning creates long, often dense shadows. This beach still life was shot without a reflector (top) and with a reflector just out of shot on the left (bottom). The reflector "bounced" sunlight into the shadow area, reducing contrast, and adding an overall warmth to the image.

Notes

Reflectors are most useful when you have one light source, such as the sun. Position the reflector on the opposite side of your subject to the light source and angle it so the shadows lighten to the desired amount.

Check that the reflector isn't intruding into the image before you press the shutter-release button!

< COLLAPSIBLE
Lightweight reflectors, such as this one by Lastolite, are designed to collapse to about half their diameter for storage.

CHAPTER 4
EXPOSURE

Introduction to Exposure

The sensor in your camera requires a certain amount of light to capture an image. Understanding and controlling this process is an important aspect of creative photography.

The word photography is derived from the Ancient Greek words φως (phos, or "light") and γραφω (graphõ, or "I write"). Therefore, photography is "writing with light," and if the art of writing is telling a story well, the same is true of photography. However, instead of choosing words for your story, you choose the amount and quality of light that is suitable for the photograph you want to create. This makes exposure one of the most important aspects of any photograph to get right (or get just about right).

Thankfully, at its most fundamental level, exposure is one of the easiest technical aspects of photography to get to grips with. There are two ways in photography that you can control how much light reaches the sensor in your camera: the first is to vary the length of time that a light-tight shutter covering the sensor is open

for, and the second is to adjust the size of a variable aperture mounted within the lens.

Shutter Speed

Your camera has a range of shutter speeds, which are a measure of the length of time that the shutter is opened to make an exposure. The range available varies between camera models, but is typically between 1/4000 sec. and 30 seconds. In addition to this, some cameras also have a Bulb mode that locks the shutter open for as long as the shutter-release button is held down.

The shutter speed on a camera is varied by set amounts, such as 1/500 sec., 1/250 sec., 1/125 sec., 1/60 sec., and so on. The difference between these values is referred to as 1 "stop." When you

∨ **GOOD EXPOSURE**
A well-exposed image is arguably one that appears "natural." This is achieved through careful control of the aperture, shutter speed, and ISO.

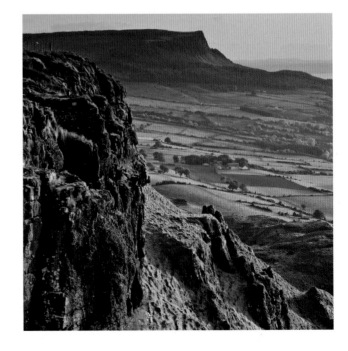

APERTURE SETTINGS

The aperture settings move in "f-stops." The quoted numbers are inverse, so the largest f-stop numbers represent the smallest aperture holes, and the smallest f-stop numbers represent the largest aperture holes. The available f-stop range will vary from lens to lens, but will go something like this: f/2.8, f/4, f/5.6, f/8, f/11, f/16, f/22. These are known as "full" f-stops, and they will likely be broken down into ⅓ f-stops, too, giving you numbers between those shown. Each full f-stop setting lets in half as much light as the larger aperture preceding it.

f/2.8 f/4 f/5.6 f/8 f/11 f/16 f/22

increase the shutter speed by 1 stop (from 1/250 sec. to 1/500 sec., for example) you halve the amount of light that reaches the shutter. If you decrease the shutter speed by 1 stop (from 1/250 sec. to 1/125 sec.) you double the amount of light reaching the sensor.

Aperture

Within every camera lens is a variable iris known as the aperture. Like the iris in your eye, it can be increased or decreased in size to take account of lower or higher light levels respectively. The size of a lens aperture is measured in f-stops, shown as f/ and a suffix number, which can be adjusted from "maximum" (when the aperture is as open as is physically possible), to "minimum" (when the aperture is at its smallest). As shown on the facing page, the smaller the number after the f/ mark, the wider the aperture, and the larger the number after the f/ mark, the smaller the aperture.

The range of apertures available varies between lens models. Typically zoom lenses have relatively small maximum apertures in comparison to primes. If a zoom lens has a large maximum aperture, it will usually be very heavy and very expensive.

There is a precise relationship between each f-stop value and the values on either side of it. If you take a typical aperture range that would be found on a lens—f/2.8, f/4, f/5.6, f/8, f/11, f/16, f/22—then each f-stop allows half as much light through to the sensor as the one preceding it. This also means that when you decrease the size of the aperture by 1 stop (from f/5.6 to f/8, for example) you halve the amount of light that reaches the shutter. If you increase the aperture by 1 stop (from f/5.6 to f/4) you double the amount of light reaching the sensor.

ISO

A third control—ISO—determines how sensitive the sensor/film is to light to start with. In this way, ISO controls how much light is needed to make an exposure, and the aperture and shutter speed control how the light is delivered. As you will see in this chapter, there are countless ways in which this can be achieved, and many creative decisions to make along the way.

∧ **APERTURE**
By altering the aperture, you can dramatically change the way the background appears.

∧ **SHUTTER SPEED**
The shutter speed you use will determine how movement is recorded in your images.

Depth of Field

Depth of field is a term applied to the area of acceptable sharpness in a photograph. In reality, only the element you have focused on—and anything else on the same plane—will be perfectly sharp, but an area in front of and behind will also appear to be sharp.

Changing the aperture has a noticeable effect on a photograph. As the aperture is made smaller, a zone of sharpness extends out from the point of focus. This effect is known as "depth of field." The amount of depth of field achievable is dependent on several factors: the lens aperture used, the focal length of the lens, and the camera-to-subject distance. Depth of field always extends further back from the point of focus than in front.

The longer the focal length of a lens, the less depth of field there will be for a given aperture. With a wide-angle lens it is often relatively easy to achieve front-to-back sharpness with a moderately small aperture. This becomes almost impossible with a long lens, even when it is stopped down to the smallest aperture. There are two simple rules to remember regarding depth of field and its relationship to focal length and the aperture setting. These are:
- The wider the aperture, the smaller the depth of field (and vice versa).
- The longer the focal length, the smaller the depth of field (and vice versa).

Depth of field also diminishes the closer the camera-to-subject distance. Macro photography, with its very small camera-to-subject distances, often involves very shallow depth of field and necessitates an accurate focusing technique.

Depth of field extends from about one third in front of the point you choose to focus on to approximately two thirds behind it. There may be occasions when you want to maximize the depth of field without changing the aperture, subject-to-camera distance, or the focal length of the lens. In these instances, try focusing roughly one third from the bottom of the frame for optimum depth of field. Alternatively, you can use the hyperfocal focusing technique (see pages 76–77).

Thankfully, determining depth of field is not a matter of guesswork. Many cameras come with a depth-of-field preview button that allows you to see exactly what is in focus before releasing the shutter. In addition, some lenses have a distance scale on the lens barrel, to help you make an assessment. So, in short, to increase depth of field you can either stop

∨ **COMPARISON**
This comparison sequence helps to illustrate how different f-stops affect depth of field and also the way in which a subject is recorded by the camera.

| f/2.8 | f/4 | f/5.6 | f/8 | f/11 |

∧ HANDHELD

In low light, larger apertures are often required to achieve a fast enough shutter speed to handhold the camera. This will reduce depth of field.

∧ CHOICE

How much or how little depth of field to apply is one of the creative decisions you need to make in photography. We don't like to look at out-of-focus areas in an image, so a shallow depth of field can help direct the eye to a (sharp) subject.

down the aperture (select a higher f-number), step back from the subject, or try focusing one third of the way into the frame. Conversely, to decrease depth of field either use a wider aperture (select a lower f-number), or step closer to the subject.

f/16 f/22

< HYPERFOCAL DISTANCE

The hyperfocal distance for this scene was 2.8ft (0.85m) with an aperture of f/14. This gave a depth of field that extended from 1.4ft (0.42m) to infinity.

Shallow Depth of Field

By using a wide aperture in conjunction with a longer-than-normal focal length, it is possible to render the background out of focus and add extra "punch" to your subject. The wider the aperture and/or the longer the focal length, the greater the extent of the effect will be. This can be useful for practical reasons, as well as helping to emphasize the subject. For example, it can help you to minimize a distracting or unsightly background, and with a long focal length you can make a background disappear into a blur.

Does this mean that you don't need to pay attention to the background at all? No, you still need to be aware of what is there, because the colors will still be in evidence, even if the detail is not. In the image of the fisherman sorting his nets below, the bright colors add vibrancy to the photo, but watch for areas of strong reds and yellows (as in the boat at the left), as these can distract the viewer. Take care about the exact point you focus on.

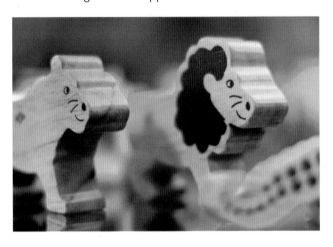

∧ CLOSE FOCUS
By using close focus in conjunction with a very large aperture, depth of field is reduced considerably.

∧ LARGE APERTURE
Using a large aperture, such as f/5.6 or more, can help to isolate a single subject from an otherwise busy scene.

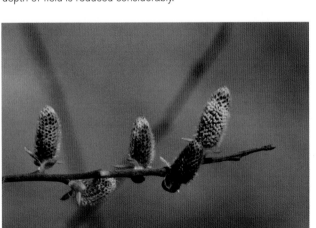

∧ TELEPHOTO
A telephoto focal length used with a small aperture will produce a very shallow depth of field—perfect for making a subject stand out from its background.

∧ BACKGROUND
Don't ignore the background, even if it's going to be blurred—strong colors such as red and yellow can still be distracting and draw the viewer's eye.

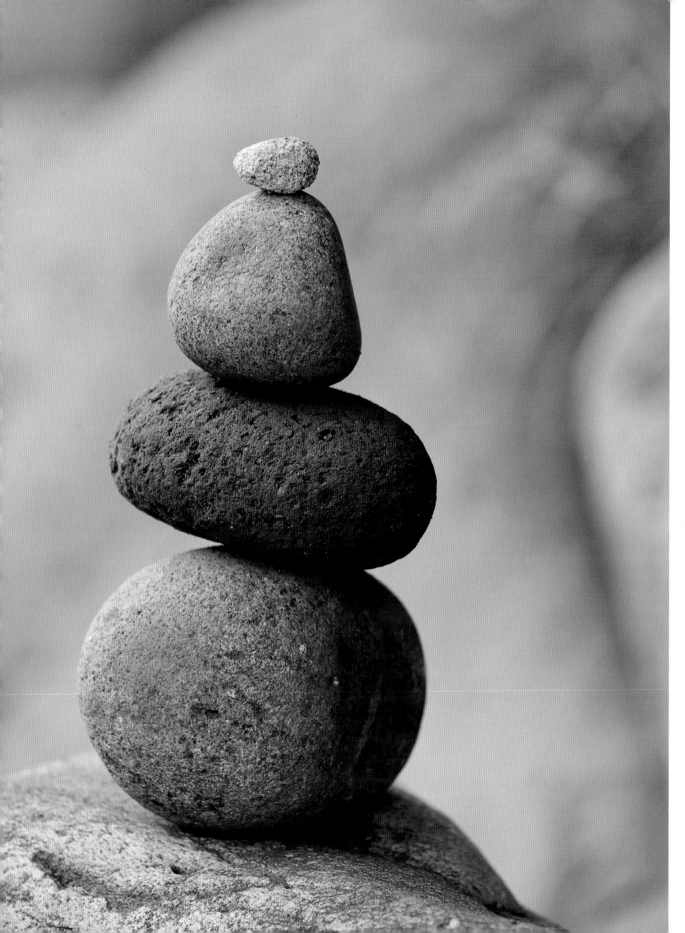

< BALANCE

With this shot it would have been easy to lose the main subject. You don't need to be able to see the detail in the background to know that it is also rock. The shallow depth of field helps the stones to stand out.

Extensive Depth of Field

If you want to maximize the depth of field in an image you need to use a small aperture and/or a wider focal length. Your choice of focal length is also important, because the wider the focal length, the more the distant elements will be rendered smaller and smaller in the composition, which can change the whole feel of the image.

There is a cut-off point with regards to focal length and technique, though: lenses as wide as 24mm on a full-frame camera can be used to widen your view, but at wider focal lengths you often need to change your technique and *step forward* to increase the relative size of the foreground. This means that you must be actively looking for objects that will provide foreground interest.

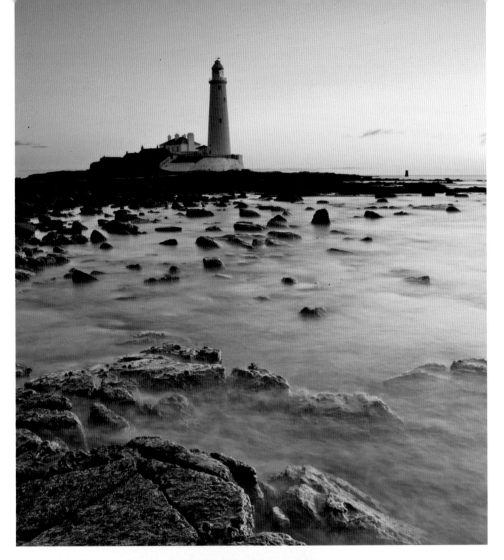

∧ **NEAR AND FAR**
For this shot, it was important that everything from the rocks in the foreground to the distant lighthouse was sharply focused. A 17mm focal length setting and an aperture of f/13 made this possible.

∧ **RICH DETAIL**
The main subject in this image was the patterns in the canyon walls. An aperture setting of f/20 allowed all the rich detail in the rock to be recorded.

∧ **WIDE-ANGLE SHARPNESS**
It is easy to get all of a scene sharply focused when using a wide-angle lens. This image was shot with a 16mm focal length, so f/18 provided full front-to-back sharpness.

⋀ SWEEPING VISTAS

A wide-angle focal length used with a wide aperture will produce the most expansive depth of field, making it the ideal choice for landscape photographs.

Movement

Conveying a sense of movement in your photographs requires anticipation, solid technique, quick reactions, and a willingness to experiment. There are three main ways to suggest motion: freezing, blurring, and panning.

While aperture choices control the amount of light hitting the camera sensor through the size of the hole in the shutter, the shutter speed controls the level of light entering the camera through the speed with which it opens and closes the shutter. The faster the shutter opens and closes, the less light gets in; the longer it stays open, the more light gets in. It is almost certain that your camera will have Shutter Priority as one of its exposure modes. With this mode selected, you can select the desired shutter speed and the camera selects an appropriate aperture according to its meter reading, so this is the mode to use when you want a very specific shutter speed.

If your subject is static, the shutter speed you use doesn't matter at all—as long as the camera is stable during longer exposures. However, shutter speed does make an important difference once there is movement in a scene. If your subject is particularly fast—a low jet screeching over your head, for example—you will need to use a fast shutter speed otherwise it will not be sharp in the final image. The slower your subject is moving, the slower the shutter speed you can use to be sure of a sharp result. Ironically, a moving subject frozen by the use of a fast shutter speed can look oddly static, and a small amount of blur can actually convey a sense of speed far more effectively than a pin-sharp image can.

Freezing

In order to successfully freeze motion, you need to use a fast shutter speed. Which you choose depends on several factors, but it is common practice to select the highest shutter speed possible in order to prevent blur from occurring.

Blurring

Blur is commonly used in landscape photography to show water as a milky wash, but it can also be used with other subjects, such as light trails from traffic. A tripod is needed to allow slow shutter speeds, while preventing camera shake. Again, the shutter speed required will depend on the speed of the subject. Blur can also be combined with flash—try using a slow shutter speed to create a sense of movement, then freeze the subject with a burst of light.

Panning

Panning involves using a medium shutter speed, following your subject through the viewfinder, and pressing the shutter-release button at the desired point. The subject will remain sharp while the background appears blurred. Panning may require experimenting with various shutter speeds to achieve the desired effect. The result will depend on the speed of the subject, and how far away you are from the action.

∧ SUBTLE MOVEMENT
A shutter speed of 1/160 sec. was just right to allow the movement in the breaking waves to blur slightly. This made the image more dynamic, but without the sea becoming blurred overall.

Freezing Movement

There can often be many moving elements in a scene that you want to photograph, whether it's people, vehicles, or even the more subtle effect of the wind. If you want to freeze any motion then the shutter speed needed will depend on the speed at which your subject is moving across the frame; the direction in which it is moving; and the focal length of the lens.

For example, a person running parallel to the camera will travel more slowly across the frame than a moving car. As a result, the shutter speed required to freeze the runner will be slower than the shutter speed needed to pause the motion of the car. If the person is running toward the camera, he or she will be crossing less of the sensor plane and will require a slower shutter speed than if they are running parallel to the camera. Furthermore, using a long focal length lens will mean that the subject appears larger within the frame, and will take less time to cover the sensor plane than if you were using a wide-angle lens.

Some of the more obvious (and popular) examples of moving elements are water in landscape photography. If you are shooting a scene that includes a river or the sea, for example, then you will need to use a relatively fast shutter speed to freeze the motion. A shutter speed

of around 1/200 sec. should suffice for most moving water, but it depends on how rapidly the water is moving: a tumbling waterfall might need a shutter speed closer to 1/500 sec. to freeze the motion, while a gently lapping sea might only require 1/60 sec.

The same thought process applies to any other moving subject you encounter: the faster the movement, the faster the shutter speed needed to stop them from

∧ HOVERING
Because this helicopter was hovering, the speed of forward motion wasn't high. A shutter speed of 1/320 sec. was fast enough to guarantee it was sharp, but there is still some blur in the rotor blades. This shows that they were moving.

Suggested shutter speeds to freeze movement

Subject	Subject filling frame	Subject half filling frame
Person walking slowly	1/125 sec.	1/60 sec.
Person walking quickly	1/250 sec.	1/125 sec.
Waves	1/250 sec.	1/125 sec.
Person running	1/500 sec.	1/250 sec.
Person cycling	1/500 sec.	1/250 sec.
Galloping horse	1/1000 sec.	1/500 sec.
Car (on urban road)	1/500 sec.	1/250 sec.
Car (on freeway/motorway)	1/1000 sec.	1/500 sec.
Train	1/2000 sec.	1/1000 sec.
Fast jet plane	1/4000 sec.	1/2000 sec.

Tips

When using shutter speeds faster than 1/500–1/1000 sec., turn off any image stabilization system. Above these shutter speeds the image stabilization system will almost certainly not resample fast enough to coordinate with the shutter, producing inconsistent and unpredictable results.

If your camera has a variety of scene modes, one of these could well be a Sports mode. This doesn't mean that it is only suitable for sports events; it just means that it is suited to capturing action, which can include anything that requires a fast shutter speed. This also makes such modes unsuitable when you want a slow shutter speed, so do not think of Sports mode as an "intelligent" version of Shutter Priority.

∧ FREEZING WATER
A shutter speed of 1/800 sec. has "frozen" individual drops
of water in this image.

∧ COUNTER THE WIND
Fast shutter speeds can be very useful on windy days—to stop the
motion in trees and grasses, for example. Here, a shutter speed of
1/320 sec. kept this wheat field "calm."

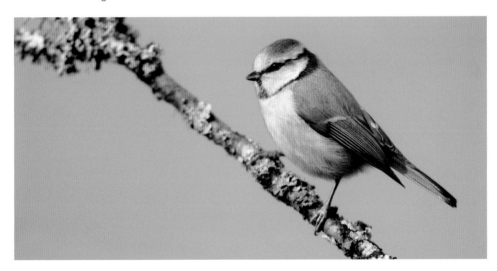

blurring in the image. The grid opposite gives an idea
of the shutter speed needed to freeze a variety of
subjects at a number of different sizes in the frame.
However, it is only a guide—use it as a starting point,
but be aware that movement needs to be assessed
carefully for every shot your take.

∧ DEPTH OF FIELD
Using a fast shutter speed
often means setting a wide
aperture. This reduces depth
of field and makes focusing
accurately more important.

Note

Image stabilization is only useful for reducing camera
shake. It does not replace the need for fast shutter
speeds when you want to freeze subject movement.

Blurring Movement

If using fast shutter speeds to freeze all movement harks back to the classic forms of photography, then utilizing slow shutter speeds is most definitely a technique of the modern movement. With our own eyes we tend to see the world as if it is all shot with fast shutter speeds, so using slower shutter speeds immediately injects a freshness into your images, giving an abstract expression of time and motion.

Rather than being caught up in the infinite detail of the moving elements, slow shutter speeds allow us to immerse ourselves in the soft and slightly dreamlike motion of people, vehicles, water, clouds, tree branches, and grasses. Some photographers may feel that this is a little too surreal at times, and that blurring movement with slow shutter speeds—despite being a relatively recent trend—is already being overused and over exaggerated.

As with many photographic techniques, though, the ability to use them subtly and in moderation is where the real skill resides. Expose the ebb and flow of a tide for too long and it almost seems to disappear in a swirl of ethereal milkiness. Try instead to find the shutter speed that allows the faster moving parts of the sea, such as the breaking waves, to display the blur of motion while the slower moving areas retain some details, and you will be on the way to creating powerful and memorable photographs. Again, there are no set speeds to use as it totally depends on the speed and direction of travel of the subject.

Suggested shutter speeds to blur movement	
Waterfall	1/4 sec.
Waves (retaining detail)	1 sec.
Moving clouds	8 sec.
Waves (smoothed out)	15 sec.
Fireworks	30 sec.
Wind-blown foliage	30 sec.
Traffic trails	30–60 sec.
Waves (misty quality)	1–2 min.
Star trails	10+ min.

Using a tripod or other firm support for the camera becomes critical when utilizing slow shutter speeds. With the shutter being open for long enough to register any vibration, it becomes more important still to use a remote cable shutter release, so that you don't have to touch the camera at all to operate it. Even the gentlest of touches can result in minor camera shake, which will soften or possibly even ruin the final image.

Although the shutter is open for some time and will capture a range of motion, it is still vital to try and time the shutter release to coincide with the moving elements being in the best possible position in the frame and at the peak of their movement. Any slow shutter speed photography usually involves some "hit and miss" experimentation, so study each image on the camera's LCD screen to see how it can be improved.

∧ SERENDIPITY
The appealing aspect of shooting traffic trails is unexpected, but interesting results. A bus passed during this exposure and the lights from the upper deck neatly framed the buildings in the background.

∧ MILKY WATER

Once your shutter speed goes to 2 sec. or slower, water becomes a milky blur. It's a nice effect, although a little overdone these days. If this is the look you are after, then it is a good idea to find water that is tumbling over a rock or rocks. The water thins over the top of the rock, revealing its texture, before turning silky white beyond it.

∧ BLURRING THE LINES

One of the key decisions to make when shooting moving water is just how much blur you want to introduce. A shutter speed of around 1/5 sec. will usually show blur while still retaining some texture in the water, but this depends on the speed of the water and its direction of travel relative to the camera.

∧ WIND IN THE TREES

Using a slow shutter speed captured a sense of the breeze blowing through this area of woodland far more effectively than a faster one would have done.

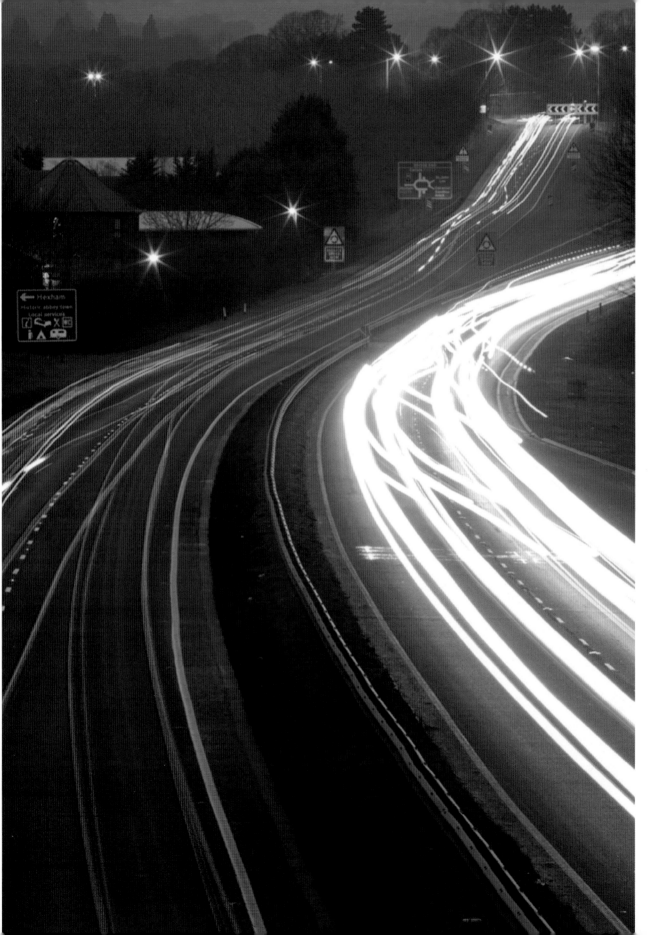

< LIGHT TRAILS
When you are shooting light trails, the line of the road will give you an idea of how the trails will flow, so use that as a guide when you are composing your shot.

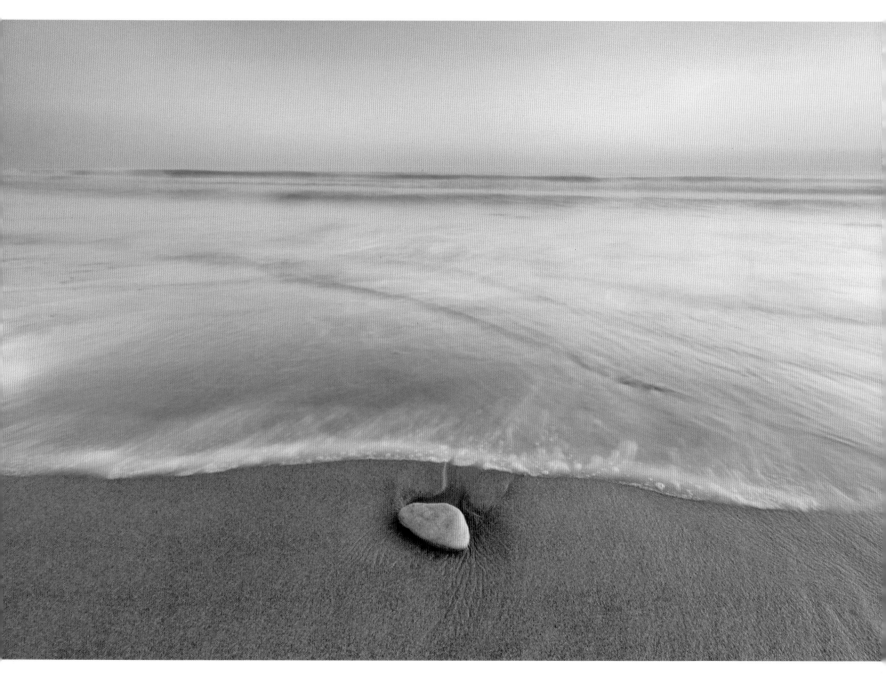

∧ ETHEREAL EFFECT
If you want to introduce blur into your images, but the light levels are too high to achieve this, you can use ND filters to slow the shutter speed. Here, a 2-stop ND filter has helped make the water appear more ethereal.

Panning

When the light level is low, it's more difficult to achieve the shutter speed you need to freeze action without using a wide aperture—and even then it may not be possible. You could increase the ISO, but that would risk a corresponding increase in image noise. "Panning" describes the act of moving your camera, timing its movement to follow a subject, so the subject will remain sharp and the background will be blurred. This often creates a greater sense of speed than a "straight" shot taken with a fast shutter speed, but at the same time is will not render your subject as an unrecognizable blur.

Shooting a Panning Shot

1. Position yourself so there is nothing between you and the point at which your subject will pass by. Think about the background—although it will be blurred, plain backgrounds often work better than busy, colorful ones.

2. Switch the lens to Manual focus and focus where you think your subject will be. Alternatively, if your camera has predictive focusing, keep the AF switched on and select the central focus point.

3. There is no correct shutter speed to use for a panning shot: you can use a higher shutter speed (if possible) for faster subjects, but it should be slower than the shutter speed you would use to freeze movement.

4. As your subject approaches, follow its movement with your camera. If you're using predictive autofocus, press the shutter-release button down halfway to activate the AF system.

5. Press the shutter-release button down smoothly as your subject reaches the closest point to you (or the area you manually focused on), and continue to follow its movement with your camera as it passes by. When you hear the shutter close, smoothly release the shutter-release button.

∧ **WIDE-ANGLE LENS**
If it's safe to get close to your chosen subject, wide-angle lenses will allow you to pan farther during the exposure.

Tips

Panning can be used in conjunction with slow sync flash. This will make the subject even sharper, as the flash will freeze any movement at the point of firing. However, do not use flash if it will be a dangerous distraction for your subject.

Panning works best when the subject is moving parallel to you.

∧ FIRST PAST THE POST

The slower the shutter speed you use, the more impressionistic your image will be.

Note

Panning requires practice and experimentation, so don't despair if you don't immediately perfect the technique.

ISO

The ISO speed indicates how sensitive the sensor (or film) is to light, which determines how much exposure it requires to record a subject or scene accurately.

The term ISO was originally used to describe the sensitivity of film to light: the greater the sensitivity of a film, the higher its ISO value. Although it was always possible to use films of different speeds for varying light conditions, the advent of digital cameras has brought the ISO rating far more into the exposure equation than it ever was before. The sheer ease with which you can flit from one ISO rating to another and back again means that it is just as much a useful exposure tool as aperture and shutter speed in influencing the creative mood of your images. Moreover, recent advances in noise reduction technology at high ISO ratings also mean that the low-light shooting capabilities of modern digital cameras are nothing short of staggering. It is now feasible to shoot day and night, and come back with very usable images.

The lowest ISO on a camera (also known as the base ISO) is usually ISO 100, although some cameras start as high as ISO 200. Using a low ISO speed produces crisp images with rich detail and vibrant color. However, as the sensor/film is less sensitive, it needs to be exposed to light for longer, leading to slower shutter speeds and/or wider apertures. While long shutter speeds are not a problem for static subjects, they are of little use for capturing movement and handholding your equipment. In addition, the use of wide apertures reduces depth of field, which can be an issue for close-up subjects. However, there may be times when you require a slow shutter speed (when recording water as a milky blur, for example), in which case a low ISO (coupled with a small aperture) is ideal.

If you require a fast shutter speed (and the largest aperture available is not enough to allow one) you can boost the ISO to suit your needs. The highest ISO a camera is capable of also varies, and some cameras have the ability to almost see in the dark with ISO

∨ **ISO COMPARISON**
At ISO 100 (below left) noise is minimal and colors are reproduced accurately. At ISO 6400 (below right) "grain" is far more evident.

∧ LOW-LIGHT ADVANTAGE

The advent of digital SLR cameras has opened up a whole new era for photography. When the sun has set, the cameras' high ISO capabilities can reproduce low-light scenes that were previously impossible to record.

values in the hundreds of thousands. Many new DSLR cameras produce near-flawless images up to around ISO 800, and some high-end pro cameras boast upper ISO ratings of 102,400, which basically allows you to take photographs of subjects at night or in low light when you can't even see them with your naked eye! Increasing the ISO also facilitates faster shutter speeds (which is ideal for reducing camera shake or freezing a moving subject) and/or allow smaller apertures (increasing depth of field).

However, there is a cost to using a high ISO setting. Sensors are designed to provide optimum quality at their base ISO, so as the ISO is increased, image quality decreases due to the intrusion of "noise." Film users face a similar dilemma, as high ISO film is always far grainier than low ISO film. This means there is often a compromise that needs to be made between the usability of the camera and image quality: a slightly noisy (but sharp) image, is often better than a cleaner image with camera shake because the shutter speed was too low.

As with aperture and shutter speed, ISO is measured in stops, so ISO 400 is 2 stops faster than ISO 100. In practical terms this means you could use a shutter speed of 1/500 sec. rather than 1/60 sec. in the same light conditions, or shoot using f/11 instead of f/5.6. As with aperture and shutter speed, ISO can frequently be set in ½- or ⅓-stop increments.

Your DSLR will almost certainly offer the facility of an Auto ISO setting, regardless of the exposure mode, but the ability to override this may only be available in Aperture Priority, Shutter Priority, Program, and Manual modes. In the increasingly common scene modes (which tend to be largely automated) you may not be able to set a specific ISO. The automation of the ISO setting can be extremely useful, provided you can determine a "ceiling" for the highest setting. This is still not a common facility, but is being included increasingly on cameras at all price levels. When an ISO ceiling (a user-set maximum ISO) is selected, you can determine an exact aperture and an exact shutter speed in manual exposure mode, leaving the camera to vary just the ISO setting in line with variations in meter readings. It will do

this without the risk of the camera setting an ISO that results in unacceptable noise levels.

Another feature frequently found is ISO expansion. This is when the camera's native ISO range can be exceeded, at either the low end or the top end of the range, or both. Different manufacturers use different setting indicators, but you can expect the ISO reading in the viewfinder or on the LCD screen to read L or L1 for a low setting and H or H1 for a high setting, instead of the usual numerical ISO indicator.

These settings can be useful when both the lighting conditions and the importance of the photo demand it, but it is suggested that ISO expansion is not used as part of your normal exposure strategy as image quality is noticeably reduced. This is fairly obvious—if the manufacturers felt that the image quality was good enough to be considered "normal," these expanded settings would form part of the native ISO range.

Notes

The relationship between ISO and exposure is simple. When the ISO speed is doubled, the exposure required is halved. For example, ISO 200 needs half the exposure as ISO 100.

If your camera has an Auto ISO setting it will change the ISO to suit the lighting conditions. This is useful if you're handholding your camera, but if it is on a tripod, using the base ISO will maximize image quality.

∧ DAWN

When light levels are low, using Auto ISO will increase the ISO setting to compensate. However, if you're using a tripod, it's better to use the camera's base ISO and work with the resulting shutter speed and aperture combination in a creative way.

Noise

Digital noise is seen as random spots of color or variations in brightness in an image, caused by arbitrary signal fluctuations in a camera's electronics affecting the purity of the data used to create an image.

Noise reduces fine detail in your images—making them appear coarser—and is especially noticeable in midtone areas. There are two types of digital noise; luminance and chroma. Esthetically, luminance noise is usually less objectionable than chroma, as luminance noise has a gritty look to it, rather like film grain (although less random). Chroma noise, however, results in color blotching that is particularly unwelcome in areas of even tone such as sky or on facial features: it is also the more difficult of the two to remove successfully.

Different cameras have different noise characteristics, but modern cameras usually have better noise suppression technology than older cameras. It's also generally true that

V LOW LIGHT
For this low-light shot, the ISO was raised to 6400 so the camera could be handheld. This has introduced obvious colored (chroma) noise into the distant hill, which is predominantly a midtone.

the larger the sensor in a camera, the better-controlled noise will be (so full-frame cameras are typically less noisy than APS-C and Micro Four Thirds cameras).

The noise characteristics of your own camera are something that will take experimentation to discover. This is done by making exposures at different ISO settings and viewing the resulting images at 100% on your computer's monitor. Once you have done that, you should have an idea of which ISO settings seriously compromise image quality and which you find acceptable.

Long Exposure Noise

Noise is not only caused by high ISO settings, but also by very long exposures (measured in seconds rather than fractions of a second). The longer a sensor is active, the hotter it gets and the greater the corruption of the image data. The very nature of a long exposure requires the sensor to be running continuously, which means that long exposures also increase the presence of noise at the lowest ISO settings.

To combat long exposure noise most cameras have a Long Exposure Noise Reduction facility that will automatically combat the noise in JPEG files. This

< NOISE
This image was accidentally underexposed. Lightening it in postproduction has meant that the noise has been increased.

function requires the same length of time as the original exposure, as it uses a second, "blank" exposure known as a "dark frame." This effectively doubles the time needed to shoot an image, so if you need to shoot continuously using long exposures, it is often better to switch Long Exposure Noise Reduction off.

Raw shooters will need to use noise reduction techniques in postproduction. Most good Raw conversion software has a noise reduction facility, and software such as Adobe Photoshop allows the addition of third-party plug-ins such as Noise Ninja (which is also available as a standalone package). Noise reduction should be used sparingly though, as too much can obliterate detail and leave your images with an overly smooth, "plastic" appearance. This will be particularly noticeable on subjects that have a delicate texture, such as skin.

∧ NOISE REDUCTION
The image on the left has had no noise reduction applied; the image on the right has.

Reciprocal Relationship

Understanding the relationship between ISO, aperture, and shutter speed means you can control the light reaching the sensor/film and manipulate it to your advantage.

When it comes to light, aperture and shutter speed share one significant similarity: each figure allows half or double the amount of light to reach the sensor/film as its immediate neighbor—a shutter speed of 1/250 sec., for example, allows twice as much light in as one of 1/500 sec.; whereas an aperture of f/8 lets in half the amount of light as f/5.6. Similarly, if you halve the ISO speed, the amount of light the sensor/film requires will double, and vice versa.

In this way, shutter speed and aperture work together to control the amount of light entering the camera. The amount of light in a scene is a given factor at any particular point in time, but there are numerous combinations of shutter speed and aperture that can be used to correctly record the amount of light in the scene on the sensor. If you alter one, the other must also be changed if you want the same amount of light to reach the sensor. For example, if you choose a faster shutter speed, you also need to make the aperture bigger to compensate, and if you choose a slower shutter speed, the aperture needs to be smaller to maintain the same overall level of exposure.

On a bright sunny day (and using ISO 100), a classic setting to use for landscapes is the so-called "sunny 16" rule, which means using a shutter speed of 1/100sec. at f/16. However, that is just one possible combination of settings that are correct for those particular light conditions. You could also use, for example, 1/400 sec. at f/8 or 1/50 sec. at f/22 and the overall exposure would remain the same for the image. However, in the first image you would more likely freeze the motion of any moving elements in the frame with a 1/400 sec. shutter speed, and have less depth of field (f/8). In the second example, moving elements would appear more blurry at

1/50 sec., but you would have a greater depth of field at f/22, so more of the image will appear sharp. These are the constant decisions and compromises that every photographer needs to make with any given scene, and is where you can apply your creative vision.

Note

Most DSLR cameras and CSCs allow you to vary the shutter speed and aperture in ½ -or ⅓-stop increments: 1/160 sec. and 1/200 sec. are the ⅓-stop increments between shutter speeds of 1/160 sec. and 1/250 sec., for example, while f/9 and f/10 are the aperture settings between f/8 and f/11.

∨ CHOICES
This feather was stuck to the lower part of the canyon wall in one of the slot canyons near Page in Arizona. There was no movement, but it was the intention to keep the viewer glued to the detail in the feather while giving a feel of the canyon beyond. An aperture of f/7.1 let the middle ground and background drift off softly.

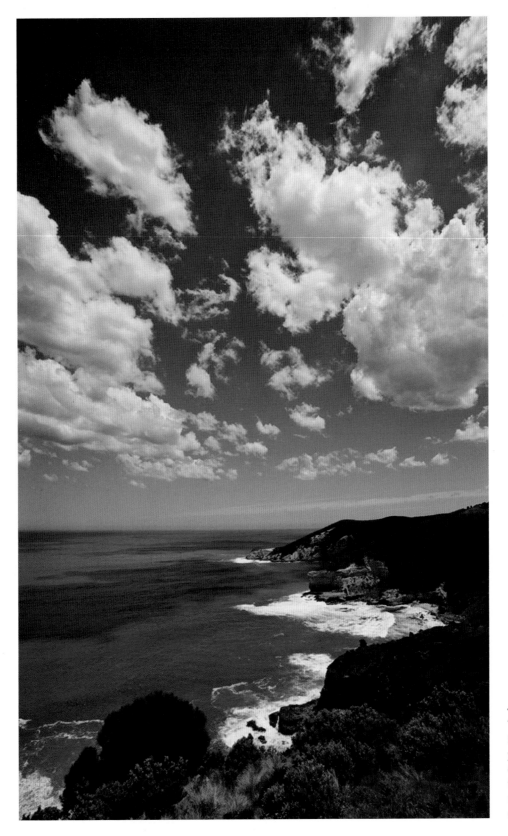

< SUNNY 16

The "Sunny 16" rule is simple, but effective: on sunny days you can use a shutter speed of 1/100 sec., an aperture of f/16, and ISO 100 to get the right exposure. Of course, other exposure settings are available!

Shooting Modes

Cameras often have specific automatic scene modes that make photography hassle free, as well as more sophisticated shooting modes that will give you more control over the aperture, shutter speed, and ISO.

Full Auto

Full Auto is probably the shooting mode that is most commonly used by beginners, and it is likely to be one of several automatic modes on your camera. Set to Full Auto (commonly marked as Auto or a green rectangle on your camera's mode dial), the camera will make all your decisions for you with regard to the aperture, shutter speed, and ISO. It is also likely to set the file quality (to JPEG) and a range of other options—almost everything except focus. It is usually the case that the user cannot override many (if any) of these settings, but Full Auto is still capable of delivering perfect images provided there aren't any awkward lighting challenges: the main thing you are giving up is control, not quality. Well-lit, evenly toned scenes should turn out fine. When they don't, it is time to start learning.

Some cameras will also offer an Auto Flash Off mode. Like Auto, this hands full control to the camera, but the flash will not fire. This is useful if you are taking pictures somewhere where flash is either not allowed or would ruin the atmosphere.

Scene Modes

This is the generic term used to describe a wide range of shooting modes that are geared toward specific shooting situations. There is a great deal of overlap between the different modes adopted by different camera manufacturers, but most will provide scene modes that include Portrait, Landscape, Sports, and Close-up, for example.

The thinking behind these modes is that an inexperienced user will know what type of shot is desired—a landscape, which would require ample depth of field, for example. So the manufacturer ensures that an adequate aperture is selected automatically when the camera is switched to the Landscape scene mode.

The disadvantage of these modes is that, as with the Full Auto option, the majority of camera settings are determined automatically, with little scope for adjustment. They are helpful for the beginner, but they also take away any incentive to learn about taking control of all that the camera offers. Scene modes are also likely to record images as JPEGs, removing many postproduction options.

With a greater understanding of both exposure and the camera itself, it soon becomes obvious that just because a scene mode is labeled "Sports," that doesn't mean this mode isn't suitable for other subjects that demand a fast shutter speed.

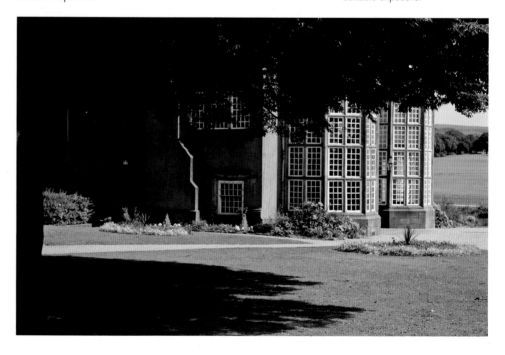

∨ FULL AUTO
This image contains a range of tones, but the dark areas are balanced by the lighter ones. If the scene you are photographing is well lit, as here, then your camera's Full Auto mode will have little trouble producing a suitable exposure.

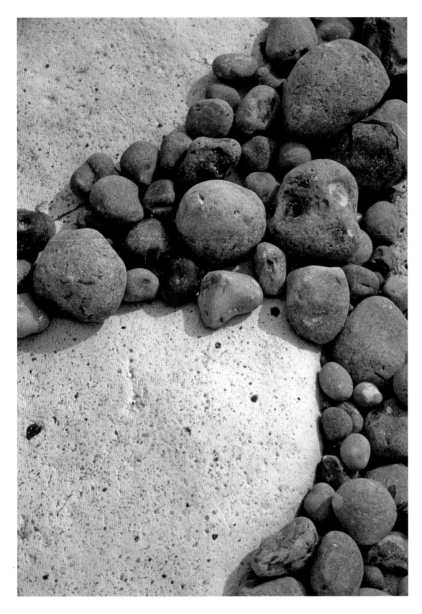

∧ AUTO EXCELLENCE

With a balance of tones, no movement, minimal depth, and no obvious focal point to pick out, this is the type of shot that Full Auto would get right every time.

∧ CLOSE-UP

Many cameras have a Close-up scene mode, but if you're using a DSLR or CSC you will only be able to focus as close as your lens allows—true macro photographs like this may not be possible.

Note

Scene modes should not be confused with picture styles of the same name. For instance, some Nikon cameras offer a Landscape scene mode and a separate Landscape Picture Control. Similarly, many Canon cameras have a Landscape scene mode plus a Landscape Picture Style.

Program (P)

Program mode offers a little more control than Full Auto and is often the next point on the learning curve for beginners. In this mode, the camera's meter determines the exposure and suggests a combination of aperture and shutter speed. This pairing can be changed using what is sometimes referred to as "program shift," but the overall exposure will remain the same. For example, if the camera suggests an exposure of 1/500 sec. at f/8 this can be changed to any equivalent exposure such as 1/1000 sec. at f/5.6, 1/250 sec. at f/11, and so on.

This enables you to select a suitable aperture or shutter speed, while still making sure that the overall exposure renders a satisfactory result without the confusion of changing shooting modes. This kind of thinking is the precursor to experimenting with Aperture Priority or Shutter Priority.

A couple of years ago, Canon introduced a new shooting mode in the form of Creative Auto, which is similar to Program, but with a low-tech approach to the user interface. A new slider control is incorporated into the menu screen, which allows the user to make conscious decisions about how blurred or sharp the background needs to be. The slider is actually controlling the aperture (and therefore the depth of field), but without reference to any of the technical terminology. The shutter speed is set automatically.

Aperture Priority (A or Av)

When you want to have complete control over the aperture, this is the mode to use. For example, you may want to use a wide aperture for a very restricted depth of field, blurring the background behind the main subject. Alternatively, you may want to use a small aperture to provide a greater depth of field, so the foreground, middle distance, and far distance are all in focus. Having selected the aperture, the camera will determine an appropriate shutter speed according to the meter reading. The difference between this and the more automated modes is that the user retains control over a wider range of settings.

Shutter Priority (S or Tv)

This works just like Aperture Priority, except that the photographer sets the desired shutter speed. This may be because you want a fast shutter speed to freeze movement in a fast-moving subject, or it could be that you want to deliberately blur the motion in an image by using a slow shutter speed, such as when photographing a waterfall. In both situations, the camera chooses the appropriate aperture.

Manual (M)

In Manual mode the user has to set both the aperture and the shutter speed independently of one another. If the selected combination does not match the exposure

∧ **APERTURE PRIORITY**

This photo was taken around the battlefields of the Somme, in France. To convey what it felt like to be a soldier at the time (they spent much of the time at ground level, either lying on open ground or down in the trenches), a low viewpoint was chosen. Selecting Aperture Priority and setting a wide aperture created a shallow depth of field to ensure the scene remained simple.

< **SHUTTER PRIORITY**

A 4 sec. exposure was needed to blur the wind-blown leaves and simplify the background behind this statue. Because the statue was in bright sunshine this meant fitting a 5-stop ND filter and switching to Shutter Priority.

reading suggested by the camera's meter, there will be a mechanism for indicating that overexposure or underexposure is likely. However, it is highly likely that the user has already determined that it is the meter reading that is inappropriate, which is why the camera has been set to Manual mode in the first place: the camera isn't always right!

Metering

"Metering" is the act of measuring how much light is required to create a photographic image. Your camera has an integral light meter, and understanding how it works will increase your photographic success rate.

A lightmeter is simply a tool that measures the quantity of light falling on it (known as an incident reading), or the amount of light reflected by the subject (a reflected reading). Incident light meters are small, handheld devices that measure the amount of light falling onto a scene. The meter in your camera is a reflective meter and this type of meter measures light that has been reflected from the scene in front of it.

Reflective Light Readings

Modern camera meters are generally extremely reliable. "Fuzzy logic" systems enable them to second-guess particular lighting situations to arrive at the required exposure. However, they are not infallible. A reflective meter assesses the world as a series of shades of gray. It assumes that the scene being metered reflects roughly 18% of the light that falls onto it. This 18% reflectivity equates to a matte mid-gray surface. It's not the most exciting color you'll ever see, but it's how an ordinary, everyday scene would look if all the tones in the scene were desaturated and then averaged out.

Ordinary, everyday scenes are all very well, but if there is a prevalence of dark or light tones in a scene, a reflective meter can be fooled into over- or underexposing respectively. In a predominantly light-toned scene—a snowman on a blanket of snow for instance—the camera meter would tend to underexpose, as it will want to push the light tones closer to the 18% gray ideal. Using the histogram on your camera is a very objective way to check exposure either before capture (in Live View), or afterward in image review. If the exposure needs correcting, exposure compensation can be used.

Incident Light Readings

Compared to reflected light readings, incident readings are much easier to obtain. Using a handheld lightmeter with its translucent hemisphere in place, simply turn to face the light falling on the subject and take the meter reading. If it is possible to do so, position yourself close to the subject to do this. An incident light reading may still require some adjustment to allow for highlight or shadow detail, but it is likely to be more accurate than a reflected light reading. This is because it is measuring the light falling onto the subject, rather than the light being reflected from it, so will not be swayed by the brightness of the subject.

∨ AVERAGE
This is the type of scene that reflective meters excel at. Dull isn't it?

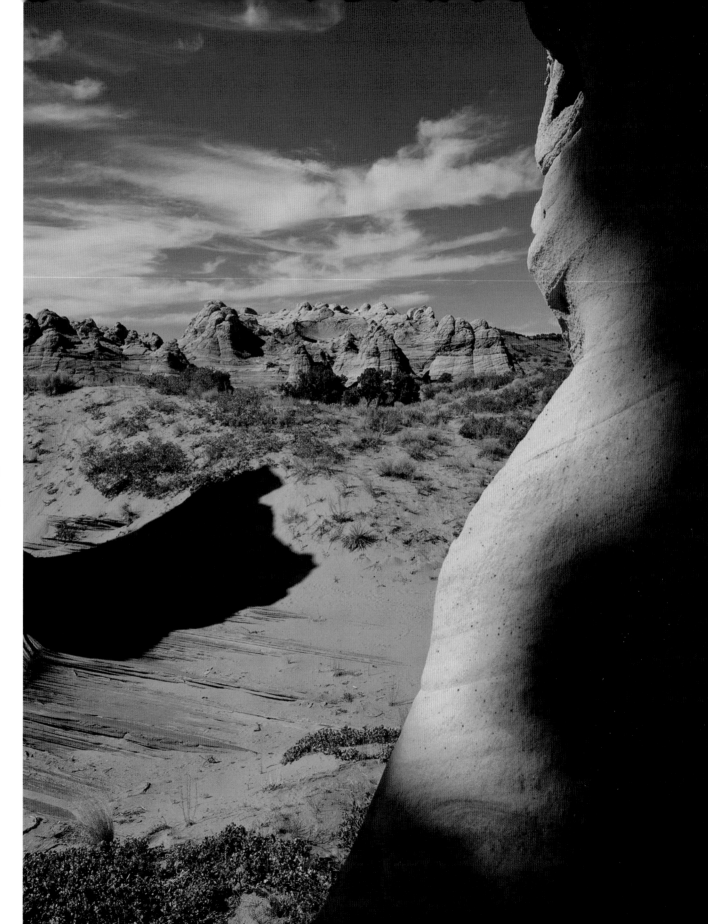

> **LIGHT LAYERS**
Where there are layers of light and shadow in a scene, it can be difficult to know which part to expose for. To keep the dark shadows in this image, the exposure was set for the highlighted rock at the right.

Metering Patterns

One way in which we can combat the limitations of a reflective lightmeter is to narrow down the metering area, which is where partial, center-weighted, and spot-metering patterns come into play. However, used incorrectly, these metering systems can provide a suggested exposure that is even more inappropriate than using a multi-area metering system to assess the whole scene. For example, if you use spot metering and the area of the "spot" falls on a particularly bright or dark part of the subject, the result is likely to be no better. Therefore, the key to obtaining the correct exposure using a reflected light reading lies not only in your choice of metering pattern, but also which part of the subject you meter from. As with many things in photography, practice makes perfect.

Multi-area Metering

This method of metering has a number of different names, such as Matrix, Evaluative, or Multipattern, although the principle is essentially the same. It works by dividing the image frame into a series of cells or zones, with the exposure for each zone measured separately. The final exposure is calculated by combining the results from the different zones, based on the camera "guessing" what sort of scene is being measured (a lighter top half would indicate that the scene was a landscape, for example). Multi-area metering may also take the focus point into account. This is usually the default setting on a digital camera, and is generally very accurate.

Center-weighted Metering

Center-weighted metering has largely been superseded by evaluative metering, but it is still usually an option on most cameras. The entire scene is metered, but the exposure is biased toward the center of the image. The size of the bias varies between camera models, but is generally 60–80%. Center-weighted metering works well when your subject fills the center of the frame, but it is less accurate when the tonal range varies across the scene.

Partial Metering

Partial metering takes readings from a tightly defined area at the center of the frame, usually around 10% of the whole area. It is especially useful when the background is significantly brighter than the subject. It can also be used, in effect, as a spot meter with a larger-than-normal "spot."

Spot Metering

Using the spot-metering mode on your camera allows you to very accurately measure the exposure needed for specific areas of a scene. The metering area is generally between 1% and 5% of the viewfinder and is usually at the center of the viewfinder. However, some camera systems allow you to move the spot metering area around the viewfinder, linking it to the focus point.

An important benefit of using spot metering is that it helps you determine the dynamic range of a scene. You do this by measuring the exposures needed for both the highlights and the shadow area. If the difference between the two exposure readings is too wide, you will know immediately that the camera will not be able to record the scene as you see it. To remedy this, you will either need additional lighting to lighten the shadow areas, or to be aware that some compromise in the final exposure will be needed (shooting for HDR perhaps?).

Multi-area metering

Partial metering

Center-weighted metering

Spot metering

> **TRICKY LIGHTING**
Shooting into the sun makes it difficult for a camera's auto-exposure to cope. For this shot, a spot reading was taken from the sky.

> **SPOT ON**
The correct exposure in this scene was determined by taking spot-meter readings from the three indicated midtone areas.

Exposure Values

Imagine trying to make successful images without a working lightmeter—it sounds like a nightmarish situation. However, in a particular lighting situation, the light that's available to make an exposure will generally always be the same.

On a sunny day, for example, with the aperture at f/16, the correct shutter speed at ISO 100 will be 1/100 sec. (or 1/125 sec. if this is the closest available shutter speed). This is known as the "Sunny 16" rule, which is basically saying that on a sunny day, with the subject in direct sunlight, the shutter speed will have the same value as the ISO setting when you use an aperture of f/16. So, if the ISO were increased to 200, the shutter speed would jump to 1/200 sec. as well; ISO 400 and the shutter speed is 1/400 sec., and so on. From this basic rule it is possible to work out the other shutter speed and aperture combinations that would also work on a sunny day.

Although you may think that the Sunny 16 rule is a little outdated, the same underlying principal—that particular lighting situations will require the same basic exposure—

Exposure settings at ISO 100

EV	f/2.8	f/4	f/5.6	f/8	f/11	f/16	
-1	15 sec.	30 sec.	1 min.	2 min.	4 min.	8 min.	Ambient light from dim artificial lighting
0	8 sec.	15 sec.	30 sec.	1 min.	2 min.	4 min.	Ambient light from artificial lighting
1	4 sec.	8 sec.	15 sec.	30 sec.	1 min.	2 min.	Cityscapes at night
2	2 sec.	4 sec.	8 sec.	15 sec.	30 sec.	1 min.	Eclipsed moon
3	1 sec.	2 sec.	4 sec.	8 sec.	15 sec.	30 sec.	Fireworks. Traffic trails
4	1/2 sec.	1 sec.	2 sec.	4 sec.	8 sec.	15 sec.	Candle light. Floodlit buildings. Fairgrounds at night
5	1/4 sec.	1/2 sec.	1 sec.	2 sec.	4 sec.	8 sec.	Home interiors with average lighting
6	1/8 sec.	1/4 sec.	1/2 sec.	1 sec.	2 sec.	4 sec.	Home interiors with bright lighting
7	1/15 sec.	1/8 sec.	1/4 sec.	1/2 sec.	1 sec.	2 sec.	Deep woodland cover. Indoor sports events
8	1/30 sec.	1/15 sec.	1/8 sec.	1/4 sec.	1/2 sec.	1 sec.	Bright neon-lit urban areas. Bonfires
9	1/60 sec.	1/30 sec.	1/15 sec.	1/8 sec.	1/4 sec.	1/2 sec.	Ten minutes before sunrise or after sunset
10	1/125 sec.	1/60 sec.	1/30 sec.	1/15 sec.	1/8 sec.	1/4 sec.	Immediately before sunrise or after sunset
11	1/250 sec.	1/125 sec.	1/60 sec.	1/30 sec.	1/15 sec.	1/8 sec.	Sunsets. Deep shade
12	1/500 sec.	1/250 sec.	1/125 sec.	1/60 sec.	1/30 sec.	1/15 sec.	Heavily overcast daylight (no shadows). Open shade
13	1/1000 sec.	1/500 sec.	1/250 sec.	1/125 sec.	1/60 sec.	1/30 sec.	Bright overcast daylight (shadows just visible)
14	1/2000 sec.	1/1000 sec.	1/500 sec.	1/250 sec.	1/125 sec.	1/60 sec.	Weak sunlight. Full moon (very soft shadows)
15	1/4000 sec.	1/2000 sec.	1/1000 sec.	1/500 sec.	1/250 sec.	1/125 sec.	Bright or hazy sunny conditions (distinct shadows)
16	1/8000 sec.	1/4000 sec.	1/2000 sec.	1/1000 sec.	1/500 sec.	1/250 sec.	Brightly lit sand or snow
17	1/16000 sec.	1/8000 sec.	1/4000 sec.	1/2000 sec.	1/1000 sec.	1/500 sec.	Very intense artificial lighting

Note

If you're using filters, these must be taken into account when setting the exposure. A polarizing filter at maximum strength will absorb 2 stops of light, for example. So, with a polarizing filter fitted (and used at maximum strength) you would need to look at the EV value for the relevant lighting situation and then deduct 2 from that value.

∧ MORNING LIGHT
Taken at sunrise, this scene had an EV of 11, so shooting at 1/8 sec. at f/16 (ISO 100) delivered a good exposure.

still holds true. The grid opposite shows a range of lighting situations from very intense to very dim conditions. Each of these has an "EV" number, which is short for Exposure Value (some handheld lightmeters offer the option of giving light readings as an EV).

For each EV there is a range of shutter speed and aperture combinations, so in a particular situation you could try setting the exposure manually using the relevant values from the table and then making your image. You may well find that working in this way is more accurate than your camera's lightmeter!

< SUNNY
This image is a classic "Sunny 16" situation, so the exposure would have been 1/100 sec. at f/16 (at ISO 100). However, a polarizing filter was used, which meant the exposure needed to be adjusted to 1/30 sec. at f/16.

Histograms

The LCD monitor on your digital camera is an excellent way to assess composition, but it cannot be relied upon to judge exposure—when it comes to subtle corrections the camera's screen can prove misleading.

To make an accurate assessment of an exposure, you need to refer to its histogram. Most cameras will allow you to view a histogram of your photographs, either in "live view" before capture, or in playback after the exposure has been made.

A histogram is a graph showing the distribution of tones in your image. The horizontal axis represents the brightness levels, from black on the extreme left of the histogram through to white at the right. Halfway across the histogram are tones that correspond to mid-gray. Subjects such as grass or stone roughly equate to mid-gray, so the histogram of a correctly exposed image of a rock face would peak in the middle The vertical axis represents the number of pixels of each tone.

There is no ideal shape for a histogram, but if it is "clipped" (when the histogram leans against one end of the graph) the tonal range has exceeded the point at which detail could be recorded. When the histogram is clipped on the left, no detail will be recorded in the darkest parts of your photograph; those areas will be pure black. When the histogram is clipped on the right, no detail will be recorded in the brightest parts of your image; those areas will be pure white.

When assessing a histogram, it's important to remember that a high number of pixels on the right-hand side is normal for scenes containing a great deal of light elements (such as snow), whereas a high number of pixels on the left-hand side is normal for scenes containing a great deal of dark elements (such as rocks). When dealing with average scenes, however, try and capture a full range of tones, with the majority of pixels to the left of the center point—underexposure is far easier to correct in postproduction than overexposure, where detail is irretrievably lost.

< This histogram is skewed to the left, with no tones lighter than mid-gray. This indicates that the photograph might be underexposed.

< The tonal range is better distributed in this histogram, with no clipping at either end. This is a good exposure.

< There are few tones in this histogram that are darker than mid-gray and the highlights have been clipped. This could indicate overexposure.

∧ ASSESSING A HISTOGRAM
With practice it becomes easier to see how a histogram corresponds to tones in an image.

∧ EVEN DISTRIBUTION
When dealing with average scenes try to keep the majority of the pixels at the left of the center point of the graph.

∧ UNEVEN DISTRIBUTION
When assessing a histogram it's important to remember that a high number of pixels at the left side is quite normal for scenes containing a great deal of dark elements.

Exposure Adjustment

Although the exposure meters on modern cameras are extremely sophisticated, there are occasions when you will need to step in to adjust the suggested exposure.

Exposure Compensation

The easiest way to "correct" under- or overexposure is to use your camera's exposure compensation facility. This is a feature found on most cameras, which usually allows you to adjust the exposure suggested by the camera by up to ±3 stops (usually in ½- or ⅓-stop increments). Having taken your initial exposure reading, simply set the exposure compensation to + (positive/more light) or − (negative/less light), depending on whether you want a brighter or darker exposure.

How much you increase or decrease the exposure will depend on the scene you are photographing: if you're shooting a small white flower against a backdrop of dark leaves then the amount you need to "dial in" will be marginal, but if you're shooting a snow scene that fills the frame, the amount you need to dial in will be far greater. Remember to set the exposure compensation back to zero when you have taken your shot, since this facility usually remains active even after the camera has been switched off.

Exposure Bracketing

If your camera has an exposure compensation facility, then it is also likely to offer automatic exposure bracketing (AEB). Setting this feature will instruct the camera to take a sequence of successive pictures (usually three) using different exposures: one at the camera's recommended meter reading; one under the suggested reading (darker); and one over the reading (lighter). As with exposure compensation, bracketing is usually adjustable by ±3 stops in ½- or ⅓-stop increments and will help you whenever you're unsure that the exposure you've set is correct.

High & Low Key

As well as helping you get your exposures right, exposure compensation can also be used creatively. Images that are composed mainly of light tones (with few or no middle to dark tones) are referred to as "high-key" images; images that consist mostly of dark tones (with few or no middle-to-light tones) are referred to as "low-key" images.

The lack of dark tones in a high-key image makes it feel more open and airy. Typically, high-key images are associated with romance, innocence, and optimism. It is a common, almost clichéd way to shoot portraits, particularly of women and children.

Low-key images are more brooding and atmospheric. They are associated with sadness, pessimism, and other negative emotions. However, a low-key approach is often used in product photography, mainly to add a sense of mystery to the product. The technique is often employed in so-called "teaser"campaigns before the release of the new product.

Note

Shooting in Manual mode will disable exposure compensation.

OVER

SUGGESTED

UNDER

∧ **AUTOMATIC EXPOSURE BRACKETING**

AEB lets you instruct the camera to take a sequence of three pictures using different exposures. Here the "overexposed" shot looks best, due to the amount of white in the frame.

< **EXPOSURE COMPENSATION**

An excessively light subject can trick the in-built light meter into underexposing. Here, an increase of 1-stop was needed to keep the snow bright.

< **JOINT EFFORT**

Automatic exposure bracketing can be used with exposure compensation to help you record overly light or dark subjects accurately.

< **COMPENSATED**
This image required positive
exposure compensation
because of the large areas
of pale tone.

> **DELICATE**
High-key exposure is
particularly effective when
shooting delicate subjects,
such as flowers.

Exposing to the Right

Digital sensors capture more usable data in the lighter areas of an image than in the shadows. If you are shooting Raw files, "exposing to the right" (or "ETTR") will help you maximize the amount of usable image data available for postproduction, while reducing problems such as noise.

Exposing to the right requires you to expose your image so its histogram is skewed to the right (without it clipping). This often means ignoring the "correct" exposure suggested by your camera and applying positive exposure compensation.

The results will look decidedly odd on your camera's LCD; an image exposed to the right will appear washed out and lacking in contrast. However, the image is easily normalized in postproduction by increasing contrast and adjusting the exposure to suit.

Before exposing to the right, you need to set the picture style settings on your camera to "neutral," or similar. This is because the histogram on the LCD is not generated directly from the Raw file but from a JPEG created using the currently selected picture style. As the picture style can affect the histogram, it can give you a false idea of the exposure.

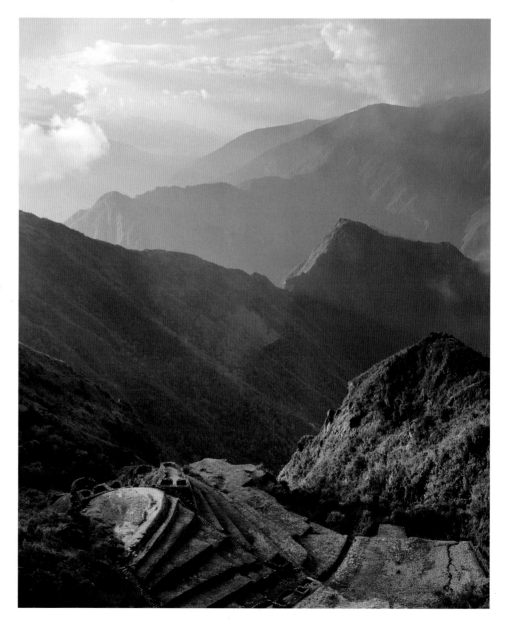

> **BETTER SHADOWS**
Exposing this image to the right enabled more shadow detail to be extracted later.

< WASHED OUT
This image was "exposed to the right". The results on the camera's LCD were not great, but this wasn't relevant. The aim was to capture as much "good" information in the darker areas as possible and the histogram showed that this had been achieved.

< CORRECTED
This is the final image. The levels have been corrected during postproduction so the image appears more natural.

Dynamic Range

The term "dynamic range" refers to the spread of tones throughout an image, from light to dark, within which detail can be recorded.

A camera can only record a restricted range of luminance (brightness) levels, and it certainly cannot match the astonishing ability of our own eyes. The range of luminance levels that a camera can record is known as its "dynamic range." The top of the range is reached when a pixel records the brightest tone possible without being pure white. At the opposite end of the scale the reverse is true, with a pixel recording detail just short of being black. If the tones exceed this range then detail will be lost, either in the highlights, in the shadows, or in both areas. This loss of detail is referred to as "clipping," at which point the photographer is usually faced with three options:

- Expose to preserve the highlights and allow the deepest shadow tones to merge.
- Expose to preserve the shadows and allow the highlights to burn out.
- Aim for an exposure between the two extremes and allow both the highlights and shadows to be clipped, but to a lesser degree.

However, not all scenes have high levels of contrast. Mist reduces contrast so that shadows and bright highlights are virtually non-existent—misty scenes are one subject that cameras can cope well with. However, other low-light scenes, such as pre-sunrise or post-sunset have very high levels of contrast. With practice it gets easier to assess a scene and decide whether a compromise needs to be made in terms of where in the tonal range detail is lost. In high-contrast scenes it's generally more appealing to expose an image so that detail is retained in the highlights.

There are several methods that can be used to overcome the problem of a high dynamic range. Filters,

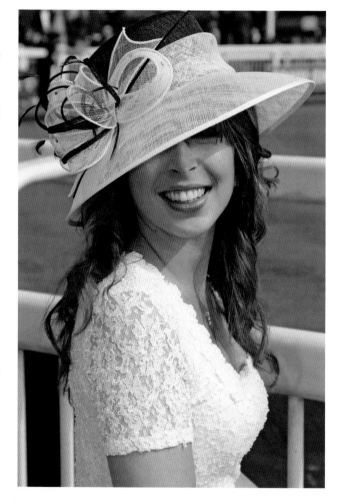

< **CONTRAST CONTROL**
In-camera dynamic range control is a simple way of preserving highlight detail. These systems usually work by suppressing highlights and boosting shadows.

particularly graduated NDs, are commonly used by landscape photographers to overcome the difference between a bright sky and an unlit foreground, while many cameras now have built-in systems that can balance the brightness and tonal gradation at the time of capture (Canon's Auto Lighting Optimizer, Nikon's Active D-Lighting, and Sony's D-Range Optimizer, for example). Some of these can also be applied to Raw

∨ **LOW CONTRAST**
Mist creates naturally low-contrast conditions, which easily fit within the dynamic range of a camera.

∧ **HIGH CONTRAST**
Sparkling reflections on water and deep shadows create a high-contrast situation that is likely to exceed the dynamic range of the camera. In these instances it is usually better to preserve the highlights and try and recover the shadows during postproduction.

images after capture, with the aim of restoring detail to the shadows and highlights.

Although each of these dynamic range tools is intended to be applied in high-contrast shooting scenarios, they can also rebalance an image when part of the subject is darker than you would wish, for reasons other than the prevailing light. Another method—as outlined on the following pages—is to shoot a sequence of images using different exposures and blend them together to create an HDR image.

High Dynamic Range

One method to overcome the limitations of a camera's dynamic range is to shoot high dynamic range (HDR) images. This technique requires some forethought when shooting, but it is a useful "get out of jail free" card.

Shooting for HDR

HDR requires you to shoot a sequence of exposures of the same scene. The typical number of images needed is three: one "correctly" exposed, another exposed for the shadow areas, and a third to record detail in the highlights. This can be achieved either by bracketing or by using exposure compensation. The amount of exposure adjustment needed will depend on the scene you are photographing: the greater the contrast between the shadows and highlights, the greater the difference between the exposure settings of the images will need to be.

One limitation of the HDR technique is that each image should be exactly the same (apart from the exposure). Anything that moves in the scene between the different shots can create unusual artifacts when the images are later merged. For this reason it is a good idea to use a tripod so that the camera is stationary between shots—handholding your camera during the bracketing process introduces another potential source of movement. However, this doesn't mean that it is impossible to create an HDR image from handheld shots, as good HDR software will have a function to align a sequence of images.

Single Raw

Although shooting multiple exposures will give you the best results, it is perfectly feasible to use a single Raw file as your source image. You can vary the exposure of the Raw image during postproduction and export these variations as individual files to create a pseudo-bracketed exposure sequence that can then be used to generate an HDR image. This is often the only way to cope with a scene in which there is movement, although you will be varying the exposure in postproduction, which increases the risk of noise.

HDR Software

Once you have your three (or more) images, they are imported into HDR software. There is a thriving market for HDR software, with commercial packages fighting it out with open-source and freeware offerings. The latest versions of Adobe Photoshop and Photoshop Elements both have a facility to generate HDR images, while Photomatix Pro is a well-regarded standalone HDR package that has many adherents.

The options for blending your images will vary between different software packages, but you should be offered a choice in how the final HDR image is created. Different HDR methods produce different results and the most

> **BRACKETING**
Three images were shot using exposure bracketing set to ±2 stops. These exposures were then merged to create a single HDR image.

∨ **KEEPING STILL**
This HDR image was created from three handheld exposures. To minimize any movement between the shots it was necessary for the photographer to stand braced against a sturdy barrier.

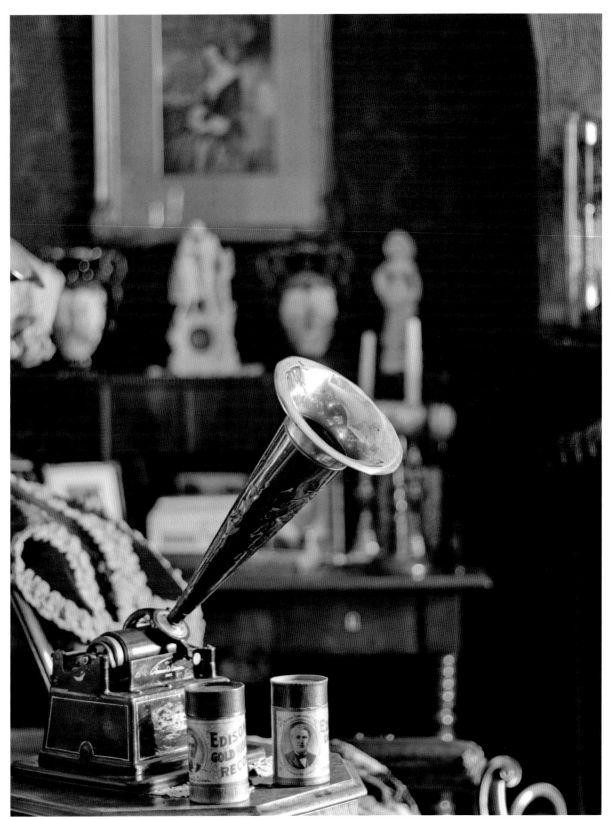

suitable will vary from image to image. Most commercial HDR software is available on a 30-day trial basis, so it won't cost anything to give it a go.

Exposure Blending

This method is a recognized HDR technique that involves using a sequence of images shot at different exposure settings. The results are generally more naturalistic than images commonly associated with HDR, as software that uses this technique works by blending images on a pixel-by-pixel basis, choosing the "best" pixels from different regions of the image sequence to create the final blend. Software that can be used to create exposure-blended images includes Photomatix Pro (using the Exposure Fusion option) and the Enfuse plug-in for Adobe Lightroom.

Because several images are blended, there will still be problems with ghosting if there is movement between the exposures, so the technique works best if a tripod is used when exposing the source images. The blended file is often a 16-bit file (as opposed to 32-bit), but this provides more than enough information for further editing.

Tone Mapping

True HDR images are usually created from a series of bracketed exposures, but they need to be tone mapped before they can be saved as a standard image file. Tone mapping refers to the conversion of the image from high dynamic range to low dynamic range. This is essential if you want to view your photos on a low dynamic range device such as a computer monitor, or as a paper print. Software such as Photomatix Pro allows you to adjust

how your image is tone mapped and it is this process that can create the bewildering variety of HDR styles found in magazines, books, and on the Internet. Simple changes in detail, contrast, saturation, and gamma can have a dramatic effect on the look of the final tone-mapped image.

Tone-mapping software broadly works in one of two ways: globally and locally. Software that uses global operators adjusts every pixel in the image, based on its initial intensity: Photoshop's Brightness/Contrast tool is an example of this. A local operator is subtler as it uses the location of individual pixels to determine their final intensity value. Pixels of a certain intensity will be altered differently if they are surrounded by darker pixels than when surrounded by lighter pixels. This technique helps to preserve detail in shadows and highlights, as well as maintaining local contrast, but it is very processor intensive. Both Adobe Photoshop and Photomatix Pro use the latter technique to create HDR imagery.

< **ESTHETICS**
HDR imagery can appear "hyperreal" (or, less kindly, "gaudy"), so some people prefer to use HDR for black-and-white images only.

< **DIFFERENT APPROACHES**
The same image was converted using Photomatix Pro's Tone Mapping (far left) and Fusion (left) blending methods. Tone Mapping has produced a distinct HDR look, while the Fusion result appears more natural. The option you choose for your own images is largely a matter of taste.

-2 stops

-1 stop

Metered exposure

+1 stop

+2 stops

∧ ∨ HYPER REALITY

This is the original image (above) at the center of the five bracketed exposures, so it is the optimum exposure suggested by the camera's meter. However, both the highlight and shadow areas have been clipped noticeably, as the scene exceeded the camera's dynamic range. Compare this with the HDR-processed image (below).

HDR can be used to create images that appear "hyperreal," with a delicacy of light and shadow that is usually only achievable by spending hours setting up lights and reflectors.

∨ **INTERIORS**
Church interiors often have very subdued lighting, with windows that are brightly backlit. This is a perfect combination for HDR. Tripods are often a must, but you should seek permission before using one: some churches have precious flooring that could be scratched by a tripod.

Fireworks

Firework displays are a popular photographic subject, although preparation is needed if you want to get the best out of the opportunity.

If you know the location of a fireworks display try to visit when it's light, to allow yourself time to look around for the best vantage point. This is often not the place where the fireworks will be set off, but the top of a hill or high building some distance from the display area. By gaining height you will be looking across at the fireworks rather than up at them. Keeping back from the main event area will also lessen the chances of you or your camera being knocked over by other spectators.

On the evening of the display, you will need to mount your camera on a tripod. A remote release is useful so that the shutter can be fired without the camera being touched, and it will also allow you to watch the display without looking through the camera's viewfinder.

Choosing the right lens can be tricky. If there is any wind, this can affect the way that the fireworks drift, so start with a wide-angle lens to make sure that you are capturing the entire display. Then gradually zoom in over the course of the display for a tighter, more abstract view of the fireworks.

If the display is a large, organized event there will usually be a regular stream of fireworks, so after a while it can become possible to anticipate when to fire the shutter. The shutter speed you use will depend on the ISO setting, but fireworks are generally more effectively recorded with shutter speeds of 1 sec. or longer. So that you don't miss anything, switch off Long Exposure Noise Reduction—it's frustrating if you have to wait for your camera to process an image before you can shoot again! Displays often end in a noisy and colorful climax, so if you know the approximate length of the display, keep an eye on the time and be ready for the final moments.

Smaller displays are usually more difficult to photograph as there are often longer gaps between

< **CLOSER**
Once you are confident that you know where fireworks will appear in the sky you can often switch to a telephoto lens and record firework close-ups.

individual fireworks. One solution is to set your camera to Bulb and lock the shutter open. After a firework has exploded, carefully cover the front of the lens with a piece of black card and remove it when you hear the next one being fired. Using this method will also allow you to build up the number of fireworks recorded within the same image. After a minute or so, you can release the shutter and review your image.

> SCENE MODE

Many compact cameras (and some DSLRs and CSCs) have a "firework" scene mode. This sets the camera so that longer shutter speeds are used. The downside is that these modes typically force you to shoot JPEG rather than Raw files.

> ECLIPSE

If you set your camera and tripod up within a crowd of spectators it is a very good idea to have an assistant who can help make sure that no one trips over your equipment.

Star Trails

The hours of darkness will push your camera to its limits, but on moonless nights there is still enough light to create stunning images.

Stars rotate around an imaginary point in the sky that is known as the "celestial pole." In the northern hemisphere, the Pole Star (or Polaris) is close to, but not exactly at, the northern celestial pole. Sigma Octantis is the equivalent in the Southern hemisphere, but as it is not a particularly bright star, it is often difficult to locate.

Creating star trails involves exposing an image for a lengthy period of time so that as the stars move across the sky they are recorded as arcs of light. The simple rule is that the longer the shutter speed, the longer the arc will be. If you were able to expose the image for a full 24 hours, the arcs would eventually form a perfect circle as the stars returned to their start point.

Film is ideally suited to the creation of star trails, simply because film cameras tend to be less battery dependant and film itself is not affected by lengthy exposures (other than by reciprocity law failure). Digital cameras, on the other hand, are heavily reliant on their batteries, and noise can become a problem with exposures of 60 seconds or more.

Shooting Star Trails

1. Choose a night with settled weather and clear skies. A moonless night away from urban lighting will make the sky appear blacker in the final image.

2. Arrive at your chosen location well before total darkness so you can see what you're doing when setting up your equipment.

3. Choose your composition. If you're using a wide-angle lens, pick something recognizable in the landscape that would make a good silhouette—this will help to give your image a sense of scale.

4. Switch your camera to manual focus and set the focus at infinity.

5. Set the camera to Bulb mode and, depending on the base ISO of your camera (or the film speed), set the aperture to f/2.8 (ISO 100) or f/4 (ISO 200). If you use a higher ISO you will record fainter stars during the exposure, but also increase the amount of noise or grain in the picture.

6. Lock the shutter open using the remote release and start your stopwatch. The longer you lock the shutter open the longer the star trails will be. Remember that one hour is equal to 1/24 of a circle (or 15 degrees of rotation), so 12 hours would result in a semi-circular set of star trails.

7. Release the shutter after the desired length of time.

Tips

If your camera has a viewfinder "blind" or cover close it to prevent light leakage back into the camera.

The direction that you point your camera in will determine how the star trails arc across your image. Facing the celestial pole will produce circular arcs that spin around that point; facing east or west will create a more subtle effect.

Note

If you're shooting digitally, your camera might apply Long Exposure Noise Reduction after the first exposure (if this option is set). This will take the same length of time as the original exposure. Some cameras will not allow you to shoot during this process, so if you wish to carry on shooting immediately after creating your star trail image, be sure to switch Long Exposure Noise Reduction off.

< POLE STAR

For this image the camera was pointed north, toward the Pole Star. The tree in the foreground was lit using the "painting with light" technique.

< LIGHT POLLUTION

The closer you are to urban areas, the more color and light will be added to the sky by street lighting.

CHAPTER 5
LIGHT & LIGHTING

Introduction to Light & Lighting

Without light you couldn't make a photograph. However, light has many different qualities that need to be understood and appreciated. The way light is reflected or absorbed by objects also determines how color is perceived or recorded.

< **COLOR**
Light plays an important part in determining color, whether it's the cool of the twilight hours or a warm dawn glow.

When you click the shutter-release button on your camera, you craft an image using light. Exposure is the technique of controlling how much light is used to make an image, but there's more to using light than measuring it like an ingredient in a recipe—the qualities of light, such as its direction and how hard or soft it is, should be an inspiration too.

Great light does not have to be dramatic light; it only has to be the best light for your chosen subject. While a solitary shaft of sunlight might be superb for lighting up a mountain top, far more subtle and diffused light may be ideal for capturing the clouds drifting over its summit. As you spend more time focusing on seeking out extraordinary light conditions, so your eye will become more trained at differentiating the types and varying qualities of light.

Light also determines color, and colors have emotional impact. The way you use color in your images will therefore determine how they are perceived, and this consideration should also be

∧ > **DRAMA**
Natural light can be dramatic (above) or it can be more subtle (right), with myriad options in between.

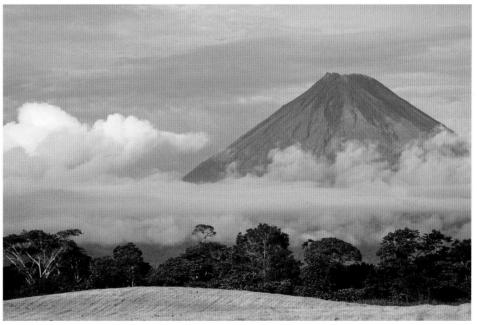

an important part of the previsualization process. In this chapter you will come to appreciate that there are far more layers to light than simply highlights, midtones, and shadows. The more adept you become at discerning the light levels in between, the better your images will become.

What is Light?

This is a question that doesn't get asked enough by photographers, but an understanding of how light "works" will help you plan how your photographs are lit and exposed.

Visible light is part of the electromagnetic spectrum, which is the range of wavelength frequencies of electromagnetic radiation. It stretches from gamma radiation at one end to radio waves at the other. Visible light is a small fraction of the electromagnetic spectrum, starting at a wavelength of around 700 nanometers (nm) and ending close to 400nm. When the wavelengths of light are separated through a prism they form the colors of the rainbow. Red wavelengths of light are longest (at 700nm) followed by orange, yellow, green, blue, indigo, and violet (at 390nm).

The sun is, by a very wide margin, the most important natural light source—even the light from the moon is reflected sunlight. However, the quality of sunlight (its color, strength, hardness, or softness) is altered to a greater or lesser degree by its passage through the Earth's atmosphere. Different wavelengths of the light are affected in different ways. The shorter, bluer, wavelengths are affected most of all, being scattered and absorbed more by the Earth's atmosphere. Conversely, the longer, red wavelengths are scattered less by particles in the atmosphere. This has a bearing on the color bias of light during the day.

This is most easily seen over the course of a cloudless day. At daybreak, when the sun is on the horizon, the light passes obliquely through the Earth's atmosphere. This causes the blue wavelengths of light to be highly scattered and absorbed. The light that reaches us is therefore biased toward red, causing the warm light associated with daybreak.

Another effect is that the intensity and contrast of the light are reduced. As the sun rises in the sky, less of the blue light is scattered and the red bias diminishes. By midday the light is far more neutral in

< FLY AGARIC
The wavelengths of light that are absorbed or reflected by an object give it its color. This mushroom reflects red wavelengths and absorbs most others, so appears a striking red color.

color (though this does depend on latitude and time of year), and both contrast and the intensity of the sunlight are at their highest. Past midday the sun tracks back toward the horizon and the light gradually warms up once more until the warmth reaches its peak when the sun is on the horizon again.

Texture

The texture of an object determines the nature and strength of reflected light. Smooth, high-gloss surfaces create a specular reflection in which the angle of incidence (the angle at which the light rays hit the surface) is equal to the angle of reflection (the angle at which the light rays are reflected away from the surface). A smooth, high-gloss surface also produces a reflected image that appears to be reversed left to right, an effect referred to as lateral inversion. The smoother and glossier this surface is, the more light it reflects and the brighter the reflection will be. The most common artificial surface that exhibits this behavior is the mirror. Gloss surfaces in nature rarely exhibit a mirror's level of light reflection.

Metals generally need to be processed by polishing to create specular reflections. Water, even when perfectly still, is far less reflective than a mirror (the surface of water is never entirely smooth and so some light is scattered randomly). Rougher, more matte surfaces scatter reflected light rays in random directions. This is known as diffuse reflection and does not produce an image. Most natural objects produce diffuse reflections.

However, not all the wavelengths of light that strike a matte surface are necessarily reflected. We see the color of an object by the way the surface reflects or absorbs different wavelengths of light. For example, a red object will absorb all the wavelengths of light except those that correspond to red. These red wavelengths are reflected back toward the eye and our brain interprets the object as being red.

A pure white object reflects all wavelengths of visible light equally; a black object absorbs all the wavelengths equally. If the surface of an object has both a specular and diffuse reflective quality only the diffuse reflection causes color to be perceived. The specular reflection is seen as a pure white highlight.

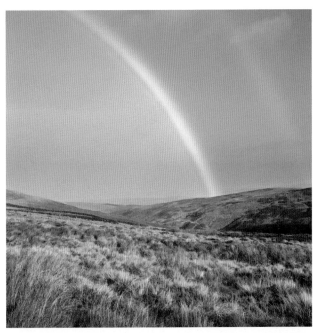

< **RAINBOWS**
Rain acts as a natural prism, separating the wavelengths of sunlight and revealing its constituent colors, which are visible as a rainbow.

< **WATER REFLECTION**
We instinctively know that reflections in water are darker than the subject being reflected. Exposing an image so that the reflections are lighter tends to look unnatural.

Direction of Light

There's a saying among photographers that there's no bad light, just bad photography, so it is important to match the right light to your subject.

The direction in which light falls on the subject plays a significant part in the overall look and mood of a photograph. In a studio environment it is fairly easy to control the direction of your lighting, but outdoors you will often have to take the light that you are given at any particular point in time. However, it is still often possible to "manipulate" the direction of light by changing your position relative to the subject.

Front Lighting

This type of lighting was once championed by camera manufacturers when they included basic instructions about how to take a photograph with their equipment: "Stand with your back to the sun…" they proclaimed. Frontal lighting is light that is cast from behind, just above, or slightly to the side of the camera (or actually from the camera itself when direct flash is used). Front lighting is relatively easy to use, as it produces low-contrast illumination that is easy to expose correctly.

Shadows are usually invisible as they are cast behind the subject, and as the light isn't striking

the front of the lens, flare is not a problem. It's a good light for simple portraits, particularly with older people, as skin texture such as lines or blemishes will be less apparent.

However, frontal lighting lacks drama. Its flattening effect can leave a scene looking very two-dimensional, which makes it less pleasing for subjects that require texture to be emphasized, or when shadow detail is required to define shape and form.

Side Lighting

Also known as oblique light, side lighting is light that is cast at 90° to the camera. Unlike frontal lighting, side lighting is ideal for showing texture and defining a subject's shape, as the shadows from anything within the scene are all visible and cut across the image, adding visual depth clues. It's also arguably a more atmospheric lighting direction than frontal lighting.

Exposing for this type of light is slightly more difficult, though, because the light goes from bright highlight to dark shadow. It is usually best to opt for an exposure that sits somewhere between these two extremes, while

∨ **SIDE LIGHTING**
Moving around to the side of the statue has turned the frontal lighting into side lighting. As a result, the statue and the stone base now appear far more three-dimensional.

< **FRONTAL LIGHTING**
This was a first attempt at creating an image of this statue. With the sun behind the camera the texture on the stonework was flattened and there were few shadows to define shape.

∧ TEXTURE AND COLOR
Front lighting can make a subject appear rather flat and two-dimensional. Here, the interesting texture of the rocks has been lost (above). However, frontal lighting can emphasize colors, making them appear more rich and vibrant (above right).

ensuring not to blow the highlights. If you're working with small subjects, this can be rectified by using reflectors or supplementary lighting.

Top Lighting
Top, or overhead, lighting is a form of side lighting, as the light is also at 90° to the camera. This type of lighting is most commonly encountered around midday, when the sun is directly overhead. The shadows cast are harsh and the highlights are too bright for most scenes, so this is a time to avoid if you can.

However, if you are in a situation where you have to be shooting at this time of day, it is better to look for more shaded scenes and try to avoid including the sky in the frame. It really is an ideal time to take a break for lunch and to plan your activities for later in the day once the sun descends in the sky.

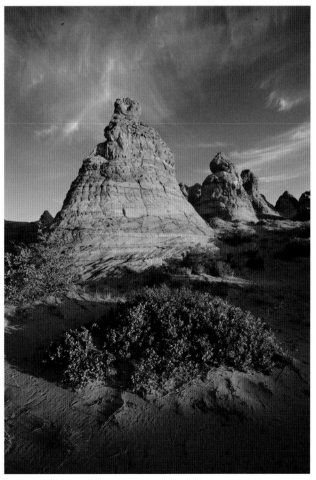

< EMPHASIS
Side lighting is perfect for emphasizing shape and texture, as in this rugged landscape.

Backlighting

If you want to add an instant sense of artiness to your photographs, then try photographing them with backlighting. It is an extreme and abstract type of light that is seldom used by most photographers, so your images will have more of a unique look if you use it.

Backlighting occurs when the light is behind the subject, pointing toward the camera. This means that contrast is high, with the background generally brighter than the unlit subject. There are several pitfalls to avoid with backlighting, including incorrect exposure and distracting sun flares appearing in the final image.

There are no hard-and-fast rules for getting the exposure right with such extreme light, so it is always worth bracketing your shots (shooting several different exposures) so that you can pick the best one later. To avoid flare, try to find something in the scene, such as a tree, to block the sunlight from directly hitting the lens. If you use a small aperture, such as f/16 or f/22, and carefully place the sun so that it just creeps around an edge of an object, you can create an effective and atmospheric sunburst in the image. Backlighting can also add an attractive halo of light to the rim of a soft-edged object and, of course, bring translucent objects, such as leaves, to life. It can also bring to life mist and fog lying over the landscape. Be warned, though: looking directly at the sun can damage your eyesight, so take precautions.

Metering for the background will render your subject as a silhouette (see page 180). One way to avoid this is to use extra lighting, such as flash, so that the exposure for the subject and background match.

Flare

A major problem with backlighting is that the risk of flare is increased. Flare is non-image forming light that bounces around the glass elements of a lens before reaching the sensor, causing streaks and colored blobs as well as a reduction in contrast across an image. Flare caused by light shining into the lens this way can't be stopped by using a lens hood, but keeping the light hidden by your subject is a good solution to this problem. Happily, if you're shooting portraits, this also helps to create an effect known as rim lighting, in which the outline of the subject's hair glows in an esthetically pleasing way.

Lens flare is also caused by side lighting, although a lens hood can help reduce flare in this instance. Alternatively, you can shield your lens with your body so that a shadow is cast across the front of the lens—the trick is not ending up in the image!

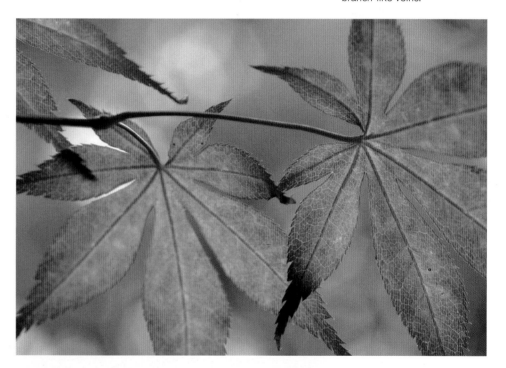

∨ **HIGHLIGHTING**
When a light source is positioned behind a leaf it helps to highlight the intricate, branch-like veins.

< **TOP LIGHTING**
Although top lighting is often best avoided, it can occasionally be used to illuminate subjects much like a spotlight.

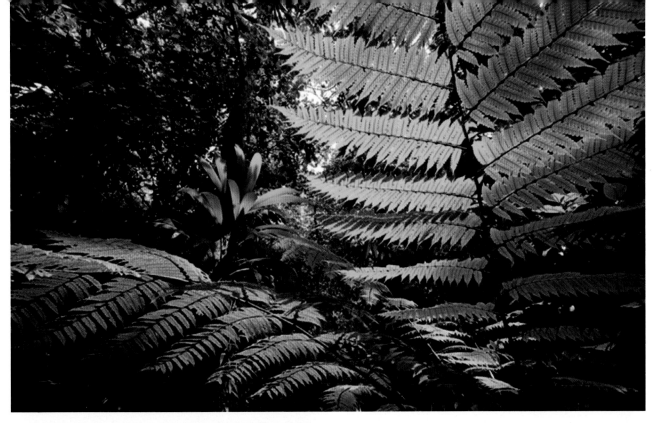

< FOREST DRAMA
Backlit leaves can add real
impact to forest shots.

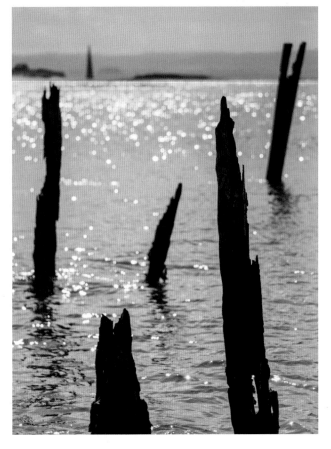

<< AVOID FLARE
Hiding your light source behind
your subject is a good way of
minimizing flare.

< INTO THE LIGHT
Shooting into the light means
that contrast is high. The
side of the subject facing
the camera will, without
supplementary lighting, tend to
become silhouetted. Color can
also become less vivid, making
images more monochromatic.

⋀ ARTISTIC FLARE
Although flare is technically a blemish, in this instance its presence suits the subject.

∧ TRANSLUCENCY
Backlighting can create bold silhouettes or highlight the fragility
of translucent objects. Occasionally it can do both.

Silhouettes

Silhouettes are created when your subject is backlit. It pays to keep things simple when you pick your subject. Choose one that doesn't have too complex a shape and that is recognizable from that shape. Think bold, hard shapes rather than subtle, soft ones. People tend to make better silhouettes in profile rather than looking directly at the camera. If possible, your subject should be in an open environment. There should be no distracting elements intruding into your subject's outline as this may make deciphering the silhouette more difficult.

Ideally there should be little or no light illuminating your subject from the front. Outdoors, silhouettes are easier to create at the ends of the day when the sky is still bright, but ambient light levels are low. In a studio, you should light your subject from behind and with little or no light at the front.

In order to shoot the silhouette you may need to override your camera's exposure meter. The meter will probably try to expose your subject correctly causing overexposure of the background. If your camera has a spot meter, use this to expose for the background and then lock the exposure before recomposing. Alternatively, apply negative exposure compensation until the background is exposed correctly and your subject is in silhouette. Turn off automatic flash to prevent your camera lighting your subject.

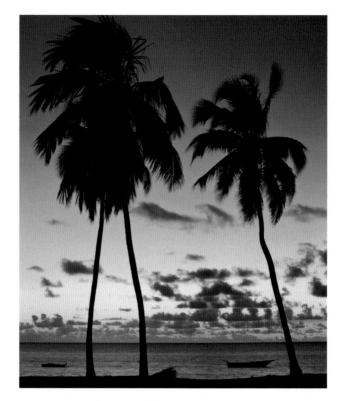

∧ ∨ HANDHELD

A colorful pre-sunrise or post-sunset sky makes an interesting backdrop for a silhouetted subject. Because the sky will still be relatively bright, it's often possible to use relatively fast shutter speeds and handhold the camera.

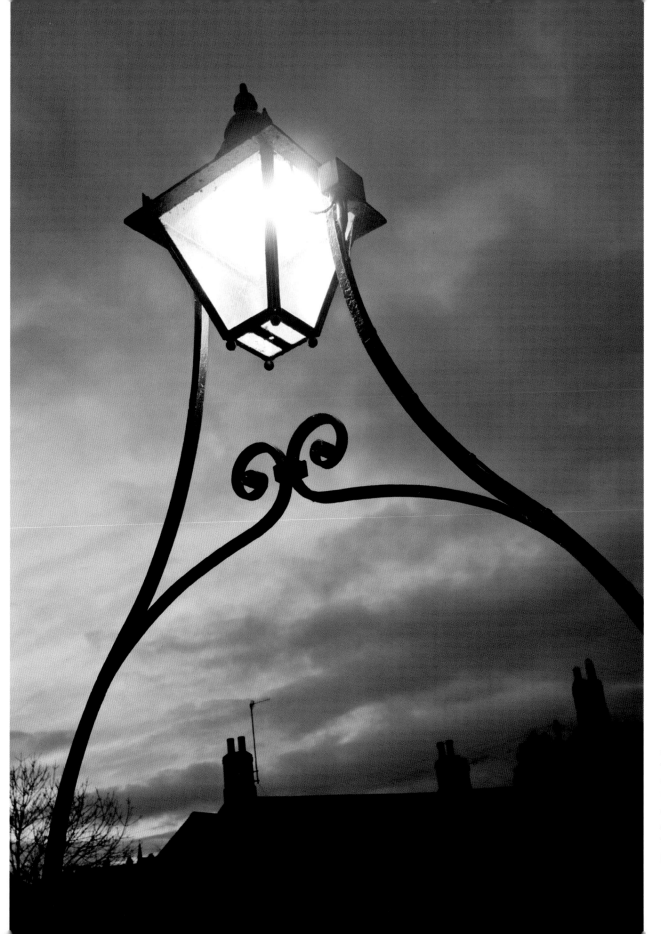

< **STREETLIGHT**
This ornate streetlight neatly frames the houses behind. Because there are no depth cues it is hard to judge relative sizes, creating an ambiguity that works well in this photograph.

Quality of Light

While we all know that the sun rises in the east and sets in the west, few of us take the time to observe how the intensity and direction of this light changes throughout the day, or during different weather conditions.

Light is generally considered to be either "hard" or "soft," but it's important to be aware that this does not refer to how bright or dim the light is. In fact, the description actually has more to do with the shadows created by the light: hard light creates shadows displaying a "hard" edge (or abrupt transition between light and dark) whereas soft light creates shadows displaying a "soft" edge (or gradual transition between light and dark). As a result, a hard light can also be weak: think of a flash diffused by a plastic panel. A soft light can also be strong: think of a bare light bulb shining uninterrupted onto your subject. Both types of light have their uses.

Soft Light

Soft light is created when the light is relatively larger than the subject it's illuminating. Soft light is low in contrast as it "wraps" around the subject. This means that shadows are lighter and more diffuse, with softer edges, and highlights are also not as bright.

In the natural world, light from the sun is soft when it is scattered by cloud or mist. This is because the light is more diffused and so appears to emanate from a greater area (thus making the light source larger). When the sun is on the horizon, its light is often softened too, due to particles in the atmosphere scattering the light more. Shade is also an example of natural soft lighting— the light in shade comes from ambient light from the sky above.

Consequently, soft light is not ideal for some subjects—big sweeping landscapes, for example. However, the soft diffused light that falls through the clouds can be the best light for more intimate photographs of the landscape and the fine detail that makes it up. The reduced range of light means that

digital camera sensors can record the full range of tones in the scene, and it also helps to saturate colors. If the day is bright and overcast, and the prospects of dramatic light are low, then either head into the forest, which works particularly well in diffused light, or turn your eyes downward and search for more abstract images of the landscape.

Artificial light is generally hard, but fluorescent strip lighting is softer than domestic bulbs because the light emanates from a larger area. Shining a light source through a translucent white panel will soften it, as will reflecting the light. Lampshades are used in domestic interiors to make lighting more subtle and pleasant, even though the intensity of the light is reduced.

∨ **BENEATH THE CANOPY**
Forests with thick canopies offer excellent diffused lighting conditions. They are perfect for teasing out subtle hues from subjects.

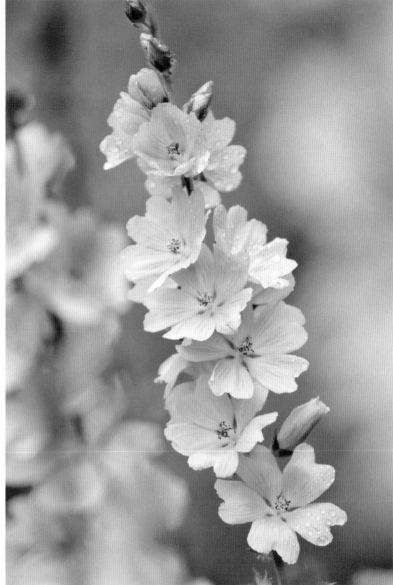

Soft light does not emphasize texture and subjects can look flat. However, while landscapes don't usually benefit from soft lighting, it's an ideal light for portraiture, as the subject doesn't need to squint, and you rarely require light modifiers to soften unsightly shadows under overhanging facial features such as the nose or chin. Soft light also suits particularly delicate subjects, such as flowers.

∧ **WEATHER WATCHING**
Shooting this wet rock on an overcast day reduced the chances of blown-out highlights and distracting reflections.

∧ **SOFT**
This image was created on a wet day, with thick cloud. This produced a soft light that suits the delicate subject.

∧ OVERCAST
This wintry landscape was photographed under the flat, almost shadowless light of an overcast day.

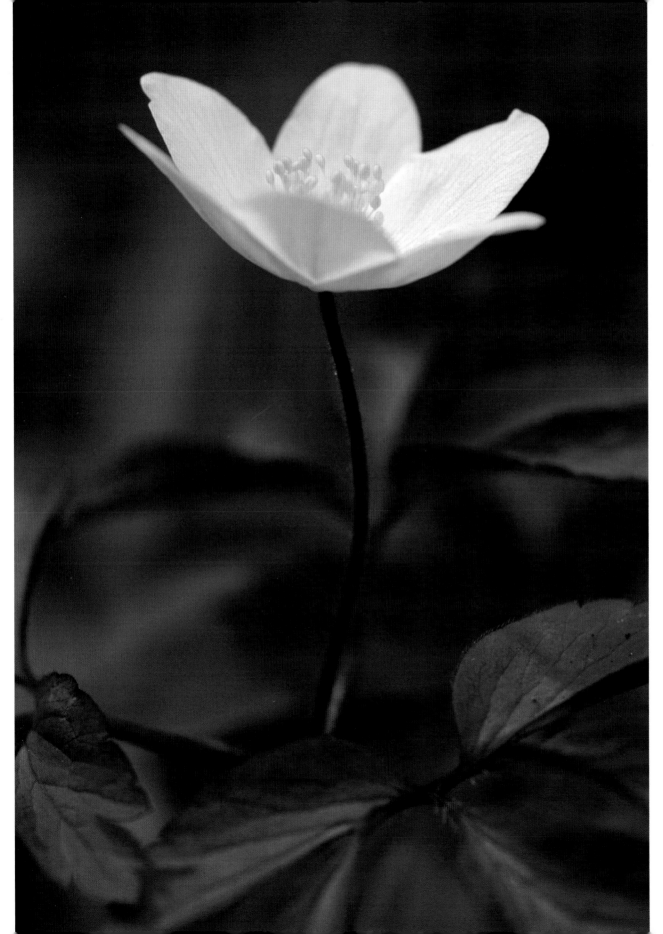

< **SYMPATHETIC LIGHT**
Soft light doesn't have to mean
"dull" light. Hard light would have
ruined this subtle floral study.

Hard Light

Hard lighting is created by point light sources. A point light is one that is smaller than the object it is illuminating. Oddly enough, the sun is a point light source. Although it's massive (over one million Earths would fit into the same space as the sun), the sun is also sufficiently far away to be relatively small in apparent size. Another good example of a point light source is an ordinary domestic light bulb.

Hard lighting produces shadows with very sharply defined edges and, if the subject is glossy, bright specular highlights. The shadows also tend to be deep, and contrast is high between the lit and unlit areas of an object. The closer the point light source to the object, the more sharply defined the shadows. One way to soften a hard light source is to move it away from the object it's illuminating. Another way is to add a diffusing medium between the light and the object. Flash is another example of a point light source. Flash is often softened either by using a reflector to bounce the light toward the subject or by using a diffuser such as a softbox.

Tip

Hard light doesn't necessarily need to be softened. There are some subjects that benefit from the sculptural effects of hard light. Portraits of men arguably benefit from the use of hard light, as does architecture with a strongly-defined form. Hard light (when used as side lighting) is also good for helping to show texture and shape.

∧ **SHARP RELIEF**
This stone carving was lit from below with a point light source. As a result, the light is hard and contrast is high. However, this has helped to emphasize the texture of the stone.

< **BOLDNESS**
The light from the sun high in a cloudless sky can be hard. This is less than ideal for most subjects, but can be good for architecture with bold form.

∧ TEXTURE

Hard side lighting is an excellent lighting scheme for emphasizing texture. This shot would have been less effective if the light had been softer and the shadows more open.

Softening Light

Learning how to control and direct light is a skill that any photographer should strive to perfect, as light can reduce or enhance shadows, increase or reduce contrast, and hide or highlight detail.

Diffusers

The main role of a diffuser is to soften the strength of the light and reduce areas of contrast. Diffusers usually come in the form of a white (or neutral colored) piece of fabric stretched over a sprung circular frame. While they might seem basic in construction, these lightweight accessories are invaluable for shooting outdoors on a bright sunny day, or indoors with flash.

When the sun is high in the sky, the light it casts is harsh and unforgiving, which creates unflattering conditions for close-up subjects and portraits. Thankfully, clouds make great natural diffusers, as they scatter light, making it appear softer and more evenly distributed. Flower photographers, in particular, are aware of the way that clouds broaden and soften light, and will often wait for bright but overcast conditions before shooting plant portraits. However, when a thin layer of cloud is nowhere to be seen, similar effects can be achieved by casting a shadow over the subject with your camera bag, a piece of white material, or even your body.

In the studio, diffusion is most commonly achieved by bouncing artificial light off a broad surface (to spread it over a larger area), using a plastic panel over the head of your flash, or employing a softbox or umbrella.

Reflectors

The main role of a reflector is to reduce or eliminate shadows by reflecting light into dimly lit areas. The intensity of this "bounced" light can be adjusted by moving the reflector closer or farther away from the subject. Reflectors generally come in the form of a white, silver, or gold piece of fabric stretched over a sprung circular or triangular frame. While a white reflector has no effect on the color of the light, silver will cool it slightly, and gold will add a touch of warmth.

While shop-bought versions are relatively inexpensive, you can also make your own reflectors using sheets of

< **TENT LIGHT**
This egg was placed in a light tent, so the illumination from two daylight-balanced bulbs (one placed on either side) was diffused by the fabric of the tent.

card and aluminum foil. Simply crumple up the foil, and roughly flatten it out again. Now, with the shiny side facing outward, fold it over a piece of stiff card. You can use this homemade reflector to bounce light into any problem shadow areas. Alternative reflector options are outlined opposite.

REFLECTORS

- **Mirrors** Great for simple still life projects and give bright, strong contrast.

- **White foamcore (foamboard)** Available at craft or office supply stores, foamcore boards come in a range of sizes and can be cut for any need. Reflectance is good and they can withstand long use. Advantage: initial cost and replacement is inexpensive.

- **Aluminum foil** Found right in your kitchen, so it is the least expensive. Reflectance varies depending on the side you choose; one side is flatter than the other. Roll out two pieces to cover a 20 x 30in. (50 x 76cm) foamcore board and tape the edges and seam with shipping tape for a silver/white reflector. Crumpling the foil before installing removes some of the reflectance and changes specularity, or its reflective value.

- **Painted wood or plywood** Good reflectance depending on the color it's painted. Gloss white is the best for reflectance and durability. Painting can be messy, but also allows you to change colors at will so you can create your own backdrops or use as a colored reflector to add a tint to the image.

- **Commercial reflectors** Products made by California Sunbounce, Lastolite, and Westcott will be more expensive, but also offer more accessories. A 5ft. (1.5m) round collapsible reflector will be translucent and have a cover that gives white/silver/black/gold sides. You can diffuse or reflect the light. In the case of the California Sunbounce or Lastolite Tri-Grip, you can purchase a clamp to attach the reflector to a lightstand.

Colored reflectors

- White will reflect soft shadows.

- Silver will reflect harder shadows with a touch of contrast.

- Gold will add a warm tone to the image. Gold is best used on people with dark skin or to add warmth. Be careful, though, you may like the warm tone on your LCD screen, but then spend time removing it when your images are viewed on your computer.

- Silver/gold or zebra stripe is meant to be a compromise that adds just a touch of warmth and contrast.

- Black will subtract light, so it's reflective value is the least.

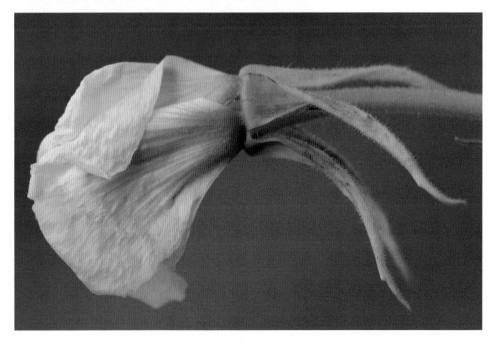

< SHINE SOME LIGHT
Reflectors are great for shining light onto small-scale subjects—you can make your own using aluminum foil and a piece of card.

∨ REVEALING DETAIL
Soft light, such as that produced by diffused sunlight, is excellent for reducing contrast and revealing detail.

Color of Light

A bias of one wavelength of light over the others will alter the color of the light. This is known as a difference in the "color temperature" of the light.

The term "color temperature" refers to the way in which the color bias of light is measured. In order to understand color temperature easily, we need to pay a visit to a blacksmith. When iron is heated in a forge it steadily begins to glow. By observing the change in color a blacksmith knows exactly when to remove the iron from the heat in order to bend, hammer, or cut it. The metal first glows red (which is why we often say something is "red hot"), it then glows orange, and after that it glows yellow. When the iron reaches yellow-orange, the blacksmith sets to work. If the iron is left in the furnace to get hotter, it will eventually turn white (which is why we use the term "white heat"), and then finally melt.

In 1848, the British physicist William Thomson devised a theoretical scale—the Kelvin scale—for determining the color of light given off by materials as they are heated. Somewhat counterintuitively, the lower the color temperature of a light source, the warmer the light is. Candlelight has a color temperature of 1800K, for example, whereas the blue ambient light found in deep shade is approximately 7000K. Light that is neutral (with no color bias) is approximately 5500K, which is the color temperature of electronic flash and the light from the sun at midday. If we return to the furnace analogy, then this topsy-turvy approach makes sense: when a fire is burning at a relatively low temperature, the flames are often red or yellow, but when a fire becomes hotter, the flames become blue, or even white.

Incredibly, most of the time our eyes and brains make adjustments to correct these casts, whether they occur as a result of natural light or an artificial source. Consequently, when we look at a white object it appears white, regardless of the temperature of the light source illuminating it. Unfortunately, a digital sensor has no way of making such a human assumption, so it faithfully displays the temperature of the light as it is, turning a white object blue, pink, green, and so on, depending on the temperature of the light source. Therefore, knowing the approximate color temperature of a light source is vital to photographers, as it helps them to avoid unnatural color casts.

< ATMOSPHERE
When the sun is on the horizon (shown here in orange) it passes through a thicker slice of the earth's atmosphere, which scatters blue light more, increasing the warmth of the light. At midday (shown in yellow) there is less atmospheric scattering, so the light is more neutral in color.

1800–2000K	Candlelight
2800K	Domestic lighting
3400K	Tungsten lighting
5200K	Midday sunlight
5500K	Electronic flash
6000–6500K	Overcast conditions
7000–8000K	Shade
10,000K	Clear blue sky

< COLOR TEMPERATURE
Every light source has its own color temperature, which indicates how "warm" (red) or "cool" (blue) it is. Our eyes and brain compensate for minor shifts in color temperature automatically, so a white piece of paper seen in daylight will also appear white under tungsten (incandescent) lighting.

∧ MIXED LIGHTING

The color temperature of artificial lighting can vary enormously. In this photograph, the streetlights in the background are far warmer than the lighting in the foreground.

White Balance

Digital cameras can neutralize the color temperature of light by using their white balance facility. This works by shifting the colors in the image in the opposite direction to the color bias of the light. The light on an overcast day is very cool, for example, so to compensate for this coolness the white balance would add more orange to the image.

There are usually several ways to set the white balance. The easiest method is to use the camera's automatic white balance (AWB) setting. When set to AWB, any color bias is automatically detected and compensated for. Unfortunately, AWB isn't perfect. It can be fooled into adjusting white balance unnecessarily by large areas of a single color in an image. For more control, cameras offer a range of preset white balance settings, such as Daylight, Shade, Cloudy, and Incandescent, which relate to specific color temperatures (as shown below right). Some cameras also allow the setting of a specific Kelvin value, often in steps of 100–200K, although this is arguably only beneficial if you have some way of measuring the color temperature of the light to start with.

The finest control over color temperatures is achieved by setting a custom white balance. This is achieved in subtly different ways on different camera models. The general idea, however, is that an image of a white (or neutrally gray) surface is shot, illuminated by the same light as your subject (the surface filling the frame entirely). The camera then uses this image to calculate the correct white balance adjustment. Typically the custom white balance preset would then be selected (although it should be noted that it is only applicable to the light the white surface was shot under—if you move to a different lighting set-up, a new custom white balance should be created).

< DUSK'S WARM LIGHT

Occasionally, the camera will try to "correct" the warm light experienced at the end of the day. To solve the problem, pair the lighting conditions with the appropriate white balance preset, rather than using AWB.

V WHITE BALANCE OPTIONS

Most cameras offer a range of preset white balance options that are broadly matched to specific lighting types. As a general rule it is best to set the white balance to match the light source.

WB Symbol	Description
AWB	Automatic White Balance
☀	Daylight: Normal sunny conditions
🏠	Shade: When shooting in shadow
☁	Cloudy: Adds warmth on overcast days
💡	Tungsten: Incandescent domestic lighting
🔆	White fluorescent lighting
⚡	Flash
📷	Custom white balance

V WHITE BALANCE

A human eye sees a white object as white, regardless of whether it is lit by an indoor bulb or the sun. Depending on the light conditions, a digital camera needs a little help to record whites as white. The effects of the most widely used white balance (WB) presets can be seen here (the rock was actually shot in open shade).

AUTO WHITE BALANCE (AWB)
(3000–7000K)

DAYLIGHT (5200K)

SHADE (7000K)

CLOUDY (6000K)

TUNGSTEN (3200K)

FLUORESCENT (4000K)

FLASH (5500K)

Time of Day

The quality and temperature of light changes throughout the day. This can make some times of the day better for certain types of photography than others.

< DAWN
Pre-sunrise colors in a wintry northern England.

Dawn

This is one of the favorite times of day for some landscape photographers. The quality of the light and the clarity of the air can be extraordinary, in part due to the lack of dust in the atmosphere after everybody has been sleeping rather than going about their daily business. Most other people still are wrapped up snugly in their beds, so there is an excellent chance that you will be the only person watching the new day arrive, which is guaranteed to lift the soul. Despite being such a glorious time to be out, there is no denying that it can be a struggle to leave your bed in the dark, gather your kit, and head out the door, but even if the photographic results aren't anything to shout about, it is just a wonderful time to commune with Mother Nature.

On the whole, dawn light tends to be slightly cooler than sunset light, due to the lack of dust in the air; the dust allows the transmission of red light, but blocks some of the blue light. Dawn light is still significantly warmer than the light you get around midday, though. The range of light at

this time of day is quite limited, especially as the first light of dawn emerges. As soon as the sky starts to lighten more, the range of light will quickly increase, so you may need to use filters to help balance the light in the scene if you want to retain some details in the shadow areas. Your eyes will naturally try to counter the temperature of the light in any scene, so you may find colors showing on your final image that you didn't think were there. If you want to catch the dawn, then you will need to be in position around one hour before the sunrise time.

∧ INCREASING DRAMA
As the sun nears the horizon before rising, the sky can take on a stunning range of warmer hues if there is mid-level cloud.

Sunrise

Although most photographers skip the dawn shoot, there will be many who will make the effort to get out of bed and to a location in time for sunrise. The first rays breaking the horizon have held a fascination for humans dating right back to our first presence on the planet and the allure of them has not dwindled since. It is the return of life, and many photographers hope to capture at least a few stunning sunrise images in any given year.

One of the most exciting challenges about shooting sunrises for a landscape photographer is the fact that usually it all happens very quickly. One moment the sun just peeks above the horizon, but within minutes it can be high in the sky, where it rapidly loses its warming soft light qualities. So, be prepared a while before the sunrise time, and be ready to react to the changing light situation—it's not good to be reaching for your filters and trying to attach a filter holder once the sun has broken cover.

Sunrise Light

The light at sunrise tends to be slightly cooler than that at sunset, due to the lack of dust in the atmosphere and the often low wind conditions first thing in the morning (it is the sun being up that starts to heat the land and drive the convection currents). The advantage of this is that the air quality is usually better, giving crystal clarity over far-reaching landscapes. It is usually better if there is some level of cloud in the sky to get the best results, since a truly clear sky will give you very little to work with in the upper parts of your image.

Mid-level clouds are usually the best for reflecting light. Even if, upon first inspection, the day appears to be very cloudy, it is still worth taking a chance on heading out, as it is amazing how many times there is a small, clear band of sky right next to the horizon when the sun rises. The light may only last for a few brief moments, but if it does break through in these conditions, then you could be in for a treat, with fiery red and orange clouds to include in your composition. The light contrast is extreme as the sun rises, with the sky being far brighter than the land, so it is a good idea to seek out any landforms that can act as bold silhouettes against the sky to add interest.

Avoiding Lens Flare

One of the technical difficulties with shooting sunrise (or sunset) is that to have the sun in the frame means that there is a greater risk of lens flare appearing in the final image. Whether this makes or breaks the photograph is down to your own subjective interpretation, but if there is significant sun flare, the image will almost certainly fail. If you are using large neutral-density graduated filters, then it will be impossible to also use your lens hood, so you have to improvise to shade your lens when possible. You can use your hand or a hat, or invest in one of the commercially available anti-flare tools, such as the Flare Buster. You can also try taking your images as soon as the sun edges above the horizon, before its full glare comes into play.

Note

It is important to plan your shoot around the sunrise and sunset time, and the best way to do this is to use a sunrise/sunset calculator. There are several available online, including the aptly named www.sunrisesunset.com.

∨ **FLARE**
With the sun low in the sky, flare is a potential problem, although sometimes it adds to the early morning atmosphere.

< THINK FAST, ACT FASTER
Once the sun breaks the horizon, there is no time to waste. You need to make rapid adjustments to your viewpoint and composition, then keep shooting as the sun rises.

< CLARITY
With less dust in the air, early morning light has a crisp quality that is difficult to match later in the day.

Midday

The light at midday is the least satisfactory of all the possible conditions for most photographers, but if you are out in the midday sun and want or need to take photographs, then there are some simple ways by which you can help ensure that you get the best images from a relatively bad situation.

Great pictures are usually made with great light, but if the light isn't playing ball, then you need to really search out some fascinating subjects to compensate for this as far as possible. With landscapes, you want to find something very interesting to put in the foreground and include some strong depth cue graphics, such as rivers, twisty country roads, or similar leading lines. It is also quite astounding what a good cloud can do to command attention in an image, so if you happen to be shooting a landscape with lovely fluffs of cumulus clouds drifting across a blue sky or the billowing masses of a cumulonimbus storm cloud brewing over a horizon, then you might still get some "wows" when you show your midday images.

Thankfully, as the afternoon progresses, the light becomes less harsh and better suited to photography.

< < **STRONG DESIGN**
When the light conditions are poor, it is more important to emphasize design elements.

< **SAVED BY THE CLOUDS**
Cumulus clouds can save a midday landscape image. Their striking shapes distract from the poor light.

∧ **SNAP DECISION**
This shot was taken very quickly when the sun suddenly broke
through the storm clouds during the late afternoon.

Sunset

This is the big money shot for many landscape photographers, whether complete amateur or consummate professional. It is by far the most popular landscape subject in the world, but what makes it so special? Well, the first thing is that it is achievable: there is no unsociable pre-dawn start needed to capture the sunset, and it can be added on at the end of any day, as long as you don't mind delaying dinner a little at times.

It is also often the most spectacular time of day for photography, since the accumulated dust in the atmosphere combines with the raking, warm low light of the sun to produce some truly stunning skyscapes and reflected light to include in your image. At some of the world's most famous landscape photography spots, sunset can see an entire legion of photographers standing shoulder to shoulder with their tripods vying for space on the ground. Even if you find yourself in this sort of situation, keep your creative thinking hat on and you may still come up with a fairly original idea for a photograph of the scene.

Sunset Light

The time around sunset provides the warmest light of the entire day, wrapping the land, sea, and sky in swathes of orange, red, and pink. Because of the matter in the air, it is rare to have great clarity of light at this end of the day, so quite often more intimate scenes work better than truly grand sweeping vistas.

The Magic Moment

As the sun progresses toward the horizon, it is often difficult to determine the optimum time for shooting your photographs. It is advisable to carry enough memory cards with you so that you are not limited in what you capture by the availability of storage space. If you have to ration your shooting, try to tune your eyes into the subtly changing conditions. Are the clouds getting pinker or more gray, for example, and does it look like thicker cloud on the horizon may curtail the sunset light? By observing closely, you can narrow the window in which you know the light is at or near its best.

< SUN SHIELD
If there is a band of thin cloud on the horizon, it can make a lovely natural diffuser for the red light of the sun.

Often, the best sunset light conditions will occur 10–20 minutes prior to the sun getting to the horizon, where it can start to lose its intensity, so don't wait until the final moments to start taking pictures. As with sunrise, you need to be aware of the potential problems caused by the sun flaring on your lens, although when the sun is shining through a thick dust layer (when it can appear like a giant, red, well-defined orb), this will significantly reduce the chances of your image suffering from flare.

< DIPPING SUN
In the natural world the warmest light (in terms of color temperature) is found at either end of the day, but the amount of cloud can make a big difference to the intensity and duration of the color. Because there was no cloud in the sky, the warmth quickly faded here, once the sun had dipped below the horizon.

< STRONG PALETTE
Sunset colors can range from orange-red through to pinks and violets, depending on the atmospheric conditions.

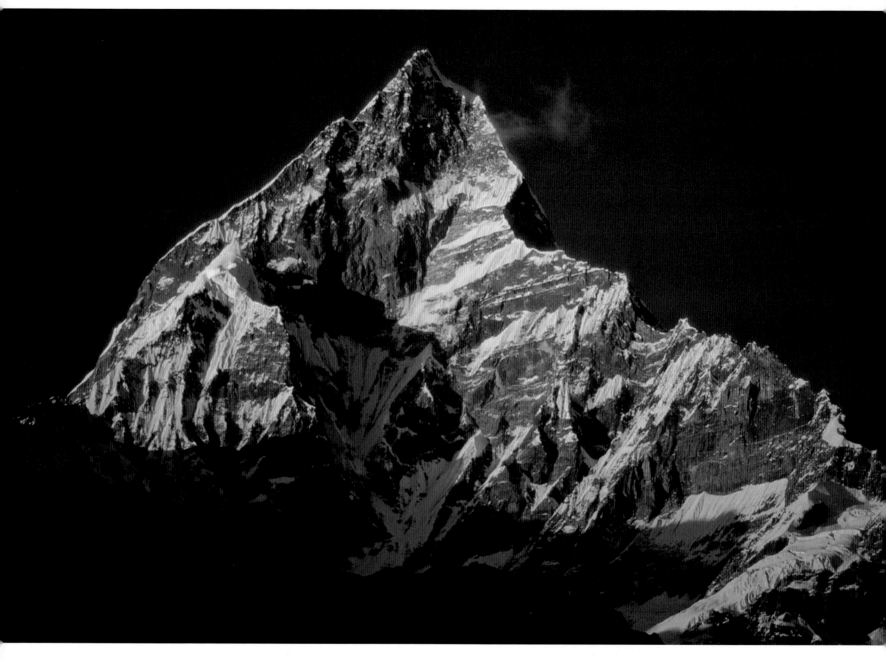

∧ IN THE SPOTLIGHT

An exciting effect of the sun setting is that it starts to spotlight parts of the landscape. This can be especially dramatic when photographing mountains.

< RICH REFLECTIONS
A combination of wet sand and still water readily reflect the colors of sunrise and sunset.

Twilight

There are few more startling scenes in landscape photography than watching the mass exodus of tripod-toting photographers the moment the sun sets at a popular location. Spend an evening at certain parts of the Grand Canyon in the USA, for example, and it might seem that there is barely a spare vantage point to be had as the sun heads toward the top of the cliff edge and the clatter of shutters going off is enough to scare birds from nearby trees. However, within a matter of minutes of the sun disappearing from view, you can find yourself almost alone on the rim of one of the world's greatest landscapes.

But just because the sun has gone, that doesn't necessarily mean you cannot take any more photographs. As twilight falls, you will find that your camera can start to record far more detail than you can discern with your naked eye, resulting in images that will be fairly unique compared to those by photographers who head home early. Indeed, ask the savviest landscape photographers to name their favorite light for shooting images and most will say "twilight."

For those with the patience to wait, the so-called "Golden Hour"—the period of 30–60 minutes after the sun sets—offers a glorious palette of colors, more balanced light, and some of the most extraordinarily subtle light that Mother Nature can conjure. It is the time when your neutral-density graduated filters can help to make a landscape photograph explode into life, with a richness of tones that is often missing at any other time of the day. The long exposures needed during twilight also mean that you can easily turn any moving elements in the scene, such as leaves on trees, rivers, or the sea, into a milky, artistic blur.

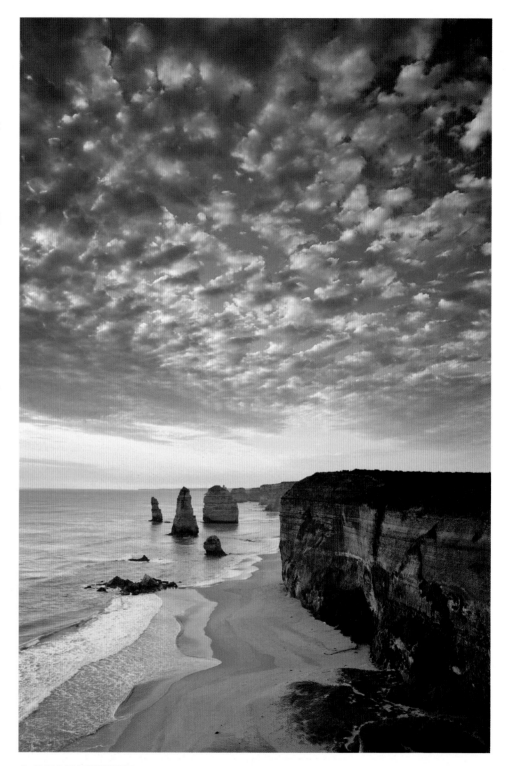

∧ GOLDEN MOMENT
Immediately after the sun has gone down it remains relatively bright, yet the light becomes softer and more balanced. The quality of this "Golden Hour" light is incredibly popular with photographers.

< SUPPORT ACT
Shooting at twilight needs
very long exposure times,
so shooting without a tripod
is virtually impossible.

> BEYOND VISION
Modern system cameras are
capable of recording color and
detail in low-light conditions
where even your eyes can't
make things out.

∧ CITY DUSK
The optimal time to shoot city night scenes isn't at night. Shooting at dusk—roughly half an hour after sunset—will produce more pleasing results. At this time of day there is still color in the sky and, because the sky is still relatively light, the shape of building rooflines is still easily discernible.

∧ MOONRISE

This scene was shot at mid-summer on the day before the moon was full. This meant that there was still enough ambient light to record the scene with a reasonably fast shutter speed and for the castle to stand out against the dusk sky.

Night

Once all of the sun's light has disappeared from the landscape and the only light on offer is the ethereal, silvery light of the moon or the stars, it takes a far more committed approach to get out and start taking photographs. In the days of film, night photography was very much the preserve of the few who knew how to deal with the extended exposures needed (if you haven't come across "reciprocity failure," then look it up on the web to see what you were missing out on!) and the practicalities of keeping camera gear working in often testing temperatures. However, modern DSLRs and CSCs provide astounding low-light shooting capabilities at high ISO ratings, which means that the night realm has become a more inviting place to linger.

From capturing a landscape bathed in the light of the moon to recording spiralling star trails, there are many exciting subjects for those willing to venture out in the dark. You will need a remote release cord (so you can trigger the camera without touching it and lock the shutter open in Bulb mode), a very stable tripod, and a fully charged battery to ensure that your camera doesn't shut down halfway though the energy-sapping long exposures needed at night. Even the best professional digital cameras will struggle to take an exposure lasting much more than a couple of hours. You also need to be careful about your camera gear suffering from the effects of condensation if the temperature of the air changes substantially during the night.

Moonlight

On a clear night at or close to full moon, there will be ample light for modern system cameras to work with. With any night exposures, it is good if you can find strong foreground subjects that will silhouette against the sky to add interest. If you want to try adding another layer of creativity, then take a powerful flashlight and "paint" in the foreground objects in your composition with its light. If you want to take photographs of the moon itself, then be aware that exposures that are longer than about six seconds will suffer from the moon starting to blur due to its movement across the night sky.

Star Trails

As the Earth rotates, the stars appear to rotate around the night sky. Using a very long exposure it is possible to record this perceived movement as star trails, or streaks, in an image. The most dramatic examples of this are often where the pole star is placed in the frame and the star trails then create circles in the photograph. The exposures you need to record the trails vary, from around 10 minutes for short trails to several hours for a full circle of star trails—full details appear on page 166.

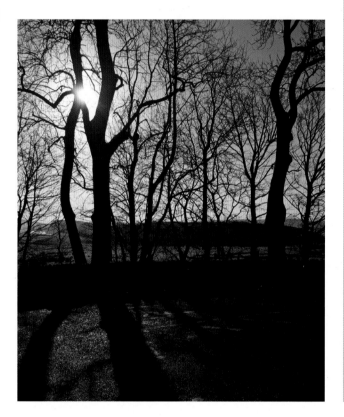

∧ DAY OR NIGHT?
This might look like a typical daytime scene, but it was actually shot at night: the light bursting from behind the trees is the moon. With the right exposure, photography can turn night into day.

∧ LIGHT PAINTING

A powerful flashlight can be used to "paint in" foreground elements in night photographs. Move the flashlight slowly and evenly over the subjects as you make your long exposure.

CHAPTER 6
FLASH

Introduction to Flash

There are many kinds of artificial light, but the one used most commonly by photographers is electronic flash.

The story of flash began in 1931, when Harold Edgerton, an electrical engineer at the Massachusetts Institute of Technology, was trying to find a way to produce a stroboscopic light that would freeze moving objects for scientific photography. Instead of the flash tubes used for regular photography at the time, Edgerton employed a tube filled with Xenon gas that could be electronically charged, fired, and then recharged for another shot. This was the first electronic flash tube, setting the stage for the small, powerful flashes that are available to us today.

One of the main attractions of flash is that it is neutral and is similar in color temperature to midday sunlight. This makes flash easy to use during the day as a fill-in light, or as the main light source. Flash is not perfect, though. When mixed with other forms of artificial lighting, such as incandescent bulbs, it can make the light appear cool or even cold, while full flash (where the flash is the main source of light) can strip an image of its atmosphere and make outdoor subjects appear as though they have been shot in a studio.

Yet despite these drawbacks, the benefits of using flash are hard to deny. When managed carefully, artificial light can produce natural results, and techniques as simple as bounce flash can help make the light from a flash much more pleasing. This chapter covers some of the flash basics and explores how your flash could become your new best friend.

ICON IDENTIFIER

Some of the symbols used with flash: it will help if you recognize these and know exactly what they refer to.

Auto flash bracketing (the same symbol is also used for automatic exposure bracketing)

Flash compensation control

Flash off (overrides the automatic flash)

Flash on or flash ready

Red-eye reduction mode (uses a pre-flash to minimize red-eye)

REAR Rear curtain synchronization

SLOW Slow curtain synchronization

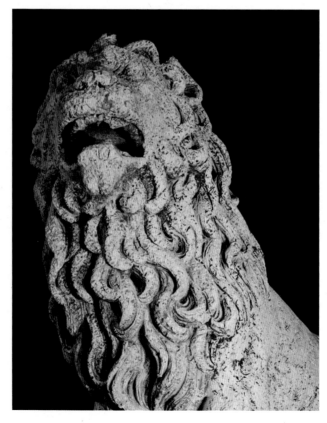

< **FLASH ONLY**
Flash is particularly useful when there are few other artificial light sources to illuminate subjects at night.

< MOVEMENT
This image was shot using slow
sync flash, with the camera
moved deliberately during the
exposure to leave a suitably
"science fiction" series of trails
and blurs.

Built-in Flash

The majority of cameras feature a built-in flash, which can be used to complement the ambient light. However, understanding its limitations will help you avoid disappointment.

The built-in, dedicated flash on your camera allows you to illuminate your subject quickly and easily. It is a convenience that we've become accustomed to on all but the most expensive professional-level cameras. While it isn't particularly powerful, and has a signature look of a short drop shadow and flat light, on-camera flash is still capable of producing great results if used well. The only place these days that you won't see a pop-up flash is on the top-of-the-line cameras such as the high-end offerings from Nikon and Canon, and almost all of the medium-format cameras made by Mamiya, Phase One, and Hasselblad.

Most on-camera flashes have a guide number of about 40ft/12m (at ISO 100). That isn't a great deal of power compared to the output of an off-camera flash (many mid- to high-end flashes have a guide number of over 100ft/30m at ISO 100), but it's perfect for snapshots or grab shots where you only need to add a small amount of light or want to capture that moment in time at a party or family gathering, or any other occasion where a larger flash isn't available. Point-and-shoot cameras are designed with this type of shooting situation in mind and excel at it.

Built-in flash is perfect for adding a touch of fill flash, but you have to watch out when using certain lenses; some longer lenses will cast a shadow on the bottom of the image, as the light spread is not high enough off the lens axis to avoid the lens or its hood, if fitted. However, on-camera dedicated flash has its uses and can be effective creatively if used and explored to its fullest.

Red-eye Correction

Red-eye can be gruesome, transforming friends and family members into strange-looking supernatural creatures. It is caused by the use of direct flash, when the light from the flash bounces off the back of the subject's eye, picking up the color of the blood vessels as it does so. The problem is made worse by the fact that flash is most often used in low-light conditions, when your subject's pupils will naturally be at their widest. Red-eye correction pulses a series of pre-flashes that cause pupils to contract, reducing the risk of the flash being reflected back out from the eye. The use of techniques such as bounce flash will also cure red-eye.

∧ BUILT-IN FLASH
Most cameras have a built-in flash, but they are limited by their low power and close proximity to the lens. Red-eye is often a problem.

∧ NATURAL LIGHT
Working on a cloudy day or by moving your subject into the shade gives you soft omnidirectional light that flatters your subject, but it will result in flatly lit portraits (top). However, you can create portraits with a completely different look by using on-camera flash and adding a touch of light to create shadow and drama (above).

GUIDE NUMBERS

Whether you use your camera's built-in flash or an external unit, the amount of light it produces will be relatively weak. The maximum power output of a flash is measured as a numerical value, which is known as the guide number (or GN). The GN is given in meters or feet for a specific ISO sensitivity and this allows you to calculate the flash's range. The average guide number for a built-in flash is 40ft (12m), but if the ISO on a camera is altered, the GN changes: the higher the ISO, the greater the range of the flash, and therefore the higher the GN.

To avoid confusion the majority of manufacturers use ISO 100 as a standard value when quoting a flash guide number. This can be used to determine the aperture value needed to correctly expose a subject at a given distance (or calculate the effective range of the flash at a chosen aperture). The formula to calculate these is:

GN/distance=aperture
GN/aperture=distance

So, for example, if a flash has a GN of 131ft (40m) at ISO 100, with an aperture setting of f/8 (and the camera set to ISO 100), the effective flash distance would be 16.38ft (5m). If the ISO on the camera is doubled, the effective flash distance is multiplied 1.4 times. So, at ISO 200 (and still at an aperture of f/8), the effective flash distance would increase to 23.16ft (7.07m).

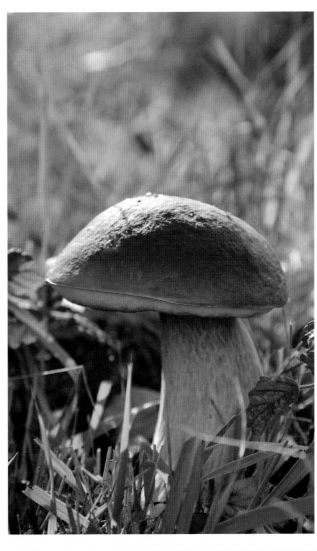

< FILL-IN FLASH
A quick burst of flash can be used with daylight to fill in shadows and reveal detail.

Effective flash distance for a flash with GN 40(ft)/GN 12(m) at ISO 100							
	Aperture						
ISO	f/2.0	f/2.8	f/4	f/5.6	f/8	f/11	f/16
100	6m (19.68ft)	4.29m (14.07ft)	3m (9.84ft)	2.14m (7.02ft)	1.5m (4.92ft)	1.09m (3.58ft)	0.75m (2.46ft)
200	8.49m (27.85ft)	6.06m (19.88ft)	4.24m (13.91ft)	3.03m (9.94ft)	2.12m (6.95ft)	1.54m (5.05ft)	1.06m (3.48ft)
400	12m (39.37ft)	8.57m (28.12ft)	6m (19.68ft)	4.29m (14.07ft)	3m (9.84ft)	2.14m (7.02ft)	1.5m (4.92ft)
800	16.97m (55.67ft)	12.12m (39.76ft)	8.49m (27.85ft)	6.06m (19.88ft)	4.24m (13.91ft)	3.03m (9.94ft)	2.12m (6.95ft)
1600	24m (78.74ft)	17.14m (56.23ft)	12m (39.37ft)	8.57m (28.12ft)	6m (19.68ft)	4.29m (14.07ft)	3m (9.84ft)

External Flash

Unlike a pop-up flash, a large hotshoe flash is a more powerful and versatile unit, making it suitable for a broader range of applications.

Most photographers begin their foray into flash with a single flash mounted on the hotshoe of their camera. These high-powered units usually offer a more controllable power range than a built-in flash, as well as wider light coverage and the ability to bounce the flash. You can also use one or more dedicated off-camera flashes to create sophisticated lighting set-ups, or mix them with larger and more powerful studio strobe lighting.

The popularity of the hotshoe flash (and, by extension, off-camera flash) has boomed over the course of the last decade as the simplicity, cost effective nature, and overall usefulness of these flashes has grown. This type of photography is now at the forefront of the photographic medium, allowing entry into areas that were once the preserve of seasoned professionals willing to make significant investments in gear. For example, it is now possible to photograph portraits, weddings, and events with a relatively inexpensive flash, where an expensive "hammerhead" unit or studio strobes would have been used previously.

Tilt, Swivel & Rotate

The tilt, swivel, and rotating head featured on the larger flash units gives them more flexibility, especially for event photographers wishing to bounce light around a room to achieve pleasing results. At a wedding, for example, it's possible to fill a room with light, illuminating the bride and groom with a soft light, rather than the harsh frontal light of direct flash.

There has been an explosion of modifiers that attach to the flash unit to give great results, allowing you to bounce light to the right, left, forward, or even behind the camera to get a soft look that in many cases rivals studio lights fitted with softboxes.

Zoom

Many hotshoe flashes have the ability to be zoomed. While each distance is different per flash unit, the feature allows you to place light over a greater distance, such as in a church or event space with high ceilings. The zoom feature enables you to focus the light and get a tighter spread in a broad area. Some flashes can zoom from 17mm (wide spread) to 200mm (telephoto spread).

Built-in Slave

The majority of hotshoe flashes have a built-in slave mode that allows it to be triggered by another flash. The light detector ("slave cell") in the hotshoe flash registers the other flash firing and then fires at the same time. All of this happens in milliseconds, so multiple lights can be fired and multiple flash systems used—a studio strobe or built-in camera flash can trigger the hotshoe flash, for example.

Bounce Card

Hotshoe flashes also come with a retractable card to add a modicum of forward bounced light onto your subject. Long preferred by photojournalists, the bounce card is a quick and easy way to spread light without having to add or carry a larger light modifier. The light quality is not the same as when using a larger reflector (the light is harder, with deep shadows), but it is still more pleasing than direct flash.

∧ **NISSIN Di 866**
The Nissin Di 866 is a powerful alternative to your manufacturer's flash unit. Coming in at a price point lower than a proprietary flash unit, these third-party brands are worth taking a look at, especially since costs can rise exponentially when adding a second, third, or fourth flash to your kit.

> ANATOMY OF A FLASH

The flash shown on this page is the Canon Speedlite 430EX II, which is a mid-range model compatible with Canon's EOS range of cameras. Its features are found on comparable flashes produced by other manufacturers.

1 | **Wide-angle diffuser panel**
Increases the angle of coverage of the flash so that scenes are lit evenly when using a wide-angle lens.

2 | **Flash head**

3 | **Battery access panel**

4 | **AF assist lamp**
If there is not enough ambient light for the camera's AF system to work normally, the AF assist lamp pulses light to compensate.

5 | **Mounting foot**

6 | **Flash mode button**
Selects the various metering modes the camera and flash combination uses to determine the correct exposure.

7 | **LCD panel light/Custom function button**

8 | **Flash charge light/Test fire button**
Lights when the flash is fully charged. The fresher the batteries, the more quickly the flash charges.

9 | **Flash exposure confirmation light**
Illuminates when the flash has fired and correctly exposed the subject.

10 | **Bounce angle index**
Shows the angle that the flash head is pointing in when using bounce flash.

11 | **LCD information panel**

12 | **Hi-speed sync/Curtain sync button**
Sets Hi-speed sync (where available) and first or second curtain synchronization.

13 | **Zoom setting**
Adjusts the coverage of the flash to suit the focal length of the lens used.

14 | **Power switch**

15 | **Option setting buttons**

16 | **Locking collar**

< SIMPLE DRAMA
A single external flash and a reflective umbrella were used here. It doesn't get easier or simpler than this, yet the result is striking.

Specialist Flash

Ring Flash

Although it was originally designed for medical and dentistry photography, ring flash is also useful for general close-up photography, as well as for portraits and fashion. Ring light has a unique and specific look, providing even, shadowless lighting with a short drop shadow. With portraits, the light fills the skin's pores so no shadow detail is seen. As a result, the skin appears to glow, which also helps conceal pimples and blemishes.

Most of these circular units are designed for short working distances and are mounted on the lens rim, with the control unit slipping into the camera hotshoe. Superior models, such as Sigma's EM-140 DG Macro Flash, feature two flash tubes that can be adjusted independently to vary the output. By altering the lighting ratio, you can deliberately create shadows, adding a sense of depth to a scene or use the full ring. Some models allow you to rotate the ring flash around the lens to better position highlights and shadows.

Battery powered ring flashes tend to have a relatively low GN, so you may need an additional flash unit to illuminate distant backgrounds. Alternatively, there is an increasing number of ring flash adapters that attach to a regular hotshoe flash, creating a ring flash "look."

Twin Flash

Arguably the most popular lighting set-up for close-up photography, twin flash units comprise two separate flash heads mounted on a ring around the lens, with the control unit slipping into the camera hotshoe. As with ring flash, the output between the two lights can be adjusted for precise control of the shadow areas. The heads can be fired together or separately. However, unlike ring flash, the heads can be moved, tilted, and sometimes even removed for increased flexibility.

Top-end models, such as the Canon Macro Twin Lite MT-24EX, even feature focusing lights, which fire a pre-flash strobe to illuminate the subject and aid manual focusing. On the downside, twin flash is one of the more expensive options and, when fired together, the two heads can create double highlights, which can be distracting. You may also need an additional flash to illuminate distant backgrounds.

∧ RING LIGHT
For this shot a Nikon SB800 was fitted with an Orbis Ring Light adapter, with additional flashes used as fill lights.

> SIGMA EM-140 DG MACRO FLASH

TTL Control

Obtaining the optimal flash output for the correct exposure used to be a complex math exercise, but modern TTL flash control makes that a thing of the past.

Everything that determines exposure on your camera—point and shoot or DSLR—is determined "through the lens," or TTL. The acronym TTL confuses a great deal of novice photographers, but it only means that the camera has the ability to automatically determine exposure (or whatever else is being referred to) using the information (light) that is entering the camera through the lens.

When you point your camera toward something—landscape, seascape, a person, or whatever—the camera can only see the world through the lens. Get used to seeing, saying, and understanding this concept, because once you understand it, your photographic life becomes much easier. When you point your camera toward a subject, whatever that subject may be, you immediately get an exposure reading. Whether or not it is the correct exposure for the scene, or the correct exposure for the creative look you're after, is not the point: the point is that the camera determines all the variables needed for a correct exposure based on that scene.

For flash photography, TTL is based on the same concept. The camera sees the world, sets an exposure for a correct image capture, then tells the flash how much power is needed for the correct flash exposure.

On-camera TTL

TTL is especially suited for on-camera flash, and is a great way to begin to understand your flash. The camera and flash combination will choose everything for you until you decide that the result is less than desirable; then you take the next step into what is termed Flash Exposure Compensation, or FEC. Whether using your built-in, pop-up flash, the flash on your point-and-shoot camera, or a hotshoe unit, you have the ability to control flash output and override the chosen camera settings: FEC is simply controlling the output of your flash through the flash.

The LCD on the back of your camera becomes the most useful tool in determining your image and in creating the look that you desire. Having the ability to see an image right before you instead of having to wait for film development is a huge asset to the digital photographer. You can adjust exposure and light output right from your camera after you determine that your initial test shot needs more or less light or needs to be shot from a different angle, or just needs something more creative.

∨ TTL FLASH
Using off-camera flash is simplified if both your camera and flash are compatible and support TTL exposure.

∧ STUDIO LIGHTS

An increasing number of cameras and flashes offer wireless TTL control. This enables you to use them in a similar way to studio strobes, with one major benefit—the camera and flashes can set the correct exposure automatically.

Flash Sync

One of the greatest benefits flash photographers received from Harold Edgerton's invention is flash synchronization.

Before Edgerton's discovery (and subsequent inventions), flash was not synchronized to shutter speed. However, after his research, flash was synchronized to shutter combinations that allow us to photograph moving targets with our flashes and achieve sharp images. Beyond sharp images, creatively we are given a few options for effects when using flash on or off the camera. We can utilize different configurations for flash synchronization: front curtain, slow curtain, rear curtain, and high-speed synchronization. But before we go into any of these modes we need to review how a modern DSLR's shutter synchronization actually works in practice.

Modern DSLRs use what is called a focal plane shutter, which is a pair of shutters or curtains that operate in conjunction with one another to facilitate exposure. When you depress your shutter-release button, the first curtain opens and exposes the sensor; then the second curtain closes to end the exposure and you've captured an image. One of the simplest ways to explain it is to experience it first hand. Place both of your hands with your palms facing flat in front of your chest, then raise one hand over your face to the top of your head, as you just about pass your eyes, raise your second hand to the top of your head so both of your hands meet above your forehead. This is basically the operation of the shutters or curtains in the camera.

When you use a slow shutter speed, the sensor in your camera is exposed in its entirety to light. However, at faster shutter speeds, the second shutter curtain needs to close the gap faster, so only a small slit of light hits the sensor at any one time to create the exposure. This isn't a problem for regular photography, but as the duration of a burst of flash is very short (typically 1/3000 sec. or faster) it will only reach the sensor for part of the exposure. As

∧ IMAGE 1
This image was taken using a shutter speed of 1/250 sec., which is the flash sync speed of the camera. Notice how it is evenly exposed across the entire frame.

∧ IMAGE 2
The shutter speed was changed to 1/320 sec. which is ⅓-stop faster than the sync speed. The dark line at the right of the frame is the second shutter curtain closing.

∧ IMAGE 3
Having changed the shutter speed to 1/500 sec. (1-stop faster than the camera's sync speed), the black line creeps in even further to the image.

∧ IMAGE 4
When the shutter is set to 1/1000 sec. (2-stops faster than the sync speed) the shutter and flash are not synchronizing at all, resulting in a black frame.

< ZOOM
This image was shot using slow sync flash. During the exposure the zoom ring on the lens was turned to create a "zoom burst" effect. The sharpness in the image is entirely due to the flash freezing any movement at the point of firing.

shown at the bottom of page 222, this will result in part of the frame being exposed to the flash. Therefore, for flash photography, your camera has a maximum synchronization speed, which is the fastest shutter speed that exposes the sensor in its entirety. This shutter speed, sometimes called the X-sync speed, is usually 1/200–1/250 sec.

Slow Sync Flash

When the ambient light level is low, you may find that the camera's flash sync speed is too fast to allow the background to be exposed correctly. This will result in your subject being perfectly exposed, but the background

∧ **SECOND CURTAIN SYNC**
Second curtain sync allows the exposure to happen first. In this image, the flash didn't fire until the end of a long exposure, so the lens could be zoomed while the shutter was open, with the flash firing at the end to freeze the subject.

appearing dark and dingy. To remedy this, you simply need to set the correct shutter speed to expose the background. The flash part of the exposure will not change (the brief burst of flash will have exactly the same intensity, regardless of shutter speed), but your background will be exposed correctly. However, you do need to watch the shutter speed—if it becomes too slow you may start to get a "flash and blur" effect, where the flash part of the exposure "freezes" your subject, but camera movement is then recorded by the slow shutter speed. Of course, this can also be used intentionally.

First Curtain Sync

First (or front) curtain sync is when the flash fires at the beginning of the exposure. This is the default setting for your flash, whether it is pop-up, built-in, or an external hotshoe unit. When the flash fires, it freezes the motion and then the exposure happens after the initial burst of flash. So, if your exposure is 1/60 sec. at f/5.6, the flash fires immediately and then the rest of the shutter time (1/59 sec., for example) happens. In this mode, you are nearly always guaranteed a sharp image, as the immediate blast of light will stop the action and the rest of the shutter time exists to finish the exposure.

Second Curtain Sync

Second (or rear) curtain synchronization is when the flash fires at the end of the exposure, just before the shutter closes. You need to take creative control here and change your flash setting from first to second (rear)

< **SYNC SPEED**
This image was shot at the camera's maximum sync speed and its lowest ISO setting. This was done to underexpose the background and emphasize the subject.

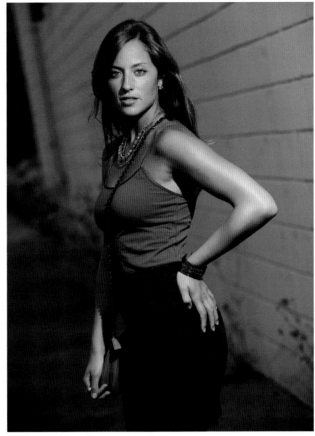

< < HIGH-SPEED SYNCHRONIZATION
On-camera high-speed sync is a great way to get fill flash where you need it. You'll need to activate it on your specific camera, but once set you'll be able to shoot in bright sunlight and add fill light on your subject successfully.

< AMBIENT EXPOSURE
Effective use of high-speed sync allows you to darken the background in bright ambient, or available, light. Simply place your bare-head flash close to the subject, set a shutter speed to underexpose for the prevailing conditions, and fire away, reviewing on your LCD screen as you go.

curtain sync (but remember to change it back). This type of flash photography allows the ambient light to be recorded by your exposure first, and then the flash fires at the end of the shutter time allotted. This technique is also commonly referred to as "slow sync flash" or "dragging the shutter."

In this instance, more light is let into the camera before the flash fires, so you have the ability to add dimension, depth, and ambient, or existing light to your images. This is especially true if you set a shutter speed of 1/30 sec. or lower. When you set a slower shutter speed, you are allowing the ambient light to reach the sensor for longer, so your final image will have brighter backgrounds. The flash then fires to expose for your main subject, which can create a "motion blur" effect with moving subjects.

High-Speed Sync

The normal sync speed of a flash can occasionally be limiting, and there are times when you may need (or want) to use a shutter speed that exceeds the flash sync speed. This is particularly true on bright days, when flash is useful as a fill-in light. Fortunately, a lot of digital SLR systems will allow you to use high-speed sync flash, providing you have a suitable, dedicated flash unit.

When a fast shutter speed is used (one that is higher than the sync speed), the flash would normally illuminate only the section of the sensor that is revealed by the shutter when it fires—the area hidden behind the shutter would be literally left in the dark. High-speed sync flash gets around this problem by pulsing the flash to simulate a continuous light source. The drawback is that the power of each flash is reduced to ensure that the flash is able to recycle quickly between flashes. This means that the effective distance of the flash is reduced, and the higher the shutter speed, the lower the distance becomes.

Fill Flash

When flash is used to supplement the ambient light, the technique is known as "fill flash." This effect can be useful for softening shadows and revealing detail.

Fill flash used to be a tricky technique to master, but TTL flash control has changed that forever. Now, it is simply a case of using enough flash to "fill" the darkest areas of your shot, without allowing it to flood the scene and become the dominant light source. This balance is achieved by adjusting the power output of your flash—most flashes should allow you to do this using either a camera menu or a control on the flash unit itself.

By simply using one control—Flash Exposure Compensation (FEC)—you can adjust the flash output for the desired result. FEC sounds like a complicated acronym holding inside of it a large and difficult series of changes to your flash, but in reality all it means is that you change the output of your flash to determine how much light you want on your subject. FEC gets overlooked by many photographers, especially beginners, due to the fact that most of us are not engineers and camera and flash manuals are not written with us in mind. They are also written as though you have a full understanding of your flash and they simply spell out the instructions on where the buttons are and how to push them.

As with regular exposure compensation (see page 150), positive flash exposure compensation will increase the flash output (making the flash brighter), while negative compensation will decrease the flash output (making the flash weaker). With fill flash, you will want to decrease the flash output, so as to make the light less obvious. The amount of adjustment you need to make will vary depending on the ambient light, but typically ½- to 1½-stops is a good starting point. TTL-controlled flashes generally cope with fill flash very effectively, and often require very little adjustment.

Flash Exposure Bracketing

Some flash units and cameras let you use flash exposure bracketing (FEB). As with exposure bracketing (see page 150), this enables you to shoot a sequence of shots with varying amounts of flash exposure compensation applied. The sequence is usually one standard exposure, one under, and one over, but this order can often be altered. If you are using a flash that does not offer this facility you can manually apply flash exposure compensation to a series of three shots to achieve similar results.

∨ **FILLING IN**
In the first shot (below left), the camera overexposed the background while trying to give good results on the flash-lit foreground. Setting the flash exposure compensation to -⅔-stop (below right) resulted in a more balanced exposure.

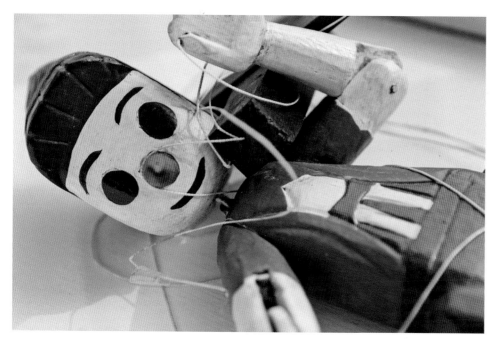

∧ OFF-CAMERA FILL

This mannequin was on a window ledge, backlit by strong sun. Off-camera TTL flash was used to lighten the shadow side of its body and reduce contrast.

∧ BALANCE

Fill flash is all about reducing the power output of your external flash so it removes shadows, but doesn't become the dominant light source.

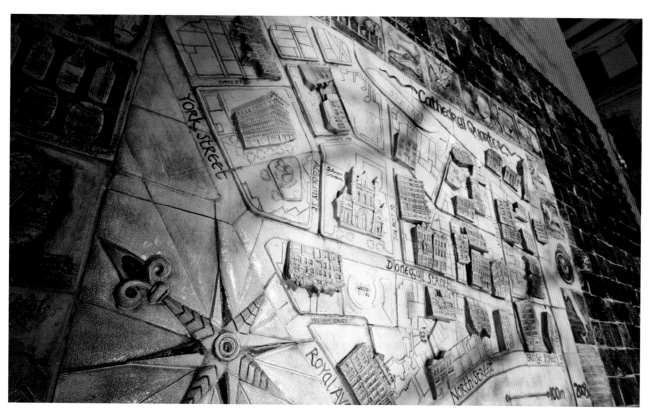

< LIFTING SHADOWS

Flash was used as a fill-in light for this image, softening some of the shadows cast across the sculpture by the side lighting.

Off-camera Flash

A flash doesn't necessarily need to be attached directly to the hotshoe of your camera. Moving your flash away from the camera is a good way of controlling how your subject is lit. For example, moving a flash to the left or right of the camera will change the flash from a frontal light source to a side light for greater interest.

< WIRELESS FLASH
Moving your flash away from the camera opens up a whole new creative world. This is the wireless flash set-up used for the shot on page 230.

The simplest way of getting your flash off-camera is to use an extension cord. These are available in different lengths and connect either to the hotshoe of your camera or to a PC connection socket.

An alternative option is wireless flash. There are two methods of shooting wirelessly, the first of which uses the camera's built-in flash to trigger a compatible off-camera flash unit. The drawback with this system is that there has to be line of sight between the two flashes for this to work correctly—if not, the off-camera flash simply will not fire.

The second method uses a radio transmitter to connect the camera to the flash. This method allows a greater working distance between camera and flash, but it does require the purchase of a much more expensive radio transmitter: third-party companies that make these include PocketWizard and Cactus.

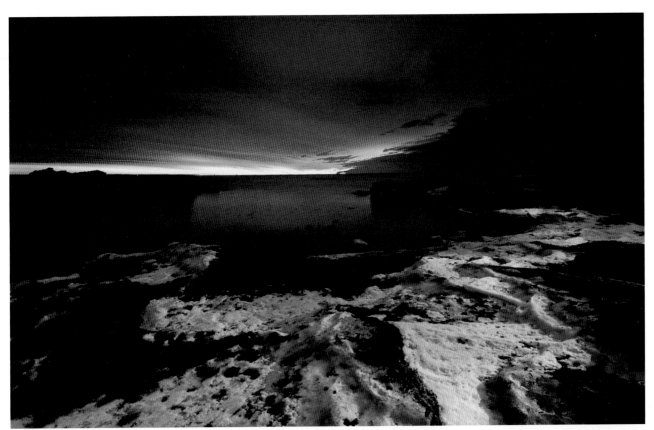

< WIDE-ANGLE LENS
A wide-angle lens was used to capture the foreground and background simultaneously, but the foreground was brightened using flash.

V SLOW SYNC FLASH
Flash can be used very creatively: for this outdoor image at dusk, slow sync flash was used off-camera.

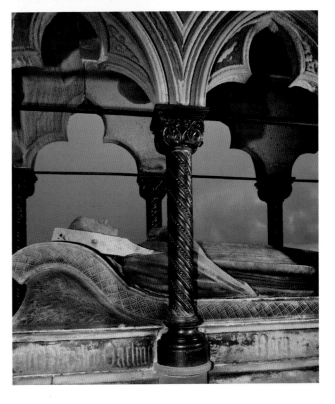

∧ SHADOWS
For this shot a 3ft (1m) long extension cord was used to move the flash to the left of the camera. This made the shadows behind the subject far more interesting.

∧ NATURAL ASSETS

As shown on page 228, off-camera flash was used to light the subject. At the same time, the sun in the background creates a high-key effect, with dappled light falling on her shoulders and hat. In this case, it is as if two lights have been used.

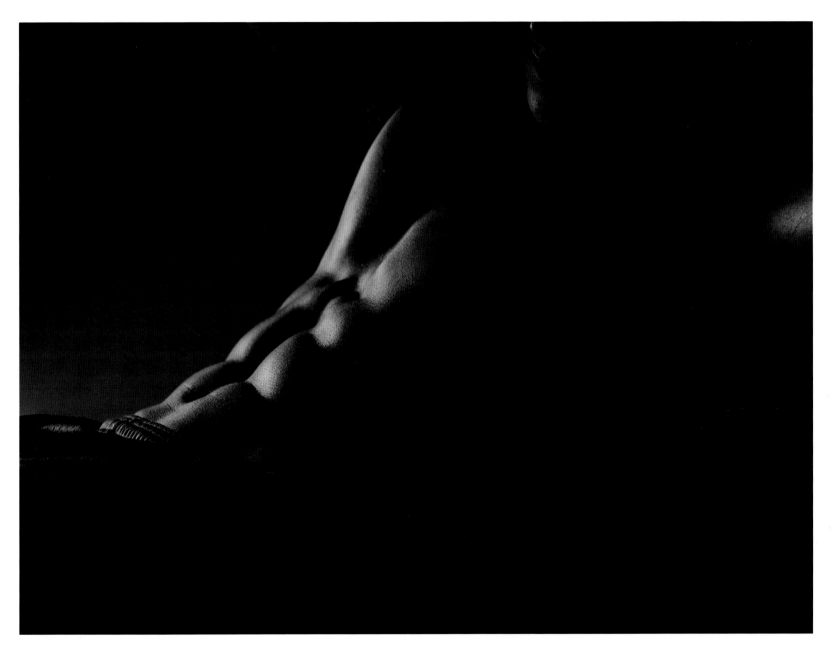

⋀ WELL TONED
For this shot, an off-camera flash was fitted with a softbox and the light was "skimmed" across the model's abdomen, creating a classic low-key look.

Modifying Flash

On its own, flash can be a hard, unflattering light source. However, it can be easily modified using a variety of techniques and accessories.

Bounce Flash

One of the biggest problems with the light from a built-in or on-camera flash is that it delivers hard, frontal lighting that isn't particularly sympathetic to your subject. If your flash has an adjustable head, a technique known as "bounce flash" can be used to soften the light. Angling the flash head up or to the side means the light is reflected from another surface back toward your subject. This has the effect of spreading the light, making it far softer. Softboxes and diffusers work in a similar way.

The easiest surface to bounce the light off is a ceiling, but this will obviously only work if you're shooting inside! If you are outside and your camera is mounted on a tripod, or you have an assistant, then a large sheet of card held above the flash is equally effective. What is important is that the surface that the flash is bounced off must be neutral in color, as the light will pick up any color and tint your subject accordingly.

The more powerful your flash, the more effective this technique is. This is because the surface you bounce the light from will absorb some of the flash and you are also increasing the distance the light has to travel before it reaches your subject: the higher the ceiling, the more light is needed to be effective.

Flash Diffusers

A diffuser works in a similar way to bounce flash, in that it spreads the light from a flash to soften it. This helps to reduce hard shadows and creates a far more pleasing, natural effect, especially for portraits.

Diffusers are available in a variety of different sizes, from very simple and small push-on devices to more elaborate and larger types that are taped to the flash head. The greater the frontal area of the diffuser, the softer the light will be. However, as with bouncing the light from your flash, a diffuser absorbs some light, so your flash will need to be proportionately more powerful in order to illuminate your subject.

Third-party manufacturers of flash diffusers include Sto-Fen and Lumiquest. A less effective (but undoubtedly cheaper), method of diffusing a flash is to tape thin, neutrally colored tissue paper over the flash head.

∧ **BOUNCE DIFFUSER**
A plastic bounce diffuser is a great tool to keep on your flash at all times. It will help to spread and throw light not only up, but also around you for soft bounce fill on your subject.

∧ **DIFFUSION PANEL**
The flip out diffusion panel is used to increase the spread of light when using wide-angle lenses to gain flash coverage over a broad area. However, they also work well to spread light across your image when using direct, diffused flash as a fill light.

< **SOFTENING LIGHT**
With the flash pointing forward, the result is a little harsh (far left), but pointing the flash upward and bouncing the light off a sheet of white card makes it far more acceptable (left).

Umbrellas

A convertible umbrella should be in every flash photographer's kit. The versatility of this simple and inexpensive modifier as main light, back light, edge, and rim light is outstanding. The umbrella is one of the best and simplest pieces of gear in the marketplace. You'll have to lose any suspicion surrounding opening an umbrella inside, though, as you'll be opening and closing them a lot! When you use the umbrella in the reflective style—the way it was first meant to be used—it gives a clean, soft light with a touch of cool contrast. You can modify the light by leaving the plastic diffuser on or off—leaving the diffuser off will add contrast, while leaving the diffuser on will add a touch of warmth to the image and soften the light just a touch more.

Shoot-through Umbrella

After shooting in the reflective style, remove the black cover and use it in the shoot-through style. The light from a shoot-through umbrella is typically a bit warmer and less contrasty than the reflective umbrella. This lighting is soft and the main point of light emitted from the flash can be aimed. A reflective umbrella throws and scatters light; a shoot-through umbrella does the same, but you can aim the central part of the light to the right or left or into a reflector so you are feathering the light to one side or another. Feathering the light allows you to direct the light and actually soften it by lighting the subject with the spill light from the umbrella and not the central core of light from the center of the light source.

∧ **FEATHERING LIGHT**
Softboxes allow you to fully control the spread of light. Feathering the light allows you to also control aperture and depth of field. Pointing the light source directly at the subject will offer more light (and more depth of field) as opposed to moving the softbox to light from its edge.

Softbox

A portable softbox is another tool that should be in the small flash photographer's kit bag. The Lastolite 24 x 24 Ezybox Hotshoe is designed with the small flash photographer in mind. It folds and stores in a nicely designed bag that accepts the mounting hardware as well. The softbox controls light spillage, which means that all of the light is concentrated out of the controlled box. Just like a shoot-through umbrella, you can control the light by directing the softbox to one side or the other, feathering the light for effect.

Snoots

A snoot (far right) closes down the light and directs hard beams of light where you aim them. The size and length of the snoot will affect the overall spread of light. A shorter snoot, say 6in. (15cm), will have a wider spread of light than a 12in. (30cm) snoot.

∧ **DEPTH OF FIELD**
Each flash modifier has its own properties. Some are softer or harder than others. The hardness of the light coming out of the modifier directly affects aperture and depth of field. In this photo, an aperture of f/16 was needed to get a good exposure as the light from the snoot is both hard and very bright.

Gels

The light from an electronic flash has a nominal color temperature of 5500K, which, like midday sunlight, is very neutral in color. This makes flash perfect as a fill-in light source during the day, but the light can appear overly cool when you are shooting at dusk. Skin tones can also benefit from being photographed under a slightly warm light. You could alter the white balance setting of course, but this can prove tricky when shooting in mixed lighting such as street lighting.

Fortunately the light from a flash can be modified very easily and cheaply using colored gels that tape over the flash head. It's possible to make your own using discarded candy wrappers, or to use professional gels made by accessory manufacturers such as Rosco or Lee Filters. The DIY approach is arguably more fun (you get to eat the candy first), but the manufactured route is more consistent.

Gels are readily available that will convert the color temperature of your flash so that it matches the output from other light sources such as tungsten lighting (requiring an 85 gel to change the color temperature of the flash from 5500K to 3200K). For a more theatrical look it can also be fun to use brightly colored gels such as red or green.

∧ THE ROGUE UNIVERSAL GEL KIT
These gels are precut to fit any flash head, and the kit comes with a thick elastic for easy and secure attachment. Each gel is marked with its color and corresponding light transmission rate, which tells you how much light it uses.

∧ FREEFALL
This mannequin was photographed in a darkened room. A red-filtered flash was fired from one side and a green-filtered flash from the other.

∧ GELS
Colored gels can be taped to the flash simply and quickly to change the color of the light.

∧ COLOR MANIPULATION
Place gels on your flashes to dramatically alter the look of your images. You can use gels for color enhancement or for color correction while shooting under mixed lighting conditions. This is the lighting set-up used for the image on page 236.

Notes

All gels will absorb some light from the flash: the more intense the gel's color, the greater the light loss.

Bouncing flash from a brightly colored surface will have a similar effect on the color of flash to using a gel.

< **GETTING CREATIVE**
For this shot, the white balance was set to Daylight with a lavender-colored gel on the front light and a red gel on the back light.

> SETTING THE MOOD

Gels don't have to be obvious. In this shot, the temperature of the light outside was dropping as it started to get dark. This meant it was not close to the approximate 3200K temperature of the artificial light in the room, or to the 5500K of flash. Rather than try and match everything, the on-camera flash was gelled so that it had a color temperature somewhere between the two ambient light sources. The result is that the flash mixes well with the interior lighting, while the background outside has been transformed into a deep blue.

Painting with Light

Not every photographic subject is conveniently floodlit, so sometimes you will have to provide your own light source. This can be in the form of a flash or even a handheld flashlight that is "painted" onto the scene.

It is worth noting that a camera flash and a flashlight have different color temperatures, with a flashlight being the warmer of the two. Which you use is partly down to esthetics and partly down to practicality: flash works well when you are photographing larger subjects, as it's difficult to direct the light, whereas a flashlight is great for photographing more intimate subjects as you can light areas of a subject very specifically.

Painting with Light: Flash

What you need: Tripod, flash unit (preferably two), fully charged batteries for camera and flash, remote release.

1. Arrive at your chosen location before dusk and select your composition. Your subject should be sufficiently close so that you can find your way between your camera and the subject quickly, but safely, once the shutter on your camera has been fired.

2. Attach the remote release to your camera and focus on the subject. If you use AF to do this, switch the lens to MF once focus has been achieved so that it doesn't shift.

3. Set your camera to Bulb and the aperture to f/11. The ISO doesn't need to be high—the base ISO of your camera should be sufficient.

4. Wait until the ambient light levels are sufficiently low that the required shutter speed is around 2 minutes. Depending on whether you are facing east or west this is usually 30–40 minutes after sunset.

5. Lock the shutter open and walk quickly over to your subject, taking your flash(es) with you. Fire the flash using the test button, aiming it toward the subject. However, don't fire the flash when you are between it and the camera, as you'll be recorded as a silhouette!

6. Move around your subject, trying to "paint" evenly with your flash. If you have two flashes, alternate between them as this will give one time to recharge while you fire the other, allowing you to work more quickly.

7. Once you feel that 2–3 minutes is up, return to your camera and end the exposure. Review the image and check the histogram to see if the exposure looks good.

Painting with Light: Flashlight

What you need: Tripod, flashlight, fully charged batteries for both camera and flashlight, remote release.

1. Follow steps 1–2 for Painting with Light: Flash, as described previously.

2. Once the ambient light levels are low, but there is still color in the sky, switch on your flashlight and shine the light on your subject. To determine the correct exposure, use your camera's spot metering facility to meter from the lit area.

3. Set the exposure, fire the shutter, and begin to move the light from your flashlight smoothly around your subject. You can stand next to the camera to do this,

Notes

The number of flashes needed will depend on the size of your subject. 30–60 flashes wouldn't be excessive for a small building, so be prepared!

When painting with light using a flashlight, set your camera to Manual so the exposure won't change with the ambient light level. It is a good idea to shoot a number of frames so that you can choose later which image has the most pleasing balance between the ambient light and the flashlight.

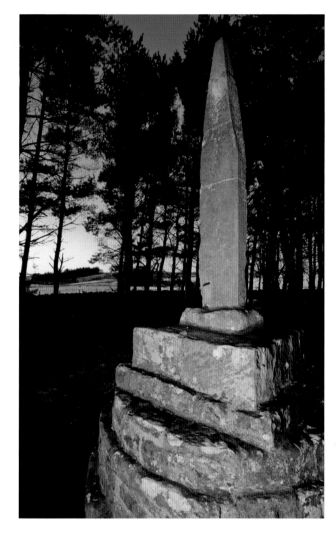

∧ CLOSE TO

The closer you are to your subject, the less powerful your flashlight needs to be. This exposure was achieved with a small flashlight, as both it and the camera were only a few feet from the subject.

< SMALL BRUSH STROKES

A flashlight can be used to pick out small details in your subject.

∨ LARGE BRUSH STROKES

A flashlight can be used to "paint" large areas of your image with broader strokes.

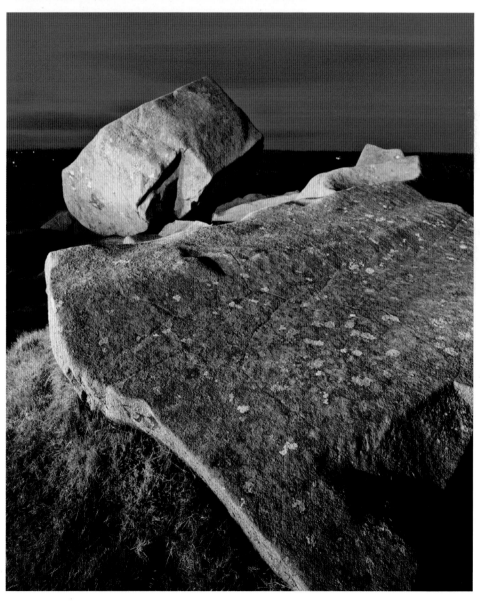

but this will light your subject from the front. For a more interesting lighting effect try moving away to either side of your camera and "painting" your subject at an angle relative to the camera.

4. Once the exposure is complete, review the image and check the histogram to see if the exposure looks good.

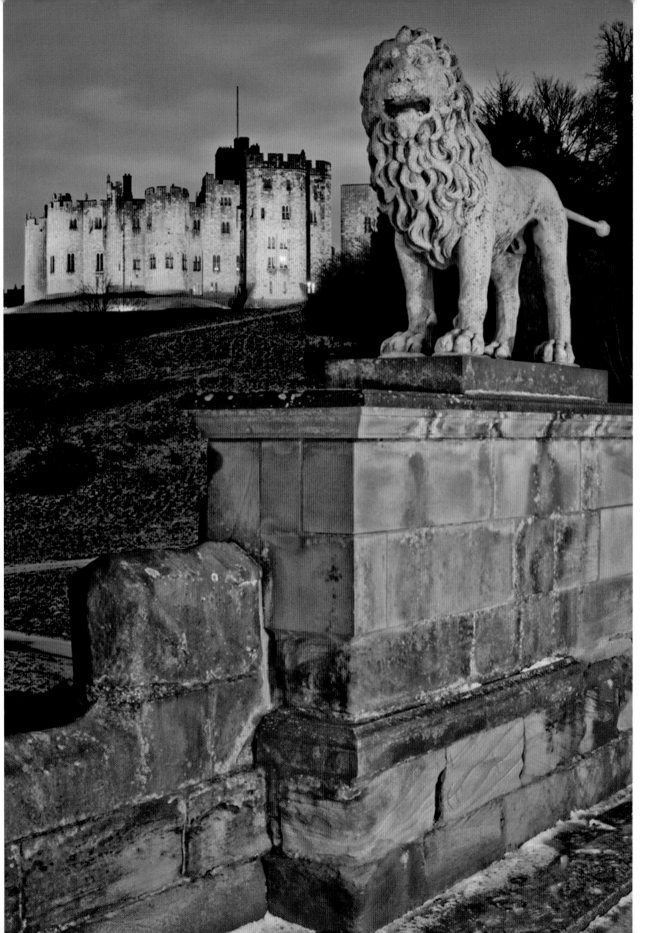

< FLASHDANCE
This decorative bridge was completely unlit, so flash was used off-camera to illuminate it. Because the wall and lion were close to the camera it only required 20 flashes to illuminate it evenly.

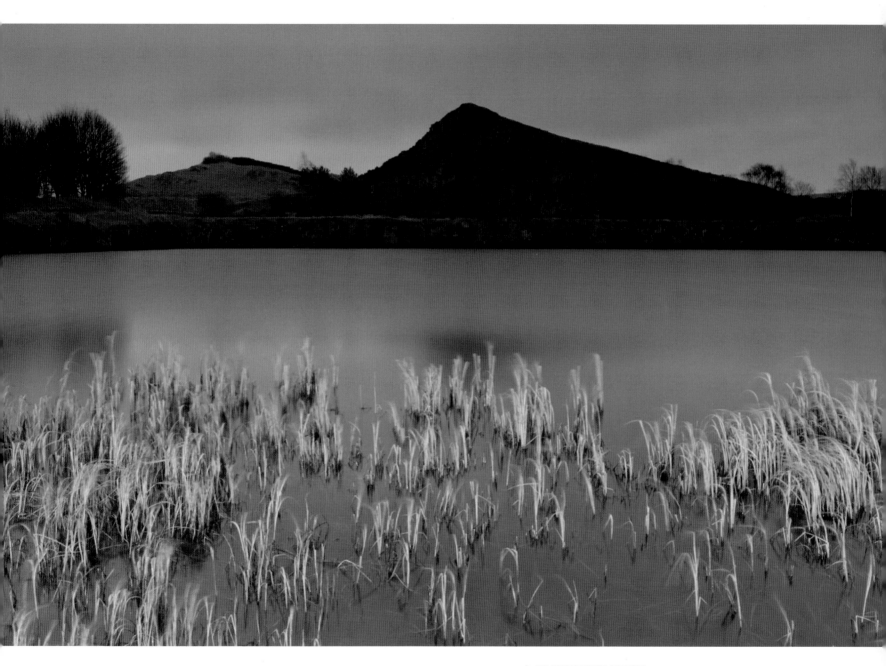

∧ FLASHLIGHT TRICK

This image was shot approximately 30 minutes after sunset, so there was still color in the sky. The white balance was set to Daylight so that the blueness of the ambient light was maintained, and a flashlight was used to illuminate the reeds in the foreground. This appeared warmer, creating an appealing color contrast.

CHAPTER 7
COMPOSITION

Introduction to Composition

Camera technology improves each year. However, despite increasing automation, one thing cameras can't do is compose an esthetically pleasing image—this is still very much dependent on the photographer holding the camera.

Composition is the act of creating something new from other pre-existing materials or elements. Composition can be applied to many different creative endeavors. Music is the most obvious, and is composed by arranging a series of notes in a pleasing or interesting way (what constitutes a pleasing piece of music is, of course, entirely subjective). Prose is also composed by choosing words and ordering them into coherent and (hopefully) lively sentences.

Photographs are also said to be composed. This is often thought of purely in terms of how the various elements in a scene are arranged, and for good reason, as this is indeed an important part of composing a photograph. However, the success (or otherwise) of a photograph is due to many other factors as well.

The composition of an image can be broken down into a number of steps. Mentally running through these steps before pressing the shutter-release button is a habit that will help save disappointment later.

Step 1: What should be in the image?
An image is an abstraction of reality. We don't see the world in a rectangular frame. Composing an image is an act of imposing order on the world, to fit it within the confines of the image space. The first step is therefore to choose what should fit within the boundaries of the image. Typically this will be the subject of the image, either filling the frame or shown in the context of its environment. The subject of an image can be as real as a person or a building, or as conceptual as a particular mood or abstract idea.

Step 2: What shouldn't be in the image?
Oddly enough, just as important as deciding what should be in an image is the decision about what shouldn't. This means being ruthless. Anything—whether it's a person or an inanimate object—that doesn't add to an image should be excluded. Something that appears to be an afterthought or is there purely by accident will detract from the main intent of your image.

A pleasing image will work because it is a considered whole, with no elements to jar or distract (although there is nothing to stop you including elements that do jar or distract, just as long as that's your intention).

There are several strategies for excluding elements. The main one is choosing the viewpoint. Often, shifting the camera's position slightly will make a big

∧ POSITION
This image is arguably a failure. There's no space around the aircraft and the composition feels too tight and restricted. There's nowhere for the eye to roam around.

∨ EXCLUDED
This statue was in the middle of a cluttered and visually distracting urban environment. A low viewpoint cut out the clutter and helped simplify the image.

< **BALANCE**
Composition in photography is often about balance: the balance of light and dark; textured and smooth; warm and cool.

∨ **TIMING**
Photography—like music—often requires exquisite timing.

difference. The simplest way to change a viewpoint is to move the camera left or right.

However, you should always consider making a vertical movement too. Finding a viewpoint above your subject so that you look down on it is a very effective way of simplifying your subject's surroundings. Looking up at your subject will have the same effect—particularly if this allows you to shoot it against a less distracting background, such as the sky. The lens you choose will also have a bearing on how well you are able to exclude distracting elements. Longer focal length lenses are generally easier in this regard. Wide-angle lenses often include too much. Arguably more care must be taken when composing with a wide-angle lens than with a telephoto.

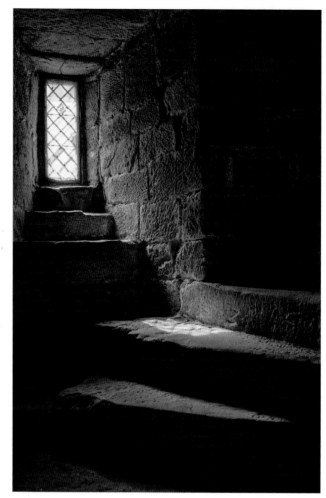

< < FAMILIARITY
If you frequently use a 35mm prime lens you will eventually be able to "see" shots that suit that focal length more easily than other focal lengths.

< HANDHELD
This photograph—although just a handheld "snapshot"—still required thought about which lens focal length to select, which combination of shutter speed, aperture, and ISO to use, and which white balance setting was required.

Step 3: Where should my subject be in the image frame?
Where you place the subject in the image determines a number of factors. One of these factors is image balance. Another is the dynamic qualities of the image: does it feel static or energetic? We'll return to these factors later.

Step 4: How will a viewer's gaze wander through the image?
When we look at an image our eyes don't keep still. They're attracted to certain elements such as vibrant colors and areas of contrast. Strongly directional elements such as lines (real or implied) help to guide a viewer's gaze through an image, while elements that dissect an image can interrupt the flow of a viewer's gaze.

A viewer's gaze ideally should remain within the image. Elements that direct the gaze out of the image will be distracting and make it feel somehow incomplete. Bright highlights act like visual magnets. This is acceptable if they're part of the subject, but less so if they're in the background and prove distracting.

Step 5: Am I holding my camera in the right orientation?
A vertical image has a different dynamic to a horizontal one. Deciding to shoot horizontally or vertically is an important esthetic choice. Unfortunately, most cameras tend to sit more easily in the hand when held horizontally than vertically. However, you shouldn't allow this to be a deterrent.

∧ VISUALIZED

One of the key skills it's necessary to learn is visualizing how you want the final photograph to look before you press the shutter-release button. This involves experimentation and practice so that you understand what your camera equipment is capable of.

Step 6: Is this the right time to make the picture?

Some images are very time-dependent: your subject may be moving and will only be in the right place for a split second; the sun may be in the wrong position; or there may be any number of other reasons. Therefore you need to think about whether this is the right moment to make an image or whether it would be improved by waiting.

Step 7: Is this the right light for my subject?

There is no such thing as good light, only light that is right for your subject. The light you use determines a number of different factors that could enhance or detract from your subject. The direction of the light will have an effect on where the shadows are in relation to your subject. This will also have an effect on how three-dimensional your subject will look in the image. The softness or hardness of the light affects the density and sharpness of the shadows. Finally, the color of the light has a big impact on the emotional impact of your image.

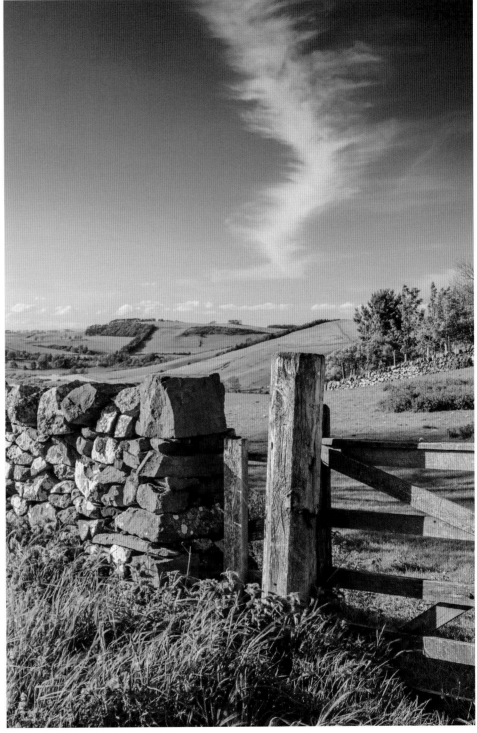

∧ CHANCE

Although previsualization is a useful skill to learn, it's still important to allow chance to play a part. This image was found coming around a corner on a walk. There wasn't time to plan as the unusual cloud was quickly dissipating.

Viewfinders

Successful composition involves looking critically at the entire viewfinder or LCD before you press the shutter-release button.

A successful image is one that's a pleasing whole. The first time this is assessed is when you look at your camera's viewfinder or LCD. When first starting out in photography many people look only at the center of the viewfinder and forget (or don't realize) that there's more to an image than this. Assessing whether a composition has worked means looking not just at the center, but around the edges too—in fact, particularly around the edges. It's all too easy for something unwelcome to creep into the image space without your realizing.

Optical Viewfinders

An optical viewfinder (OVF) is one that shows you a direct view of your scene, like looking through a small window. This is the type of viewfinder found on DSLRs, as well as some compact cameras.

The major drawback of an optical viewfinder is that few of them show the entire image the sensor will record. There are cameras that show a 100% view in an optical viewfinder, but these tend to be at the "professional" end of a manufacturer's camera range. More common are OVFs that show a 95–98% view.

Fortunately, losing 2–5% of the actual view isn't too much of a problem and there are workarounds. One solution—if you have a zoom lens—is to compose and then, ever so slightly, zoom in. Another solution is to crop the image in postproduction to the view that you saw originally. Alternatively, you could make a final check by switching to "live view," which will usually show you a 100% view.

Electronic Viewfinders

An electronic viewfinder, or EVF, can relate to one of two things—the "live view" image on a camera's rear LCD screen or an eye-level viewfinder that uses a small

LCD screen rather than an optical viewing system. While these systems typically show you 100% of what will be recorded by the sensor, they are not without their problems. Many EVF displays are cluttered with icons and shooting information by default. This will obscure important details that can be overlooked. Some of this information is useful before you make your image, but when you are composing a shot, it should be switched off so that you see the image unimpeded.

The LCD screen on the back of a camera can also be difficult to see in bright light. Before making a composition decision you should try to shade the LCD as best you can (particularly if the LCD is the only method you have of composing an image). There are commercial shades for LCDs that are effective in reducing glare on the screen. However, it's easy enough to make your own out of stiff card. All you

∨ CROPPED
You'd see the image inside the white box when looking through an optical viewfinder that showed 95% of a scene. However, the camera would shoot everything outside the box as well.

<< LEVEL
When you are photographing water that stretches to the horizon, it is important that the horizon is level (water never slopes!). Your camera's "live view" mode will often allow you to overlay a grid that can help with this.

have to do is make an open-ended box, with the base slightly larger than the size of your camera's LCD. Alternatively, a black cloth draped over your camera will work just as well, which you would then duck under. Rather fittingly, this resembles the hood of a view camera, the glass focusing screen of which needs shading for similar reasons.

One excellent feature that is generally available when using an EVF is a grid overlay. The most common grid type is one that dissects the screen with two sets of equally-spaced horizontal and vertical lines. This is helpful when composing using the "Rule of Thirds" (see page 254). Grids are also useful for checking that horizontal or vertical lines within the image are straight. One example when this is invaluable is when shooting bodies of water. A visual check that the horizon is level at the time of shooting will save precious time in postproduction.

<< CLUTTERED
With every possible icon switched visible, an EVF can quickly become cluttered.

Viewpoint

Simply put, the viewpoint is the view you see through your camera's lens when you compose a shot.

<MOSS GARDEN
Photographing this moss from a low angle gives a "worm's eye" view that few of us are familiar with. As a result, the subject has an "otherworldly" feel to it, which will automatically engage the viewer for longer.

Your viewpoint is affected by the distance and angle between you and your subject. The two are intertwined—the further back you are from your subject, the shallower the angle. Close to, the angle will be steeper, particularly if the subject is smaller or larger than you.

It's probably fair to say that most photographs are shot at the photographer's eye level. And why not? It's a viewpoint that we're used to. However, it's not particularly creative. Digital cameras—especially those with fold-out LCD screens—have made it far easier to compose photographs from below or above eye level. The height that you shoot from should be a height that

produces the most sympathetic or interesting view of your subject. Looking down to shoot something shorter than you (a child or animal, for instance) or looking up to shoot something taller than you, will produce an odd and unflattering perspective of your subject. This will be exacerbated by the use of a wide-angle lens, particularly if you're virtually on top of your subject. Getting down or up to your subject's level will produce far more natural-looking and intimate images. That's not to say that being higher than your subject is necessarily a bad thing. Looking down from a greater height will produce a more emotionally remote, abstracted image of your subject.

∧ **HEIGHT**
Shooting at the same level as
your subject will give a natural,
more flattering result.

< **ABOVE**
By gaining sufficient height
(such as in a hot-air balloon
to shoot this image) you
immediately make your image
more abstract. Fine detail is
lost, but it is replaced by a
greater emphasis on shape,
line, and color.

Orientation

When you compose an image there are a few basic decisions you need to make, starting with which way you hold your camera.

< **BROAD EXPANSE**
Shooting horizontally emphasizes a subject's breadth. In this shot there's a real sense that the pictured geographical feature continues to both the left and the right outside the picture space.

At its most basic, a photographic image is a four-sided rectangle (at the point of capture—you could, of course, reshape the image in postproduction). Unless you're shooting with a camera that uses a square format, the rectangle can be oriented either vertically or horizontally. There is no right or wrong orientation for a camera. How you hold your camera depends on the subject that you're shooting.

Horizontal
Arguably the subject that is most associated with the horizontal image is landscape. This is understandable, as we tend to look at views from side to side, and rarely up or down (as we'd end up looking at our feet and then into the sky). The word horizon is closely related to horizontal, strengthening the association.

Horizontal images appear more stable than vertical images (they have a broader base and an apparent lower center of gravity). This makes them less dynamic. A diagonal line that runs from corner to corner will never be as steep as a similarly-placed diagonal line in a vertical image. Vertical lines in an image will never be as long as horizontal lines, unless they leave the image space (in which case their length can only be implied).

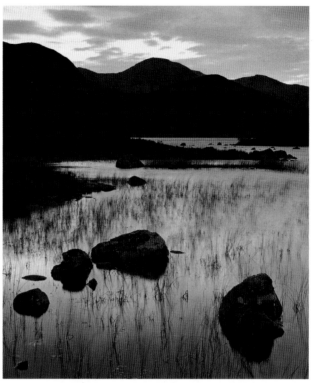

Portraiture isn't usually associated with the horizontal format. People are taller than they are broad. A person shot full-length in a horizontal image will be relatively small within the picture space. However, shooting horizontally is a good way to place a person in context, to show something of the life that person leads.

Placing a vertical subject within the image space can prove problematic. Placing the subject centrally has a tendency to cut the image in two. This works if the aim is to produce a symmetrical arrangement, but can look odd when the image balance is wrong (see the relevant sections about symmetry and image balance later in this chapter). Placing a subject left or right of the center is often a better option, though thought must be given to how the larger of the two spaces is used.

Vertical

Framing a shot vertically will emphasize height and depth over breadth. Tall buildings will appear taller and more imposing (particularly as you may have to move further back from the building when shooting horizontally, thus making it appear smaller).

The vertical format is ideal for head-and-shoulder portrait shots, allowing the face to dominate the frame. It's a powerful statement, particularly if the subject is looking directly at the camera. However, it's arguably not subtle and leaves little room for interpretation by the person looking at the final image.

< **ORIENTATION PREFERENCE**
The orientation of your camera is an important consideration when composing a shot. Does the orientation of these shots give them a different feel?

< **HEAD HEIGHT**
Head-and-shoulder portraits work well in a vertical orientation—particularly if you don't want to include any other elements in the image apart from the subject.

"Rules" of Composition

There is a number of classic compositional "rules" that are a good starting point when learning about composition. However, they are only a guide, so should not necessarily be followed slavishly.

You'd expect that these compositional rules should be followed. In fact, it's better to think of them as guidelines rather than rules—useful in that they work and are a good way of learning the basics of composition, but definitely guidelines. Being creative means bending or even breaking rules. You'll find your photography will soon look forced and repetitive if you stick to the rules too rigidly.

Rule of Thirds

This rule is the most commonly described and practiced. It's a simple rule. It requires you to mentally divide the viewfinder (or LCD) with two horizontal and two vertical lines spaced equally (dividing the image space into thirds). In fact many digital cameras have an option for overlaying a grid on the LCD or in the viewfinder, spaced in just such a way to make it easier to apply the rule. The idea is that horizontal or vertical lines in the image space should be aligned with one (or more) of these imaginary horizontal or vertical lines. A good example of when this rule could be applied is when shooting landscapes.

The horizon could be placed either on the upper horizontal line (making the foreground more dominant) or on the lower horizontal line (making the sky more dominant). The rule works in the sense that placing the main subject centrally will often produce a static-looking image that lacks energy.

However, the rule also suggests that placing important lines or the image's subject closer to the edge of the frame should be avoided. This is as untrue an idea as that of not placing your subject at the center.

A further refinement to this rule is that the most effective place to situate the focal point or subject of an image is on one of the intersections of the horizontal and vertical lines.

< PLACEMENT
The stone barn was deliberately placed on an intersection of thirds lines at the right. The composition wouldn't be as effective if the barn was placed more centrally or even on an intersection at the left side.

∧ HORIZON

Positioning the horizon in a landscape image on the upper (or lower) horizontal thirds line is a classic use of the rule of thirds. It allows greater emphasis to be attached to the foreground or sky, depending on which area is most important and interesting.

∧ FOR THE SAKE OF ART

Composing a photo is an art not a science. If the occasion warrants it, there's nothing wrong with bending, or even breaking the rules. Placing the tree in the corner of this image seemed the right way to compose this shot to make the most of the swirls of cloud pointing toward it.

∧ BREAKING THE RULES

This image "breaks" the classic compositional rules by placing both the main subject and the horizon line centrally.

Golden Ratio

This rule is also referred to as the "golden section." The rule of thirds was first put forward in the 1790s, making it a relatively recently defined compositional rule. In contrast, the golden ratio is ancient. There is evidence to suggest that the concept is over 2400 years old.

The essential idea of the golden ratio is that a line divided in two in such a way that the length of the longest part (a) when divided by the length of the shorter part (b) will produce a figure that is equal to the original line length divided by the longest part (expressed mathematically this is a + b is to a as a is to b). The figure produced is 1.618 and is referred to using the Greek letter Phi.

Photographs aren't one-dimensional of course. To apply the idea to a two-dimensional image you start with a rectangular image with an aspect ratio of 1:1.618. By drawing a square at one end of the image, another rectangle within the image with the same proportions is formed. Continue to repeat this pattern within each new rectangle and you will have divided the image according to the rules of the golden ratio.

As with the rule of thirds, placing important elements in the image on the lines and intersections formed by the squares and rectangles will create a pleasing composition. Dividing an image this way is known as creating the "golden rectangle."

A further variation of the golden rectangle is known as the "golden spiral." By drawing a quarter circle in each square, a spiral is formed.

> **VISUALIZED**
The golden rectangle and spiral are comparatively hard to visualize when composing a shot. It's easier to crop an image later using the rule. Photoshop allows you to display the golden spiral when using the Crop tool.

Golden Triangle

The "golden triangle" is a way of dividing the image space up using a number of triangles of different sizes, but with exactly the same shape (the triangles being equiangular). The largest triangle is formed by dividing the image diagonally from one corner to the other. To follow the rule, place visually important elements in the image within the different triangles.

The rule works particularly well if you have strong diagonals in the image that follow the line of the triangles. Placing a single element on an intersection point of the triangles arguably feels more dynamic than using an intersection point and the rule of thirds.

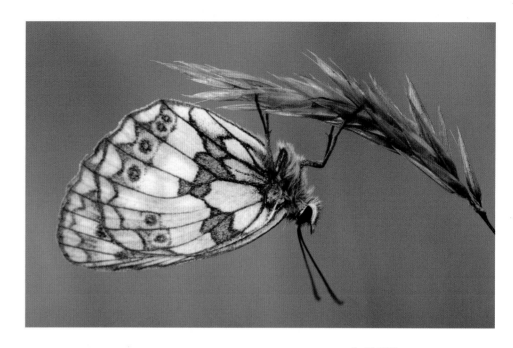

∧ FLOW
Here, the golden spiral operates from right to left, following the curve of the plant and then flowing into the curve of the butterfly's wing.

< GOLDEN TRIANGLE
This image has been divided into three triangles. These keep the castle, lower illuminated building, and background church spire separate.

Rule of Odds

The rule of odds is a very simple rule: an odd number of elements in a scene is esthetically preferable to an even number. This is because with an odd number of elements there is always one that is central, framed by the others. An even number of elements is less conclusive and is more likely to produce an image that is symmetrical.

However, the rule only works when the number of elements in the frame is easily recognized and counted—3 and 5 work particularly well. If you were photographing a forest from a distance, the difference between 103 trees and 104 trees would be irrelevant.

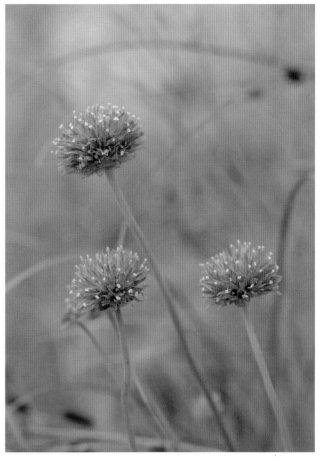

∧ > ∧ **RULE OF ODDS**
Including an odd number of objects within your composition means the central object(s) are naturally framed. Generally, the results tend to be stronger than if there is an even number. This rule can be applied to any subject, big or small, and regardless of focal length.

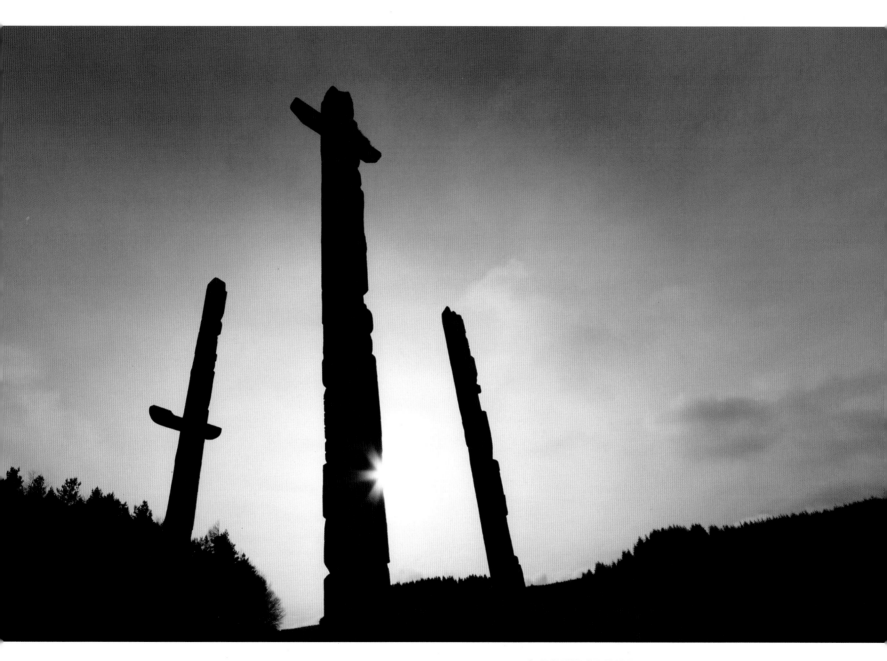

∧ POWER OF THREE

There's something very satisfying about the number three. It's an odd number, but three objects keeps compositions simple and avoids cluttering the image space. It's also easier to compose your shots, as there are only two decisions to make: where to place the central object relative to the outer two and where to place all three within the frame. The greater the number of objects, the more difficult these decisions become.

Rule of Space

If your subject is a person or group of people (or even animals) you naturally tend to look at them first and then to where they are looking within the image space (unless they are looking directly at the camera, of course). The "rule of space" is based on the idea that space should be left in the image for the subject to look into. This is quite a subtle rule as you use it to imply something about the subject, for example, that they're deep in thought or that they're looking at something either inside or outside the image space (leaving it up to the viewer's imagination to decide what this is).

A variation of this rule applies to subjects that are moving. Again it's arguably preferable for there to be more space in the direction in which the subject is moving (the active space) than behind the subject (the dead space). Leaving a space in front implies intent or the sense that there's a journey to be made across the image space. That said, leaving more space behind the subject can be very effective in implying the end of a journey and to show where the subject has come from (or in the case of a jet aircraft contrail, say, what's been left behind).

∧ **GAZE**
The rule of space can imply a world beyond the frame of the photograph, and start to suggest a narrative. It is up to the viewer to determine what or who this woman is looking at, for example.

∧ **LOOKING**
The puffin is looking out into empty space, implying that it may soon take off on another food-gathering flight. Try covering up the left half of the image to see how awkward the composition feels without the space.

∧ **SUBJECT**
It isn't just living subjects that can benefit from the rule of space. This wind-blown tree's bent form suggests movement, so space has been included at the left of the frame to account for this.

∧ WHITE SPACE

The very simplest images are those that consist of just the subject against a plain background. Using a white background for this shot meant the darker details of the fly were clearly defined (particularly the legs and the delicate hairs). However, it was equally important to leave some space at the left to balance the image.

Balance

Balance is a cornerstone of composition—without it, an image can lose its harmony.

< **REFLECTION**
A mirror reflection will always appear balanced, as each half of the image is almost identical. The risk with this type of composition is that it can appear somewhat static.

The idea of visual balance is simple: if your image was on a pivot, would it tip because it was visually heavy on one side, or would it remain perfectly balanced? Symmetrical images are good examples of balance at work. However, by their nature, symmetrical images can look static, and create the impression that there are two separate halves to the image. Asymmetrical balance, although more difficult to achieve, is preferable as it looks less contrived.

A simple definition of a symmetrical composition is one in which one half of the image is a mirror or is similar in some way to the other half, so that if you were to fold the image in half, the two halves would match. Reflections in still water are a good example of symmetry because the water is an almost exact mirror of the subject it's reflecting. Other types of symmetry are more complex. As well as "mirror" symmetry there is "radial" symmetry, in which the symmetry radiates out from a point. A good example of this type of symmetry is the petals of a flower.

Symmetrical compositions are inherently restful, but there is little tension involved and no visual puzzle to be "solved." However, more negatively, symmetrical compositions can seem dull and lacking in dynamism. Another danger of repeatedly using symmetrical compositions is that they can begin to look contrived.

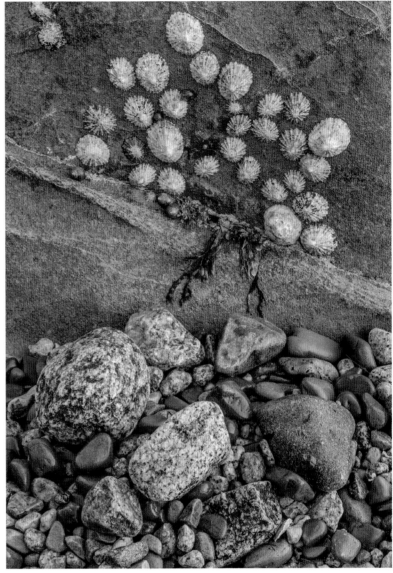

A more subtle type of symmetry is one that involves a resemblance of shape or color in the two halves of an image. Although this may not produce a perfect mirror, this type of symmetry requires more decoding by a viewer and is thus more likely to retain interest.

One powerful way to use symmetries is to deliberately add an element that breaks the symmetry somehow. This is a good way to draw the eye to this element as it will add a note of dissonance to the image. The key is to decide where to place this element. Placing it on the "fold line" will be less powerful than placing it above or below.

∧ SYMMETRY

Images that are symmetrically balanced can lack dynamism and appear static. This image is perfectly balanced, with the centerline of the building running exactly down the center of the image. However, it's more of a record shot, rather than a photograph that's visually interesting.

∧ SUBTLE

A subtle symmetry is created when elements that resemble each other in shape or color are used. In this shot, the shape formed by the lower pebbles is roughly the same as the cluster of limpets.

⋀ MIRROR-LIKE

Symmetrical compositions by their very nature feel balanced. This can lead to calm, but relatively uninteresting images. One way to add tension to a symmetrical image is to include an element that breaks the symmetry. In this image, the inclusion of the boats adds visual interest to the otherwise balanced composition.

> CALM

The combination of a symmetrical composition, long exposure, and conversion to black and white has "calmed" this image, creating a balanced, reflective mood.

Visual Weight

When we look at an image we tend to home in on the part of that image that most interests us. A subject that draws the eye in this way is said to have "visual weight."

< **ACTIVITY**
Include a person in a landscape shot and what the person is doing will be of more interest than the landscape itself. Note that this image also employs the "rule of space."

There is one subject that has a tremendous visual weight: people. Place a person in an image and invariably everything else in the image is demoted to second place. This is as true of landscape images as it is of conventional portraiture. A lone figure in a landscape (as long as they are recognizable as such) will draw the eye directly to it. Interestingly, the human face has greater visual weight than the rest of the body. This is mainly due to the fact that we are social creatures and look at people's faces to try to judge what a person is thinking and what their mood or intention is.

Certain colors also have a strong visual weight. Red has a greater visual weight than blue or green and all three are heavier than yellow. Darker, more saturated colors also have more visual weight than light, less saturated colors (though pure white has a much higher visual weight than pure black).

Other factors that affect visual weight are: shape (objects that have regular shape are "heavier" than irregularly shaped objects), texture (detailed objects or those with a complex texture are "heavier" than smoother objects), and position in the image space (visual weight

∨ **PEOPLE**
∨ **PEOPLE**
Even if they are relatively small in the frame, a person in an image will be the main focus of attention. Cover up the figure in this photograph to see the difference it makes to how you perceive it.

∧ **COLOR**
Certain colors have a greater visual weight than others. Red, for example, is particularly "heavy," which is why it is used for warning signs. However, note how the figure at the top right corner still manages to draw the eye, despite its position and size in the frame.

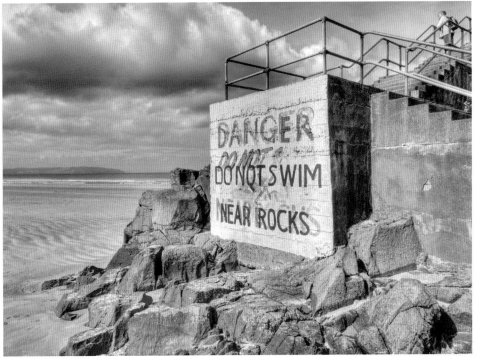

increases the farther an object is from the center of the image—objects right of center appear heavier than identical objects left of center, and an object in the top half of an image appears heavier than an identical object in the bottom half). Diagonal lines also have more visual weight than both horizontal and vertical lines. Finally, text and recognizable symbols are particularly visually heavy.

When composing an image you need to think about visual weight. Something that is "heavy" visually will dominate the image. If this isn't your subject you may find that your subject is ignored or is seen as less important.

Lines

Lines can help us to direct the viewer around the picture frame, suggesting which areas of an image are more important, and proposing how we should feel about those areas once we arrive there.

There are three basic angles of line in an image: horizontal, vertical, and diagonal. Although often visual, these lines don't have to physically exist—they can also be implied through the way elements in the image are aligned, or the direction someone is looking in.

A leading line is one that leads the eye to the main subject of an image. Good examples of elements that can be used as leading lines are paths, roads, plow furrows in a field, and geological strata. Typically, leading lines begin in the foreground of an image and lead the eye upward. However, there is no reason to stick with this formula rigidly. If you can find them, leading lines starting at the top of the image space and leading downward can be just as effective.

The one danger with lines is that if used carelessly they can lead the eye out of the image space. It pays to be aware of any potential lines in an image that may do this accidentally and keep them out of the composition.

Horizontal Lines

More often than not, landscape photographs include a natural straight line: the horizon. When we see a horizon we feel calm and grounded. Even though the horizon may not feature in a photograph, the frame can often still be divided into two unequal parts, instructing the viewer where to look first and how much importance to attribute to each area. By creating a "fake" horizon you are providing the viewer with a comfortable, familiar "landscape," while encouraging the same sensations experienced when faced with the real thing.

A word of warning, though: horizontal lines can also act like barriers, preventing the viewer's eye from wandering around an image.

Vertical Lines

We often associate vertical lines with growth and strength—trees and flowers rise from the ground with tall, straight stems, and buildings also rise upward. When used in a photograph, these lines tend to direct the eye up through the frame at some speed, so it's important to include another element to help guide the attention back down into the frame.

Alternatively, the line can be interrupted by an object, highlighting its importance in the composition, and preventing the eye from racing out of the top of the frame. Vertical (and horizontal) lines can also be used to link elements of the composition together—these lines often take the form of edges between shapes or colors.

Diagonal Lines

Of the three types of line, diagonal lines are the most dynamic and have the greatest amount of energy. These are the lines that draw the eye rapidly, so need to be used with care—if the visual journey doesn't end at a point of interest, the viewer's eye may simply continue traveling out of the frame.

∧ USING VERTICAL LINES
Vertical lines direct the viewer's eye up and out of a photograph. To prevent this from happening, you can interrupt the line with an object.

< FORCE
Lines can add energy to an image. Here the lines of the cloud help to convey motion, reinforcing the struggle of the figure. A clear blue sky would not have been as effective.

< DIAGONAL
Diagonal lines move the eye most quickly through an image. However, without a point of interest at the end of the journey, the eye may simply move out of shot.

∧ LEADING LINES

The jetty provides the viewer with an obvious "path" into the image. Leading lines generally need to take us somewhere, which in this instance is the boats in the middle distance.

∧ JOURNEY
The journey through this image starts with the large hay bale at the left of the shot—this is our "entry point" into the picture. From there, the lines in the field take our eye through the photograph.

Curves

As with lines, curves in an image can be either physically real or they can be implied. In both instances they can guide the viewer through an image.

"Real" curves include rivers, railroad tracks, even the edge of the sea as the tide ebbs and flows. There are two basic shapes to a curve: the "C" shape and the "S" shape. The shape of the curve approximately matches the shape of the letter it's named after. The C curve is the simpler of the two shapes, the S curve more sinuous and complex. The S curve is typically longer than a C curve and so it takes the eye more time to follow its line.

The S curve's more meandering quality is arguably more restful and hypnotic than a C curve.

Using a curve in a composition is a powerful way to guide the eye through the image space—it's almost impossible to look at a curve and not follow its length. This means that it's important to consider what happens when the eye reaches the end of the curve. One solution is to place the focal point of the picture

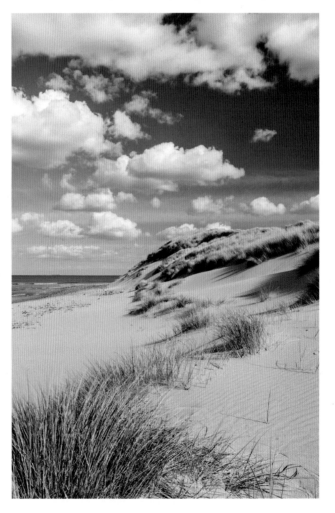

◄◄ IMPLIED CURVES
Curves can be implied. In this image, the areas of light and shade suggest a curved path through the image.

◄ S CURVE
A gently meandering S curve helps the eye to slowly wander through an image. Curves (S curves in particular) feel more natural than straight lines with good reason. Perfectly straight lines are very rare in nature and only tend to be found in artificial structures.

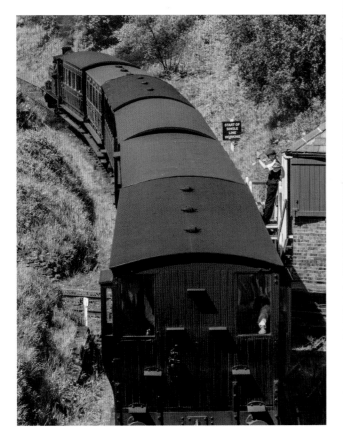

∧ C CURVE
The C curve formed by the roof of the train takes us on a visual journey up and through the image.

< TRAM LINES
Lines are a very powerful way to direct a person's gaze through an image space. To see the effect, cover the tramlines in the foreground. Does the image (in this "cropped" form) work as well, or are the tramlines a vital component of the composition?

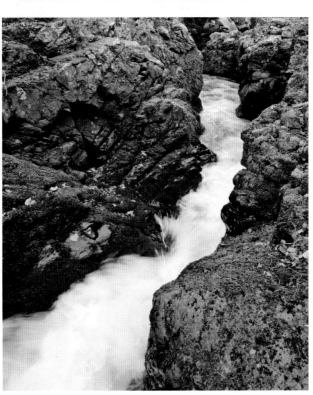

< WATERFALL
Another C curve, this time formed by the white foam of a bubbling waterfall.

at the end of the curve, so that the eye has a natural destination place in the image. What should be avoided is placing the subject so that it has no connection to the curve. Doing this will produce a slightly unsettling effect: the eye will need to move away from the curve to look for the subject (if at all—it may be that the subject goes unnoticed or is relegated to just a supporting role in the composition).

However, you don't need to have a separate subject in the image. The curve itself could be the subject. A good example of this is a river winding through a landscape. This will have an emotional resonance of its own. Anyone looking at the image will just enjoy the visual journey.

< **PATH**
The path in this photograph takes us on a visual journey to the refuge hut in the distance. Without the path, the hut would be far less obvious.

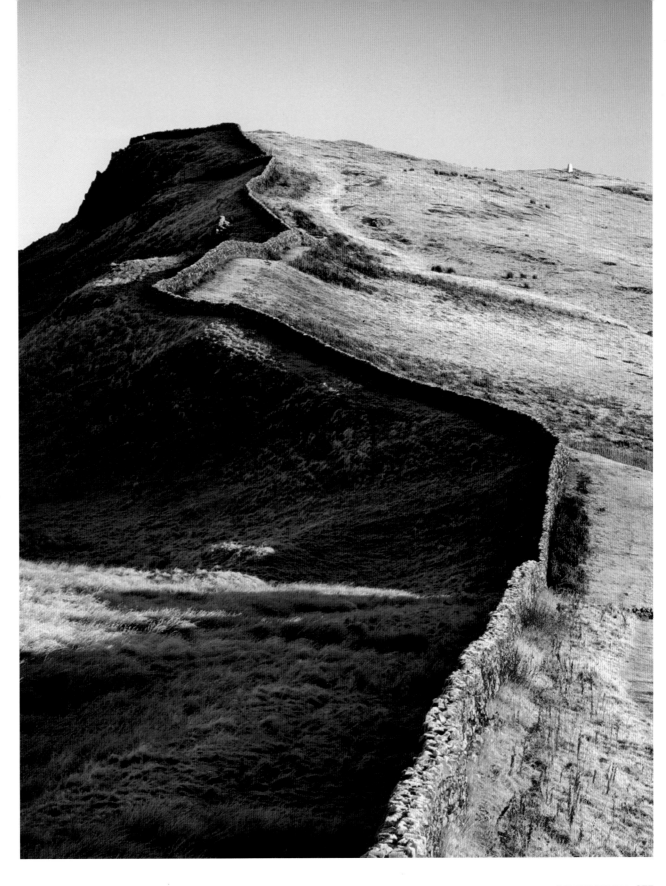

> WALL
Side lighting helps to define
the textural quality of the
landscape—in this case
emphasizing the wall that
zigzags up through the frame.

Framing

Framing will help to focus attention on your photographic subject.
Used well, it will also add depth and interest to your composition.

< HIDING
Framing can be done for many reasons. In this instance, the overhanging branches of the trees break up the lackluster pale blue sky. However, care needed to be taken to make sure that the frame didn't overlap or obscure important parts of the castle.

Framing is the technique of using an element in a scene to partially or even fully surround the main subject. There are several reasons to do this. The first is that it will help to direct the eye toward the main subject, provided that the framing element isn't too intrusive or distracting. It will also help to make an image more three-dimensional by adding another depth-cue to the composition. Framing elements can help hide or reduce the impact of other, unwanted elements in a scene.

By carefully choosing your frame you can give your subject more context. A framing element that is related to the main subject (such as an open doorway framing a room) will help to tell the story of the image very

economically. Framing elements that don't match the main subject will add an air of mystery. By juxtaposing two disparate elements there is an immediate tension to the image, which the viewer of the image will need to resolve.

Framing elements don't necessarily need to be sharp. By throwing them out of focus they will be less likely to distract from the subject, and as a bonus will also increase the apparent depth of the image. If the framing element is in shadow, care must be taken that this does not influence the exposure to the detriment of the subject, particularly if the subject is brightly lit. Framing elements that are silhouetted are very effective and are less likely to be distracting.

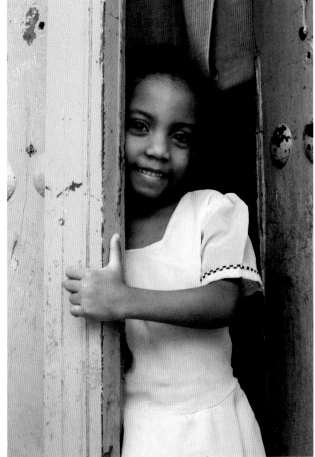

∧ **SIZE**
The subject can be relatively small compared to the framing element, as long as it has greater visual weight.

∧ **SHY CHILD**
The shyness of this young girl is conveyed by the way she is framed by the door to her house.

Repetition

Once you start to look, repetitive patterns can be found everywhere, both in the natural world and in the built environment. Repetition is pleasing to the eye; it's not dynamic, but soothing.

Humans have a particular fondness for repetition in images, especially if there's a strong suggestion that the pattern continues outside the boundaries of the image space. To achieve this, the repeating pattern will need to extend right to the edge of the image, or the space around the edge of the image will need to be similar in size to the spaces in the repeating pattern.

The problem with repeating patterns is that they don't hold the attention for long. To add a dynamic quality to a repetitive pattern, add an element that breaks the pattern somehow. This element will immediately become the focal point of the image. The eye will quickly scan across the repetitive areas of the image and stop when it comes to the break in the pattern. Think about the placement of this element within the frame. If possible, position it where it will have maximum visual impact—too close to the edge of the frame could make its placement look half-hearted.

Long focal length lenses are ideal for cropping in on patterns. However, depth of field can become an issue if the pattern is not on a flat plane parallel to the camera. Therefore, if the pattern is three-dimensional think carefully about where to place your focus point to maximize sharpness. Remember, depth of field extends less far in front of the focus point than it does behind.

∧ SEATING
These carved armrests in a local church were photographed with a telephoto lens and wide aperture to convey the idea that the pattern continues indefinitely.

∧ APPLES
By positioning the camera directly above the apples, the shapes, textures, and colors form pleasing patterns.

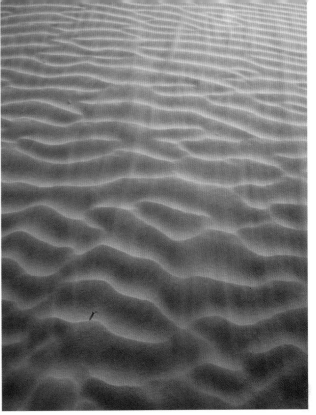

∧ LUNAR TICS

This image relies on the repetition of the moon across a single image for its effect. It was achieved by using a 26-minute exposure in Bulb mode, keeping the lens covered with a black cloth. Every three minutes the black cloth was lifted for one second to expose the moon. As the moon climbed in the sky it was recorded in a different place in the image. The key was allowing enough time to elapse between each lifting of the cloth so that the moons didn't overlap each other.

∧ PATTERNS IN NATURE

When shooting abstract landscapes, it is good to include repetitive patterns.

∧ LOOKING DOWN

The shot was taken handheld in dim lighting. To maximize depth of field, the focus was on the rail at the top of the picture.

∧ FOCAL POINT

Anything that breaks a pattern will become the focal point of the image. Where did you look first?

Filling the Frame

Filling the frame will leave the viewer in no doubt as to what the subject of the photograph is.

< **DUNE**
Filling the frame with the subject—like this dune in Namibia—adds to the feeling of it being large and imposing. The people give it added scale.

< **DUNE**
Filling the frame with the subject—like this dune in Namibia—adds to the feeling of it being large and imposing. The people give it added scale.

∨ **DISTANCE**
Filling the frame is easier with a longer focal length lens than a wide-angle. Using a longer lens also means that you can stand back from your subject, which makes the perspective more natural.

By filling the frame with your subject you exclude everything but your subject. This immediately creates striking images with impact. However, it's an approach that needs to be used with care. Because your subject dominates the frame, any flaws will be immediately apparent. If your subject is a person they have to be comfortable with this possibility.

Successfully filling the frame means doing precisely that. When composing the shot it's important to check around all four edges of the frame. If you're not filling the frame so that your subject stretches to the four corners, you need to either get closer or zoom in more (the latter is preferable for live subjects as this is less intimidating).

Where you focus is also important. Getting in close or using longer lenses may restrict your available depth of field. You will need to decide which part of your subject needs to be critically sharp and compromise on other areas if they fall outside the zone of depth of field.

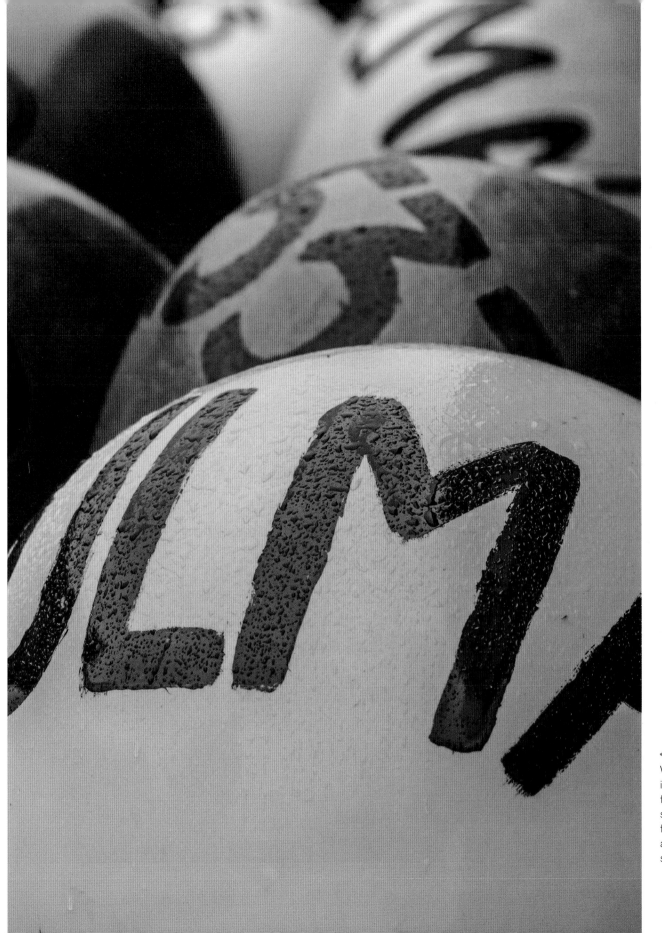

< FOCUS
Where you focus is critically important when filling the frame with your subject. In this shot, the focus was on the front float—it didn't matter too much about the ones behind it being slightly soft and out of focus.

Simplification

What you leave out of a photograph is as important as what you leave in. Adopting a minimalist approach to composition will take that concept to its ultimate conclusion.

<SHAPES

A 2 sec. exposure has blurred the movement of the sea in this coastal scene. Shooting on a heavily overcast day and converting the photograph to black and white further simplified the composition.

The world is a complex place. All photographs are a simplification of this complexity. However, it's possible to push this simplification further to create minimalist images that have just the bare amount of visual information in them. The essence of simplicity is reducing visual clutter, which can be achieved in a number of ways. Using a long focal length lens helps in two respects. The narrow angle of view immediately forces a more constrained, simplified view of a scene. Using a large aperture will also restrict depth of field, helping to simplify the image further.

The way you expose an image will also determine how simple that image is. A shallow depth of field simplifies images, but if you have movement in a scene, you might also use a long shutter speed to soften and blur the movement. However, it's often difficult to combine a long shutter speed and large aperture to minimize depth of field and blur movement. You could wait until the light levels are naturally low, such as after sunset. Alternatively you could use extremely dense neutral density (ND) filters to artificially restrict the amount of light reaching the sensor, allowing the use of a long shutter speed and large aperture.

In the natural world, snow and mist simplify landscapes. Snow obliterates texture and color, so under the right conditions a snow-covered landscape can appear naturally minimalist and monochromatic. Mist reduces color as well as contrast. When mist is particularly heavy it can restrict visibility to the point where only objects close to the camera can be discerned clearly.

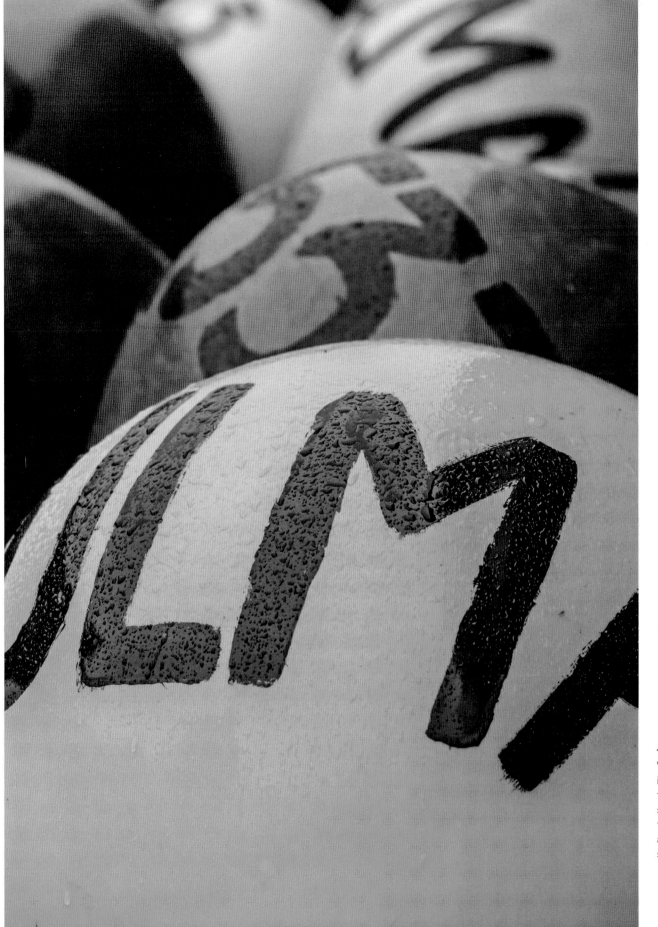

< FOCUS

Where you focus is critically important when filling the frame with your subject. In this shot, the focus was on the front float—it didn't matter too much about the ones behind it being slightly soft and out of focus.

Context

Placing your subject in context is the exact opposite of having it fill the frame.

When you place your subject in context, the subject is a far smaller part of the image and is shown in its environment. This helps you to tell the story of your subject. A simple head-and-shoulders shot of a person tells you nothing about them other than what they look like, yet showing the same person hard at work shows you what they do for a living, their work environment, and even potentially whom they work with.

However, there is a fine balance that has to be struck when showing a subject in context. You shouldn't allow the environment to become more important than the subject. This is relatively easy to avoid with people as they have a high visual weight (if there is more than one person in an image, your subject should be the larger in the frame relative to the others). If your subject is inanimate, you will need to think carefully about its relative size and positioning within the image space.

> **REVEALING TEXTURE**
In the late afternoon or early morning light, shadows help to reveal texture in surfaces such as sand, bark, and paintwork.

> > **ENVIRONMENT**
Your subject shouldn't be lost in an image when you show context. In this image the lighthouse is still visually dominant even though it's relatively small in the frame.

Simplification

What you leave out of a photograph is as important as what you leave in. Adopting a minimalist approach to composition will take that concept to its ultimate conclusion.

<SHAPES
A 2 sec. exposure has blurred the movement of the sea in this coastal scene. Shooting on a heavily overcast day and converting the photograph to black and white further simplified the composition.

The world is a complex place. All photographs are a simplification of this complexity. However, it's possible to push this simplification further to create minimalist images that have just the bare amount of visual information in them. The essence of simplicity is reducing visual clutter, which can be achieved in a number of ways. Using a long focal length lens helps in two respects. The narrow angle of view immediately forces a more constrained, simplified view of a scene. Using a large aperture will also restrict depth of field, helping to simplify the image further.

The way you expose an image will also determine how simple that image is. A shallow depth of field simplifies images, but if you have movement in a scene, you might also use a long shutter speed to soften and blur the movement. However, it's often difficult to combine a long shutter speed and large aperture to minimize depth of field and blur movement. You could wait until the light levels are naturally low, such as after sunset. Alternatively you could use extremely dense neutral density (ND) filters to artificially restrict the amount of light reaching the sensor, allowing the use of a long shutter speed and large aperture.

In the natural world, snow and mist simplify landscapes. Snow obliterates texture and color, so under the right conditions a snow-covered landscape can appear naturally minimalist and monochromatic. Mist reduces color as well as contrast. When mist is particularly heavy it can restrict visibility to the point where only objects close to the camera can be discerned clearly.

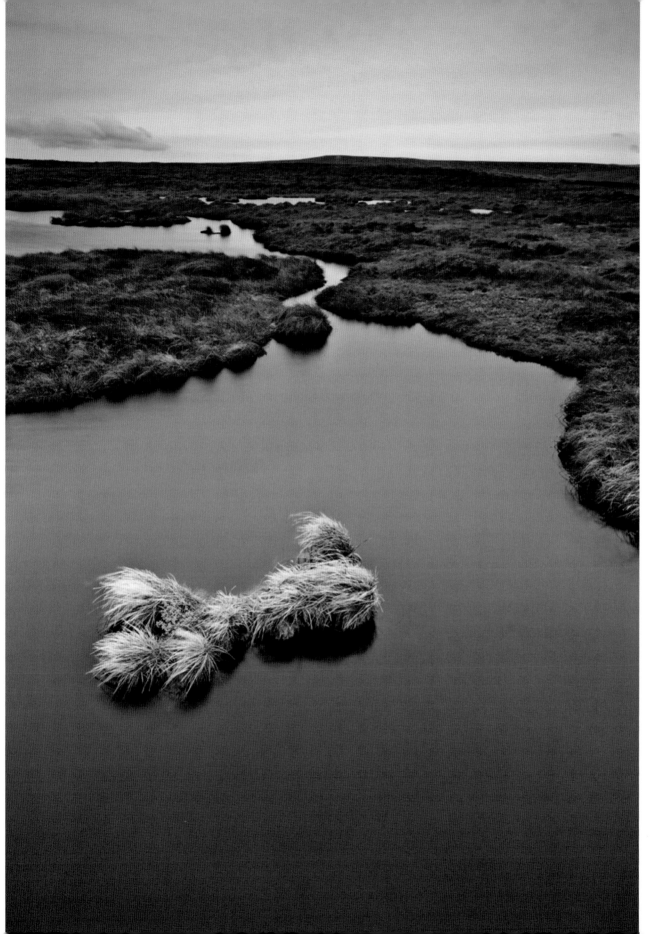

< **MOVEMENT**
Low light and the need to use
a long shutter speed can help
to "tidy" an image. Wind was
whipping across this open moor,
disturbing the surface of this
pool, but a shutter speed of 6
sec. softened the ripples away.
Ironically, the image looks calm
and tranquil, even though it was
incredibly windy at the time.

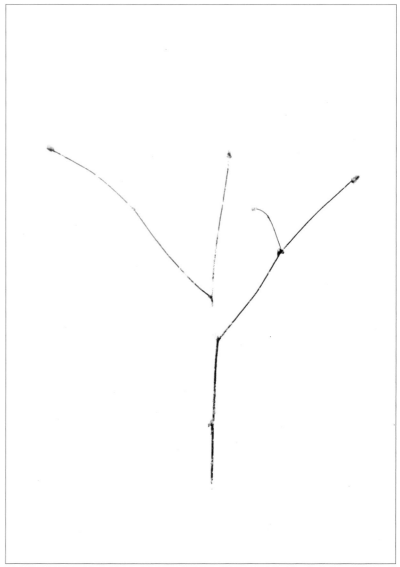

∧ GRAPHIC SIMPLICITY

Snow and bright, overcast skies can simplify the landscape, especially if color is also removed from an image. This tree (above left) becomes more graphic when positioned against a "white" sky, while the branches (above right) would have been lost against a background of similar tones without the snow to add contrast.

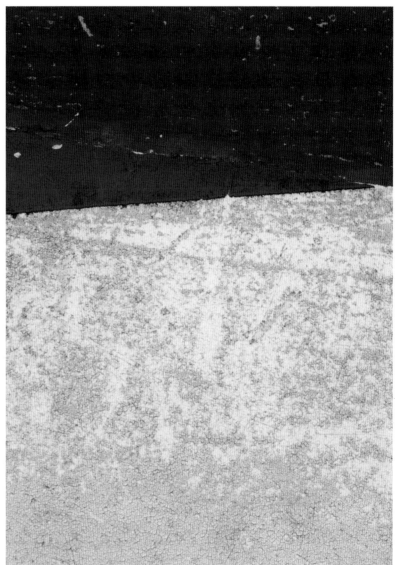

∧ ABSTRACT

These abstract images are from a series of photographs of boat hulls. Although abstracted, the "rules" of composition can still be applied, such as the rule of thirds (above left) and the use of line, shape, and brightness to create balance (above right).

Abstracts

One of the joys of photography is creating a photograph that is not instantly recognizable. This will make it more difficult to interpret, but will impart a sense of mystery that will invite a lingering look.

< **REFLECTIONS**
Abstract photography is the process of using symmetry, color, texture, and repeating shapes or lines to create an image. The subject matter doesn't need to be recognizable or the pictures to have any great meaning—it is purely art.

An image that does not represent "reality" in a literal way is said to be abstract. Rather than relying on detail, abstract images tend to be more about shape, texture, color, or all three. Abstract images are harder to "read" than a more literal representation and create more of a puzzle for the viewer of the image to work out, potentially holding the viewer's interest for longer.

Abstract images can be created in a number of ways. Longer lenses are useful to crop in tightly on a subject, reducing the amount of visual information that would help make the image more recognizable. Using a large aperture to minimize depth of field or even deliberately defocusing, so that the scene is reduced to patches of color, are also very effective ways of creating an abstract image.

There are two approaches you can take when composing an abstract image. The first is to apply the compositional rules and concepts previously described to align elements within the image space—even to have a primary element towards which the eye is directed. This creates a more formal image, albeit one that is still relatively hard to read. The second approach is not to use any rules of composition at all, and to produce a more

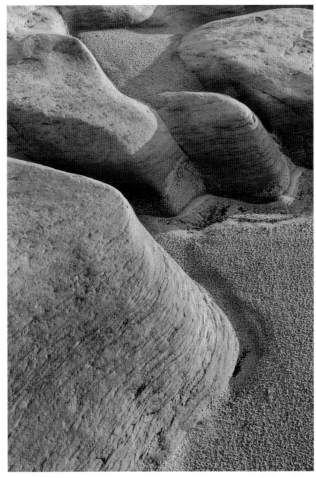

< **EXCLUSION**
It's generally more difficult to shoot abstract images with a wide-angle lens. Abstracts rely on the fact that there is little more information in the image than is strictly necessary. For this image, the longer end of a wide-angle zoom helped exclude anything other than the curves of the rock.

∨ **MACKEREL**
Altocumulus (or mackerel) clouds make pleasing abstract images, but also warn of rainy weather to come.

∧ **MAKING LIGHT WORK**
When the sun reappeared from behind a cloud the grooves in the wood of this boat's hull lit up, adding a sense of three-dimensionality to the scene.

free-form image with no particular point of interest. This means that the viewer's eye is freer to wander around the image space. To create visual interest it's therefore important to be bold with shape, texture, or color.

Abstract photo opportunities can be found anywhere and everywhere. Look around your home. Even the most mundane objects can be shot in an abstract way. Look for interesting texture or patterns within your subject. Using the selective focus technique will increase the sense of mystery found in a good abstract photograph.

Cropping

The digital revolution has opened a new area of creative composition control by providing easy ways to change the format of the final image.

In the days of film, unless you were very dedicated, you pretty much had to stick with the original format of the film you used in making your final images, especially if you were shooting slide film. Today, however, many digital cameras offer various built-in crop modes so that you can capture scenes with crops that range from standard 3:2 and 4:3 all the way through to 16:9 panoramic.

If your camera doesn't offer in-camera cropping it can be performed during postproduction instead (in some ways it is preferable to do this on a bigger screen). Most image editing software offers a crop tool, which can move you from a traditional 3:2 format image to a square or even an extended panoramic format in a matter of seconds.

There are many reasons to crop a photograph. Sometimes you may not be able to get as close to your chosen subject as you'd like, so cropping will help to remove any extraneous detail and help to simplify your image. Another good reason is that your composition may work more effectively in a different shaped frame, as demonstrated opposite.

< > RE-VISUALIZED
There is nothing particularly wrong with the composition of this 3:2 format image (left), which appears as the sensor recorded it. However, as shown opposite, cropping enables the image to be "re-visualized" in a number of ways, which shifts the balance and focus. Which version do you prefer?

Color

If light is the crucial factor in making a landscape photograph work, then color is a factor that can help turn it from a good photograph into a powerful image that is capable of eliciting an emotional response.

< **RAINBOW**
In 1704, physicist Sir Isaac Newton published a series of experiments proving that white light could be refracted via a prism to create the colors red, orange, yellow, green, blue, and violet—the same colors seen in a rainbow.

Nature is a smorgasbord of color, and although the obvious, punchy colors demand much attention, there is far more to capturing color skilfully and knowledgably when it comes to producing compelling photographs. Although it is often best to go with your intuition when deciding what to include and exclude from a composition, it is well worth spending some time looking at and getting to grips with color theory: about how colors work, how they work together, and how humans perceive colors and their associated messages about mood.

Using color to add impact to our photographs is not as complicated as it might sound—most of the time we arrange hues, tints, and shades in esthetically pleasing ways simply by instinct. However, by understanding the basic rules of color theory we can remove the guesswork, creating color combinations that convey our personal style, while communicating our feelings about the subject.

It is important to note that the psychological effects of color can vary between cultures: black suggests death in western civilization, for example, whereas white is the

<< **THE SCENT OF LAVENDER**
This image features a plant that we know to be lavender. This knowledge—and the unmistakable color—help us to conjure up the scent.

< **NATURE'S BEST**
Nature has an uncanny ability to produce stunning colors that match color theory!

∨ **WARM GLOW**
The warm pink glow on this decommissioned lighthouse was from vividly colored pre-dawn clouds behind the camera: sometimes you don't need to be pointing your camera at the most dramatic part of a sky for a good picture.

"color" of mourning in China. Despite these variables, some responses are universal: blue and green, for example, are considered cool colors, promoting a sense of tranquillity and peace; whereas red and yellow are thought to be warm colors, linked intrinsically to danger and excitement.

The effect of color in a photograph should not be underestimated: color has the ability to stimulate the senses, triggering the smell of freshly cut grass or the sound of a police siren, for example. It can make us feel happy or sad, energized or tired. It can awaken happy memories, or cause us pain and anguish. By studying the way that certain colors relate to each other—and the physical and emotional responses they evoke in us—we can begin to see how color affects both the mind and the body, and how we can use that in our photography.

The Color Wheel

Having proven that color is a property of light and not, in fact, a physical property of an object, Sir Isaac Newton went on to display his core colors in the form of a wheel (or circle).

How much of the wheel was apportioned to each color depended on its wavelength and its width in the color spectrum. With the help of this device, Newton was able to prove that relationships exist between certain colors in the visible spectrum.

Over the next three centuries, scientists, painters, and philosophers all adopted the color wheel, altering its design, and even its shape, to suit their purposes. The most popular version (still used by artists today) contains three primary colors: red, yellow, and blue. These colors cannot be created by mixing others on the wheel together and are placed equidistant from one another.

However, while this is all well and good for painters mixing pigments, the colors in a digital image are created by mixing red, green, and blue (green replaces yellow). The absence of these colors makes black and all three mixed together at their maximum values makes white. Red, green, and blue are referred to as primary colors. Different media use subtly different primary colors (for instance, a painter would regard red, yellow, and blue as primaries), but the result is the same: mix two of the primary colors at their maximum value and you produce a secondary color. In this way, red and green mixed together produce yellow; green and blue produce cyan; and blue and red produce magenta.

The relationships between colors are seen most easily on a color wheel, as shown opposite. The color wheel is also a useful tool for anticipating which colors will work well together and which don't. This color harmony is something that we will return to later in the chapter.

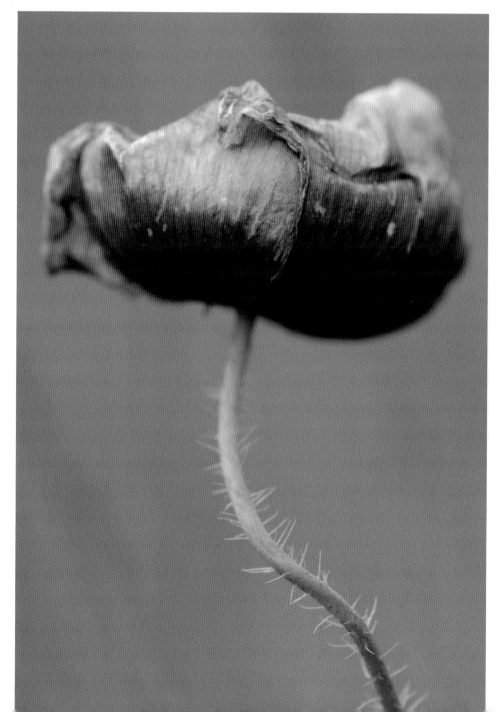

> **PRIMARY**
Red and green are two of the primary colors in digital photography (the third being blue). In painting, yellow replaces green as a primary color.

THE COLOR WHEEL

The primary, secondary, and tertiary colors of the color wheel make clear the relationship between each one, and how each is formed by mixing with its neighbor.

PRIMARY COLORS

SECONDARY COLORS

TERTIARY COLORS

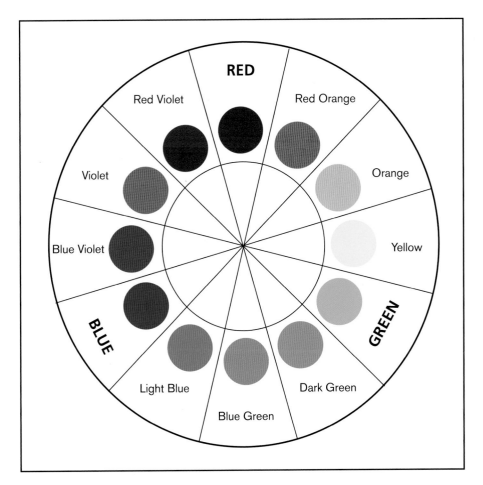

< ∧ COLORS

Red, green, and blue are the primary colors when using the (aptly named) RGB model. When two adjacent primaries are mixed together equally (and at their maximum values) they produce the color exactly at the mid-point between the two primaries.

Seeing Color

Color is an important part of how we perceive the world. Understanding how we react to color is another tool that can be used to compose a photograph.

Human perception of color is based not only on the physics of how our visual system is "hard wired," but also on the contexts we place on colors, the causes of which stretch all the way from the present day back through our entire existence as a species. For example, red is a color very much associated with danger, which stems from our early encounters with dangerous foods and creatures in our world.

Our brains are wonderfully powerful and will do their utmost to normalize things for us to help our understanding of the world, and this applies to our vision as well. It will trick us into seeing things that do or don't exist, purely to make them seem "normal." For example, if you have ever taken a photograph inside your house and then wondered why the image that comes out of your camera is all tinged with orange, it is because your brain has been tricking you.

The tungsten light bulbs that burn in most homes emit a warm, orange light, but when we are in the house our visual system modifies this view to make it seem as though we are seeing the scene under standard, non-tainted light conditions. The same applies to landscape photographs taken when color casts are present in the light, such as the blue shadow areas that you find when taking images around midday, or the warm light of sunrise and sunset. We see some of this warmth in reality, but it seems accentuated in our images of the same scenes. This phenomenon is known as the issue of constancy: our visual system's endless campaign to adjust what we see to make it easier and faster for the brain to process what is going on around us, to reduce our confusion.

So, be warned: the colors that we see in our final photographs will almost always differ from what we thought we were seeing live on location. As with most things, however, the more you practice, the more chance you will have of predicting what the differences will be and then can adjust your photograph accordingly to take account of them.

Qualities of Color

Colors have three basic qualities: hue, saturation, and value. If you use Adobe Photoshop you may even have seen some of these terms referring to sliders that allow you to alter and select colors.

Hue is essentially a synonym for color. Red is a hue, as is yellow, green, blue, and so on. Scientifically, a hue can be described in relation to a particular wavelength of light. Red, for example, corresponds roughly to a wavelength of 700 nanometers.

Saturation describes a hue's intensity or vibrancy. A vibrant hue is one that has no black, white, or gray mixed in. A completely desaturated color is essentially gray. Saturated colors are inherently more eye-catching than less saturated colors.

Value describes the lightness or darkness of a color. The higher the value of a color, the closer it is to white. Yellow therefore has a higher value than green. The lower the value, the closer the color is to black. Higher-value colors are typically more eye-catching than colors with a lower value.

∧ **ATTRACTS THE EYE**
While it might take up less than half the frame, the red of these berries dominates the composition: saturated colors are always eye-catching.

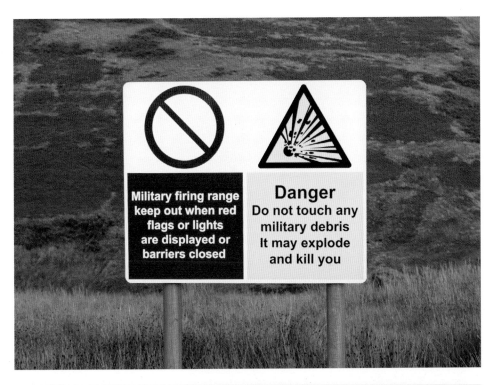

< STARK WARNING
Warning signs often employ highly saturated warm colors because of their high visibility.

∨ WARMTH WITHIN
Colors can be warm or cool. Here, the warmer colors of the far room appear far more inviting than the slightly cooler colors of the foreground.

Color perception

Color	Connotations
Red	Positive: warm, exciting, energetic, stimulating, inviting, love, comforting Negative: aggressive, unsubtle, anger
Orange	Positive: warm, sensuous, passionate, fun Negative: frivolous, immaturity
Yellow	Positive: optimistic, emotional strength, spirit-lifting, friendly, creative, confidence Negative: fear, depression, irrational, frustrating
Green	Positive: harmonious, refreshing, natural, balanced, restful, peaceful, healthy Negative: bland, stagnant, static, passive, jealousy
Blue	Positive: intelligence, serene, logical, cool, calm, reflective, trust, efficiency Negative: cold (emotionally), aloof, unfriendly, depression
Violet	Positive: spiritual, luxurious, authentic, truthful Negative: introverted, decadent
Brown	Positive: serious, stable, earthy, reliable, warm, strength Negative: unsophisticated, conventional
White	Positive: sterile, pure, clean, efficient, space, naivety Negative: cold (emotionally), unfriendly
Gray	Positive: solidity Negative: neutral, bland, boring
Black	Positive: security, sophisticated, substantial, infinite Negative: menacing, oppressive, cold (emotionally), heavy, suffocating, mourning

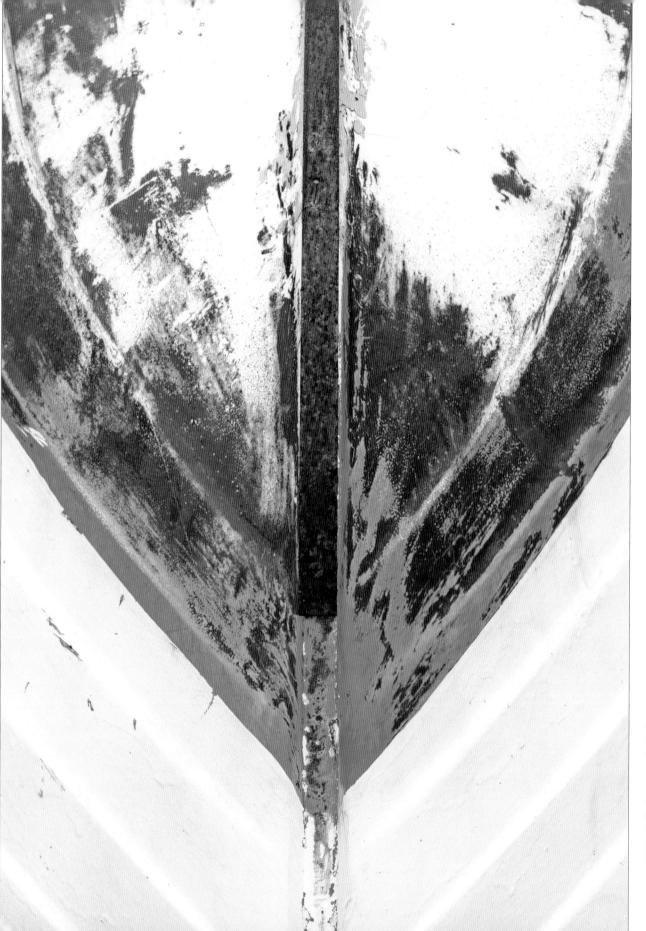

> **HIGH DYNAMICS**
The highly saturated treatment of this HDR image creates a bold, attention-grabbing image.

< **PROGRESSIVE**
Colors are said to be either "progressive" or "recessive" in the way in which they appear to come forward or recede in an image respectively. Warmer colors are typically progressive (with red being the most progressive color of all); cooler colors are typically recessive.

Recording Color

Recording color accurately largely depends on the camera's white balance setting, but there is plenty of room for creativity.

In the past, balancing out the difference between what we see with our own eyes and what the camera records would have involved attaching color-correction filters to the front of the lens to counter whatever color cast the light conditions were throwing up. Consequently, a warming filter—such as one from the 81 series—would have been used to eradicate blue casts in shadow areas when shooting around midday, while blue filters would be employed to balance the warm light encountered at the start and end of the day.

For photographers using digital cameras there is the option of changing the white balance of the image, either in-camera if you are shooting in JPEG format or during postproduction if you are shooting Raw format. It is good to remember, though, that just because it is possible to counter the color casts caused by natural light, it may not always be desirable to do so from an artistic point of view. We have become very skilled at interpreting photographs as a subjective representation of reality, so keeping those saturated warm color casts of sunrise and sunset, for instance, may actually help people to interpret the image in a way that evokes what it was like to actually be there.

It is important to remember that color has an emotional effect, so by biasing the color temperature of an image in a particular direction you can create an emotional impact that wouldn't have been there otherwise. An overall warm tint is flattering to skin tone, for example, but it also has connotations of health and happiness. A cooler overall tint has the opposite effect—it's not particularly flattering and can convey ill-health and unhappiness. This emotional manipulation through the use of overall color tint is often used in movies and on television.

∧ GETTING THE BALANCE RIGHT
We can tell very quickly when the "wrong" white balance has been used in images of people. The image above left appears far more natural than the version above right.

< UNSAVORY FOOD
We're actively repelled by food that has a blue tint, so when shooting images of food a touch of warmth goes a long way to making the food look appetizing. Compare the two halves of this image. Which do you find more appealing?

WB: 4800K

CORRECT WB: 5800K

< ∨ KEEP IT COOL

Color temperature can be used creatively. Here, the image (left) was deliberately kept slightly blue (4800K) in overall color as that very effectively conveys a sense of a cold winter's morning. The "correct" color temperature of 5800K (below) is "warmer" and far less atmospheric.

> WARMER FEEL

Although the "wrong" white balance setting (5500K) means the girl's top isn't white (far right), the warming effect it has on the shot as a whole produces a more inviting result. Sometimes, the "correct" white balance setting is not the "right" one.

CORRECT WB: 4000K

DAYLIGHT WB: 5500K

Color Harmony

Color harmony is all about choosing colors that will work well together, and identifying those that will not.

Warm Colors

As mentioned previously, warmer colors are progressive and cooler colors are recessive. Creating a warm color harmony image will therefore make your subject or scene appear closer than when a cool color harmony is used. It is often possible to isolate or almost isolate a subject based on a single color, and this is a sure way to create bold and simple images that command attention, even if they lack some subsequent visual depth to keep a viewer engaged with the image for a long period of time. Because of this, when single color images are printed, they are often good background photographs, useful for adding a rapidly assimilated mood to an environment, such as a room in your house, an office, or a café.

Red

This is one of the boldest colors to seek out. It isn't the most prevalent of colors in nature, but it does exert a great pull on a viewer's eye, so if you can isolate a red subject for an abstract image, then it will definitely jump out at you when you look through your images later—as the painter Henri Matisse once commented "A thimble of red is redder than a bucketful." Red is associated with danger, blood, daring, energy, and boldness, and can also be used to illustrate power and vitality. It commands great visual attention, so you need to be careful how you use it, because if it isn't the subject of the photograph, it can easily distract from the true subject.

Yellow

Pow! Photographs based on yellow subjects will simply leap out at you. It is the brightest of all colors and is representative, among other things, of health, sunshine, happiness, and playfulness. It is vibrant and emotionally stimulating, and it is relatively easy to find occurring in nature. From vast swathes of sunflowers or fields of rape to the gentle nodding daffodils of spring, or even the sun itself, there are plenty of inspiring examples of yellow to focus on. However, yellow has also been known to provoke feelings of frustration, and also to increase metabolism. When used as a pure hue, yellow can make a bold statement, but care should be taken not to overuse it, as it can cause weariness in the viewer.

< ∨ RAISING THE TEMPERATURE
There are some subjects that appear far more attractive when a "warmer" approach is taken. Portraiture is one such subject, food is another. This cake looks distinctly less appealing when it is "cooler" (below).

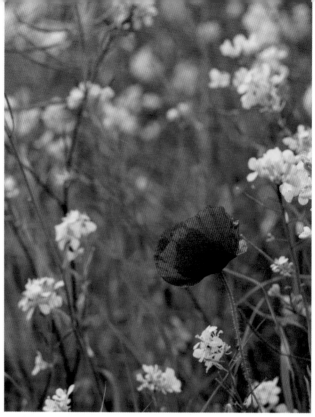

∧ PURE RED
Red always dominates a composition, even if both yellow and red are used in their purest form.

< DEMANDING YELLOW
Yellow is so bright that you can have slightly less of it in the frame and it still dominates.

Orange
Orange is associated with energy, happiness, and warmth. As a combination of red and yellow, orange also inherits exciting and restorative properties. While not as attention seeking as red or black, it still has the ability to draw the eye, hence its use in traffic lights. It also happens to be one of the most comforting colors, although it can also be used to add the feeling of energy or serenity, depending on the brightness of the orange you encounter.

> UTAH ROCKS!
There are few better places on the planet than Utah, USA, for indulging in shooting orange.

∧ DESERT HEAT
The oranges and yellows of the desert evoke an almost physical feeling of "warmth."

∧ GLOWING SUNSET
Orange is frequently found in nature, especially in the warm light of sunset.

Cool Colors

Blue

This is one of the most prevalent colors in nature, thanks to the sky, sea, and ice, plus a host of obliging flowers. It is a quiet color that can be used to promote feelings of peace, solitude, spirituality, and sometimes sadness. It's a cool color that appears to recede in the frame, making it an ideal background hue. Blue is also thought to slow down the metabolism and lower the pulse rate.

While a strong blue cast is not always what you want in your images, it can be useful if you are attempting to show any of the concepts mentioned above, so think carefully about the subject matter of the image before trying to remove a blue cast, either with the use of warming filters or in postproduction. It is quite bold when used on its own in an image, but recedes markedly if combined with the more dominant red or yellow.

Green

This is the granddaddy of nature's colors, and it is hard to avoid if you're a landscape photographer. Green, of course, is directly associated with the concept of nature (just look at how many companies employ green in their logos to try to make them seem more eco friendly!), but it can also be used to suggest growth, renewal, youth, health, hope, and new life. It is fairly easy to create images dominated by green, especially if you head into a forest or woodland during spring and summer when the trees are swathed in leaves. Green inspires feelings of peace, relaxation, and safety, as well as encouraging a sense of harmony.

< < SENSE OF COLD
In order to communicate the coldness of the ice to the viewer, the white balance of the Raw file was changed to Tungsten when the shot was processed.

< GREEN OVERLOAD
Using too much green can lead to flat, uninteresting pictures. The shapes of the ferns here help to add a point of interest.

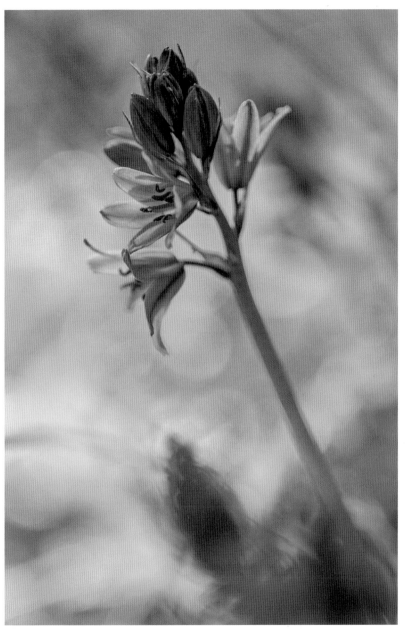

∧ BLUE AND GREEN
Garden flowers are more typically warmer in color.
Bluebells are an interesting exception and, when
coupled with green foliage, allow the creation of
images with a cool color harmony.

∧ ALL BLUE
On its own blue can be quite bold, as in this
near-monochromatic detail study.

Complementary Colors

With nature being so complex, it is relatively rare to find scenes where just one color dominates. The challenge with most scenes is to find compositions that use the powerful tool that is color, but combine the various colors present in an intelligent way that adds to the impact of the final image, rather than detracting from it.

Opposites Attract

Complementary colors are those that sit opposite each other on the color wheel, so green lies opposite red, blue lies opposite orange, and yellow is opposite violet. These colors readily appear in nature: the red and green of berries on a leafy tree or poppies in a grassy field; blue and orange can be found in the sky and rocks, or the sky and the sea; while yellow and violet are to be seen together in many flowers.

The reason that we find these color combinations attractive is again partly due to our brain wanting to bring order to our chaotic world. If you stare at a red apple for a minute or two and then look straight at a white piece of paper, you momentarily see a green apple on the paper. This illusion is caused by our visual system trying to balance the red by adding green to the scene in an attempt to obtain a mid-gray level of brightness. If you want to test your vision further with some optical color illusions, then just do a quick search online for them; there are many to be found.

Balancing Brightness

Although featuring these complementary colors in roughly equal quantities in an image can be successful, the German poet J.W. von Goethe first expounded the idea that they are likely to appear more attractive when the quantities of each are balanced relative to the brightness of the colors themselves. For this theory to work in practice, however, it does demand a high level of purity in the colors, which is not that common in the natural world, but having said that, it is worth bearing in mind the brightness of the colors when putting together a composition.

For example, orange is a lot brighter than blue, so to maintain balance in an image containing both, it is a good idea to include around a third orange and two-thirds blue. Red and green are fairly even in brightness, so aim to divide the space in the frame equally between the two. On the other hand, yellow is far brighter than violet, so the ratio with these colors needs to be closer to 1:5 to ensure the yellow doesn't overwhelm the violet.

∧ **COMPLEMENTARY COLORS**
Complementary colors sit opposite each other on the color wheel. When they are placed next to each other they create the strongest possible color contrast, with each making the other appear more intense.

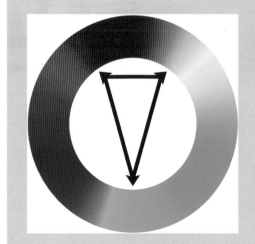

Base color	Split-complementary color combinations
red	yellow-green and blue-green
orange	blue-green and blue-violet
yellow	red-violet and blue-violet
green	red-orange and red-violet
blue	red-yellow and red-orange
violet	yellow-green and yellow-orange

< **SPLIT-COMPLEMENTARY COLORS**
Split-complementary colors are similar to complementary colors. However, instead of two colors, there are three: a base color and two colors that are adjacent to its complement. It's a strong, bold color scheme, though not as bold and with less tension than when two complementary colors are used together.

∧ PURPLE HAZE
Certain flower species are natural sources of complementary colors: these purple foxgloves are complementary to the surrounding green foliage.

∧ COMPLEMENTARY BALANCE
Once you have found complementary colors to shoot, consider how much of each color you need for balance. Roughly one-third orange and two-thirds blue is one example.

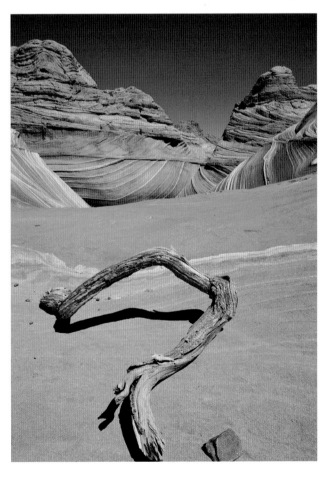

< < BOLD IMPACT
Orange and blue are complementary colors, producing an arresting contrast when used together. When creating this image, all other details and colors were excluded, to simplify the composition and create the most impact.

< BLUE-SKY DAY
Complementary colors, such as blue and orange, are naturally attractive to the eye.

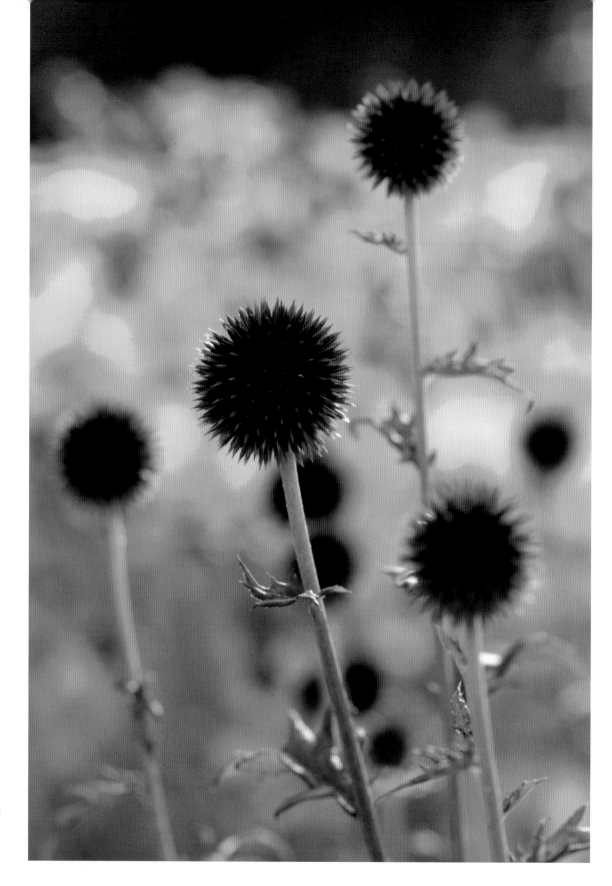

> **VIOLET REACTION**
Yellow and violet are situated
opposite each other on the
color wheel, and create
strong contrast.

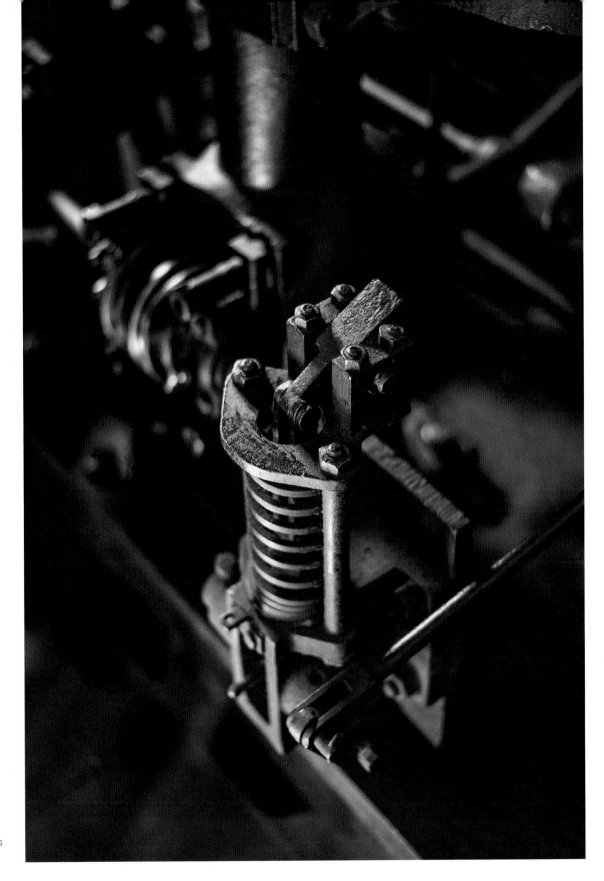

> **HARD METAL**
The complementary colors
in this shot were enhanced
during postproduction to
accentuate the cold harshness
of the machinery.

Analogous Colors

Far from the drama of the world of complementary colors lies the more serene realm of analogous colors—those colors that sit next to each other on a 12-segment color wheel. The subtly different analogous colors, such as yellow-green, yellow, and yellow-orange, blend together easily to create images that are pleasing to the eye, although you have to take care not to let that drift into boring! Because these colors are more subtle, they may take a fair bit of searching for in a landscape. They are often within relatively small areas, or even on the same object, such as a tree trunk or in the leaves of a plant.

Some other appealing analogous color combinations that you will be able to find quite readily in a landscape are those around red, red-orange, and orange, and of course green, green-yellow, and green-blue.

As with the complementary colors, it is important to bear in mind the relative brightness of each of the analogous colors you are wanting to include, and to ensure that the balance of the brightness levels is controlled as much as possible to assist the viewer in quickly identifying the main subject of the photograph. For example, if the focus of your image is the intricate detail on a green leaf, but there are some green-yellow flower buds in the background, the buds will naturally command more attention because of the extra brightness of the yellow in their color. To get around this, you might decide to recompose the image so that the buds are hidden, or perhaps to use a shallower depth of field to render the buds more blurred.

> **ANALOGOUS COLOR HARMONY**
Analogous color harmonies are composed of three to four colors that are adjacent to each other on a color wheel.

<< REDS
This analogous color harmony uses colors from the red/violet area of the color wheel...

<< BLUES
...whereas the analogous color in this photograph comes from subtly different shades of blue and blue-green.

∧ **PINK REFLECTIONS**
The analogous colors in this shot come from the reflected violet-pink sky on a mirror-like surface of water.

∧ STRONG VEINING
Nature supplied the analogous color harmony in this fall leaf—all you would have to do is photograph it.

Other Color Harmonies

Monochromatic Color Scheme

The simplest color combination is when variations of the same color are placed together (the variation coming from the changes in the relative brightness or saturation of the color). This is known as a monochromatic color scheme and although it's not a color harmony in the strictest sense, it is a combination you come across occasionally, particularly in nature (think of all the variations of green that can often be found together). Monochromatic color schemes never look unbalanced and appear restful to the eye, particularly when blues or greens are used.

Triadic Color Harmony

A triadic color harmony uses three colors that are at an equal distance on a color wheel. The combination is vibrant, although you have to be careful to get the balance right between the colors. Generally, the best method of achieving this is to have one dominant color with the other two used equally as support.

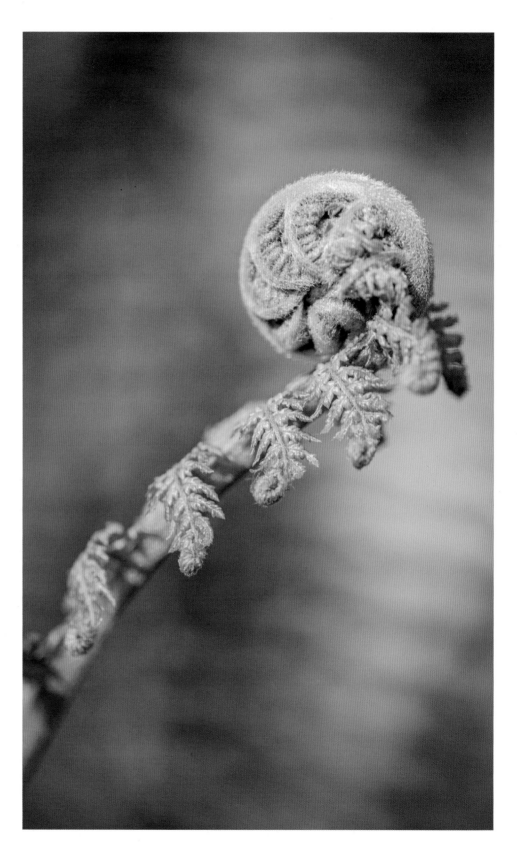

> **UNFURLING FROND**
Monochromatic color schemes are readily found in the natural world, such as this unfurling frond that was photographed against a rich green backdrop.

Tetradic Color Harmony

A tetradic color harmony is made up from two sets of complementary colors (four colors in total). On a color wheel, the relationship between the colors in a tetradic color harmony is shown by a rectangle. The key to using a tetradic color harmony is not to use the four colors equally, but to use one of the colors as the dominant color and the other three as support (being careful to keep the warm and cool colors balanced, as warm colors are visually heavier than cooler colors). Tetradic color harmonies are visually striking and eye-catching, and arguably more suited to boldly colored artificial subjects than to natural scenes.

Square Color Harmony

A square color harmony is similar in principle to a tetradic color harmony, in that four complementary colors form the basis of the harmony. However, it differs in that the four complementary colors are spaced equally around the color wheel. As with tetradic color harmony, it's more visually pleasing if you use one of the colors as the dominant color and the other three as support.

> **TETRADIC & SQUARE**
Stained-glass windows are a good place to see the bold use of color harmonies such as the tetradic and square harmonies.

CHAPTER 9
FILE MANAGEMENT

Introduction to File Management

You have plenty of space on your memory card and an itchy trigger finger, so what's to stop you from filling the card with images and worrying about the consequences later?

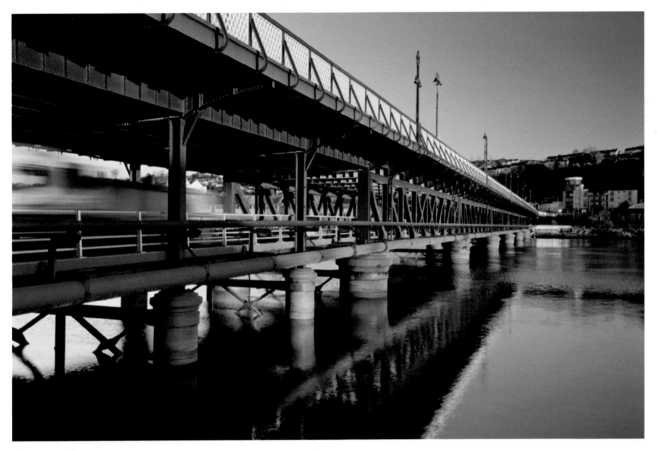

< **BRIDGE TOO FAR**
For some scenes, such as this road bridge, shooting multiple variations is necessary if you want to try and capture the "right" amount of traffic crossing the bridge. However, this means more images to look through and potentially process on your computer.

This chapter is about managing your files after you've shot them. This means importing them into your computer and organizing them, as well as the naming conventions and keywording that will help you find them later on.

However, the efficiency of your workflow begins long before you sit down at your computer. Unlike shooting on film, each digital image that you shoot is "free," so it is very tempting to adopt a "shoot anything and everything" approach. In doing so you will soon amass hundreds or thousands of images, and quickly discover that there is

a cost involved after all: not a financial cost, but a time cost. Every image that you shoot will need to be assessed, processed if it's a Raw file (or possibly retouched if it's a JPEG), and then resaved. This takes time if you do it properly, and while certain operations can be automated, you could still find yourself overwhelmed by the amount of work that needs to be done.

Therefore, a more parsimonious and thoughtful approach to shooting will pay dividends in the long term. Not only will you need to spend less time processing your

files, but you will likely find your photography improving more quickly. Try to imagine that each image you shoot has a financial penalty, and before you press the shutter-release button, decide whether you'd be prepared to pay that price. If you wouldn't, then ask yourself why not. If the truthful answer is that the image isn't good enough to justify the penalty, then perhaps you should reconsider pressing the shutter-release button.

Developing a workflow is very much a personal choice and there is no single right answer. The chart right illustrates a potential Raw workflow, from the initial importing of the Raw files through to the output of the image as either a print or to a web site. Although it looks like a long list, some of the tasks are automated and others can be completed relatively quickly through familiarity with the software you use—things will get faster and easier. However, you should also be open to new ideas: any software application that has the potential to speed up one part of the workflow should be assessed carefully and integrated if it is suitable.

> **RAW WORKFLOW**
This is a typical Raw workflow, which sees the images move from the memory card through to print or a web site. Not all of the stages will be necessary for every image, but running through a checklist like this will mean that nothing gets missed.

Importing
Import images to computer
Rename
Back up
Assess and rate

EDITING
Reduce sharpening to minimum
Set camera profile
Rotate, straighten, or crop as required
Correct for lens distortion and chromatic aberration
Clean up dust spots or blemishes
Noise reduction
Apply white balance corrections
Adjust exposure if required
Basic image adjustments such as contrast
Advanced image adjustments such as conversion to black and white

EXPORTING
Export as 16-bit TIFF
Load image into image-editing program
Final image adjustments
Convert to 8-bit and save to appropriate folder
Update digital asset management database

PRINTING
Open and duplicate image
Resize duplicate as required
Sharpen duplicate as required
Print
Close duplicate without saving

WEB USE
Open and duplicate image
Resize duplicate as required
Sharpen duplicate as required
Apply identification watermark
Convert to sRGB
Save as JPEG with relevant file name
Upload to target web site
Delete JPEG

Computer Hardware

Your images cannot be processed perfectly in your camera—they first have to be copied to a computer. Embarking on a digital journey therefore involves decisions about what computer hardware you wish to use.

After your camera and lenses, the next important item on your list is a personal computer (PC). This can either take the form of a desktop tower with a separate monitor, an all-in-one unit such as Apple's iMac series, or a laptop. Which you choose will depend on your needs—if you travel a lot, a laptop would make sense, for example. However, there are invariably compromises to size that can make laptops less than ideal for photographic work, and it is unusual to find a laptop that is the equal of a desktop PC for the same price. Adding more memory or a larger hard drive is often more expensive than adding the same or similar to a desktop computer, but on the flip side, who wants to carry a desktop computer onto an airplane as hand luggage?

Windows vs. Mac

If you're contemplating buying your first PC, then perhaps your initial decision is whether to buy one that runs the Windows operating system, or an Apple Mac running OSX. Both systems have their adherents who will forcefully defend it against the other, but it's probably fair to say that both systems have their strengths and weaknesses.

Most of the essential software you'll need is available for both Windows and Mac operating systems: Adobe supplies Photoshop and Lightroom for both, and other productivity software, such as Microsoft Word, is also readily available to run in either environment.

Where a Mac loses to a Windows PC is in the amount of useful photographic freeware and shareware that is available—free and low-cost programs and utilities. However, this is changing and there is now a wealth of indispensable software available from Apple's App store. Macs are also generally more expensive than an

∧ **COGS**
A good workflow should be efficient, like a well-oiled machine—your computer is a key part of making that happen.

TABLET DEVICES

Until recently, a laptop was the only option available to the photographer who was away from home, but needed to view and edit files "in the field." Now, tablet devices such as the Apple iPad, are a viable alternative. There are still some issues that make these devices less than ideal for serious work—a lack of storage space, relatively slow processors, and low-resolution screens that (generally) can't be color calibrated—but their small size makes them ideal if you need something discreet that can be carried in your camera bag.

∧ **APPLE iPAD**
The market-leading tablet device.

equivalent Windows computer, and it is more costly to expand their initial capabilities with additions such as a second hard drive. Mac supporters would argue that the cost difference is easily narrowed by the fact that Macs are more of an "all-in-one" solution than a Windows PC, and don't necessarily require the purchase of extras such as anti-virus software.

Unfortunately there isn't the space in this book to list all of the arguments that could be made for both systems, so whether one or the other is right for your needs is very much a personal decision. If possible, try both systems before you buy and canvas the opinion of friends who may have experience of one or the other. Whichever you choose, learn how to use it well to get the most out of what it has to offer.

Performance

Regardless of whether you opt for a Windows or Mac computer, there are three potential performance bottlenecks that will slow down your workflow. If you find this is the case, it may be worth considering a gentle upgrade to a few key components.

The first is really only a consideration if you are buying a computer, and that is the CPU (Central Processing Unit) or, simply, "the processor." The greater the resolution of your camera, the more data your computer will have to work through. The slower the processor in the computer, then the slower that data is processed. Most current PCs now come with multi-core processors, which means a number of separate processors are built into one component. Multi-core processors run in parallel, dividing computing tasks between the different processors to maximize performance. Theoretically, the greater the number of cores, the greater the efficiency, and therefore the faster your software will run.

The second element of a computer that affects performance is the memory or RAM (Random Access Memory), which is where the computer stores information temporarily. If an application, such as Photoshop, does not have enough physical memory to run, then it will start to use the hard drive as "virtual memory" instead. As a hard drive is a mechanical device, it takes time to read and write data, causing delays to the completion of tasks. Increasing the memory in a PC is often a simple way to improve performance, but how much memory you can install will depend on the computer and the operating system. If you have an up-to-date PC running the latest 64-bit operating system then you may find that adding more RAM becomes a necessity rather than a luxury.

The final component that can affect the performance of your PC is the hard drive. A near-full hard drive will cause lots of problems, both in terms of running out of storage and hampering the efficiency of the operating system. If you are a prolific shooter, then it's very easy to fill a hard drive relatively rapidly. If your budget will allow, aim to buy the largest hard drive you can for your computer, and consider investing in external hard drives as well.

∧ **ALL-IN-ONE**
The Apple iMac series is a neat combination of monitor and computer system in an ultra-slim chassis.

∧ **TOUCH SCREEN**
Some desktop PCs, such as this Dell Inspiron 23 7000 AIO 560 all-in-one feature touchscreen technology.

∧ **PORTABILITY**
Laptops are a good choice if you are a frequent traveler—this one is one of Dell's Inspiron range.

Monitors

A number of factors need to be considered when buying a monitor. The first (and perhaps most important) factor is size. Most monitors now have an aspect ratio of 16:9, which is the proportion of the width of a monitor compared to its height. So, if the width were 16 inches, the height would be 9 inches. However, the size you will see quoted when you are buying a monitor is the diagonal measurement from a top corner to the opposite corner at the bottom.

The bigger the screen, the greater the resolution is likely to be. Resolution is important, particularly if you want to use your monitor to display the output from an HD source such as a Blu-ray player (your monitor should be HDCP compliant if this is something you plan to do). True HD requires a resolution of at least 1920 x 1080 pixels, while Ultra HD (4K) has a resolution of 3840 x 2160 pixels. The inputs available on the back of a monitor will also determine how useful it is as an HD device. The monitor should have HDMI or DVI ports as well as a VGA connection for maximum flexibility.

Another important factor, which is a little less obvious is the monitor's viewing angle. Cheaper LCD screens often have a relatively small viewing angle, and if you stray away from the optimum viewing angle the screen will appear to darken and the colors will shift their hue. This is not ideal if you want to produce consistent and accurate color images, so a viewing angle of more than 160 degrees should be the minimum you consider in a monitor.

Color Calibration

Once you've bought your monitor you should calibrate it for color accuracy, because the color output of your monitor is unique: no other monitor will be exactly the same. This is potentially a problem if you want accurate color when you view your images on screen and later, when you come to print those images. Color calibrators allow you to measure the color output of your monitor and adjust it to make it more accurate.

Color calibrators are a combination of a colorimeter, which sits over your monitor, and dedicated calibration software. The software displays a series of color patches and the colorimeter measures the saturation and brightness of these. Once the calibration process is complete a file called an ICC monitor profile is created. Your computer's operating system and compatible software (such as Photoshop) will use this profile to modify the monitor output to ensure accurate colors.

The color output of the monitor will change over time so it is important to re-calibrate your monitor regularly, ideally at least once a month. You should also leave your monitor to warm up for at least 10 minutes before performing any critical image editing.

Tip

Hardware color calibrators are relatively inexpensive, but if you don't want the expense there are free and shareware software calibrators available. These rely on user judgement, so are inevitably less accurate, but it is better to make some attempt at calibration rather than none at all. On a Mac, try using the Display Calibration Assistant built into the operating system, or SuperCal, which is available as shareware. For Windows, try QuickGamma.

∧ **APPLE THUNDERBOLT DISPLAY**
A 27-inch high-end monitor.

∧ **CALIBRATION**
The X-Rite ColorMunki Photo monitor calibrator in use.

∧ CALIBRATION
Calibrating your monitor is essential if you want the colors you see on screen to accurately reflect the colors of your photograph.

Computer Software

The software you choose to use will have some bearing on how your images will finally turn out. Although all editing software has basic features in common, some is better specified than others.

Commercial Software

If your camera can record Raw files, then it will undoubtedly come with software created by the manufacturer to process those files (with the exception of certain Leica models, whose owners can download Adobe Lightroom). Although this is convenient, the disadvantage is that the quality of the software isn't always as good as the commercial alternatives, and it may be less well specified. That does not mean that the Raw software that came with your camera should be discounted: it is free (or the price is absorbed into the cost of the camera) and it should allow you to make most of the adjustments you'll need to apply to your images. However, if you find it unsatisfactory, Raw conversion will be something that you need in your editing software. The good news is that most commercial programs are highly sophisticated in this regard.

Even if you don't want or need to shoot Raw files, editing software is still a near-essential consideration. There will be times when you need it to correct slight technical issues (lighten or darken an image, perhaps, or tweak the white balance) and you may also want to use it for more creative purposes (to convert images to black and white, make montages, or produce stitched panoramas, for example).

Adobe Photoshop

Ask anyone to name an image-editing software package and they'll probably say Adobe Photoshop. Now in its 14th iteration (the slightly controversial CC or "Creative Cloud" subscription model), Photoshop is an image-editing "Swiss Army knife," with features aimed at a multitude of users from photographers to designers and web site developers.

One of the big strengths of Photoshop is the concept of plug-ins. These are tiny pieces of software that can be downloaded and "bolted" onto Photoshop to expand the range of features available. Adobe Camera Raw (ACR) is just such a plug-in and one that allows you to load Raw files into Photoshop. Because ACR is not built into Photoshop directly, it means that Adobe can update it frequently to keep pace with new camera models. It is then just a matter of downloading the latest Camera Raw plug-in, rather than a new version of Photoshop.

Adobe Lightroom

In addition to Photoshop, Adobe also produces Lightroom for both Windows and Mac OSX operating systems. The first version of Lightroom was released in 2007 and has been continually updated since. Unlike Photoshop, Lightroom is specifically aimed at photographers (rather than designers, web site developers, 3D artists, and so on), although many of the tools found in Photoshop have Lightroom equivalents.

Lightroom is intended as a "one-stop shop," with workflow tools that help you with every image-editing task conceivable, from importing and adding keywords, to printing, without recourse to any other software. However, some photographers use Lightroom as the first stage in Raw file editing and then export the image for a final polish in Photoshop.

Unlike Photoshop, Lightroom does not physically alter your images as you adjust them. It is a non-destructive process in which a "recipe" of adjustments is built up as you apply changes. It is therefore possible to return to your photographs at any point and reinterpret them in a completely different way without losing any image quality.

What Lightroom arguably lacks when compared to Photoshop is the ability to make accurate localized corrections to a photograph. However, there is some degree of control, and in some areas Lightroom actually improves on its long-standing stablemate—it is easier to add a split toning effect, for example. Like Photoshop, Lightroom also supports third-party plug-ins that can be used to expand the capabilities of the software.

Adobe Photoshop Elements

Photoshop Elements is a far less expensive little brother to Photoshop, but for some photographers it offers everything they need, from Adobe Camera Raw, through to essential editing tools. Some of the more sophisticated editing tools found in Photoshop are missing from Elements, but that does not mean that it is not a credible option to consider—unlike Photoshop, Elements offers image organization and management tools in addition to editing.

Apple Aperture

Aperture is only available for the Mac operating system (it's made by Apple), but it is an integrated package that allows you to import, keyword, and edit Raw images. A lot of the tools will be familiar to users of Lightroom, and, in a similar way to Lightroom, the program allows you to make non-destructive edits to your images. However, Aperture also includes facial recognition and the use of GPS metadata to match your photographs to a particular location. It also has options for sharing your images on social media web sites and for collating them into books.

Corel PaintShop Pro

The original version of PaintShop Pro was released in 1990, pre-dating mainstream acceptance of digital photography by over a decade. It started life as a simple way to convert between image formats such as .BMP and .GIF. Now, it is a fully-featured image editor that can import a wide variety of Raw format files. As with Photoshop, PaintShop Pro accepts plug-ins to extend the capabilities of the software. At present PaintShop Pro is only available for the Windows platform.

DxO Optics Pro

As the name suggests, DxO Optics Pro is far from a simple Raw converter. At its heart is a technology designed to help correct any optical flaws in your images due to the limits of your lenses. This includes a facility to correct for distortion, chromatic aberration, and image softness. More impressively, extreme lens defects such as volume anamorphosis can be corrected simply and quickly (volume anamorphosis is the apparent stretching of your subject around the edges of an image, typically seen with very wide-angle

lenses). This level of control is achieved through profiles that can be downloaded for different lenses, with the corrections specifically targeted for those lenses.

Phase One Capture One

Produced by Phase One, Capture One is available in two versions: Pro and Express. Capture One Pro is the more expensive of the two, but is more fully-featured than Express. However, you may find options such as tethered shooting (when the output of your camera is sent straight to your PC over a connecting cable) are not needed, in which case Express is a good compromise and is competitive in price to Adobe Lightroom. Both versions of Capture One are available for Windows and Mac OS.

As with Lightroom, Capture One is a workflow package in which images can be imported, keywords added, and image adjustments made. Images can then be output in the format of your choice for general use.

HDRSoft Photomatix

HDRSoft's Photomatix software is a highly regarded HDR image creator that is available in several forms. It can be used as a plug-in for Adobe Photoshop, Adobe Lightroom, and Apple Aperture, or as one of two standalone programs—Photomatix Pro and Photomatix Essentials. Photomatix Pro is the more expensive (and more comprehensive) version of the program, while Photomatix Essentials is a cut-down version with fewer features and a lower retail price. Both versions are available for Windows and Mac.

∧ PHOTOMATIX

If you're looking to create HDR images, then dedicated HDR software often delivers the best results. There are numerous programs available, but HDRSoft's Photomatix software is a favorite with HDR image makers.

Open-source Software

A recent development has been the ready availability of open-source photo-editing software. This software is either free or available for a small fee and is often as sophisticated as commercially developed editors such as Photoshop. Because open-source software is not written by a professional team, support is sometimes patchy, and updates may be less frequent than commercial software. Open-source software may also lack polish and be less well-documented. The upside is, of course, the cost and open-source software often has a devoted following, with online forums where help is readily found.

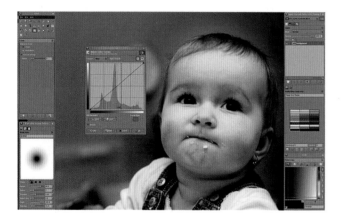

GIMP

GIMP, or the "GNU Image Manipulation Program" to give it its full title, is the most popular open-source image editor. It was originally written for the UNIX operating system, but is now available for both Windows and Mac. GIMP is not promoted as a straight Photoshop replacement, although many functions, such as the ability to use layers, are comparable. Most major file formats are supported by GIMP, and importing Raw files is achieved either through GIMP or by using plug-ins such as UFRAW (Unidentified Flying RAW). Although using GIMP is relatively straightforward, some technical knowledge is needed to install both it and any plug-ins you may wish to use.

∧ TRIAL
It is worth trying different image-editing programs to see which one you like best—if you are new to digital photography you will find that some are more intuitive than others.

PhotoScape

Mooii Tech's PhotoScape software takes a different approach to interface design to Photoshop and GIMP, so if you're familiar with that style it may take some getting used to. That said, PhotoScape is easy to use and well specified. There are options for converting color files to black and white and adding effects such as "antique photo." Raw files can be converted to JPEG for editing. Unlike GIMP, Photoscape is only available for Windows.

Web-based Editing

Another alternative to commercial software is web-based applications. These applications run in your web browser, regardless of the computer platform that you use. The advantage of web-based applications is that they are in constant development, and any upgrades will be immediately and automatically available to you. There are several web-based photo editors that are free to use. As a general rule, they lack the sophistication of software such as Photoshop, but this may well change as they develop.

Pixlr

Pixlr is probably the most sophisticated of the web-based photo editors. Its interface is reasonably similar to Photoshop, although black-and-white conversion is limited to a simple "desaturate" option and creating a half-tone effect. Although layers are supported with Pixlr, there is no equivalent to Adobe's adjustment layers.

SumoPaint

SumoPaint is very similar in functionality to Pixlr, but with fewer options for photo effects. Black-and-white conversions are still limited to "desaturate," but you can tint and add color to your monochrome photographs.

∨ **SOPHISTICATION**
Web-based editing is a viable option for some people, but the features tend to be more simplistic than standalone editing software that you install on your computer.

Import

Your first task once you return home with your memory card of images is to import them to your computer.

Some software will automate the image importing process for you, allowing you to specify where the image should be imported to, what—if any—keywords should be added to the metadata, and whether any process (such as renaming) should be applied to the files as they are imported. Adobe Lightroom falls into this category.

If your software doesn't do this for you, you will have to copy the files manually. Your computer may well offer to do this for you when you first plug the memory card into your USB reader. If this is the case, just follow the instructions on screen. There may be options to rename the files during this process, in which case use the file naming convention you have chosen.

However, if your computer does not offer to import your files automatically, you will need to double-click on the memory card drive icon on the desktop. Double-click on the DCIM folder, and then on the specific camera folder. Select the files you want to import, right click, and choose **Copy...** from the menu. Navigate to the folder you want to import to, right click, and select **Paste...** Then sit back and wait for your images to copy across.

Backing Up
Your images are an investment in time, and effort, so it makes sense to take care of them. Your computer's hard drive is a mechanical device, and although hard drives are very reliable, it may fail without warning. For this reason it is important that your images are backed up on a regular basis, and this is worth doing as soon as you import the files from your camera. You can then format the camera's memory card, knowing that your images are saved in two places—your computer's hard drive and as a back-up copy. If your image collection is relatively small they could

be burned to a CD or DVD, but this should only be seen as a temporary solution as optical media can corrode over time. A better solution is to copy your computer's hard drive to an external hard drive, and continue to make regular back-ups. For even more security you could consider using two hard drives and keeping one at a friend or relative's house, swapping the two drives over at least once a week.

To make the back-up process less painful, it pays to use back-up software rather than dragging and dropping files between hard drives. Good back-up software should be smart enough to know when a file hasn't altered between back-ups, so only new files are copied to the back-up hard drive. This facility can reduce the time taken to back-up a hard drive by a considerable factor.

The ultimate external back-up drive is a RAID (Redundant Array of Inexpensive Disks). This is a device that has a number of hard drives built into it. Data copied to the RAID is divided and duplicated across the hard drives so that if one drive fails the

∧ CARD READER
Unless you connect your camera directly to your PC, a memory card reader is a vital piece of equipment. A multi-card reader, such as Kingston's USB 3.0 Media Reader, will be useful if you have a variety of cameras that use different memory card types.

< RAID
LaCie 2big USB 3.0.

∧ SECURITY

Backing up your computer's hard drive should be an integral part of your workflow. Both Windows and Mac OSX have built-in back-up utilities—this is Apple's Time Machine.

data can still be extracted from one of the good hard drives. The greater the number of hard drives in the RAID the more secure the system. Your computer should make the use of the RAID transparent so you don't have to worry about how the data is distributed across the system.

The next big revolution is Cloud computing and several companies already offer online image-storage services. This has the advantage that your images are stored off-site and so are less vulnerable to hard drive failure (although you have to rely on your chosen storage service having a stringent back-up policy). You will also have access to your images wherever you are in the world, just as long as you have a Wi-Fi connection.

Assessing Your Files

Once you've imported your files and backed them up, it is time to assess them for quality. Whether you delete failures entirely is up to you, but if an image is technically deficient there is a strong case for deleting it immediately.

Images that you are esthetically unsure about are another matter entirely. It's all too easy to make snap judgements about images, with some standing out as being the best of the batch, but there may be more subtle images that don't appeal immediately. Those are the images that should be left alone initially. One option is not to edit the images from a shooting session for a few days if possible. This will allow you to think more carefully about which images work and which ones don't—sometimes the "quieter" images can become favorites after this time of reflection.

At this stage you may want to do a "rating session" on all the images from the shoot. It is usually easier to go through the images in several stages, as opposed to trying to give each one a final rating straight away. Instead of trying to decide whether every image is one of your best ever or just pretty good, simply rate it as "pretty good" or "better" and add a star to its rating. On the next pass through the "better" set, decide if the image is "very good" or "better still." On the final pass through (by which time you will know the images well), look to highlight the outstanding images from that shoot.

File Naming

Each time an image is created, your camera assigns it a file name. However, it is a good idea to rename your files to something more useful, either during the import process or during editing. The key is to use a file naming convention that is infinitely expandable, without repeating, but that is also comprehensible to you.

A system that works well is to split the file name into two halves, with the first half representing the year and the month the image was shot. Using this system, 1504 would indicate 2015 and April (the year is first so that when images are sorted by file name the most recent appear at the top of the list).

The second half of the filename is a four-digit number that gives a count of the images shot in that month. You

Notes

The Mac OSX operating system has back-up software called Time Machine built into it. This application can be set to automatically (and regularly) back-up your hard drive. Super Duper is a third-party alternative.

Windows 7 comes with the Backup and Restore application, while Hyper-V is a commercial alternative.

can use as many digits as you like, but four is usually sufficient (that will allow you to shoot 9999 images in one month, which is quite a lot!).

Keeping Track

As with file naming, creating a good, expandable filing system is important if you want to keep track of your image collection—it will be fairly easy to find a specific picture in a folder containing a dozen photographs, but not quite so straightforward when you have thousands of pictures. There are many possible ways of filing your images and, in many respects, as long as you know how your system works everything should be fine. The problems may start when someone else needs to sort through your images. It is then that a logical system saves time and patience.

A simple solution might be to create a master folder for each category within your main "photographs" folder—"Architecture" for instance. You could then create a subfolder to refine the category—such as "United Kingdom"—and then keep adding subfolders so that the categories become increasingly specific. Eventually, images can be moved to the relevant subfolders depending on how you've categorized them. So, for example, images of Westminster Abbey would be found in Architecture>United Kingdom>England>London>Westminster>Abbey. The Abbey folder could be divided still further if there were specific details that you had multiple shots of, such as Exterior and Interior.

If you shoot Raw, then you may want to mirror this folder system to store both Raw and processed files, so you have two folders—Photography Raw and Photography Converted—each with the same subfolder structure. Keeping your Raw files and converted files separate like this means that you won't see the same files twice in your digital asset management software.

Digital Asset Management

What we have discussed so far is known as "digital asset management" (or DAM), which essentially means having a system in place so that you can keep track of all your

image files. Although Raw conversion software such as Lightroom will maintain a catalog of your images, there is still a place for a standalone program dedicated to digital asset management.

At its most basic, a DAM application is a database of images. Good DAM software should allow you to quickly search for images (either by file name or by keywords read from image metadata); sort your images based on different criteria; and allow you to apply labels or ratings so that you can group images temporarily or permanently as required.

Some DAM software also supports facial recognition, which once the software has learned a particular face, can be used as a search criterion for images. There are several packages available for both Windows and Mac, ranging from comparatively simple and free software, to commercial packages.

∧ **PICASA**
Free-to-use DAM software with basic RAW editing tools.

< FILED

When every one of your images is renamed and categorized you will be able to find a specific shot without too much effort. With careful filing, it would be easy to tell when and where this image was taken. It would be equally easy to relocate it in the future.

Metadata

As well as the image data, useful information known as "metadata" is embedded in all of your digital files.

When you create an image with a digital camera, shooting information, such as the shutter speed and aperture, is saved within the file. This is known as "metadata," which can be read and displayed by imaging software such as Photoshop. It is an excellent way of learning more about your photography. As an example, if you look at the shutter speed field in the metadata, you will begin to get a better idea how different shutter speeds affect the look of your images.

How much information is written to the metadata will depend on your camera: some cameras are relatively terse and only create the bare minimum of metadata, while other cameras embed more information than you'd think would ever be needed. This camera-created metadata is known as Exchangeable Information File Format data or EXIF data for short. It is possible to edit the EXIF data after capture by using specialized software, but it is advisable to leave this information as it is.

User Information

As well as camera-generated EXIF data, user-editable information can be embedded in a file, either during the import process or during postproduction. This editable metadata can take different forms, but the most common is the International Press Telecommunications Council (or IPTC) format, which was originally developed for photojournalists, but is now widely used by most image-editing software. Both Adobe Photoshop and Lightroom allow you to edit IPTC-standard metadata. The most useful fields in the IPTC metadata are the photographer information fields—your name, address, email, and so on—and the description and keyword fields.

A big problem facing photographers is that of "orphan works." These are images that are available electronically, but for which ownership information has been lost. This means that these images could potentially be used commercially without recompense to the original

Note

Adding your name and contact details to an image does not guarantee that it won't become an "orphan work," as metadata can be removed as easily as it is added. However, it provides some safeguard, and is better than nothing.

<< **CAMERA DATA**
This is the EXIF metadata of an image created using a Canon EOS 7D camera.

< **USER DATA**
The edited metadata of the same image, showing information added to the description and keyword fields.

photographer. Filling in the photographer information fields will help to reduce the risk of this happening to your images.

Some cameras allow you to add your name and copyright information to your images as they are shot, and it is well worth doing this, as it is one less step to think about during the import process. Generally, the copyright in the image belongs to you, the photographer, and therefore the name and copyright fields would be tagged with the same information. However, copyright can be assigned to anyone you like, and if you take photographs for the company you work for, you may find that they insist on owning the image copyright.

Contextual Information

In addition to information about yourself, you can also add information to the metadata about the image. The starting point is to add a description of the image in the Description field. It is up to you to decide how the image should be described, but a good rule of thumb is to describe where and when the image was shot, the names of any people in the photograph, and any other information that is relevant and important.

The Keyword field should consist of words or short phrases that describe the various elements of your image. A picture of an apple might have the keywords Apple; Fruit; Food; Tasty; Harvest; Healthy Lifestyle; Ripe; Red; Nature; Freshness; Healthy Eating; Green; and Dieting applied to the metadata, for example. Keywords do not necessarily need to be a literal description of an image; you could also add more conceptual ideas.

Adding information to the Description and Keyword fields is important if you plan to use image-cataloging software, or if you supply images to a photo library. Both rely on keywords to enable searches to be made for particular images. For this reason it is important not to add irrelevant keywords to the IPTC metadata, as this confuses search results and can make the process frustrating.

Outside the Raw File

There is one final example of metadata that you will encounter if you use Photoshop and Adobe Camera Raw on a regular basis. So far, all of the metadata we've

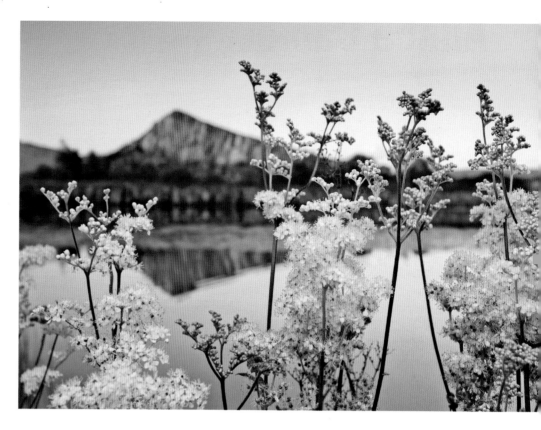

discussed has been embedded in the file itself. However, when you use Adobe Camera Raw to adjust the settings of a proprietary Raw file, these settings aren't applied directly to the actual file. Instead, a new file is created in the same location as the Raw image.

This new file shares the same name as the Raw file, but has the extension .XMP. The XMP file is essentially a "recipe" of the changes you have made in Adobe Camera Raw and the next time you open the Raw file, ACR will read the XMP file and re-apply these changes. If you delete the XMP file, Adobe Camera Raw reverts to the settings applied at the time of exposure.

An XMP file is what is known as a "sidecar" file, storing information that can't be written to the metadata of the main Raw file. If you move or delete your adjusted Raw files to a new location, you will need to make sure the XMP files are also moved or deleted at the same time. Lightroom does not create XMP sidecar files; all the changes you make to a Raw file are held in Lightroom's central database.

∧ **KEYWORDS**
Try to be as comprehensive with your keywords as possible. For this image, geographical details about the location were included, from the specific area, all the way to the country, and even the continent. Next came keywords that noted the time of day, then keywords describing the flora in the foreground. Finally, more descriptive keywords were added that reflected the mood of the image—calm, peaceful, and so on. Searching for any one of these keywords would locate this image.

Adobe Camera Raw

If you intend to use Photoshop to edit your Raw images, Adobe Camera Raw is the first stage in that process. In fact, it is almost possible to take an image to completion in Adobe Camera Raw and just use Photoshop for a final polish.

Adobe Camera Raw (or ACR) is Adobe's proprietary Raw file processing tool, which was introduced in 2003. Over the years it has become popular with many photographers shooting Raw, as an alternative to the software supplied with their camera. As well as being the backbone for Raw file conversion in Photoshop, ACR is also used by Photoshop Elements (in a slightly simplified form) and also works in a "behind-the-scenes" capacity with Adobe Lightroom, making it one of the most widely used Raw converters today.

The various Image Adjustment Tabs are the core of ACR. The adjustments you can make using the various tabs range from basic adjustments, such as contrast and exposure, to more complex alterations that can correct lens distortion and chromatic aberration. There simply isn't space to run through everything in its entirety, so here we will concentrate on the core features in the "Basic" panel (shown below) that will likely be used to polish every Raw file you shoot.

White Balance

At the top of the Basic adjustments panel is White Balance. The initial settings of your Raw file in ACR are those set by your camera at the time of shooting (this is shown as As Shot on the White Balance pop-up menu). However, a significant benefit of Raw files is that you

< **BASIC**
It doesn't take too many "basic" adjustments to start bringing a Raw file to life.

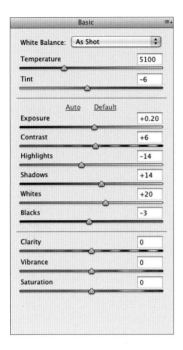

< FUNDAMENTAL
ACR's Basic adjustment panel contains all of the essential tools you need to make fundamental changes to your Raw photograph's color and exposure.

can adjust the white balance if you wish to, by selecting a preset value from the pop-up menu. This is similar to changing the preset on your camera, with similar settings available (Daylight, Cloudy, Flash, and so on). There is also an Auto option that instructs ACR to adjust the white balance of your image automatically (again, similar to setting Auto White Balance on your camera).

As an alternative to the presets, you can use the Temperature slider to alter the color temperature: dragging the slider to the left increases the amount of blue in your image, making it cooler, and dragging the slider to the right increases the redness of your image, making it warmer. If you know the precise color temperature that your image should be set to, you can type the Kelvin value into the text box to the right of the slider.

The Tint slider below adjusts the green/magenta content of your image. This is particularly useful if you shot under fluorescent lighting, as this can have a strong green bias (in which case you would add magenta).

Tonal Adjustments

If you click Auto under Tonal Adjustments, ACR will automatically adjust the tonal range of your image. Although this will often do a reasonable job of creating a pleasing image, it should only be seen as a starting point

for further refinement. Click on Default to restore your image to its starting point.

The Exposure slider is very similar to applying exposure compensation on your camera, in that a positive value will lighten an image and a negative value will darken it. ACR's Exposure control works in stops (again, this is similar to your camera), which means that a value of 1.0 in ACR equals 1 stop. This slider is a good first step in normalizing your image if you've exposed to the right (see page 154). You can also rescue underexposed images, although there is a risk of increasing noise at the same time.

If the highlights in your image are slightly clipped it is possible to recover some detail by using the Highlights slider; the Shadows slider performs a similar function on shadow areas, lightening them without affecting pure black, and extracting detail from the shadows if any is present. Note that overuse of either option can cause unexpected tonal shifts.

Of the remaining sliders, Whites increases the range of light tones that are set to white, while Blacks adjusts the black point.

Brightness is similar to Exposure in that moving the slider to the left or right will darken or lighten your image respectively. However, unlike Exposure, the shadows and highlights are compressed, rather than eventually clipping at maximum adjustment.

Contrast, rather logically, increases or decreases the contrast of your image, affecting mainly the midtones. Pulling the slider to the right increases contrast, making dark-to-middle tones darker and lighter-to-middle tones lighter. Decreasing the contrast pulls all the tones in the image closer to an overall midtone.

Increasing the Clarity of your image increases local contrast, making your image appear sharper. However, if the setting is applied too heavily, halos can begin to appear around edge details in your image. Decreasing Clarity makes your image appear softer, which can be very effective with portraits and black-and-white images.

Vibrance and Saturation alter the vividness of the colors in your image. Pulling the sliders to the left decreases the color intensity, moving them to the right increases it. Vibrance is the subtler control of the two as it prevents colors becoming too saturated.

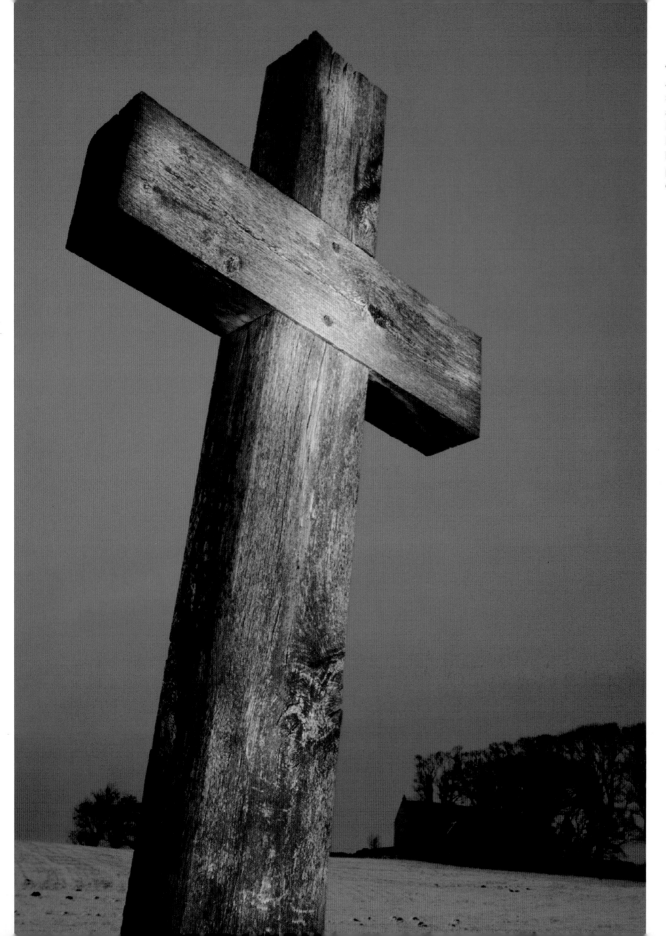

< **WHITE BALANCE**
Although it is a good idea to set the white balance correctly at the time of exposure, this is less important when shooting Raw as white balance can be adjusted when the file is processed. There is no loss of image quality in doing this.

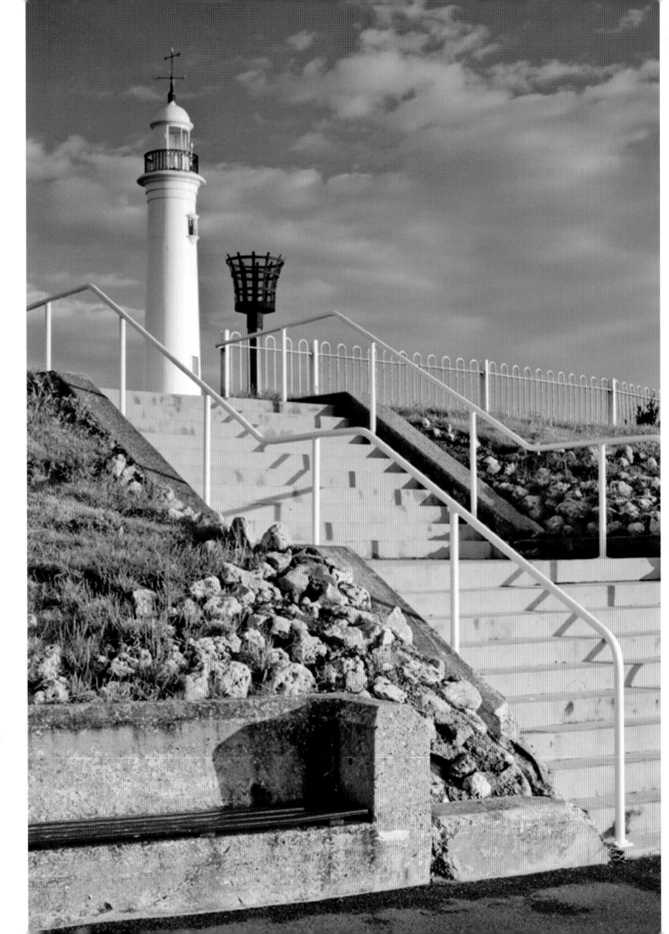

> RECOVERY

Subjects that are white can pose problems with exposure, particularly when there is a direct light shining on them and they have a slight sheen. Highlight detail was lost from the brightest part of the lighthouse in this shot, but ACR's Recovery tool pulled back some of the lost detail.

CHAPTER 10
POSTPRODUCTION

Introduction to Postproduction

In order to realize the full potential of your photographs you will often want or need to process them on a computer. This isn't a new phenomenon— photographers have been tweaking, correcting, and improving images post capture since the advent of photography.

Although postproduction isn't new, today's sophisticated imaging software has certainly made it easier and more accessible than ever before. While some photographers embrace and enjoy this facet of photography, many don't. However, some degree of post-processing is important if you wish to realize your photo's potential— and essential if you shoot in Raw.

Postproduction retouching shouldn't be confused with image manipulation. Manipulation is the application of techniques that alter a photograph to create an artificial result—effects that would be impossible to achieve in-camera. In contrast, retouching is intended to enhance or correct the original, with many photographers doing little more to their images than simply tidying them up, adjusting contrast, and adding a small degree of saturation to enhance the image's color and impact.

Adjustments

There are two broad types of adjustment you can make to an image: global and local. A global adjustment is made to the entire image, whereas a local adjustment is made to a specific area only. An example of a global adjustment tool in Photoshop is Levels, as any changes you make when using the tool are applied across the entire image. However, the Clone Stamp and Healing Brush tools are applied locally, as you retouch specific parts of the image by hand.

A common approach to image adjustments is to start globally and adjust an image until it is broadly satisfactory. Then, start to make local adjustments for specific areas that may need more work. One problem is knowing when to stop, as it is possible to overwork an image to its

detriment. A good way of working is to prepare an image to a certain point and then leave it for a period of time— five minutes or so. Then, when you return to the image, it is often easier to assess whether it is ready or whether more polishing is required.

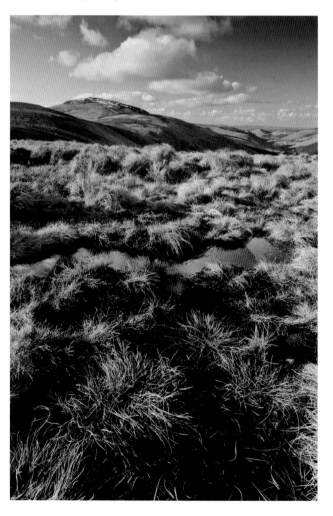

< **LOCAL ADJUSTMENT**
This image has had an exaggerated local adjustment made for the purposes of illustration. However, it could have been subtler, with a local adjustment applied that sharpened the same area to bring out detail in the grasses, for example.

◁ **GETTING IT RIGHT**
Although you should strive
to get the exposure right in-
camera, this is often difficult
in changeable, high-contrast
situations. This shot, for
example, was exposed to
retain as much detail in the
shadows as possible, without
blowing the highlights in
the window frame. Adobe
Lightroom's Graduated Filter
tool was then used to darken
the top window.

Layers

The adjustments you make to an image will permanently alter your picture and the more you adjust it, the more difficult it will be to restore it to its original state. One way around this problem is to use "layers."

Once you've made an adjustment to a photograph in your image-editing software, it is almost impossible to recover what was there previously once the photograph has been saved. Adobe solved this fundamental problem with the concept of "layers," which it introduced with Photoshop 3 in 1994. A layer has a similar effect to placing a sheet of glass over your image: you can draw or paint on the "glass" without altering the image below. Parts of an image can be copied to a layer, allowing you to make local adjustments. You can also add a stencil to a layer—known as a layer mask—which will allow you to specify very precisely which parts of a layer are shown and which are hidden.

Multiple layers can be added to an image and are shown stacked on the Layers palette (see opposite). The order of the layers in the stack runs down from top to bottom, with the highest layer in the stack being above all the other layers. The very lowest layer, at the bottom of the stack, is usually called Background. The order of the layers in the stack can be changed by clicking on a layer and dragging it up and down the stack. Layers can be turned on or off by clicking on the eye icon on the left side of the Layers palette. To permanently remove a layer, drag it down to the trash can at the bottom right of the palette.

∨ **CORE CONCEPT**
This giant apple wasn't really towering over the landscape when the image was made. Instead it's been cut from a different image and pasted into a new layer above the landscape image.

Tip

The Layers panel should be visible when you first install Photoshop. If it is not, you can display it by selecting *Windows > Layers.*

Opacity

Once you've created a layer, you don't necessarily need to display it at full "strength." You can alter the transparency of a layer by altering its Opacity value. When Opacity is set to 100% the layer is fully visible and at 0% it is completely transparent. You can also alter the way a layer interacts with those below it in the layer stack by changing the Blend mode using the pop-up menu. The default is Normal, but there are options such as Multiply and Screen that radically alter how the pixels in the layer interact and are mixed with pixels in the layers below.

Compatible File Formats

Not all file formats support layers. JPEG is not compatible with images with layers, and the layers must be "flattened" before you save in this format. Photoshop's PSD format and TIFF are both compatible. Flattening layers merges them all together so that only the Background layer remains. You can also select multiple layers and merge those together. To select multiple layers click on the layers you want to select while holding down shift. Options such as flattening or merging layers are found on the Layer options pop-up menu or by navigating to the Layers menu at the top of the screen.

LAYERS PANEL GUIDE (PHOTOSHOP)

1. Layer filter pop-up menu. Once a layer stack is a reasonable size it can sometimes be difficult to find a particular layer. Layer filtering allows you to specify which layers are displayed depending on certain criteria.
2. Filter for pixels layers.
3. Filter for adjustment layers.
4. Filter for type layers.
5. Filter for shape layers.
6. Filter for smart objects.
7. Turn layer filtering on/off.
8. Layer options pop-up menu.
9. Blend mode pop-up menu. Normal by default.
10. Layer opacity. Lowering the opacity of a layer decreases the visibility of pixels in the layer.
11. Lock transparency. Locks areas of transparency in a layer so that they can't be edited.
12. Lock image pixels. Locks the pixels in the layer so they can't be edited.
13. Lock position. Locks the pixels in the layer so that they can't be moved.
14. Lock all. Locks all aspects of a layer so that it can't be edited further.
15. Fill. Adjusts the transparency of the image pixels in a layer, but not pixels that have been added using a layer style.
16. View layer icon. Clicking on the icon turns a layer off temporarily. Click again to turn the layer back on.
17. Adjustment layer.
18. Inactive layer.
19. Layer mask.
20. Background. By default the lowest layer in the stack.
21. Link layers. By selecting multiple layers you can link them together for moving or merging together without affecting other layers in the image.
22. Add layer style. Adds an effect to the currently highlighted layer, such as a drop shadow.
23. Add layer mask. Adds a mask to the highlighted layer.
24. Create new fill or adjustment layer.
25. Create a new group. You can collect layers together as a group. This can be used to tidy up the layers panel and stop it looking too cluttered. Like individual layers, groups can be switched off temporarily, this will also switch off all the layers within that group.
26. New layer. Click on the icon to add a new or drag an already existing layer to the icon to make a copy of that layer.
27. Delete layer. Drag a layer down to the trash to permanently delete it.

V COMPLEX

It doesn't take long for a layer stack to look cluttered. Working logically, renaming layers, and collecting layers into groups will help you keep track of the stack. To rename a layer double click on its original name shown in the stack.

Adjustment Layers

Even when you use layers, adjusting an image is still something of an all or nothing affair—if you make multiple changes to a layer, it may not affect the image beneath, but it's still hard to undo. You could go back through the image history and undo all the changes you've made, but this isn't ideal. What would be useful is to apply a global change and then be able to undo it or alter it at any point after that. Fortunately, you can do just that with adjustment layers.

An adjustment layer is added to the layer stack just like a normal layer. However, it contains no pixel information. Instead, it is an instruction to affect all the layers below it with a particular adjustment. Like a standard layer, an adjustment layer can be temporarily turned off, its opacity altered, or it can be deleted entirely.

Let's say you want to make a Levels adjustment to your image. If you click on the **Create new fill or adjustment layer** button on the layers palette and then select **Levels** from the pop-up menu, a Levels adjustment layer will be created and the standard Levels dialog box will then open (either as a separate dialog box in earlier versions of Photoshop, or as a Properties panel in later versions). You would then make the necessary Levels adjustment, which would apply to every layer in the stack beneath the adjustment layer.

If you find that you want to fine tune this layer later, clicking on it (or double clicking) will re-open the Levels dialog, showing your current adjustment, which you can refine as you see fit. As you will see in the next chapter, a common adjustment layer is Black & White.

< SUBTLE
A combination of layers and adjustment layers will allow you to process your images in a sophisticated and subtle way, without affecting the quality of the underlying image.

Note

Not all of Photoshop's tools can be applied as an adjustment layer, but many can:

Solid Color...
Gradient...
Pattern...

Brightness/Contrast...
Levels...
Curves...
Exposure...

Vibrance...
Hue/Saturation...
Color Balance...
Black & White...
Photo Filter...
Channel Mixer...
Color Lookup...

Invert
Posterize...
Threshold...
Gradient Map...
Selective Color...

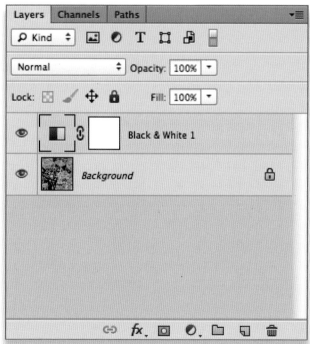

∧ ADJUSTMENT LAYER

Adjustment layers can be added to an image to perform global adjustments to the layers beneath it. Here, a Black & White adjustment layer has been added. The first image (above left) shows the layer temporarily turned off, while the second image (above right) shows the adjustment layer turned on.

Actions & Batches

It would be laborious if you wanted to make the same adjustments to several images, but had to adjust each one individually. Fortunately, actions and batch processing can help.

Actions

Some of the digital "effects" that you apply to your images can be quite elaborate and take some time to complete. If you enjoy using a particular effect—and intend to use it again—then it is worth saving the various steps involved as an "action." An action is essentially a list of how you use Photoshop from the point at which you create a new action and start to Record. This automatic note-taking is halted when you press Stop. Once the action has been recorded, pressing Play will apply exactly the same processes and settings to any other photograph. Actions can be renamed for ease of identification and can be organized into different Sets.

To play an action, highlight the name of the action and press the Play button at the bottom of the palette. Individual processes can be temporarily removed from the action list by clicking on the check mark on the left edge of the palette. Clicking in the same place again adds the process back into the list. Double clicking with the left mouse button on the action name will allow you to rename it.

Photoshop will retain your actions when you close the program, so they do not need to be saved. However, bear in mind that they are lost and cannot be retrieved once they have been deleted.

< **ACTIONS PALETTE**
The Actions palette is where your pre-recorded actions reside. To make it easier to locate them you can put them into different groups or "sets"— this is a Gum Bichromate action (see page 402) stored in a self-explanatory set called Black & White.

1. Stop playing/recording an action.
2. Start recording an action.
3. Play a recorded action.
4. Create a new set.
5. Create a new action.
6. Delete an action.

> **LITH ACTION**
This image has been given a lith treatment (see page 406). By having the various steps recorded as an action, you simply need to press "Play" to apply the effect to future photographs.

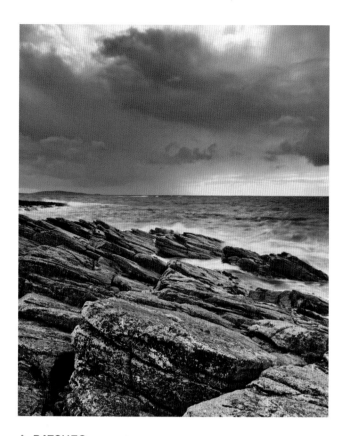

∧ BATCHES

Processing one Raw file is fairly straightforward, but if you want to process dozens of images from the same shoot in the same way, then batch processing makes it easy to change the exposure, contrast, color, white balance, sharpening, and so on.

Batches

When you open several Raw files simultaneously in Adobe Camera Raw, it displays them as thumbnails in the filmstrip down the left side of the ACR window. Initially, the first image in the sequence is selected, but you can change which image is selected by clicking on its thumbnail. Any changes you make in ACR are applied to the selected image.

However, if you select more than one image, the changes you make will affect all of the selected photographs. To select a number of images, hold down the Shift key at the same time as you click on the image thumbnails (you can Shift-click on a thumbnail again to remove it from the selection). To choose the master image, click on either of the arrows at the right to cycle through the selected images.

∧ ACR FILMSTRIP
With three images selected.

∧ SYNCHRONIZE
The Synchronize button allows you to choose which settings are applied across your images.

If you have changed the settings of one image, you can synchronize those settings with any or all of the other images. Either select the range of images you want to change, or click on **Select All** at the top of the filmstrip, and then click **Synchronize**. A dialog box is displayed, allowing you to choose which image adjustment settings you want to apply to your images. Clicking on the pop-up menu at the top of the dialog box allows you to select a range of settings to use.

Cropping

Cropping a photograph is a useful way to reduce the size of an image or to reshape it to a new aspect ratio.

Effective cropping is an incredibly important skill. In an ideal world every photograph we take would be tightly composed, with no extraneous objects jutting into the frame, or obvious visual unbalance. Unfortunately, life isn't like that: sometimes we can't get as close to a subject as we would like, or we might change our minds about the orientation of an image once we view it on screen. The fact is, no matter how hard we try, some pictures still require a tighter crop to meet their full potential.

Cropping is also a popular method of enlarging a subject, making it appear as if it were captured using a longer focal length. As a result, cropping can compensate in situations when you didn't have a suitably long lens at the time of capture. However, when you crop an image you are also removing pixels, reducing the image's resolution. Therefore, you should only crop when it is beneficial.

With the quality of digital sensors being so high today, there is an argument that the advantages of using a shorter focal length—and then cropping the image accordingly—can potentially produce a better result than using a longer focal length in the first instance. For example, the risk of camera shake is reduced using shorter, lighter lenses and a shorter focal length produces a larger depth of field. Also, the majority of lenses perform better at the center of the lens than at the edges, where vignetting and distortion can be a problem—cropping alleviates these problems. However, cropping an image to enlarge your subject will also highlight imperfections or exaggerate poor focusing and, in practice, it is best to only crop an image for the sake of improving composition.

A great way of learning to crop images effectively after capture is to equip yourself with two L-shaped pieces of black card, each about 4cm in width and at least 18cm long on the longer edge. With an image on your computer screen, displayed at roughly the same width as the longest edge of your card, move the two pieces of card around to find the most pleasing crop, as shown right. A similar technique can be used in the field to select your composition at the time of shooting.

Although some cameras have a built-in crop facility, this is typically restricted for use with JPEG images and to a limited range of aspect ratios and sizes. Cropping in your image-editing software allows more control over the cropping process. However, always keep an unaltered copy of the original image, just in case you change your mind or wish to crop the image in a different way.

Tips

If you shoot Raw files, any cropping done in your Raw conversion software is likely to be applied to the image only when it is converted into a JPEG or TIFF. This means you can re-open the original Raw file at any time and re-crop it if you choose to.

In Photoshop, if you move the cursor to just outside one of the corner handles, it will change to a double pointing curved arrow. When this is active, you can rotate the crop selection. This allows you to crop and straighten a crooked image at the same time.

∧ MULTIVIEW

With judicious cropping it's often possible to create several different images from the original file. This image could potentially be cropped in one of four ways (if not more) to create a subtly different emphasis on the various parts of the landscape.

< ∨ PANORAMIC CROP

Cropping is an incredibly effective way of getting the precise shot you envisaged. Here, the pebble beach at the top of the shot had to go, but a panoramic crop was needed to keep the miniature island.

< L-CARD

Two L-shaped pieces of card can be used to determine the best crop for an image.

< GRID

You can usually call up a grid overlay when you crop. This is a useful tool for judging the position of elements in the cropped image and ensuring straight lines are level (the horizon, for example).

∧ VERTICAL

Panoramic crops don't have to be horizontal—with the right subject, a vertical panorama can be equally striking.

Cropping in Photoshop

Although the following steps were performed in Adobe Photoshop, cropping is usually a similar process, regardless of the software you use.

To crop an image:

1. Open the image you wish to crop and select the Crop Tool in the toolbar. Here, we're going to remove some of the sky from this image—the composition works as it is, but a more panoramic crop will give it a different look.

2. In the tool options bar at the top of the screen you can enter an exact width, height, and resolution for the final crop, or you can select from several preset aspect ratios (3:2, 4:3, 5:4, and so on) using the drop-down menu at the left. However, most photographers will crop their images manually, because cropping is an intuitive process that relies on many of the compositional rules and skills outlined in earlier chapters, rather than preset sizes and shapes.

3. Click on the image and drag the cursor to make your initial, rough selection. When you let go, the crop marquee will appear and the area to be discarded will be shaded (usually gray). This gray mask makes it easier to visualize how the cropping will affect the final image. You can usually edit the transparency of the mask depending on how much of the background you want to show through.

4. At the corners and sides of the selection marquee are "handles." When you move the cursor over a handle it changes to a double pointing arrow to indicate that you can resize the crop border. Utilize these to adjust and fine tune your selection. If you drag a corner handle, you can adjust the width and height at the same time. When you are happy with your selection, crop the image by pressing Enter/Return or simply double click.

1

2

3

4

Resizing

Whether you want to create prints for your living room wall, upload files to a stock library, or email images to friends and family, knowing how to resize your digital files will enable you to tailor each picture to the requirements of your audience.

There are two popular methods for changing the size of an image: resizing and resampling. Using the resizing technique, the pixel dimensions of the image remain unaltered and the file size is unchanged. By contrast, when you resample an image pixels are created or removed, so the file size becomes larger or smaller accordingly.

To resize an image:

1. Open the image you wish to alter in Photoshop and then choose **Image > Image Size**. In the Image Size dialog make sure that the Resample Image box is empty and Constrain Proportions is checked.

2. Enter the desired height, width, or resolution in the relevant Document Size box. As soon as you enter one figure, the other two will alter accordingly. Resizing an image in this way means that the Pixel Dimensions (and the overall number of pixels in the image) remain fixed.

3. Once you're happy with the new document size, click **OK** to apply the changes to the image. Be sure to rename the file before saving it.

To resample an image:

1. Open your image and choose **Image > Image Size** from the main menu. Make sure that both Resample Image and Constrain Proportions are checked.

2. Enter the desired height, width, or resolution in the relevant box. As soon as you enter one figure, the Pixel Dimensions will alter accordingly. Resizing an image in this way will make the file size larger or smaller.

∧ RESIZE
When you resize an image the file size and pixel dimensions stay the same.

∧ RESAMPLE
When you resample an image you add or remove pixels, so the file size changes. As a result, resampling can lead to a loss of quality.

3. Below the Resample Image box you will find a drop-down menu offering five methods of interpolation. For most purposes the Bicubic option is ideal, but photographers looking to create large prints may find the Bicubic Smoother offers better results. The Bicubic Sharper option can save valuable time when saving images for web display, but is best avoided for high-quality output. Finally, Nearest Neighbor and Bilinear should both be avoided for anything other than web use. At this point it's worth mentioning that interpolation will make noise and image artifacts more noticeable, so you should only increase the file size when it is absolutely necessary.

4. Once you're happy with the Pixel Dimensions and file size, click **OK** to apply the changes to the image. Be sure to rename the file before saving it.

Perspective Correction

Photographers usually want rectangular or square subjects to look correct in their images. However, if your camera is not parallel to the subject, they will be distorted.

1

2

3

Converging verticals are a common headache when using wide-angle lenses. This type of perspective distortion is most noticeable when photographing a subject with parallel lines, such as a building. As a result of the distortion the subject's sides can appear to lean, creating an unnatural-looking result that may ruin the picture.

Perspective distortion can be corrected at the time of capture by keeping the camera parallel to the subject—typically, this means moving back and using a longer focal length—or by using a dedicated perspective control lens. When neither option is practical any distortion can be corrected during postproduction.

There are various ways to correct converging verticals post capture. Dedicated software and plug-ins are available online, and there are several methods using Photoshop (depending on the version). For this tutorial we will utilize the program's Transform tool.

To correct perspective:

1. This image was taken using a wide-angle focal length of 12mm. The old, derelict building appears to be leaning slightly, which in this instance is distracting.

2. With the file opened in Photoshop, select all of the image by clicking **Select > All**. When correcting converging angles, a grid is a useful aid. This can be overlaid by choosing **View > Show > Grid** from the main menu.

3. Now, choose **Edit > Transform > Perspective.** Eight small squares will appear around the image edges. Click and drag the corner squares in the opposite direction to the way the verticals are tilting. In this instance, that meant clicking on the top left square and dragging it inward until the sides of the building appeared parallel.

4. Fine tune your adjustment, and when you are happy with the degree of correction, click **Return/Enter** or double click on the image. After you have stretched and squeezed your photograph, there may not be enough picture left on one side, or at the top or bottom. Therefore, you may also need to crop the photograph as well.

Levels

Levels is a sophisticated way to adjust the tonal range of your images, allowing you to adjust the strength of the shadow, midtone, and highlight areas with great precision.

LEVELS PANEL

1. **Preset:** choose from a range of preset adjustments.
2. **Channel:** choose RGB, or select individual Red, Green, or Blue channel.
3. **Histogram.**
4. **Black-point slider:** Allows you to set the black point in the image.
5. **Gamma (midtone) slider:** Adjusts the overall brightness of the image.
6. **White-point slider:** Allows you to set the white point in the image.
7. **Black output levels slider:** Allows you to make the black point lighter.
8. **White output levels slider:** Allows you to make the white point darker.
9. **Accept changes and close dialog window.**
10. **Cancel changes and close dialog window.**
11. **Apply automatic Levels adjustment.**
12. **Set options for the Levels tool.**
13. **Black dropper tool:** Click on the image to set the black point.
14. **Gray dropper tool:** Click on the image to set a neutral gray point.
15. **White dropper tool:** Click on the image to set the white point.
16. **Toggle Preview on and off.**

In an ideal world every "standard" image would contain a range of tones from black (shadows) to white (highlights), with plenty of information in between. As a result, every histogram would start at the left side, rise to a peak just short of the center, and then descend gradually to the right edge, leaving a short flat stretch at the end.

Unfortunately, not all subjects and situations offer a standard distribution of shadows and highlights, and not all histograms display a full tonal range. Thankfully, it is possible to make tonal adjustments and improve brightness and contrast using two tools that are found in most image-editing programs: Levels and Curves. Here we will look at using Levels in Photoshop to make global adjustments to an image.

Adjusting Levels:

1. Open the image you wish to amend in Photoshop. We're going to apply Levels using an adjustment layer, so choose **Layer > New Adjustment Layer > Levels**. By creating this new layer, you can make adjustments without damaging the original file in any way, and you can also go back and adjust the Levels later on if you want to. With the most recent versions of Photoshop, changes are made in the Layers panel, which opens at the side of the screen; in earlier versions, Levels will open as a standalone dialog box, as it would if you activated it from the top menu using **Image > Adjustments > Levels**.

Note

Output Levels changes the RGB value of the darkest and lightest tones in a photograph. Move the black output level slider to the right and the darkest tone is lightened; move the white output level slider to the left and the lightest tone is darkened.

2. The Levels dialog contains three controls (arrows) underneath the histogram. The first control (at the left) is the black-point slider, the center control is the gamma (midtone) slider, and the last control (at the right) is the white-point slider. Using these three sliders you can adjust the overall brightness and contrast. Before proceeding, make sure that the **Preview** box (at the bottom of the Levels dialog box) is checked.

3. Move the left slider (black arrow) to the beginning of the left edge of the histogram (A), where the data begins. This ensures that the darkest part of the image is black.

4. Next, move the right slider (white arrow) to meet the edge of the right side of the histogram (B), where the data ends). This ensures that the brightest part of the image is white.

5. If you would like to lighten or darken the midtones in the image you can move the central slider (gray arrow) slightly to the left or right (C). This works in a similar way to increasing or decreasing the exposure.

6. Once you're happy with the results, click **OK** to apply the changes to the image (if Levels was opened in a dialog box). If Levels was accessed from a side panel the effect is applied automatically.

∨ **IMAGE ADJUSTMENTS**
This image (below left) was dull and flat. Moving the black and white sliders into the end of the histogram increased the contrast, while adjusting the middle gray slider lightened the image overall (below right).

A

B

C

Curves

There is a number of tools in Photoshop that allow you to lighten, darken, or add contrast to an image. There is no right or wrong tool to use, but Curves is arguably the most useful.

Curves: Lightening & Darkening

The main feature of Curves is the line running diagonally, from the top right corner of the central adjustment box (see right) to the bottom left (1). This line is the Input line. If you're wondering where Curves comes into this, you can add control points to this line that can be pulled to turn it into a curve. Changing the shape of the Input line controls how the tones in the image are adjusted. Below the central adjustment box is the horizontal Input values strip (2). This represents the original distribution of tones in the image, from black on the far left to white on the far right.

Running vertically to the left of the central adjustment box is the Output value strip (3). This represents the degree to which the Input values will alter once the shape of the Input line is changed. Recent versions of Photoshop also show a histogram (4) within the adjustment box to show the distribution of tones in the image.

When the Input line is straight, the input and output values match. This indicates that no tonal adjustments have been made. To change the shape of the line click anywhere along its length to add a control point. If you move this control point up the Input value stays the same, but the Output value is increased. The Input tones below the control point (5) are altered in the image to match the Output tones to the left (6). This has the effect of lightening the picture (far right). If the control point had been pulled down, the image would have darkened.

By adding more control points and moving these points you can make an increasingly complex curve that will alter different parts of the tonal range. By moving the black point (7) and white point (8) triangle below the Input value strip you can quickly set which tones in the image are darkened to pure black and lightened to white respectively. When you

∧ **PRE-ADJUSTMENT**
This image has not been adjusted.

∧ **POST-ADJUSTMENT**
By moving the control point upward, the image is lightened. The tones closest in value to the Input value (in this case the midtones) are adjusted more than those farther away (the tones at the extremes of the tonal range in this example).

move the triangles, the end points of the curve above move in the same direction. You can also set the black, midtone, and white points of the curve by clicking on the relevant color picker below the Input values strip.

Curves: Contrast

You can add contrast to or remove it from an image using Curves. To add contrast create two control points on the Input line. Until you're happy with how the technique works, start with the control points equally spaced, one-third and two-thirds along the length of the line. Pull the higher control point up, see far right (1), and the lower control point down (2). The Input line should form an S shape. The image will now have more contrast because the lighter tones have been lightened further and the darker tones darkened (the mid-tones will be relatively unaffected). The stronger the S shape, the greater the increase in contrast. To remove contrast add the two control points again, this time pulling the higher of the two down and the lower up. Now the lighter tones have been darkened and the darker tones lightened, bringing all the tones in the image closer to a mid-tone.

Curves: Color Balance

You can also use Curves to adjust the color balance of your images. The default setting of the Channel pop-up menu is RGB (meaning all colors are affected equally). However, when Channel is set to Red, Green, or Blue the curve that you create affects only the selected color channel. If you select Blue, for instance, you can add a blue tint to an image by adding a control point and moving the curve up. By moving the control point down, the amount of blue in the image is reduced, adding a red-green tint.

Notes

Keep Preview checked to see how the image changes as you alter the shape of the Input line.

If you're adjusting JPEG files it's a good idea to work on a copy of your image, rather than the original. This way you can return to your master file if a mistake is made.

< ∧ **ADJUSTING THE CONTRAST**
The original image (above left) lacked contrast. By applying the S curve shown in the Curves panel above, contrast was increased to create the adjusted image (left). Applying an S curve is a very simple way to add contrast and "bite" to an image. By adding more control points it's possible to finely tune specific parts of an image's tonal range.

Retouching

Despite huge advances in "cleaning" technology, each time you change lenses you run the risk of dirt entering the camera body and appearing as dark spots in your images. Thankfully, these blotches—and other blemishes—can be removed using a variety of retouching tools.

The Clone Stamp

The Clone Stamp tool is the oldest and simplest retouching tool, found in most image-editing programs. It works by copying pixels from a specified source area and pasting them over the offending blemish. Photoshop's Healing Brush tool works in a similar way, but it also copies texture and blends colors to create a more natural-looking result. The Spot Healing Brush tool uses the same technology as the standard Healing Brush tool, but in this instance there is no need to specify a source—instead, you just click and drag your cursor over the offending area. Finally, the Patch tool blends colors and copies texture, and is ideal for larger corrections.

Although these are Adobe's names for the tools, most editing programs have similar retouching options available: here we will look at the Clone Stamp and Healing Brush tools.

Using the Clone Stamp:

1. Open the image you wish to amend in Photoshop. Create a new layer by choosing **Layer > New > Layer** from the main menu. When the New Layer dialog box appears, give it a memorable name, such as "Clean up," and press **OK**. By creating this new layer you can clone or move pixels without damaging the original file in any way.

2. Click on the Zoom tool and then click on the image until the offending area has been enlarged by 100%. (You can click on the Hand tool and move around the image by holding the cursor down and dragging it across the frame.)

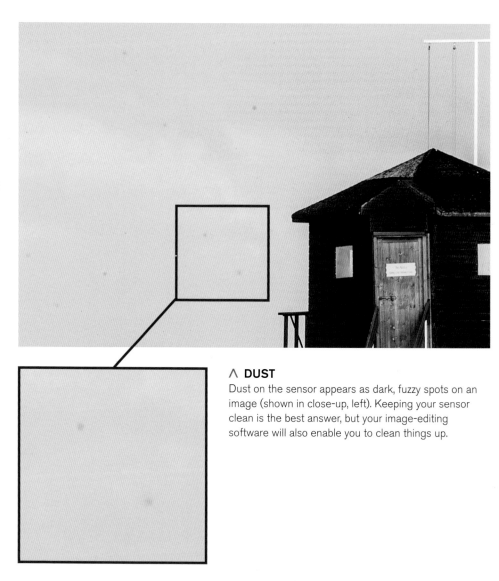

∧ **DUST**
Dust on the sensor appears as dark, fuzzy spots on an image (shown in close-up, left). Keeping your sensor clean is the best answer, but your image-editing software will also enable you to clean things up.

3. Select the Clone Stamp tool from the toolbar by clicking on it. Make sure that the Sample all layers box and the Aligned box (both in the top toolbar) are checked. Choose a style and size of brush from the drop-down menu in the top toolbar—choose a soft-edged brush for areas of detail, and a hard-edged one for areas of uniform color. You need to use a brush that is slightly larger than the blemish.

4. Move the cursor (which will now be in the form of a circle) to a "clean" area, preferably next to the blemish, and similar in texture and color. Hold down the Alt key and click the cursor simultaneously. Now release the Alt key.

5. Move the cursor to the site of the blemish, cover it with the circle, and then click again to paste the pixels you collected in the previous step over the offending area.

6. Use the Hand tool to move around the image, and repeat steps 3–5 until all the dust marks have disappeared. Try to gather pixels from a fresh source every few clicks, or your circular stamping may start to form a pattern and appear obvious.

Using the Healing Brush:

1. Open your image and choose **Layer > New > Layer** from the main menu. When the New Layer dialog box appears, give it a memorable name, such as Healing, and press **OK**.

2. Click on the Zoom tool and zoom the image to 100%.

3. Select the Healing Brush tool and make sure that **Sample all layers** and **Aligned** (both in the top toolbar) are checked. **Source: sampled circle** should also be checked, while **Source: pattern circle** should not.

4. Choose a style and size of brush from the drop-down menu in the top toolbar. You need a brush slightly larger than the blemish you want to remove.

5. Move the cursor (which will now be in the form of a circle) to a "clean" area, preferably next to the blemish. Hold down the Alt key and click the cursor simultaneously. Now release the Alt key.

6. Move the cursor to the site of the blemish, cover it with the circle, and then click again to blend the pixels and conceal the problem area. As the Healing Brush tool blends texture and color from the source and destination areas, the result should appear more natural than using the Clone Stamp tool.

7. Repeat steps 4–6 until all of the blemishes on your image have been removed.

∧ CLONE TOOLS
Photoshop's Clone Stamp tool (top) sits just below the Healing Brush tool (bottom).

< SHIPSHAPE
Dust will show up most obviously in areas of light, continuous tone, such as the large expanse of sky in this silhouette. This is an example of the type of photograph that needs to be examined thoroughly for any blemishes.

Sharpening

Almost every digital image requires a certain degree of sharpening. Before applying the effect it's important to understand two things: firstly, an out-of-focus picture will never magically become pin-sharp, and secondly, sharpening should be applied at the end of the workflow process.

Despite its rather misleading name, sharpening works by increasing the contrast along edges and has nothing to do with improving detail or resolution. As a result, a sharpening filter works best with images already displaying good contrast and fine detail—it cannot rescue an out-of-focus image. While sharpening makes the dark side of edges darker and the light side lighter, over using this effect can lead to unsightly artifacts in areas of high contrast. At this point, it's worth noting that JPEGs are automatically sharpened slightly by the camera, so any extra effects should be used with caution.

The amount of sharpening you apply depends on how you plan to use the final file (print, web site, and so on), which is why it should always be the last step in the workflow process. In addition, as sharpening alters pixel values, it is considered a destructive process, which is why it should be applied during output and not as a part of the general image-editing workflow.

Photoshop offers several sharpening filters, of which Unsharp Mask (USM) is the "traditional" option. USM works by creating a copy of the original image, blurring the second version slightly, sandwiching the two layers together, and then calculating the difference in tone between the two versions. This technique enables the program to identify areas of high contrast and make improvements to seemingly increase sharpness.

To apply Unsharp Mask:

1. Open the image and make sure that it appears full screen (**View > Fit on Screen**). Open the USM dialog box by selecting **Filter > Sharpen > Unsharp Mask** from the top menu. Check that the preview image is set to 100%.

< **UNSHARPENED FILE**
The original RAW file has been adjusted and converted to a TIFF, but no sharpening has been applied at this stage.

< **SHARPENED FILE**
The Unsharp Mask filter has now been applied to the TIFF.

∧ **UNSHARP MASK**
Applying Photoshop's Unsharp Mask (USM) filter, with settings of Amount 100%, Radius 1, and Threshold 0.

2. The USM dialog box features three settings that can be individually adjusted: Amount, Radius, and Threshold. The first setting (Amount) determines the extent to which contrast is enhanced along edges. The second setting (Radius) dictates the size of the area to be affected. The final setting (Threshold) determines how much difference there must be in contrast between two pixels for the sharpening to be applied (if this slider is set to 0, then all of the pixels will be affected).

3. The amount of sharpening required will depend on the intended output of the image, but to start with you might like to try: Amount 100%, Radius 1, and Threshold 0. In order to find the most appropriate settings, it's worth experimenting with the sliders, and checking the results in the Preview box. Once you're happy with the Unsharp Mask settings, click **OK** to apply them to the image.

Smart Sharpen

Although USM is commonly used to sharpen images, Photoshop's Smart Sharpen filter is more intuitive.

1. Open the image you want to sharpen, duplicate it, and resize the duplicate to the required print size (you can close the original image at this point).

2. Select **Filter > Sharpen > Smart Sharpen**. Zoom into the image at 100% magnification. This is useful to see the effect that sharpening is having. The Amount

< APPLYING SELECTIVE SHARPENING
An image doesn't need to be sharpened in its entirety. Here, the rocks were selected and sharpened to bring out detail, but the water was left unsharpened to minimize any loss of quality.

slider controls the degree of sharpening. The higher the Amount, the greater the increase in edge contrast, making the image appear sharper (though increasing unnatural halos at the edges). The Radius slider allows you to specify how many pixels surrounding the edges in the image are sharpened. The higher the Radius value, the further an increase in edge contrast spreads across the image.

3. Remove determines how Photoshop sharpens the photograph. If your image is soft because it is slightly out of focus set Remove to Gaussian Blur—this won't rescue images that are completely out of focus, but it will sharpen a soft image slightly. Lens Blur works similarly, but it is a bit more aggressive in finding edges in the image. Motion Blur attempts to reduce the blur caused by camera shake or movement during exposure. Set the Angle to approximately match the direction of motion blur in the image.

4. Check More Accurate to increase the accuracy of sharpening—with the penalty of Smart Sharpen taking slightly longer at sharpening the image.

5. Click on the Advanced button to fine tune how the highlights and shadows in your photograph are sharpened and click **OK** to apply the sharpening.

Panoramic Images

Shooting panoramic images once meant purchasing specialized and expensive equipment, but digital cameras and image-editing software have changed all that.

There is no absolute consensus on what aspect ratio makes an image panoramic. However, for the sake of simplicity, an image with an aspect ratio of 16:9 (like a widescreen TV) is a good starting point. You can create panoramic images digitally in one of two ways. The simplest way is to crop an image after shooting, as outlined on page 354. Unfortunately, this involves losing much of the image's resolution, limiting the size an image can be printed without a noticeable drop in quality. A better solution is to shoot a number of images sequentially, moving the camera left or right (or even up or down) between each shot. These individual images are then "stitched" together later in postproduction.

Shooting Panoramic Images

Consistency is the key when shooting images for panoramic stitching. The sequence of images should be shot using the same exposure settings, and if you're shooting JPEG, functions such as white balance should be consistent too—these are more easily adjusted in postproduction when shooting Raw. The easiest way to be consistent is to shoot in Manual exposure mode using a custom white balance. Another function that should remain the same throughout the sequence is the focus distance—switching to manual focus is best.

Composing a panoramic takes a certain amount of imagination, as you can't see through the viewfinder what the finished image will look like. First decide where the panorama will start and end. If it's a horizontal panorama you will also need to decide what details at the top and bottom you want to include. Shoot more than is strictly necessary—anything that isn't needed can be cropped later, but you can't add something that wasn't shot in the first place. It may sound odd, but if you're shooting a horizontal

panoramic sequence it's better to keep the camera vertical and vice versa. Shooting this way will require you to shoot more images, but it does give you more scope for cropping later. The width of the panoramic and the focal length of the lens you use will be factors in the number of images you need to shoot. As you shoot, try to overlap each image by roughly one third. This is necessary for your postproduction software to find common points of reference between the images.

It's possible to shoot a panoramic sequence handheld. Keep your camera as level as possible as you shoot. If you vary the height during the sequence it will be difficult to crop a decent sized rectangular image later. It's easier to shoot the sequence with the camera mounted on a tripod, but first ensure that the tripod is level using a spirit level.

Strangely, wide-angle lenses aren't ideal for shooting a panoramic sequence. Lens distortion and slight changes in perspective can be a big problem in the postproduction phase. A moderate focal length or even a telephoto lens will suffer less from these problems.

One problem you may encounter is movement between images. Water, particularly tidal, is one problem area. You may find imperfect joins once the image has been stitched. Inspect the stitched image at 100% magnification to check that everything is seamless. If it isn't, use a clone tool to patch up the joins.

Stitching

Once you have created your sequence you'll need to stitch the images together. If you use a current version of Adobe Photoshop, then the Photomerge function is all you'll need. Some cameras come with free stitching software. This varies in quality, but is generally adequate. Commercial alternatives include Panoweaver and PTGui.

Note

Some cameras have an option to shoot "sweep" panoramics in which the camera is moved in one fluid movement and a panoramic image created in-camera. However, this is usually only available when shooting JPEG and often the resolution is limited.

∧ **SEQUENCE SHOT**
A sequence of seven images shot with the intention of creating a stitched panoramic. Note the overlap between each image in the sequence.

< **STITCHED UP**
The stitched sequence of the seven vertical images. The ragged edges and foreground detail were cropped out of the final panorama.

∨ **CROPPED**
The finished, cropped image, which can be printed 1m (3ft) across at 300ppi. This wouldn't be possible by cropping a single 3:2 format image.

∧ SWEEPING VIEWS

Panoramic images are a great way of encompassing a broad landscape. Here, a standard 3:2 format image would have resulted in too much sky and/or ground: the narrow band of the mountain, early morning mist, and warm sunlight are important in this shot.

CHAPTER 11
BLACK & WHITE

Introduction to Black & White

Creating striking black-and-white photographs was once the preserve of the expert. Now, with a digital camera and the right software, this art form has never been more accessible.

In 1826, the first ever photograph was created. It was in black and white. The idea of creating a color photograph wasn't too far behind, but for most of the 19th century—and well into the 20th—photography was essentially a monochromatic art form.

Black-and-white photography requires you to interpret the world in a different manner to the way you do when shooting color. A black-and-white photograph is a less literal representation of the captured scene. Because there are no color cues, tone and contrast become more important as a means of defining the relationship between the various elements of your photograph. Learning how to see "beyond" color takes practice, but becomes second nature surprisingly quickly.

Seeing in Black & White

There is more to creating a black-and-white (or "monochrome") image than simply removing the color. The image of the cube shown to the right is composed of the three primary colors—red, green, and blue. In color, red, green, and blue are very different, but desaturating the image converts the three colors into the same mid-gray tone. This is because primary red, green, and blue have the same reflectivity.

What is needed is some way to control how colors are converted to black and white. When shooting with black-and-white film this is achieved by using colored filters that let through the wavelengths of light that are similar to the color of the filter, and reduce, or block entirely, those wavelengths that are dissimilar. So, a red filter lets through red wavelengths of light, but blocks blue ones. This has the effect of lightening anything red in an image and darkening anything blue, separating the tones.

∧ **DOCUMENTARY**
Black and white has a natural affinity with street photography and other "reportage" styles.

Although you could use colored filters when shooting digitally, a better option is to simulate them in your Raw conversion software or image-editing program. This will give you more choice as to how an image is converted into black and white, as you can mix the "strength" of the various colored filters for effect.

∨ **CUBE**
Simply desaturating the color cube (below center) produces one overall gray tone. The cube at the bottom was converted to black and white by mimicking a red filter. The red face is lightened the most; the blue face is almost black.

< MONOCHROME

Producing stunning black-and-white photographs is about more than simply desaturating an image: the process starts at the picture-taking stage and continues all the way through to postproduction.

Shooting in Black & White

On the face of it, capturing an image for black-and-white use should be much the same as capturing color, but there are different considerations.

Most cameras have a black-and-white option when you are shooting JPEGs, and some are even able to mimic colored filters. These options will usually be found in the camera's shooting menu. Shooting in black and white with JPEG is permanent—you cannot add the color back once the image has been saved to the memory card (although you can, of course, reset the camera to shoot color from that point on).

Activating your camera's black-and-white mode will also have an effect on Raw files. If you use the Raw conversion software that came with your camera, then these black-and-white settings will be used when you import your Raw files, but unlike a JPEG these settings aren't permanent. Instead, they are just a starting point in the Raw file conversion process, and you can revert to a full-color image by changing the relevant color option in the Raw software.

One option when you're working in black and white (or intend to) is to shoot Raw and JPEG simultaneously, with the camera's picture style set to black and white (or monochrome) and the "filter" option on the camera set appropriately. You can then use the JPEG files as a very quick guide to show you how the Raw files could be converted to black and white. Once you've finished the Raw conversion process, the JPEG files are discarded.

Color vs. Black & White

Although the way in which you record your images is important, you also need to consider the technical differences between color and black and white. Color relies heavily on… well, color… for its impact, as well as subject matter and composition, whereas black and white relies rather more heavily on the subject matter and dynamic range. This means that not all subjects that work well in color will be equally effective in black and white

<SIMPLICITY
Graphic subjects typically work well in black and white, especially when there is a full range of tones.

(and vice versa). Composing a monochrome image can therefore be quite different, as you are looking to distribute tone throughout the image in a way that doesn't apply to color photographs.

Metering for black and white is different too. Color works best within a narrower exposure range than black-and-white images, making the midtone crucial; it is quite common (though hardly desirable), to allow shadows to block up and highlights to burn out in a color photograph.

By comparison, it is usually necessary to ensure the tonal range in a monochrome image just reaches the white point and provides a full range of tones right down to black (except in "high key" images). In effect this means that, given two versions of the same scene, an ideally exposed color image and an ideally exposed monochrome image will be different, with the mono image being tonally richer than the color version and darker overall. The mono image will also benefit from slightly greater contrast, as color images rely on a combination of both tonal contrast and color contrast for effect.

< **BEACH SCENE**
This shot works equally well in color or black and white, but the monochrome version required editing to optimize the tonal range. Increasing the contrast is often necessary with black-and-white images if you want to avoid a "flat" result.

Color to Black & White

Using your image-editing software is the best way of creating black-and-white images, but you will likely discover there is more than one way of losing your color.

Adobe Photoshop is a complex program aimed at a variety of users, from graphic artists to movie effects specialists to, of course, photographers. Since the first commercial version of Photoshop was launched in 1990, Adobe has augmented its line-up with Photoshop Elements for the home user and Lightroom, which has a more specific photographic leaning.

Because of its popularity, we will be using Photoshop for the tutorials in this chapter, but the tools are common across all Adobe products (albeit in a slightly different guise at times). The majority of image-editing programs also have similar tools. If yours does not, then it might be worth downloading the open-source GIMP editing program (see page 332), or you may want to visit Adobe's web site to download a trial version of its software.

∧ **FLAT TONES**
You have no control over how the tones are converted to black and white when using Desaturate. For this reason the results can look very flat.

< **EASY OPTION**
The simplest method for converting a color image to black and white is to desaturate it. Most image-editing programs have a Desaturate command, or you can use a saturation control tool and set the saturation to 0. In Photoshop this tool is called Hue/Saturation.

Desaturate

By far the simplest and quickest way to convert a photograph to black and white in Photoshop is to select **Image > Adjustments > Desaturate**. However, the results can often look flat, as there is no control over how the different colors in the photograph will be converted to monochrome tones.

The same effect can be achieved with **Image > Adjustments > Hue/Saturation** and dragging the Saturation slider down to -100, although you also have the option here to tint your images a single color.

Channel Mixer

Each pixel in your digital photographs is made up of a combination of red, green, and blue. The Channel Mixer allows you to blend different proportions of these colors to create the final tones in your black-and-white images. For example, by increasing the red percentage value you would lighten the gray tones derived from the red parts of your photograph; decreasing the percentage of red would darken the gray tones derived from red.

1. Choose **Image > Adjustments > Channel Mixer** and check **Monochrome** at the bottom of the dialog box. Your image will be converted to black and white, but this is just the default conversion.

2. Use the Source Channels sliders to adjust the mix of red, green, and blue. A total percentage is shown below the sliders, and it is important to keep this as close to 100% as possible: a total greater than 100% will cause clipping in the highlight details of your photo; less than 100% will cause clipping in the shadows. Therefore, if you make an adjustment to one slider, you will have to make an opposite adjustment to one or both of the other two to maintain the correct tonal range.

3. The Preset drop-down menu at the top of the dialog has a range of default settings that mimic the effects of using different color filters. Selecting one of these presets will set the sliders automatically to the relevant red, green, and blue mix.

4. Moving the Constant slider to the right will lighten your photo—moving the slider to the right will darken it.

< MIXER
Photoshop's Channel Mixer used to be the preferred way of converting images to black and white, because it allows a certain amount of control over the conversion process. However, compared to more recent tools it is now a fairly primitive solution.

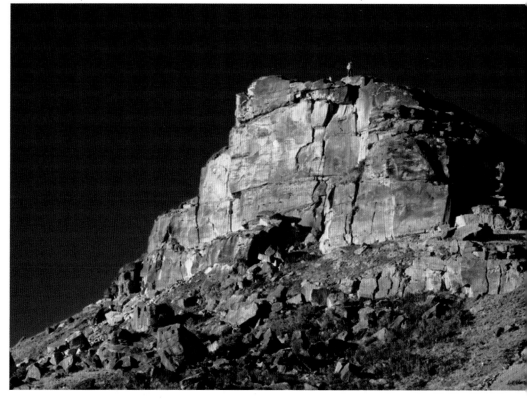

∧ ROSEBERRY TOPPING
The Channel Mixer's Black & White with Red Filter preset was used to convert this image from color to black and white. The blue sky has darkened considerably compared to the color original, but the red rock is much lighter.

Black & White Adjustment

The Black and White adjustment tool offers the most sophisticated Photoshop conversion method. As with the Channel Mixer you control how colors are converted into tones, but the range of colors you can adjust far outstrips the three in Channel Mixer.

1. Open **Image > Adjustments > Black and white**. Your photograph will be converted to black and white.

2. Although you can click on **Auto** to create an automatic color mix based on the colors in your image, you can also adjust the mix of colors by moving the sliders. The greater the percentage of a color, the lighter the gray tone conversion of that color will be; the smaller the percentage, the darker the gray tone. Selecting **Preview** allows you to see the photograph before and after conversion.

3. At the top of the dialog window is a Preset drop-down menu, which houses a range of default settings that mimic the effects of using different color filters, as well as a pseudo-infrared treatment. Selecting one of these presets will set the sliders automatically to the relevant color mix.

4. If you want to save a particular color mix for future use, click on the icon at the right of the Preset drop-down menu. Select **Save** and give your custom preset a relevant file name. Once saved, you will find your custom preset in the Preset drop-down menu where it can be selected for future images.

5. Selecting **Tint** at the bottom of the dialog box allows you to tint your image a particular overall color, as with Hue/Saturation.

< ∧ SHADES OF GRAY
Yellow, orange, and red filters are often used by landscape photographers to deepen blue skies and add drama to outdoor images. An orange-red filter was simulated when converting this image (left), which also lightened the rocks in the foreground, separating them tonally from the fields behind.

> BLACK AND WHITE
Like the Channel Mixer, Photoshop's Black and White tool allows you to control how the colors in your image are converted to shades of gray. However, the range of colors on offer is far more extensive.

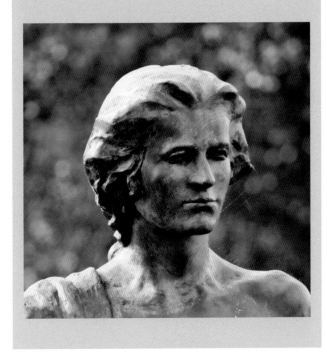

Black and White

Preset: None

OK

Cancel

Auto

Reds: ■ 40 %

Yellows: 60 % ☑ Preview

Greens: 40 %

Cyans: 60 %

Blues: ■ 20 %

Magentas: ■ 80 %

☐ Tint

Hue _____ °

Saturation _____ %

COLOR

The original color photograph is vibrant, rich in red, green, and blue. Even though it makes a strong color photograph, there is also potential for a black-and-white version.

DESATURATE

A simple desaturation converts the image to black and white, but the photograph looks flat and dull. The tones are all very similar and the various elements of the picture seem to be merging into one another. It's a black-and-white photograph, but that's probably the best you can say about it.

BLUE

For the second conversion, the blue tones were made lighter and the reds darkened. This would be equivalent to using a blue filter. It has made the sky a lot paler and the body of the locomotive much deeper. There's a lot more contrast now.

GREEN

This time, a green filter has been simulated. The foliage, the grass, and the trees have been lightened, but the locomotive looks flat and uninspiring.

RED

Finally, the reds were adjusted to simulate the use of a red filter. The sky has darkened and now looks more interesting. The locomotive has more character, too, as the red of the body is lighter and stands out from the black areas more. This is the conversion that works best for this shot.

Beyond Black & White

Photographers have experimented with different visual styles and methods since the medium was invented. With its suite of tools, your image-editing program is ideal if you want to expand your monochrome repertoire.

< **TONAL RANGE**
One of the most appealing aspects of this scene is the wide range of tones in the sky and reflections in the water—applying a solarization effect (see page 392) would push this richness still farther.

Converting your digital photographs to black and white and making basic tonal adjustments is just the start of the many alterations that can be made. Black-and-white photography is a far more expressive medium than color and a photograph can be subject to a wide range of visual interpretations. It would be possible to ask a group of photographers to convert the same basic digital file and see widely differing results. What they will do is bring a bit of themselves to the task, and you should learn to see your photographs as an extension of your personality.

In the rest of this chapter we'll explore some of these possibilities, referring back to traditional darkroom techniques when necessary. The various techniques can be mixed and matched, so each example is not an end in itself. The key is to try each effect and see what most closely matches your personal style. Once you feel comfortable with an effect, try changing some of the settings—there are no right or wrong answers and experimentation is part of the fun.

You will get the best results working directly from your original Raw files. If you have shot in JPEG, copy the files and work on copies rather than on the originals—once you've saved over the original, there's no going back and trying again. As before, we will be working in Photoshop, but Photoshop Elements, Lightroom, PaintShop Pro, and most other good-quality image-editing programs will have the same (or similar) tools.

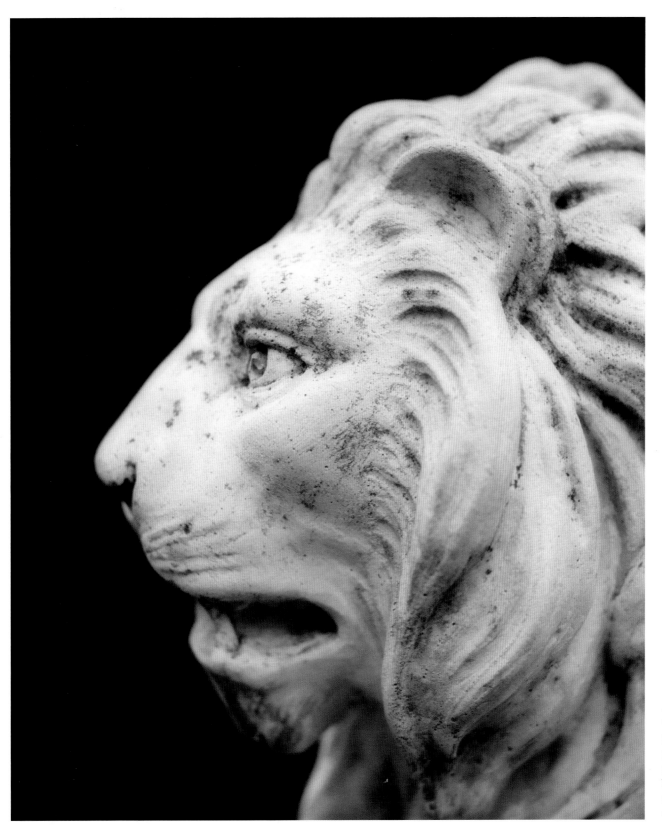

< TONED AND TAMED
This photograph has been fairly heavily altered from a "straight" black-and-white image. It has been warm toned and a soft-focus effect applied. The original file was just a base to work from.

Soft Focus

Sharpness through good technique is something to strive for in your photographs. Or is it? Applying a soft focus effect will bring out the romantic side of your photography.

The most frequent use for a soft-focus filter is to hide wrinkles and blemishes on a person's face. Various strengths of soft-focus filters are produced to achieve this, although breathing on your lens will create a similar effect—you just need to be quick! Another homemade approach is to stretch fine material such as pantyhose over the lens. Different colors of material would, of course, add a color cast, but this is less of a problem if the photograph is going to be converted to black and white.

However, the drawback to all these approaches is that once shot, you are committed to your photograph having a soft-focus quality. Using your image-editing software to soften a sharp photograph in postproduction gets around this problem. The process described here will also allow you to selectively apply soft focus, a level of control that is almost impossible when creating the effect in-camera.

It is not just portraits that benefit from the application of a touch of soft focus. Landscapes and architecture also work well in soft focus, although you will need to pick your subject wisely. Photographs with a high level of contrast will respond well to the technique, while misty scenes— which are already soft and low in contrast—will not.

Applying Digital Soft Focus

1. Open the black-and-white photograph that you want to add soft focus to.

2. Make a copy of the Background layer by dragging it down to the Create a new layer icon at the bottom of the Layers palette.

3. Select **Filter > Other > Maximum**. Use the slider to select a radius. The radius you use will depend on the size of your image. Click on **OK** to continue.

∧ FACE OF AN ANGEL
Some architectural subjects can work well with a soft-focus treatment. In this instance the statue has taken on a diffuse, "heavenly" glow.

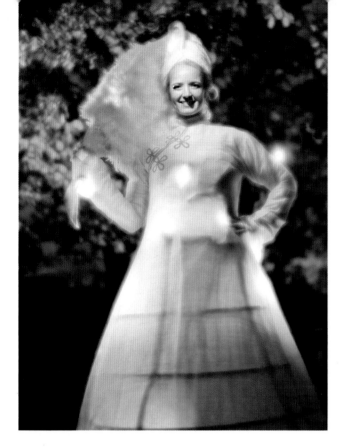

∧ QUEEN OF THE NIGHT

This performer was rigged up in LED lights during an evening performance event. Because the ambient light levels were low, a high ISO was needed. This resulted in a "grittiness" that was out of keeping with the subject, so a soft-focus effect was added.

4. Select **Filter > Blur > Gaussian Blur** and set the pixel radius to half the value used with the Maximum filter. Click on **OK**.

5. Set the Opacity of your layer to between 20% and 40%, depending on how pronounced you want the soft-focus effect to be.

6. Add a layer mask to your layer and use the Brush tool to paint in any areas you want to remain sharp, using black as your foreground color.

7. Add a **Curves adjustment layer** at the top of the layer stack and adjust the contrast to suit.

8. When you are happy with the effect, flatten the layers and save your image.

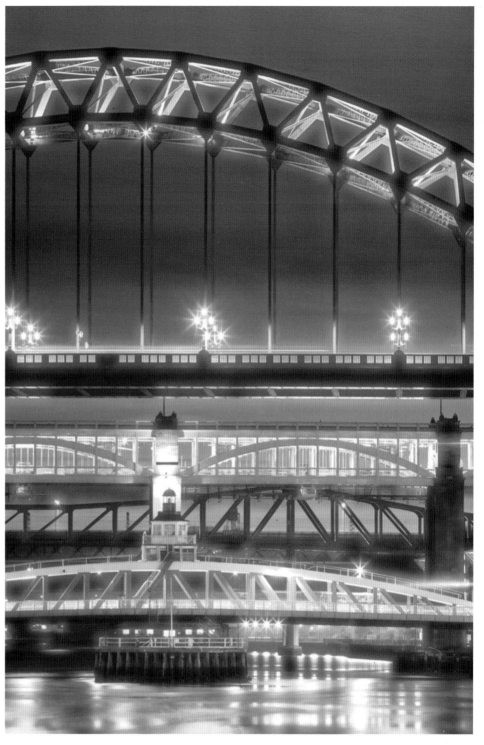

∧ BRIDGES

Adding a soft-focus effect to a lit cityscape works well. The less-attractive details are partially obscured by the effect, while the lights gain an appealing and romantic glow.

Film Grain

Each year sees an increase in the quality of output from new digital sensors. Rather ironically, this often makes digital photographs appear too "clean," and lacking the bite and texture of those shot on film.

Black-and-white negative film is composed of a plastic base coated in an emulsion of photosensitive silver halide crystals. When light strikes the crystals during exposure, they are chemically altered so that when the film is developed they are replaced by black (and therefore opaque) metallic silver. At the same time, the unexposed silver halide crystals are washed away, leaving those areas of the film clear. The sensitivity or speed of a film is determined by the size of these silver halide crystals: the larger the crystals, the more sensitive or faster the film, but also the more grainy the photographs will look.

The appearance of noise in a digital photograph when the ISO is increased is analogous to grain, but digital noise is arguably less attractive, as it tends to be more regular in pattern. By contrast, film grain has a pleasing randomness about it that is visually more interesting. Fast, grainy film is often used creatively with subjects that suit its gritty quality. Fine detail is lost when using grainy film, so simple and uncluttered compositions suit the medium well. There are commercial plug-ins for Photoshop and other image-editing programs that mimic the look of particular types of film, but film grain can be effectively replicated using the standard set of filters.

Adding Digital Grain: Method 1

1. Open the photograph you want to add grain to. It is a good idea to start with an image that has little inherent digital noise.

2. Select **Filter > Noise > Add Noise** and check the **Monochromatic** option at the bottom of the dialog.

3. Select either **Uniform** or **Gaussian** distribution. The difference between the two options is more important

∧ **PYLON**
Industrial subjects suit a gritty, grainy visual style, particularly simple structures, such as this electricity pylon.

when adding noise to color photographs—which one you choose for this exercise is more a matter of taste.

4. Adjust the Amount slider. The greater the Amount, the more noise you will add, but the more detail in your photograph will be lost.

5. When you're happy with the amount of noise you will add to the image, click **OK**.

6. If you decide you want to decrease the effect of the noise added, select **Edit > Fade > Add Noise**. Use the Opacity slider to vary how heavily the noise affects the photograph. The lower the Opacity, the less obvious the effect of the Add Noise filter will be.

Adding Digital Grain: Method 2

1. Open the photograph you want to add grain to.

2. Add a Hue/Saturation adjustment layer and set the Saturation to -100. This will ensure the image remains black and white when grain is added.

3. Select the image layer (this will typically be called Background, unless you've changed the name).

4. Select **Filter > Texture > Grain**.

5. There is a variety of grain effects that can be applied to your image from the Grain Type drop-down menu. Some effects are more natural looking than others, but don't be afraid to experiment. For this exercise choose Enlarged.

6. Use the Intensity slider to vary the intensity of the grain. The greater the Intensity, the greater the effect (and the greater the loss of detail there will be).

7. Adjust the Contrast slider to suit. Leave Contrast set at 50 if you do not want to change the contrast. At 0, the contrast will be decreased with the application of the Grain filter; at 100, the contrast in your photograph will be increased. Fast (and therefore grainy) film generally has lower contrast than a slow, finer-grained film, so don't overdo the contrast if you want to emulate the fast film look.

8. Click **OK** to apply the filter.

9. You can decrease the effect by selecting **Edit > Fade > Grain** from the main menu. Use the Opacity slider to adjust the intensity of the grain effect: the higher the Opacity, the more obvious the effect.

< ∧ HANDS ACROSS THE DIVIDE
Because fine detail is lost with the application of digital grain, it's often the case that the simpler the photograph, the more effective the finished result. Compare the untreated detail of the silhouetted statue (left) to the main image (above). In the main photograph, the shape of the statue is still discernible, despite the heavy application of grain.

Toning

A black-and-white photograph doesn't need to be purely shades of gray. Toning a photograph using a variety of chemicals to create an overall color tint was common practice in the darkroom.

The most familiar type of toning is sepia, a pigment made from the ink of the cuttlefish. Anyone with a collection of old photographs will instantly recognize sepia's warm, brown tint. Although almost a cliché, sepia toning has a practical purpose. When a darkroom print is toned, the metallic silver in the print is converted to another compound. In the case of sepia, the compound is a sulphide. Toning a print often improves the archival properties by making the compounds in the print more stable and resistant to atmospheric effects.

Digitally toning a photograph will not increase its ability to resist fading when printed, but if used imaginatively and subtly it can enhance the effectiveness of your photograph. The art of toning is to choose a color that adds to your picture rather than detracting from it. A warm tone would not necessarily enhance a cold subject, and vice versa. This applies to both temperature and to the emotional atmosphere you wish to convey. It also pays to be subtle—a delicate approach to toning is often more pleasing than oversaturating your photograph.

Applying Digital Toning

1. Open a black-and-white photograph.

2. Add a Hue/Saturation adjustment layer.

3. Check the **Colorize** option in the Hue/Saturation dialog box.

4. For a sepia-toned image, move the Hue slider to the left to 40, change the Saturation value to 20, and leave Lightness at 0.

5. For a cool blue tone, move the Hue slider to the right to 225, change the Saturation value to 20 again, and leave Lightness at 0.

6. Click **OK** once you are happy with the effect.

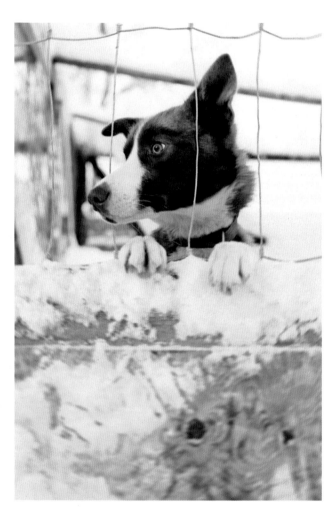

< **SWEDISH SLED DOG**
A blue tone emphasizes the cold, icy feeling of this photograph, and fittingly suits the slightly melancholy expression of the subject.

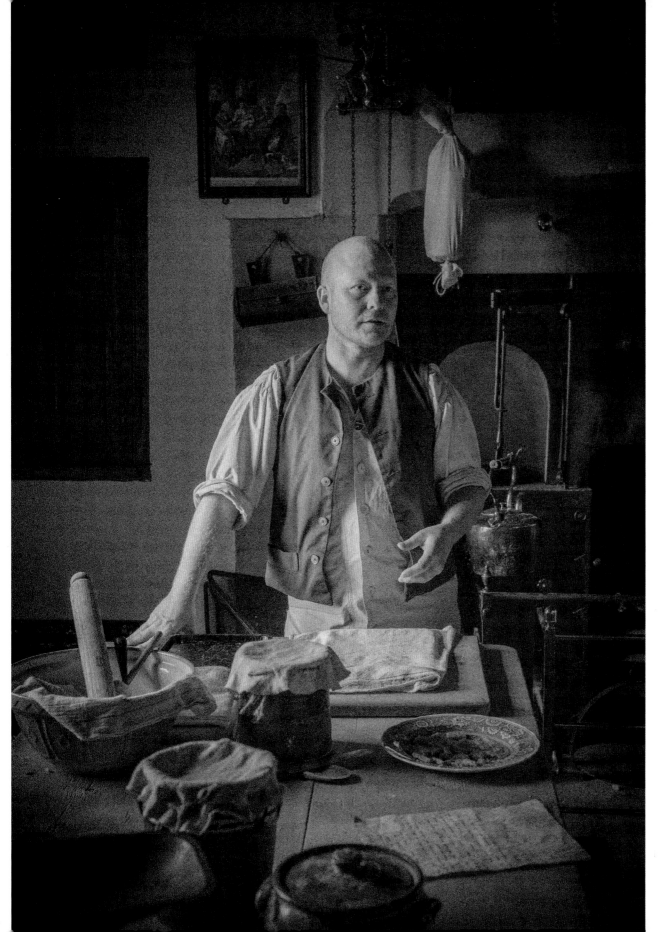

<SYMPATHETIC

Black and white is a less literal medium than color photography. This means that there's arguably more scope for postproduction effects. However, the effects that are applied should still be sympathetic to your subject. This image suited a sepia tint. A cold, blue wash would have been less effective.

Aging your Photos

One of the attractions of black-and-white photography is its timeless quality. This can be pushed to the extreme by artificially "aging" your images.

There are several ways in which a photograph begins to show the effects of age. Ironically, light will have an adverse effect on a printed photograph. Over time, exposure to light will begin to fade a print, reducing the overall contrast. If the print is handled often, it will also start to pick up scratches and marks.

Old photographs also have an interesting visual quality due to the type of film and cameras they were created with. Often, old photographs were shot with lenses that were less sharp than their modern counterparts. This softness particularly affected the corners of the image. Old film types typically had low ISO settings as well, so the camera lens would need to be set to maximum aperture to achieve a reasonable shutter speed. This also contributed to the edge softness of the resulting image. Using a wide aperture also causes vignetting, where the corners of a photo are darker than the center. Artificially recreating all or some of these effects will help you to create a convincing "old" photograph.

Digital Aging

1. Open the black-and-white photograph you want to age and follow steps 2 to 6 on page 388 to create a sepia effect.

2. Add a Curves adjustment layer. As photographs age, they start to lose contrast and become flatter in appearance. Adjust the curve to reduce the contrast and lighten the image. Click **OK** when you're finished.

3. Select the image layer (this will typically be called Background, unless you've changed the name).

4. To simulate lens softness, select **Filter > Blur > Radial Blur**. Set the blur method to Spin, Quality

to Best, and Amount to 1. Select **OK** to continue. The edges of the photograph should now be soft, but the center left relatively unaffected.

5. Another characteristic of old photographs is a darkening of the corners. To add this effect to your image, select **Filter > Lens Correction**. Pull the Vignette slider to the left to darken the corners. There is no correct value, only personal taste. Select **OK** to apply the filter.

6. Finally, add some "grain" using one of the methods outlined on page 386–387.

∨ **TEMPLE GUIDE**
Picking the right subject is important if you want to create a convincing "old" photograph. This portrait of a guide in the temple of Medinet Habu, Egypt has the perfect timeless quality.

∧ FISHING BOAT
This fishing boat looks weather- and time-worn. The color version was interesting, but the "aged" black-and-white conversion has far more atmosphere.

Solarization

A solarized photograph is one that has had part of the tonal range reversed so that dark areas become light or vice versa. The technique was perfected by Man Ray and Lee Miller in the 1930s.

Solarization was discovered in the 19th century, when it was noticed that extreme overexposure of a negative would cause highlights to be rendered as black or dark gray when a positive print was made. The name came from the fact that this effect was most often observed when creating photographs that included the sun. Photographers Man Ray and Lee Miller refined the technique and made it more repeatable by using a bright light source to briefly expose a print while it was being developed.

Overexposing a digital photograph in-camera has no equivalent effect—once the highlights of an image have been clipped, they remain clipped and therefore pure white. It is only by using an image-editing tool such as Photoshop that a similar effect can be created digitally. The easiest way to emulate a solarized photograph digitally is to use a curves adjustment. Curves will allow you to radically alter a proportion of the tonal range while minimizing the effect on other tones.

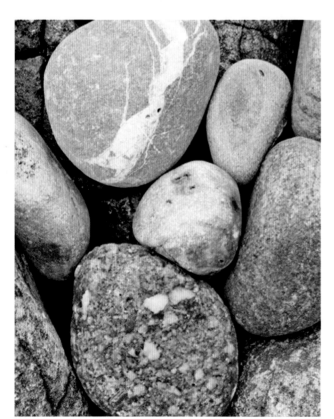

< > PEBBLES
Though there's nothing wrong with the original black-and-white photograph, it could arguably benefit from a little added "punch." Solarizing the image by inverting the dark tones in the shadows (using the curve shown below) did exactly that.

Digital Solarization

1. Open the black-and-white photograph you want to solarize. A simple design with well-defined areas of light and dark will generally produce the most effective results.

2. Add a Curves adjustment layer and add an adjustment point midway along the output curve.

3. Pull either the left (black) end of the curve up, or pull the right (white) end of the curve down.

4. Pull the midway adjustment point in the opposite direction so that the curve is shaped like a bell curve.

6. A U-shaped curve will cause the tones in the photograph that are darker than mid-gray to become progressively lighter, with pure black becoming pure white, but leaving the original light tones unaffected. An inverted U curve will produce the opposite effect.

7. To refine the effect, adjust either the position of the original points on the curve or add more adjustment points and move them around to create a more complex curve.

8. Click on **OK** once you are happy with the effect.

∧ **WHITE SILHOUETTES**
Solarization was embraced by surrealist artists such as Man Ray because of its otherworldly effect on otherwise normal images. Here, a black sky and white silhouettes have been created by reversing the curve shown on the page opposite.

Cyanotypes

This alternative process has a history stretching back to the mid-19th century. As the name suggests, cyanotypes are notable for their subtle cyan-blue tones.

The cyanotype process was developed by the English astronomer Sir John Herschel. Rather than using silver, the cyanotype process uses a mix of iron salts (usually ferric ammonium citrate) and another chemical (such as potassium ferricyanide) as a photosensitive medium.

When exposed to ultraviolet (UV) light, the reaction of these two chemicals produces Prussian Blue, the color that gives the cyanotype its distinctive hue (and name). The length of exposure to UV light determines the depth of the blue that is produced.

The trick to producing a convincing digital cyanotype is recreating the Prussian Blue. The RGB value that most closely matches Prussian Blue is R:00, G:31, B:53—and this is the tone of blue and level of color saturation you should aim for. However, this value should only be used as a starting point—there is absolutely no reason why digital cyanotypes shouldn't be more or less vivid.

<∧ **IRISES**
With this shot, particular care needed to be taken with the Channel Mixer to ensure the flowers were much lighter than the background. Proportions of Red +25%, Green 0%, and Blue +75% gave the most pleasing effect.

Creating Digital Cyanotypes

1. Open the color photograph you want to convert to a cyanotype. A simple design with a good contrast range will generally produce the most effective results.

2. Add a Channel Mixer adjustment layer.

3. Check the **Monochrome** button at the bottom of the options dialog box.

4. Move the sliders to mix the Red, Green, and Blue channels to give the most pleasing result. A greater proportion of blue to red and green will give a more authentic cyanotype look. However, a mix of more than 100% of all the channels combined will cause detail to be lost in the highlights of the photograph.

5. Click on **OK** when you are happy with the color.

6. Add a Curves adjustment layer to the image, above the Channel Mixer layer.

7. Select the red channel from the drop-down menu and pull the curve down at the center.

8. Select the blue channel and add an anchor point that allows you to push the curve upward at the center.

9. Click **OK** once you are happy with curves adjustments.

10. Add a new layer directly above the Background layer. Set the foreground color to R:00, G:31, B:53. Fill the layer with this color and then set the layer blend mode to **Color**.

11. Flatten the image and save.

∧ **SHEEP WOOL**

There was no direct light on the stone wall in the background, but the sheep wool and barbed wire were lit by the late-afternoon sun. The tonal contrast between the three subjects made this image a perfect candidate for a cyanotype treatment.

Splash of Color

Before the invention of the color photographic process, color was added to photographs by hand using special oil paints. In the right hands, the result was a delicate blend of photography and art.

It may seem slightly perverse to add color back into your carefully converted black-and-white photograph, but recoloring an image gives you the freedom to be as literal or as abstract with color as you like. It's not even important to be precise when applying color. Ignoring boundaries and allowing color to bleed from one area to another will give your photographs a hand-crafted look.

Of course, the entire image does not need to be colored either, and using color selectively is a good way to focus attention on one particular part of your photograph. A single object in bright primary colors will leap out from a monochrome background.

Adding Color

1. Open a black-and-white photograph.

2. Add a new layer to your image and set the blend mode to **Color**.

3. Select the Brush tool. Change the hardness and size of the brush if necessary. The smaller and harder the brush, the more delicate your painting will be. Set the brush opacity to 25%.

4. Choose a suitable foreground color using the color picker or swatch palette and paint over the area of your picture you want to add color to.

5. If you make a mistake, use the Eraser tool to remove unwanted color.

6. Continue painting, changing the brush size and color as appropriate.

Subtracting Color

1. Open a color photograph. One with a distinct and brightly colored subject is preferable.

2. Use the Magnetic Lasso tool to draw a selection around the subject. Don't worry if the selection isn't exact at this point.

3. Once you've made your selection, invert it by choosing **Select > Inverse**.

4. Add a Black and White adjustment layer and select the most effective conversion preset for your particular photograph.

5. The subject of your image will now be the only element still in color—everything else will be in black and white.

6. If the boundary between the color and black-and-white areas needs refining, click on the Channels palette and then on the Black and White adjustment layer's mask. The subject of your photograph should now be covered in a semi-opaque color.

7. Zoom into the area that you want to adjust and select the Brush tool. Set the Opacity of the brush to 100%, change the size if required, and set the foreground color to black (R:00, G:00, B:00). Paint the areas of the subject that are not covered in the semi-opaque color.

8. When you are finished, select the RGB channel in the Channels palette and turn off the Black and White adjustment layer mask by clicking on the eye symbol on the left of that channel.

< BLURRED LINES
A variety of colors were used to tint this image of the Angel of the North, Tyne & Wear, UK. The loose approach is an interesting contrast to the very geometric structure of the sculpture.

∧ VICTORIAN MAILBOX
After converting the background to black and white, the red of the mailbox was too vibrant. A Hue/Saturation adjustment layer allowed the red to be toned down for a more subtle effect.

Split-toning

Split-toning is a traditional darkroom technique that involves using two chemical washes to tint the highlights and shadows in two different colors.

Effective split-toning is one of the more difficult darkroom effects to achieve. The technique involves washing a print in toner after it has been developed normally. Chemical solutions used range from sodium thiocyanate to gold chloride, with each chemical toner tinting the print a different color. The effect is varied still further by the amount of time the print sits in the toning bath—the longer the bath, the more pronounced the colors. These chemicals are usually safe when handled respectfully, although the general advice is to wear gloves and work in a well-ventilated room. Fortunately, the digital version of this technique has far less potential for personal harm!

The most interesting split-toning involves employing two tones that are distinct from one another. Most photographers opt for a subtle approach, with a warm set of highlights and a cooler range of shadow tones. However, as with so much of photography, there is no right or wrong answer. Experimentation is the key to find out what works for you and each individual image.

Digital Split-toning

1. Open the black-and-white photograph you want to split-tone. This technique will work with any image that has a wide tonal range.

2. Add a Hue/Saturation adjustment layer, but do not make any changes to the default values at this stage. Rename the layer Shadows.

> **SETTING THE TONE**
The image adjustment options in Adobe Camera Raw include a sophisticated split-toning tool.

3. Add a second Hue/Saturation adjustment layer above the first, but again do not make any changes to the default values. Rename this layer Highlights.

4. Click on the layer mask of the Highlights layer to select it and then go to **Photo > Apply Photo**. Leave the default values as they are and click **OK**.

5. Double-click on the Hue/Saturation icon on the Highlights adjustment layer. Select the **Colorize** option from the dialog box and adjust the Hue slider to tint the highlights in your photograph to the desired color. Click **OK**.

6. Click on the layer mask of the Shadows layer and then go to **Photo > Apply Photo**. Leave the default

values as they are and click on **OK**. Select **Image > Adjustments > Invert** to invert the layer mask.

7. Double-click on the Shadows adjustment layer's Hue/Saturation icon. Again, select the **Colorize** option and adjust the Hue slider to tint the shadows in your photo the desired color. Click **OK**.

8. To adjust the balance of colors between the two adjustment layers, select either of the two layer masks and use **Image > Adjustments > Levels** to change the density of the layer mask. Darkening the Highlights layer mask will reduce the effect of the highlight color, while lightening the Shadows layer mask will reduce the effect of the shadow color.

∧ **CAUSEWAY**
A 10-stop ND filter was used here to artificially extend the shutter speed of this shot. In Photoshop, the corners were darkened and a split-tone was applied.

Infrared

Visible light is just one part of the electromagnetic spectrum that can be used to create photographs. Infrared photography has long been popular due to the dreamlike quality of the images produced.

<SUGAR COATED
This photograph was shot with an IR-modified DSLR. In true infrared photographs trees can appear almost "sugar-coated" when lit by strong sunlight. This is because the chlorophyll in leaves is a strong reflector of infrared light.

Infrared (or IR) photography uses the part of the electromagnetic spectrum ranging from 700nm to 900nm. This light is invisible to the human eye, but is abundant in sunlight, making landscapes a popular subject for IR photography.

IR photography is particularly effective when shooting subjects that either emit IR light or naturally reflect this portion of the spectrum. Green foliage is a good example of a subject that reflects IR light well. In black-and-white photography, this results in foliage being rendered in very pale tones, sometimes completely white.

Digital sensors are highly sensitive to IR light, although this is usually filtered out so that it does not affect your "standard" photographs. However, there are third-party companies that will reverse this so your camera becomes more sensitive to IR, although this type of conversion is usually permanent.

Alternatively, you can buy a filter that blocks visible light and only allows through IR light. Using a filter increases exposure times, so they are only useful for static subjects. Fortunately, it is also possible to recreate the look of an IR photograph in your image-editing software.

Digital Infrared

1. Open the color photograph you want to convert to infrared. This technique is particularly effective with foliage-rich landscape images.

2. Infrared photographs are generally very grainy, so to simulate this, select **Filter > Add Noise** and set the Value to 5. Click **OK** to continue.

3. Add a Channel Mixer adjustment layer.

4. Check the **Monochrome** button at the bottom of the Channel Mixer dialog.

5. Getting the right proportions of red, green, and blue takes some experimentation. Start by setting the values to Red -50, Green +200, and Blue -50.

If any of the tones in your image start to look as though they are brighter than white, lower the Constant slider value to compensate for this. The effect you are looking for is that the blues in the photograph darken considerably and any greens become lighter. When you are satisfied with the effect, click **OK** to continue.

6. Flatten the photograph and duplicate the background layer twice.

7. Set the blending mode of the upper duplicated layer to Screen.

8. Set the blending mode of the lower duplicated layer to Linear Burn.

∧ **YORKSHIRE MOORS**
A key effect of IR images is the darkening to almost black of blue skies. This is most striking when there is a scattering of cloud.

Gum Bichromate

This process is associated with the Pictorialism movement of the late-19th century. The aim of the Pictorialists was to emulate the techniques of non-photographic art forms, such as painting.

The beauty of the gum bichromate process was its manipulability. During the creation of a gum bichromate print, details in the photograph could be altered by using a brush, or erased entirely, and levels of contrast and tone could be finely tuned. Each print made using the process would therefore be unique and irreproducible. This fulfilled the goal of the Pictorialists that photography became an art rather than a purely mechanical process.

The technique used here to emulate the gum bichromate process is only a starting point. Experiment with different effects such as selectively blurring elements in your photographs, or overlaying different textures. The beauty of the gum bichromate method is that there is no right answer—only what you believe to be esthetically pleasing.

As a final touch, choosing which paper to print your image onto will make a considerable difference. The more textured the paper, such as a rough watercolor paper, the more this will emphasize the artistic impact of the image.

Creating a Digital Gum Bichromate

1. Open the black-and-white photograph you want to convert to a gum bichromate. This process is particularly effective with naturally soft images.

2. Add a Gradient Map adjustment layer to the image. Add a new gradient by clicking on the gradient strip in the adjustment layer's dialog box. When the Gradient Editor is displayed, type Gum Bichromate into the Name field and select **New**.

3. Double-click on the color stop, below the gradient strip, at the far left. When the Select stop color dialog box is displayed, set the RGB values to R:82, G:68, B:54. Click on **OK** to return to the gradient editor.

4. Now, double click on the color stop at the far right. When the Select stop color dialog box is displayed, set the RGB values to R:194, G:190, B:155. Click on **OK** to return to the gradient editor. Close the gradient editor by clicking on **OK** and again to exit from the Gradient Map dialog box.

5. Set the foreground color to R:200, G:200, B:200 and the background color to R:140, G:140, and B:140.

6. Add a new blank layer and, using the Fill tool, fill the layer with the foreground color. Select **Filter > Render > Clouds** to fill the layer with a random

∧ **SADDLE TOR**

Other techniques can be applied to your photographs before creating your digital gum bichromate. Some time was spent dodging and burning this photograph to get a good balance of tones in the sky and the foreground rock.

blotchy texture. Set the blend mode of the layer to Overlay and the Opacity to 30%.

7. Add a new blank layer and, using the **Fill** tool, fill the layer with the foreground color. Select **Filter > Noise > Add Noise**. Set the Amount to 80% and check the **Monochromatic** option. Click **OK** to exit.

8. Select **Filter > Blur > Gaussian Blur**. Set the Radius to 4 pixels and click **OK** to exit. Set the layer's blend mode to **Overlay**, leaving its Opacity at 100%.

9. Click on **Add Layer Mask**. Select **Photo > Apply Photo** and choose **Layer to Background** from the drop-down menu. Click **OK** to exit.

10. Add a new blank layer and, using the Fill tool, fill the layer with the foreground color. Select **Filter > Noise > Add Noise**. Set the Amount to 80% and check the **Monochromatic** option. Click **OK** to exit.

11. Select **Filter > Blur > Motion Blur**. Set the Angle to 45° and Distance to 5 pixels. Click **OK** to exit.

12. Select **Filter > Blur > Motion Blur** again. Set the Angle to -45° and Distance to 5 pixels. Click **OK** to exit. Set the blend mode of the layer to **Overlay** and leave the Opacity at 100%.

13. Click on **Add Layer Mask**. Select **Photo > Apply Photo** and choose **Layer to Background** from the drop-down menu. Click **OK** to exit. **Select Image > Adjustments > Invert**.

14. As a further refinement, copy and paste a textural photograph (such as a photograph of stone or cloth) into a new layer. Set the blend mode to **Overlay** and adjust the opacity to suit.

> **ETHEREAL STATUE**
A soft-focus effect around the statue draws the eye to the face and chest. To achieve this, a rough selection was made and the Blur tool was used, before giving the image the gum bichromate treatment.

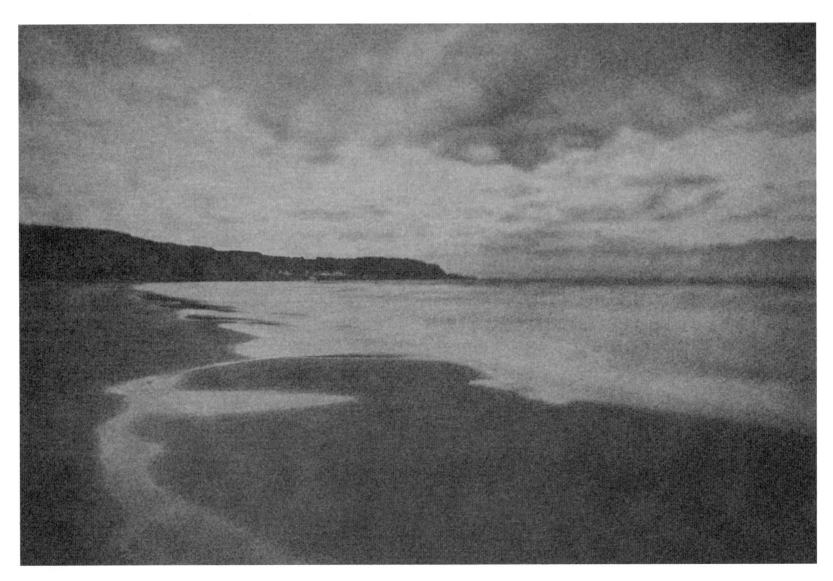

∧ **ANTRIM COAST**
The sky was overcast and there was a chill wind blowing along the beach the night this photograph was taken. Using a blue tone and the gum bichromate process helps to convey the feelings of the night of the shoot.

< **STONE TOWN**
The largest town on the island of Zanzibar has a timeless quality that is perfectly suited to the pictorial qualities of the gum bichromate process.

Lith Printing

A darkroom "lith" print is made using suitable photographic paper processed in lithographic developer. Lith prints are notable for a tonal range of deep shadows to creamy highlights.

Lith printing in the darkroom is a time-consuming and fiddly process. The variables involved mean that each print is unique and essentially unrepeatable. Creating a lith print involves overexposing a print by a stop or two. Darkroom prints get darker the longer they are exposed to light, so overexposing a print counterintuitively means giving it less light. Once the print has been exposed, it is then developed in a lith developer. The colors of a lith print tend to be warm—a mix of chocolates and ivories. Lith prints also tend to be more grainy than a normal print created from the same negative.

The technique described here emulates the distinctive look of a lith print. An image with a good contrast range is recommended as a start point. Because the chemical process is so variable (even the age of the developer you use has an effect on the color of the final print), there is ultimately no "correct" solution—to vary the effect try altering the hue and saturation values in step 4 and the brightness and contrast in step 7.

Digital Lith Printing

1. Open the black-and-white photograph you want to turn into a lith print and add "grain" (see page 386).

2. Copy the Background layer and rename this new layer "Lith effect." Set the blend mode to **Multiply**.

3. Add a Levels adjustment layer above this new layer. Set the Shadow output level to 30. Click **OK**.

4. Add a Hue/Saturation adjustment layer above the Levels layer. Select the **Colorize** option from the Hue/Saturation dialog box, and set both Hue and Saturation to 30. Click **OK**.

5. Select both adjustment layers by holding down the Shift key and clicking on each in turn. Select **Create Clipping Mask** from the Layers palette menu. This will confine the effect of these two layers to the lith effect layer.

6. Select the original photo layer (this will typically be called Background, unless you've changed the name).

7. Add a Brightness/Contrast adjustment layer. Set Brightness to 50 and Contrast to 100.

∧ **BROODING LANDSCAPE**
Dark, stormy landscapes suit the lith print technique. A 3-stop ND grad filter was used here to avoid overexposing the sky, giving a good range of contrast to work with later in Photoshop.

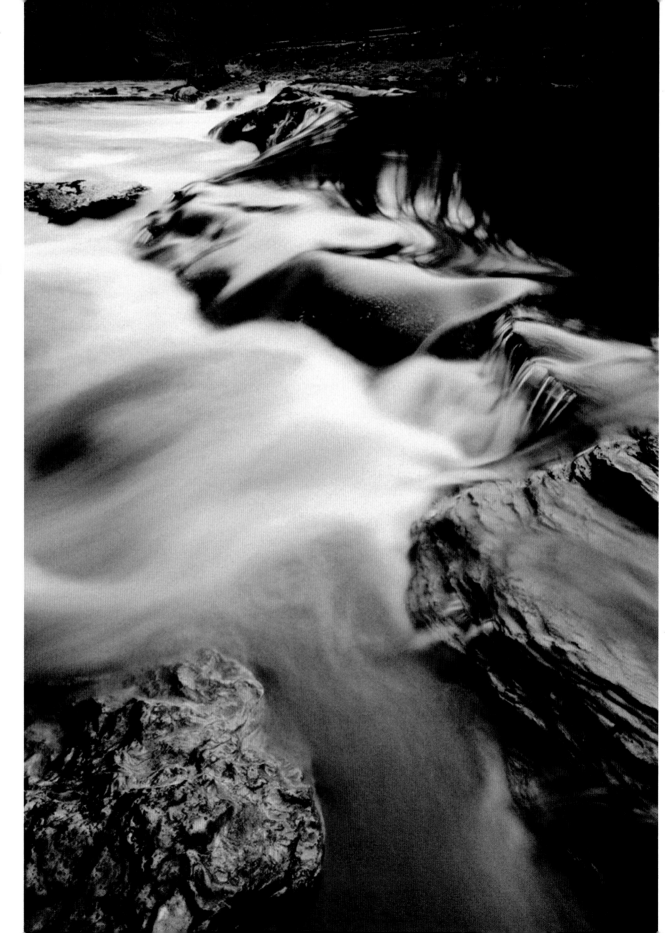

> RICH AND PEATY
The water of the River Roe in
County Derry, Northern Ireland
had a creamy, peaty quality
that worked well as a digital
lith print.

CHAPTER 12
PRINTING

Introduction to Printing

To convert the pixels on the screen of your computer's monitor to a physical form you need a printer. However, printers come in all sorts of shapes and sizes, and some types are better at certain tasks than others.

Inkjet printers are ubiquitous. This has partially been driven by improvements in technology, but the biggest influence on the rise of the printer has been digital photography. Interest in photography is booming like never before and it's only natural that photographers want to be able to make a permanent, physical copy of their favorite images. Inkjet printers allow a photographer to control every aspect of image making, from initial exposure through to the final print. Not so very long ago this level of control was only available to those who were willing to spend hours in a darkroom.

Being a photographer involves a series of meticulous steps, from finding the correct composition and exposure at the capture stage to refining the image quality in postproduction. Printing is merely an extension of this, and achieving a final, satisfactory print involves working through a number of very precisely defined stages. However, before we look at those, let's first turn our attention to buying a printer to start with.

Replacement Cartridges

Buying an inkjet printer is only the start of the costs you will incur. Replacing a full set of ink cartridges can be expensive. However, depending on what you regularly print, you will find that some cartridges are used more quickly than others, so it is rare to need to replace everything in one go.

Check the cost of cartridges for a particular printer before you buy it and look for the manufacturer's fact sheet. This should give you some idea of the printer's potential ink usage. Avoid printers that use a single ink cartridge for all the colors—once one color is depleted, you will need to replace the whole cartridge, even if the other colors are still usable.

Image Quality

The resolution of a printer is measured in dots per inch (dpi). This is the number of individual spots of ink that are laid down across an inch of paper. The different inks in the printer are mixed in varying proportions to simulate the full range of colors in the original photograph.

Printers are capable of printing at different resolutions up to their maximum dpi. The higher the dpi of the printer, the more dots of color it can use for every pixel in the photograph, and the better the tonal gradations on the print. The downside of this is that printing time and ink usage increase the higher the dpi is set.

Printer Speed

Printing a full-quality photograph will never be instant, but some printers manage it more quickly than others. The printer specifications should tell you what the typical print speed is and will be measured in pages per minute. Don't dismiss printers that seem relatively slow, however, since sometimes quality is sacrificed for speed and vice versa. If you regularly print large numbers of photos, speed will be important. If you only use your printer occasionally, the waiting time may not be as onerous as you think if it results in the best possible reproduction of your image.

Print Size

Printers come in all shapes and sizes. Generally, the bigger the printer, the higher the cost. If you only ever intend to print Letter-sized (A4) prints, then a printer capable of printing larger than this is a waste of money. If you occasionally want to print larger photographs, investigate the cost of a photo lab printing them for you. Rather than buying a large printer, the price differential over time—once you've included ink and paper costs—can be in the lab's favor.

> **PRINTING PRESS**
The printing press revolutionized book publishing: inkjet printers have had a similar effect on digital photography.

Inkjet Technology

There is a bewildering choice of inkjet printers on the market today, with new models announced regularly. Chosen wisely, a printer will last for years—the key is to know what you want before buying.

Think of a printer for creating photo-quality prints and you'll probably picture an inkjet printer. Inkjet printers for home and small-office use have revolutionized photography, allowing the printing of photo-quality imagery at a relatively low cost.

The basic principle of an inkjet printer is fairly straightforward. Paper (or another suitable medium) is fed into the printer using a rotating roller. As the paper passes through the printer, the document being printed is gradually created by a moving print head. The print head squirts tiny amounts of colored ink as it scans backward and forward over the paper. Inkjet printers use at least four colors to produce a full color image: cyan, yellow, magenta, and black (some inkjet printers refine this further by adding lighter versions of these four colors for improved color rendition). Each of these colors is held in individual reservoirs, either altogether in one cartridge block or as a series of separate cartridges.

The clever and less straightforward part of an inkjet is the mechanism used to squirt the right amount of ink out onto the paper. There are two technologies commonly used to achieve this. The first method, known as "thermal" printing, uses heat to create bubbles within an ink-filled chamber in the print head. These bubbles cause a change in pressure that forces droplets of ink out of the print head and onto the paper. Canon and HP commonly use this method in their inkjet printers (Canon uses the name Bubblejet for this reason).

The second method, known as "piezoelectric," uses piezoelectric material in a chamber inside the print head. When a current is passed through the material it changes shape. This causes a change in pressure within the printer that forces ink droplets out. Epson commonly uses this technology.

Both systems have advantages and disadvantages. Thermal inkjet printers are usually cheaper to produce, but the ink needs the addition of a volatile compound for the process to work. This compound can cause clogging in print heads.

A slightly underrated aspect of inkjet printers is the precision of their roller mechanisms. The paper must be pulled through the printer extremely precisely to avoid noticeable gaps in the output. And this happens over and over again without fuss. Inkjet printers are astonishing pieces of technology.

The company that produces a particular inkjet printer will also produce the ink cartridges for it. This means that the ink will have exactly the right formulation for the print head to work effectively. Some manufacturers, such as Epson, fit their ink cartridges with microchips. These microchips communicate information about the level of ink in the cartridge to the printer. Once the cartridge is empty the printer will stop working. However, to prevent the user from simply refilling the cartridge, the microchip cannot be reset.

∧ **EPSON STYLUS PHOTO R3000 PRINTER**
A3+ inkjet printer using Ultrachrome inks.

∨ **RESOLUTION**
Modern inkjet printers are extremely high resolution. Canon's Pixma Pro-1 has a resolution of 4800 x 2400 dpi.

< < **CMYK**
This book is printed in a different, but related way to prints made with an inkjet printer. Cyan, magenta, yellow, and black dots (left) are used to build up the full-color images you see on the page (far left).

Droplets of Ink

The concept of inkjet printers squirting droplets of ink onto paper is a very simplified explanation of what happens when a print is made. For a start, the ink droplets are extremely small, typically measuring just 50–60 microns in diameter (as a comparison, a human hair is approximately 70 microns in diameter). Because droplets of ink are used, inkjet printers cannot print continuous tones. Instead, it is the extremely small size of the individual dots bunched together that conveys the illusion of continuous tone.

As previously mentioned, inkjet printers use four basic ink colors: cyan, magenta, yellow, and black. These four inks can be used to create a full-color print by a process known as dithering. Dithering is a technique where the printer adjusts the sizing and spacing of the individual droplets of ink. By dithering the colored inks in the right proportions, the eye is fooled into seeing a full range of colors. It is only when the print is looked at microscopically that it's possible to see how the trick is done.

One way to assess the capabilities of a printer is to look at its maximum dpi value. Dpi stands for "dots per inch"

and is a measure of how many individual droplets of ink a printer can print across one inch of paper. The higher the dpi value, the finer the droplets of ink, and the sharper the final print. The dpi value is therefore the resolution of the printer. Usually printers can print an equal number of dots vertically as well as horizontally. If a printer is shown as having a maximum dpi of 600, it's usually fair to assume that this means 600 x 600 dots will be printed for every square inch of paper. If a printer has a higher resolution in one axis compared to the other, two figures are usually shown (4800 x 2400 dpi, for example).

However, just because a printer has a high maximum dpi doesn't mean that it has to use its capabilities to the full every time a document or image is printed. Printers will typically lower their dpi when printing out in draft or normal mode in order to conserve ink.

The maximum dpi of a printer also only tells part of the story. The type of paper you use will affect the sharpness of the final print. Gloss paper suffers less from dot gain than matte paper, and so prints will look far sharper on this type of paper.

Note

Giclée is a term used to describe a print made with an inkjet printer. The word comes from the French word for nozzle: *gicleur*. The verb form of gicleur is *gicler*, which means "to squirt or spray."

Ink

You won't be surprised to learn that your inkjet printer uses ink to create a print. However, there's more to the story than that.

There are two types of ink currently used by inkjet manufacturers: dye and pigment. Both have advantages and disadvantages, so there's no clear winner.

Dyes

A dye is a colored substance that is either a liquid or is soluble in liquid (water is most often used as a base in which to dilute a dye). When applied to a material (such as cloth or paper) the dye alters the color of the material either temporarily (dyes can be washed away) or permanently (when fixed using a mordant). Dyes were originally derived from natural substances such as plants. Think of the way that the juice from berries stains clothing—a natural dye in action. However, today most commercial dyes are created synthetically using industrial processes.

Using dyes to create the ink for an inkjet printer has a number of advantages. Dyes are inexpensive, so reduce the cost of creating inks. Dyes are also vibrant in color, which means that highly saturated prints can be made reasonably easily. However, dyes aren't particularly

lightfast. A print made using dye-based ink is prone to fading even over relatively short periods of time. That said, technology moves on and modern dye-based inks are much improved compared to those from 10 or even five years ago.

Pigment

A pigment is a colored particulate substance that isn't soluble in liquid. Instead, the particles of pigment are held in suspension by the liquid (again, this is most often water). Pigments aren't absorbed by material in the way that a dye is. Instead the pigments sit on the surface of the material.

Pigments are far more lightfast than dyes. They are an archival product, retaining their color over long periods of time. A print created using pigment ink should potentially last 100–200 years without fading (when using archive-grade paper and when displayed under reasonable light levels).

However, dye-based printers are still being manufactured, so if pigment inks are so good, why

∧ CIS INKS
The ink set for a CIS system fitted to an Epson printer.

∧ EPSON STYLUS PRO R3880 PRINTER
An A2 printer, with full pigment ink set installed.

Notes

Light is destructive over time, causing damage to visual media such as paint and photographic images. This is seen as a reduction in the saturation of colors and the lowering of contrast. Taken to the extreme this could mean loss of the image entirely. The more lightfast an image, the greater it is able to resist this damage. Images that are not lightfast should be kept out of direct sunlight and in extreme cases only viewed under a subdued light source.

Printer manufacturers use proprietary names for their pigment-based inks. Epson uses Ultrachrome and Canon uses Lucia. Confusingly, HP uses Vivera for both its dye and pigment-based inks.

Not every printer will have a compatible CIS product. The most popular printers by Epson, Canon, and HP are usually supported, but these might not necessarily be the most up-to-date models.

don't all printers use them? Well, pigment inks have their drawbacks. For a start, they are more expensive to produce than dye-based inks. They are also not as vibrant as dyes—although technology continually develops and modern pigment inks are far superior to those from a few years ago. Pigments can also create problems with print heads, as the particles in the ink can bond together and clog the print head nozzles if a printer isn't used regularly.

The prints from early pigment-based printers also suffered from a visual effect known as metameric failure (more often, and inaccurately, referred to as metamerism). A print that appears to shift color under different light sources suffers from metameric failure. For example, a cool gray under daylight-balanced lighting may appear to be a warm gray under tungsten lighting. Again, ink technology has improved and metameric failure is not the problem it once was.

Continuous Ink Systems

Keeping an inkjet printer supplied with ink can be an eye-wateringly expensive process. A popular solution to this problem has been the installation of a continuous ink system (or CIS). These are made not by the printer manufacturers, but by third-party companies. A CIS replaces the manufacturer's ink cartridges with new cartridges that are connected to bottles of ink by long, flexible tubes. The bottles can be continuously topped up so that you never run short of ink. The bottles hold far more ink than the original cartridges so ink is bought in bulk, which substantially reduces the cost. Lyson is probably the best-known maker of a CIS product, although there are different systems to choose from.

There is a big drawback to using a CIS, though. When you install a CIS, you are essentially modifying your printer, which will invalidate your warranty. It's therefore not a good idea to install a CIS product if your printer is still under warranty.

A slightly less worrying drawback is that the ink in a CIS is not the same ink that will have been used in the printer's original cartridges. This means that you will need new profiles for the paper you use

regularly. Fortunately, profiles for popular papers will generally be available from the web site of the CIS manufacturer. If you use a more obscure type of paper you may need to create a bespoke profile. Manufacturers such as Lyson usually also produce their own range of papers and will supply profiles free of charge for these products.

∧ **BLACK AND WHITE**
Printing black-and-white images used to be a challenge for inkjet printers, resulting in prints that suffered from metameric failure. However, this is no longer the case with modern printers.

Print Media

Preparing an image for printing involves a number of creative choices and those choices don't end when you switch on your printer.

You may have a printer, but now you need something to print on. The most obvious and easily obtainable print media is paper. However, there are many different kinds of paper, some more suitable to certain printing tasks than others. The type of paper you use is also an esthetic—and therefore very personal—choice.

Other issues you need to consider are more technical. As mentioned, there are two types of ink currently used by inkjet printer manufacturers. Some papers are suitable for both types, while other papers are designed specifically for one or the other. The size of your printer will also determine the maximum size of the paper you can use. However, there are some inkjet printers that will allow you to use roll paper. Although your printer will still restrict the width of a print, the length would be limited only by the size of the roll, or perhaps the amount of ink in your printer's cartridges!

You don't necessarily need to print on paper either. If you're using an inkjet printer there are other media options that are worth exploring.

Paper

When you think of making a print it's almost certain that you'll think of using paper to do so. Paper is a ubiquitous product. Not so long ago it was thought that digital technology would reduce the need for paper; the "paperless" office is a phrase that was once thrown about quite freely. Instead, we use more paper than ever before, with the popularity of home printing being one of the contributing factors.

Paper is freely available and comes in a wide variety of sizes, weights, and finishes (see page 418). Most printer manufacturers produce paper designed specifically for use with their printers, but you don't need to stick with that—there is a bewildering range of printer paper available from third-party manufacturers ranging from everyday gloss paper to specialist archival fine-art papers.

Canvas

An inkjet printer doesn't use heat to bond ink to a surface (as laser printers do), so this expands the range of media that can be used. A popular way to display images is on canvas. Until relatively recently this was only possible using commercial offset printing. However, this is an expensive process only suitable when large numbers of a particular print are required. A more bespoke service was only made possible through the widespread availability of inkjet and, to a lesser extent, dye-sublimation printers.

There is now a wide choice of companies that will print and finish individual canvas prints relatively cheaply, but there's no reason not to print on canvas at home.

< **CANVAS**
Canvas has a very distinctive, regular texture.

Unfortunately, not all printers can print to canvas so the first step is to check whether your printer can. Printing to canvas is generally more effective with pigment-ink printers than those that use dye-inks. A big difference between canvas and paper is that canvas must be kept taut once the image has been printed. This is usually achieved by stretching it tightly over a wooden frame to prevent it sagging.

Film

Inkjet printers can also be used to print to inkjet-compatible transparent film, which is a film with one slightly roughened side that the ink can bond to. Printing onto film has numerous uses, from creating images that can be backlit to printing large-format negatives that can be used to make contact prints for traditional printing processes.

∧ SOFTNESS

The choice of media you use to create a print often depends on the subject. This long-exposure black-and-white image has a soft quality, making it ideal for printing on matte paper or even onto canvas.

Paper

In the pre-digital days there was only one type of photographic printing paper. This was paper coated with a light-sensitive emulsion of silver-halide salts that was developed and fixed in a series of chemical baths.

Digital printing paper shares many of the qualities of darkroom printing paper, but with one important difference: it is not light sensitive. Paper designed for inkjet printers has a special coating on the surface, known as the ink receptor coating (IRC), which can have a gloss, semigloss, or matte finish—the one you select is very much a personal choice.

Gloss is by far the most popular type of paper, partly because the finish is very similar to a traditional darkroom print. The surface of gloss paper is generally durable and resistant to damage caused by handling. Contrast and the saturation of colors is higher on gloss paper compared to semigloss or matte paper. The latter factor is due to the fact that gloss paper has a relatively high color gamut compared to semigloss or matte paper.

Another advantage of gloss paper is that an image will appear sharper, particularly in comparison to matte. However, gloss paper is reflective, and in the wrong light it can be difficult to see an image that has been printed on it. There is also an argument that gloss paper lacks subtlety: for some subjects it can appear too strident.

A reasonable compromise is semigloss paper. This is less reflective than gloss paper and also has a lower apparent contrast and color range. Semigloss paper therefore lacks some of gloss paper's punch, but if you intend to display prints under difficult lighting conditions it is a useful choice.

Matte paper is non-reflective, which makes it ideal for prints that will be displayed in rooms with numerous point light sources (although putting a matte print behind glass will negate this advantage). Matte paper absorbs more ink than gloss paper, so images look slightly softer in comparison, and color and contrast is also lower. However, matte paper is worth considering for images that require a more subtle approach.

Note

Semigloss paper is also known as satin, silk, eggshell, oyster, or luster, depending on the manufacturer. Most gloss and semigloss papers only have a coating on one side of the paper.

Note

Using an inkjet printer, the same text was printed onto two different types of paper, one uncoated (below left) the other coated (below right). The text on the uncoated paper is far less sharp because of ink spread.

:hat AEB all :hat AEB all
sistent. Dep sistent. Dep
1/2 or 1/3 1/2 or 1/3
ll depend o₁ ll depend o₁

< **SHINY**
Prints made on glossy paper are highly reflective. Ideally they should be displayed away from point light sources.

< **PAPER APPEAL**
Paper comes in many forms,
but some are more suitable
for printing onto than others!

Texture

The surface of paper can be perfectly smooth or it can be textured. As a general rule, gloss paper is either smooth or subtly textured, while matte paper can be smooth, slightly textured, or heavily textured. As with most aspects of photography and printing, the choice of which paper you use is very personal. However, images will invariably look softer on textured paper. Another potential problem with textured paper—particularly if it has not been designed specifically for printing purposes—is that dust from the paper may cause damage to print heads and the paper may jam the printer.

Size

Paper is sold in set sizes and there are two size systems that are commonly used today: the ISO 216 standard and the North American ANSI system.

The international ISO 216 standard uses the letter A followed by a number to define the size of the paper. The largest ISO standard size is A0, which is 841 x 1189mm. The next largest size is A1, which is created by halving A0 along the longer side to create a sheet that is 594 x 841mm. The size of each successively smaller sheet in the series is derived this way, so A2 is half the size of A1 (and one quarter of the size of A0), but twice the size of A3 and so on. The smallest ISO standard paper is A10, which is a minuscule 26 x 37mm.

Each size—from A0 to A10—has the same width-to-height proportions of 1:1.41, although an interesting anomaly is the A3+ or Super A3 size. This is a paper size not recognized by the ISO 216 standard, but it is now a widely accepted size supported by printer and paper manufacturers. Indeed, many printers are now sold on the basis of being A3+ compatible.

The ANSI system is used only in North America and in countries such as the Philippines. It is based around the standard North American Letter size of 8½ x 11 inches (or ANSI A, roughly equivalent to A4). Unlike the ISO 216 standard, a single letter (starting with A and ending with E), defines the different sizes in the series. The ANSI series also differs from the ISO 216

standard in that the aspect ratio is not constant through the series. It alternates between 1:1.29 (so that the height of the paper is 1.29 times longer than the width) and 1:1.54 (when the height of the paper is 1.54 times longer than the width).

Paper format	Size (mm)	Size (inches)	Aspect Ratio
ANSI A	216 × 279	8½ × 11	1:1.29
ANSI B	279 × 432	11 × 17	1:1.54
ANSI C	432 × 559	17 × 22	1:1.29
ANSI D	559 × 864	22 × 34	1:1.54
ANSI E	864 × 1118	34 × 44	1:1.29

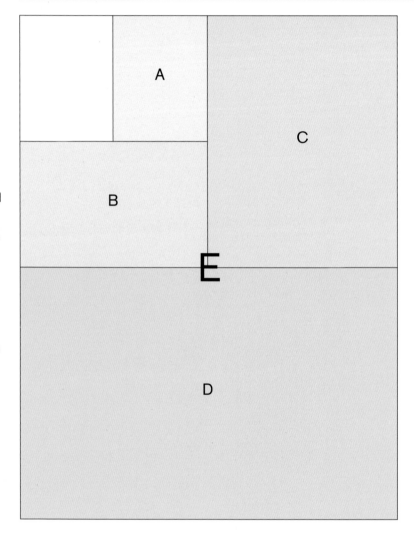

∧ **ANSI PAPER SIZES**
The proportions of the ANSI sizes noted above are illustrated left. It is interesting to note that when ANSI B is used vertically it is also referred to as Ledger, when used horizontally (as in the illustration) it is also known as Tabloid.

Paper format	Size (mm)	Size (inches)
A0	841 × 1189	33.11 × 46.81
A1	594 × 841	23.39 × 33.11
A2	420 × 594	16.54 × 23.39
A3+	330 × 483	13 × 19
A3	297 × 420	11.69 × 16.54
A4	210 × 297	8.27 × 11.69
A5	148 × 210	5.83 × 8.27
A6	105 × 148	4.13 × 5.83
A7	74 × 105	2.91 × 4.13
A8	52 × 74	2.05 × 2.91
A9	37 × 52	1.46 × 2.05
A10	26 × 37	1.02 × 1.46

∧ ISO 216 PAPER SIZES

The 3:2 aspect ratio of many digital cameras is a reasonable match to the ratio of the ISO 216 standard.

ICC PROFILES

Every digital imaging device (cameras, monitors, printers, and so on) has a different color gamut, which is the range of colors the device can successfully reproduce. To start with, your printer will not be able to reproduce all the colors on your monitor (and vice versa), but to make matters more complicated still, the type of paper you use will also affect how colors are reproduced on your prints. This is because different types of paper absorb the inks in different ways—matte paper, for example, is far more absorbent than gloss.

To avoid problems arising, Photoshop—as well as other image-editing programs—uses information files known as ICC profiles to help translate the color characteristics of one device when used with another. If you have calibrated your monitor, for example, then Photoshop will know exactly how your monitor displays colors, because it will have an associated profile.

You will also need a profile of the paper that you want to use with your printer. When you print an image, Photoshop compares the two profiles and modifies the printing process so that the colors on the print will be as close to those on the monitor as possible.

If you use paper by the same manufacturer as your printer, you will usually find the correct paper profiles were added when the printer drivers were installed. If they are not already there, they are usually readily available for download from the manufacturer's web site. Third-party paper producers also often produce profiles for popular printers. If no profiles are available, you can have them made for specific printer/paper combinations by a specialist, or invest in a printer profiler device.

Installing profiles

If you have downloaded or created a paper profile, it must be installed so that Photoshop knows where to look for it.

Mac OSX

Move the profile to **Library > ColorSync > Profiles** on your computer's hard drive.

Windows XP/Vista/7

Right click on the profile and select **Install Profile** from the pop-up menu. Alternatively, move the profile to **Windows > System32 > Spool > Drivers > Color** on your hard drive.

Windows 8

Click **Start > Control Panel > Hardware and Sound > Color Management > All Profiles > Add**. Locate the color profile you wish to install and then click **Add**.

> PINK PROFILE

A color profile should ensure that the image you see on screen is translated accurately into print, so every subtle hue is retained.

Resolution

The resolution of a digital photograph is defined by the number of pixels used to create the image: the more pixels it has, the higher the resolution.

The standard for printing photo-quality images is 300 pixels per inch (or ppi). If your photograph is 3000 pixels wide, this will create a print that is 10 inches (25cm) across at 300ppi (3000/300 = 10). Without changing the number of pixels in your photograph, you could set the ppi to 150. This will create a print 20 inches (50cm) across (3000/150 = 20). However, the quality of the print will be lower, as the same number of pixels are now spread over twice the distance. At 75ppi, the print will be 40 inches (100cm) across with a greater loss of quality.

Although this may seem like a drawback, bear in mind that the larger the print, the farther back you will need to stand to look at it. It is possible to use a low ppi value and still produce an acceptable print at a normal viewing distance, even if closer examination reveals flaws.

You can resize your images and change the ppi and print size of your photograph using the instructions on page 357. However, it is worth remembering that if you choose a dimension value that is greater than the original, your image-editing software will need to add pixels to your image using a process known as interpolation. This means the software is essentially making an educated guess on what is needed to fill the gaps when it increases the size of your image. It is surprising how large a digital photograph can be resized without too much loss of quality, although flaws will be more apparent the closer you look at the print.

< IMAGE SIZE
Photoshop's Image Size dialog box allows you to alter the size and resolution of your images. The details here are for an image from an 18MP camera. At 300ppi, the maximum print size without resizing would be 16.94 x 11.27in. (43.02 x 28.62cm).

∧ PRINTS AND PPI
The image above left is set to 300ppi; the image above right is set to 15ppi. Reducing the ppi value has resulted in a much larger print (of which only a very small section has been shown here) at the expense of image quality.

> PIXEL COUNT

The more pixels a camera is capable of recording, the higher its resolution. The higher the resolution, the larger the size of the prints that can be made.

Proofing

"Making a proof" is the term used by printers when making a test print, but it is also an exercise that applies to photographers as well.

Making a test print is a very methodical way to work and has much to recommend it. Usually, a test print will be made on the same paper as the final print, but to save paper, smaller pieces can be used rather than a full-size piece—as long as the pieces are large enough that an accurate assessment can be made.

However, making test prints can be a laborious process, particularly if a few prints are needed to work out any issues. Fortunately, Photoshop allows you to emulate the printing process on screen using a technique known as "soft proofing." Soft proofing temporarily alters the colors and brightness of an image so that it looks like it would do when printed out on a particular paper. To use soft proofing you will need the relevant (and accurate) monitor and paper profiles installed on your computer.

Soft Proofing an Image:

1. Open the image that you want to print.

2. Select **View > Proof Setup > Custom**.

3. Click on the **Device to Simulate** pop-up menu and select the relevant paper profile from the list. Check both **Black Point Compensation** and **Simulate Black Ink**. Leave **Rendering Intent** set to the default. If you want to save these settings for future use click on **Save** and use an easily remembered name for the setting.

4. Click on **OK**. Your photograph will generally now look much flatter than before. This is because paper does not have the dynamic range of a computer monitor.

5. Select **View > Gamut Warning**. Colors on the monitor that cannot successfully be reproduced

by your printer will be grayed out. Toggle the gamut warning using Shift+Ctrl+Y (Windows) or Shift+Cmd+Y (Mac) to see the changes more easily.

6. Turn off soft proofing by pressing Ctrl+Y (Windows) or Cmd+Y (Mac).

Successful Soft Proofing

Once you've switched on soft proofing you may find that you need to make color, brightness, or contrast adjustments to the image. The most efficient way to do this is to duplicate your image (**Image > Duplicate**) so that you have two copies open. Select **Window > Arrange > Match Zoom** and **Window > Arrange > Match Location** so the two images are at the same zoom level, then activate soft proofing on one image and deactivate it on the other. You can then use your software's adjustment tools to alter the soft-proofed image so that it matches the non-soft proofed image as closely as possible.

∨ **LESS CLUTTER**
Turn off Photoshop's various tool panels by pressing the Tab key. This will make the screen less distracting to look at as you work on your soft-proofed image.

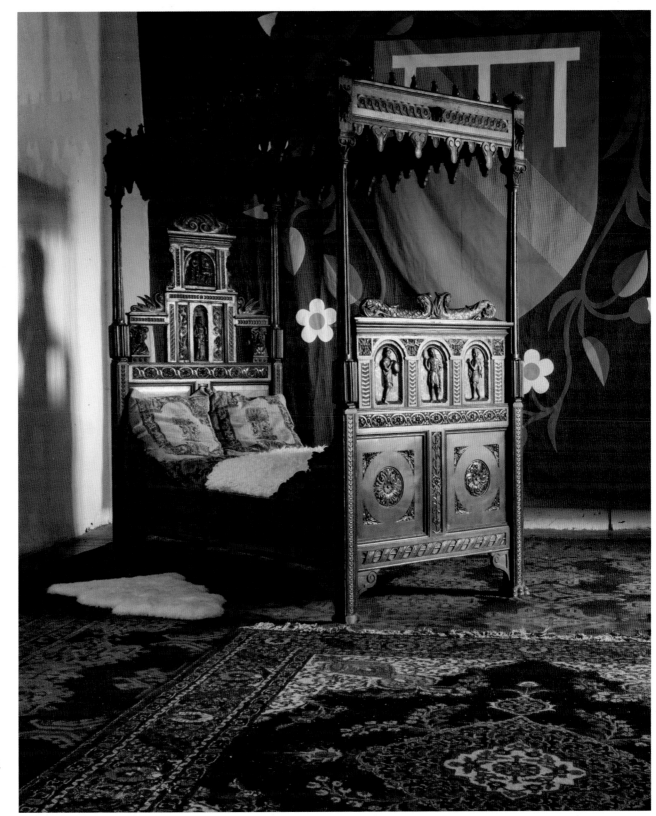

> COLOR CHECK

Soft proofing an image will allow you to see if there are any colors in your image that could prove problematic in print. You can then fix this without making potentially costly test strips with your printer.

Printing: Photoshop

Once you've prepared your image it is time to print it out, but Photoshop's Print dialog box can be a confusing affair initially.

Once you understand how Photoshop's Print dialog all fits together there is logic to the order in which the options are selected, although it's worth noting that some options are printer-specific. In the example below we're using an Epson R2400 printer. You'll find, however, that there should be equivalents for other models and brands of printers.

The key to successful color printing is to let Photoshop handle color management, regardless of the printer being used (unless you don't have appropriate ICC profiles for the paper that you're using). When Photoshop is in control of color management it will automatically convert your image to the correct printer profile when the image is printed. Later versions of Photoshop use a "document specific" approach to printing, so that you'll need to set up the printer for each separate image you want to print.

Print Settings

1. Open your image and select **File > Print**.

2. Click on the **Printer** drop-down menu on the Printer Setup panel (1) and select your printer if not already selected. Set the number of copies you want to print (2) and adjust the orientation of the print if necessary (3).

3. On the Color Management panel, click on the **Color Handling** drop-down menu (4) and set it to **Photoshop Manages Colors** (on Windows you will also need to check ICM and then set ICC/ICM to **Off [No Color adjustment]**). Choose the correct profile for the paper you're using from the **Printer Profile** drop-down menu (5). As a final test of color, check **Match Print Colors**, **Gamut Warning**, and **Show Paper White** (6).

4. Click on **Print Settings** (7).

5. Set the paper size to the size of paper you're using (8).

6. Select **Print Settings** from the drop-down menu (9).

7. Set the relevant Media Type from the drop-down options (10)—Mac—or from Paper & Quality Options—Windows. Depending on the printer you're using some types of paper will not be listed. On the Epson R2400, for example, matte papers are not listed if a Photo Black cartridge is installed, and gloss papers are not listed when a Matte Black cartridge is fitted.

8. Select **Best Photo** (11) from the Print Quality drop-down menu.

9. For maximum quality (at the cost of slower printing) uncheck **High Speed** (12).

10. Click **OK** (Windows) or **Save** (Mac) to return to the main print dialog (13).

11. Leave Normal Print (14) set as it is and ensure that Rendering Intent (15) is set to **Relative Colorimetric**. Check **Black Point Compensation** (16) if it is not already checked.

12. You can move your image around the area of the paper (17). When **Center** is checked, the image will be printed at the center of the paper with an equal border on all four sides. When it is unchecked you can specify how far down the paper the image will

Note

Prior to Photoshop CS6 some of the functionality of Print Settings is set via a separate menu option **File > Page Setup.**

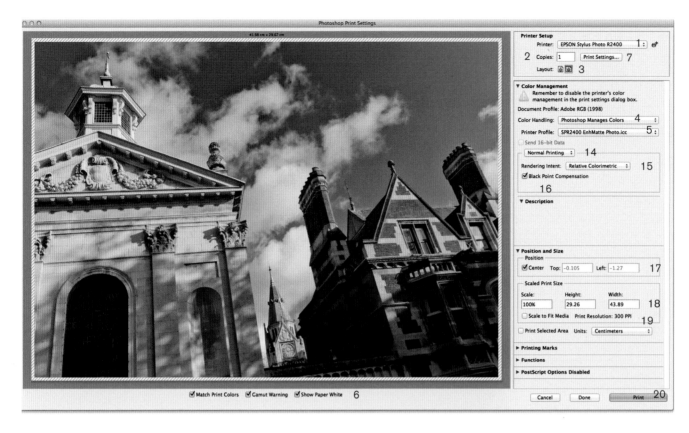

appear by adding a value into the Height box, or a distance in from the Left of the paper's edge.

13. If you've not already resized your image before printing you can scale the image within the paper area by either altering the Scale as a percentage of the original image, or by specifying a new Height and Width (18). If you check **Scale to Fit Media**, Photoshop will automatically resize the image to fit the paper size (19), altering the ppi setting if necessary.

14. Click on **Print** to make your print (20).

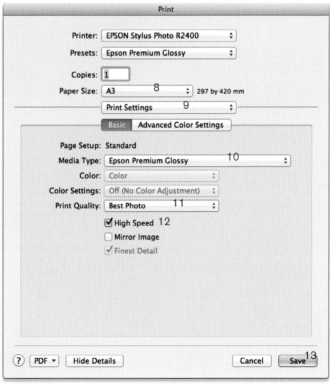

Printing: Elements

Photoshop Elements shares many of Photoshop's tools and functions,
but its Print dialog is arranged in a notably different way.

Basic Print Settings

1. Open the image you wish to print and then select
File > Print.

2. Click on the **Select Printer** pop-up (1) and choose
your printer from the drop-down list if it is not
already selected. Set the paper size you're printing
on to (2) and adjust the orientation of the print if
necessary (3).

3. Select the print size from the Select Print Size drop-
down menu to set the size of the image (4). Check
Crop to Fit to crop the image so that it fills the
selected paper size above (5).

4. Set the number of prints you wish to make by
increasing or decreasing the value in the Print x
copies of each page text-entry box (6).

5. Click on **Rotate 90° to the left** or **Rotate 90° to
the right** to rotate the page. Check **Image Only**
so that only the image is rotated (7).

6. Pull the zoom slider left or right to zoom the image
within the page (8).

7. You can move your image around the page (9). When
Center Image is checked, the image will be printed
in the center of the paper with an equal border on all
four sides. When it is unchecked you can specify how
far down the paper the image will appear by adding a
value into the Height box, or a distance in from the Left
of the paper's edge. Change the Units as desired.

8. Click **Print** (10) to make your print.

Advanced Print Settings

1. Click on **More Options** (11) on the print dialog screen.

2. Click on **Printing Choices** (12).

3. If you want to print any of the Photo Details (the
information taken from the metadata of your image)
check all that are relevant (13). The information will
be printed below the image on the page. If you print
the image so that it fills the page, Photo Details will
not be printed.

4. If you're creating a transfer to be pressed onto a
T-shirt, the image needs to be mirrored. Check **Flip**

Image (14) if you have not already mirrored the image using Elements.

5. You can print a Border around your image (15), specifying the Thickness in a unit of your choice. You can also set the Background to a color other than the paper color.

6. If you plan to crop your image once it is printed, make sure that you check **Print Crop Marks** (16) so that guides are printed on the page to make this easier.

7. Click **OK** to return to the main print screen saving your choices (17), **Cancel** to return to the main print screen without saving your choices (18), or **Apply** (19) to save your choices before you click on **Custom Print Size** (20) or **Color Management** (21).

8. Click on **Custom Print Size** to set the size of the image on the page. Check **Scale to Fit Media** (22) so that your image is resized to fit onto the selected page size. Change the image size by altering the Height and Width (23) using the desired Units (24).

9. Click on **Color Management**. Click on the **Color Handling** drop-down menu (25) and set it to **Photoshop Elements Manages Colors**. Image Space shows the current working space of the image (26). Choose the correct profile for the paper you're using from the Printer Profile drop-down menu (27). Leave Rendering Intent as Relative Colorimetric (28). Click on **OK** to return to the main print screen.

Troubleshooting

Although inkjet printers are robust devices things do occasionally go wrong. If a print doesn't turn out as expected, run through this list of common problems to see if there's an easy solution.

Uneven Vertical Lines

Vertical lines that have a jagged, toothlike appearance are a sign that the print head has moved out of alignment. The utility software that came with your printer will have a print head alignment option.

Regular Horizontal Gaps

Ink can dry and clog the print head nozzles, and if your prints display regular horizontal gaps—or if it looks as if there is color missing—this is a good indication that one or more of the print head nozzles is blocked.

Your printer's utility software will have an option to perform a head-cleaning routine. This uses ink, so it is not a good idea to run a head clean unnecessarily. Once the head-cleaning process is complete, print out a test sheet to check to see whether the printer is back to normal. There is often the option in the utility software for printing out a simple page that uses all the print heads, making it easy to see which has a problem.

Using your printer little and often is the best way to avoid clogged nozzles. Some printers will automatically cap the print heads when the printer is switched off. This prevents ink from drying when the printer is not in use.

Soft or Blurred Prints

If you're using matte paper, this is often an indication that the printer has printed on the uncoated side, so the ink has been absorbed more by the paper.

Ink Blobs on the Print

It is theoretically possible to use any type of paper in any inkjet printer. However, in practice, some papers are more suitable than others. If a paper hasn't been designed for your printer the ink may not be absorbed, leading to it sitting on the surface of the paper. This tends to happen more with gloss paper than with matte paper, purely because matte is naturally more absorbent. The solution to this problem is to use a different type of paper.

Blank Pages or Random Alphanumeric Characters

Your printer needs to be connected to your computer all the way through to the completion of each print job. If the connection is interrupted, even for a split second, this can cause data corruption. A cable connection is generally robust but can be knocked out accidentally. If you're connecting to a printer via a WiFi connection make sure that there is a strong signal between the two devices. Don't keep your printer too far from the router used to direct the WiFi signal.

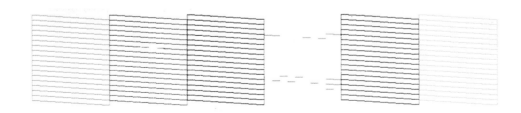

< TEST STRIP
The incomplete nature of this test pattern is a good indication that the print head needs cleaning using the printer's utility software.

Paper Jamming

Dust inside the printer can build up and start to jam paper as it passes through. Some paper, such as uncoated watercolor paper, can be a source of dust. If paper starts to jam regularly, clean the rubber rollers that pull the paper through the printer carefully with rubbing alcohol. When the printer isn't in use, keep the dust flaps closed or cover it with a plastic cover. Another sign of dust is when white specks start to appear on prints.

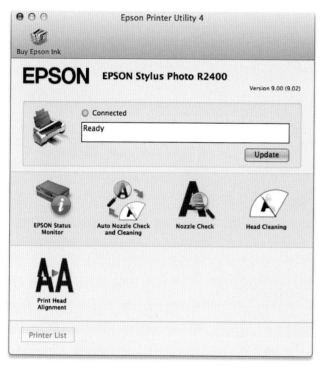

∧ MAINTENANCE MODULE
The utility software that came with your camera will help you solve many problems with your printer's output.

> QUALITY CONTROL
If you want the highest quality prints, it's important to keep your printer well maintained. Clogged nozzles are a major cause of inkjet printer problems.

Beyond the Printer

There is more to printing than just making prints: here is a selection of ways that you can use your digital images.

∧ **PERSONAL TOUCH**
Handmade books are very personal items and can be as simple or as elaborate as you like.

Making a Book

The creation of a book of your photographs is a particularly satisfying process. In compiling items for a collection you will learn to be critical of your own work—you will wish to include only your best images—and enjoy the creativity of choosing work with a cohesive theme or style, or a logical timeline.

Perhaps the simplest handmade book form consists of two hard covers with separate "hinges" that enable the covers to open. The pages of photographs, either single or double-sided, are then hole-punched and bound with bookbinding posts. These are readily available online from bookbinding suppliers.

If you're feeling more adventurous, it's possible to stitch the pages and covers together by hand. It's good fun to choose a color scheme for your book, with coordinating cover papers and materials for the bindings, and this all adds to the personal feel of your book.

Handmade books are not only extremely satisfying to create, but they can make wonderful gifts and keepsakes.

A book made up of images that are personal to the recipient—such as photographs of their wedding, for instance—will almost certainly be treasured for a lifetime, and could even be handed down to future generations.

The alternative to making a handmade book is to create a photobook, either using an online service or main-street store. Companies that print photobooks typically offer a range of book sizes and paper types. There is generally a compromise to be made between cost and the number of pages in a book, the paper quality, and the binding (hard, cloth-bound covers are more expensive than printed soft covers).

Most photobook printers will offer a range of templates to make the design process easy. A good template should offer the ability to add text onto a page so that images can be captioned. The one drawback with using a template is that your photobooks won't necessarily reflect the character of you or your images. Some photobook publishers allow you to upload your own books in the form of a PDF. Creating a book this way does require some knowledge of layout and design, but the resulting book can be personalized far more easily. A book that is saved as a PDF can also be distributed more easily to computers and tablet devices.

< **ROARING SUCCESS**
Creating a photobook is a great way to finish themed projects. This is a book about lions that was being worked on just for fun.

Terminology

Most book printing web sites keep things simple and don't use too many confusing technical printing terms. However, it's worth taking time to understand some of the more basic concepts, as they will be relevant when you are designing your book.

Alley

Blank space between two columns of text.

Binding

The method used to join the pages of a book together. This can be achieved one of several ways, depending on the thickness of the book. The simplest method is using staples, though this is less effective for thicker books. A more effective method once a book reaches a certain size is to bind the pages together with glue. However, this makes a book difficult to open fully.

Bleed

Books are usually printed slightly larger than required. This excess area is then trimmed away so that the book is the correct size. However, the trimming process isn't always precise. If you have an image that fits to the edge of the page this may lead to a white line running down the page edge. A bleed is when an image is extended outside the intended dimensions of the book at the design stage. This allows for any inaccuracies during the trimming stage. The bleed is typically 2–5mm along each outside edge, though your intended book printer should be able to supply the exact dimensions required.

Gutter

Once a book has been bound it may become difficult to open fully. This will make it difficult to see images or text clearly if they are placed close to the spine. A gutter is a margin or blank space on the inside of the page that allows for this. The type of binding used will determine how large the gutter needs to be.

ISBN

Companies such as Blurb and Lulu allow you to sell your book through online bookstores such as Amazon.

< BLEED AND CROP
The area covered in light diagonal stripes is the bleed used when creating this page using Adobe InDesign. The inner of the two vertical and horizontal marks at the top left of the page shows how the page should be trimmed after printing.

< GUTTER
The area of light diagonal stripes is the gutter down the middle of a two-page spread. When designing this book it was important that no text entered the striped area.

However, your book will need to have an ISBN, short for International Standard Book Number. Every commercially sold book has a unique ISBN, allowing books to be cataloged and identified more easily. ISBNs are either 10- or 13-digit numbers.

Laminate

A thin, glossy coating typically applied to book covers to make them more robust.

PDF

Short for Portable Document Format. Developed by Adobe, this is the standard digital file accepted by most printers when submitting a book design.

Proof Copy

If you intend to sell your book commercially, it is a very good idea to order a copy before it goes on sale. This is known as a proof copy and will allow you to check that colors are correct and that the spelling and grammar in the text are accurate.

Greetings Cards

Everyone likes to receive a greetings card, whether it's for a special occasion or just because someone wants to cheer you up. Making greetings cards out of your own images makes the process a touch more personal.

There are three methods for creating greetings cards. The first is to print out a card design using standard paper and then trim and fold as necessary. The second method is to buy a blank greetings card and print directly to that, or to a suitably sized piece of paper and then stick this to the card. The third method is to use a commercial company. Online photo printers often offer this as one of their services. The advantage of producing a greetings card this way is that there will be a template to work to and often the price includes a correctly sized envelope.

The first method involves more work, but is the most flexible in terms of the size of the card you can produce—though you have to be careful that your card will still fit into a standard size envelope. The card size when folded has to be slightly smaller than the envelope—particularly if you're using thicker paper. This method is also not suited to using gloss paper. Firstly, many paper manufacturers print their logo across the backs of gloss papers and secondly, the surface of the paper is often difficult to write on as it usually has a slightly waxy finish.

If you create a card using this method, it is a good idea to build very faint crop lines into the design. This will make the trimming process far easier. The image on the front of the card needs to be to the right of the fold line, and any information about you or the card goes to the left. This is true whether you're creating a tall vertical card or one that sits horizontally. The one difference between vertical and horizontal cards is that the image and text on a vertical card should both be vertical and in the same orientation; the image on the front and the text on the back of a horizontal card should be facing in opposite directions.

Subjects

If you're producing a one-off card for someone special it's generally easy to pick a subject. It would usually be something that is recognizable or has relevance to that person. However, there's no reason not to bring your cards to a wider audience.

Local stores are often amenable to selling greetings cards made by individuals. In this case, the most obvious subjects are local landmarks, particularly ones that have a high appeal to tourists. However, these places are often over-photographed so you may find that there is competition from other photographers. If this is the case you need to use an image that either takes a different slant on the subject or that is esthetically more pleasing than the competition. This means being honest with yourself as to whether your image makes the grade. Cards that "tell a story" are popular. People often read meaning into an image that didn't occur to you. You may think a sunset is a sunset, but it could be the perfect card for someone who is retiring, for instance.

∨ **HORIZONTAL**
This is a greetings card designed to sit horizontally. Note that the main image is rotated 180° to the text that appears on the back.

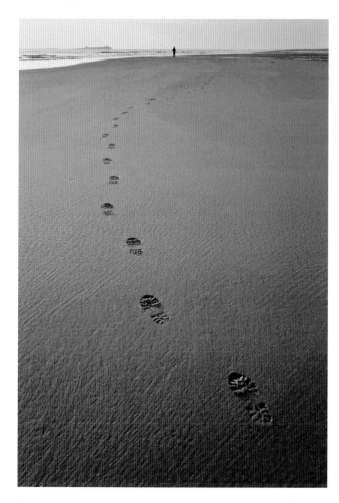

∧ ALLEGORICAL

This image has proved popular as a greetings card because it can be interpreted in a number of different ways.

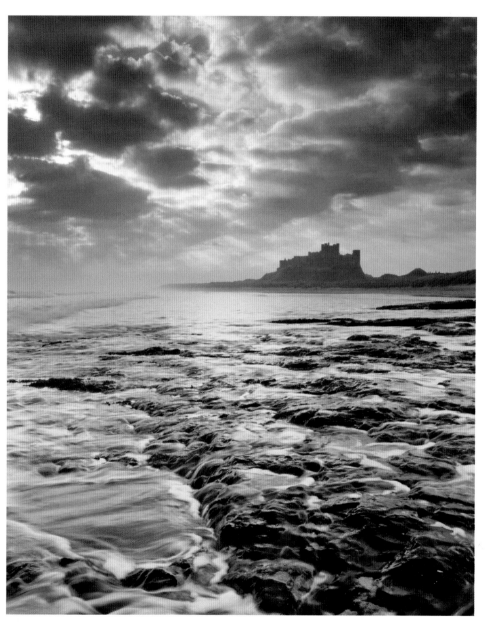

∧ STORMLIGHT

Although this is a much photographed subject in the area, the drama of the light is attractive to people, making it a commercially successful image.

Hosting an Exhibition

Making prints that no one but you ever sees can be perfectly satisfying. However, this satisfaction doesn't compare to the satisfaction that can be had by hosting a successful exhibition.

In many ways, putting on an exhibition is like putting together a photobook. An exhibition doesn't necessarily need an overall theme (although it does help), but like a book it should be composed only of your very best work.

Once you have a coherent theme and representative portfolio, you'll also find it easier to persuade gallery owners to host your exhibition. Gallery owners are professionals and so you need to be professional in your dealings with them. If you're vague about your photography, or show weak material, you won't get anywhere. Another common mistake is to show your portfolio to the gallery owner and then criticize its shortcomings—if you don't like your work, why should the gallery owner?

Once you've secured gallery space you'll be able to work out how many images are needed to fill it. It's tempting to shoehorn as many images in as possible, but this is often counterproductive. Showing fewer images allows each individual image room to breathe. If images are crowded together the impact of individual images is lessened appreciably. Less is often more when it comes to putting an exhibition together.

Printing & Framing

The prints you make for an exhibition must be free of technical errors. If a print isn't right in any way it shouldn't be used. Once you've had the prints made you then need to mount and potentially frame them. Mounting prints is relatively inexpensive—particularly if you print your images to a size that matches mounts that can be bought off-the-shelf. If you print to a non-standard size, you will either have to cut mounts yourself or have the prints mounted professionally.

Framing prints will obviously add considerably to the cost of putting together an exhibition. However, framing your prints will look more professional—you may even find that a gallery owner insists on it. To reduce costs, you could consider using standard sized frames bought from a store. It is also a good idea to use frames that are reasonably neutral in design—you're not buying the frames to suit your own tastes and simple frames won't date as quickly as more elaborate designs. They can also be reused for future exhibitions.

If you intend to sell your work, think hard about what to charge. Don't undersell yourself, but also don't price yourself out of the market. The price you charge for a print has to at least cover the costs of the materials and any commission you may be

∧ FRAMED
Simple frames will have more appeal to potential buyers.

∧ POSTCARD
This is the front of a postcard that photographer David Taylor had printed to publicize his first solo exhibition.

∧ > THEMES
There's not much thematic unity between these two images, so it's doubtful they would work well together in an exhibition.

charged by the gallery. A reasonable starting point is to charge three times the cost of the print, plus any commission charges.

Publicity

With the venue, the dates, and the prints arranged you need to let people know about the exhibition. This is made easier if you are showing in a gallery, as the gallery owner or manager will probably take care of the publicity for you. However, be prepared to talk to the press at the owner's request. Again, this is when having a strong theme for the exhibition will help. A theme will have a better hook for a story than a disparate collection of images. You'll also find it easier to discuss a themed exhibition with journalists, particularly if it's a subject that you feel passionately about.

If you are publicizing the exhibition yourself, send out a well-written press release to local newspapers that clearly states the theme of the exhibition and includes representative images. You should also include relevant contact details as well as the venue and date.

Flyers and posters are a good way to attract attention in the area local to the gallery. Print posters on good inkjet paper so that colors are accurate. If it's possible to fix a poster legitimately outside, then pay to have it laminated so that it will be able to stand up to the elements. Approach local stores and libraries to ask if they'll display posters in a prominent place for you, as well as taking flyers if you have any printed.

Consider having an open evening for your exhibition. Again, if you're in a gallery the owner may arrange this for you. However, you should be able to invite guests too. Let them know in plenty of time so they have a chance to arrange their schedules. It's a good idea to invite journalists too. It's another good reason for them to write about you and your exhibition!

Although it's wonderful to invite family and friends to your exhibition, remember that they're often not the people who will buy your prints. Be prepared to invite local business people as well. Even if they don't buy prints, it's a good way to make contacts that could be useful in the future. Drinks and party food are a good way to keep people at the exhibition, as it adds to the sense of occasion and makes them feel welcome.

Email and social media are powerful ways to alert people to your exhibition, but the key is not to alienate potential visitors by bombarding them with information. A subtle and intriguing campaign often works more effectively than aggressive and repetitive marketing. If your exhibition is on over a reasonable period of time, a month say, putting out more publicity halfway through is a good way to remind people that the exhibition is still open.

If you're planning to hold more exhibitions, use the first to gather contact information to build up a mailing list. Put out a comments book inviting people to leave their email address so that they can be told about the next exhibition you hold.

Finally, enjoy yourself! Putting together an exhibition is a steep learning curve, but the experience is invaluable.

∨ **SOCIABILITY**
Social media web sites, such as Twitter and Facebook, are a great—and free—way to bring your exhibition to public attention.

Glossary

Aberration An imperfection in a photograph, usually caused by the optics of a lens.

Acid-free paper Paper that is pH neutral. Acid-free paper is more stable and is therefore considered archival.

Additive color Color produced by light when it falls onto a surface. The three primary colors are red, green, and blue.

AEL (AutoExposure Lock) A camera control that locks in the exposure value, allowing a scene to be recomposed.

AEB (Auto Exposure Bracketing) A camera function that captures a predetermined number of images (commonly three, but also five, seven, or nine) at different exposure settings, usually straddling the meter's nominally correct exposure. The exposure increment between each shot can be adjusted.

Aerial perspective Reduction in contrast and color saturation that increases with distance. Caused by dust and haze, it helps to convey a sense of depth.

Ambient light The natural light prevailing at the time of shooting.

Angle of incidence The area or angle at which light hits a subject.

Angle of reflectance The area or angle at which light reflects off a subject.

Angle of view The area of a scene that a lens takes in, measured in degrees.

Aperture The opening in a camera lens through which light passes to expose the sensor. The relative size of the aperture is denoted by f-stops.

Aperture priority An exposure mode in which the user sets the aperture while the camera adjusts the shutter speed to suit the light conditions and selected ISO setting.

Artifact Something unwanted in the digital file, usually a fault of the image sensor's ability to record the requisite data.

Artificial light A man-made light source such as a flash or continuous tungsten lighting.

Aspect ratio The proportion of an image's width to its height. Common standards include 3:2, the aspect ratio of full-frame and APS-C format sensors, and 4:3, the aspect ratio of the Micro Four Thirds system.

Autofocus (AF) A reliable through-the-lens focusing system allowing accurate focus without the user manually turning the lens.

Backlight When your light source is facing into the camera from behind the subject.

Balanced Fill Flash Mode (BL) Atypical of Nikon flash, BL or Balanced Fill Flash allows the camera to tell the flash exact output for a certain scene when using direct flash.

Barrel distortion A defect in the lens design that causes straight lines to be curved from the center out.

Bind To join sheets of paper together to form a book or other publication either by glue, wire, or other means.

Bokeh A commonly used non-technical term to describe the out-of-focus background of an image.

Bounce flash An indirect lighting technique well suited to on-camera flash where the flash head is swiveled and light is bounced off nearby surfaces to give a softer overall lighting effect.

Buffer The integral memory incorporated in a digital camera.

Built-in flash A flash permanently installed onto a camera body: either the small flash of a compact or point-and-shoot camera or the pop-up flash found in most DSLRs and CSCs.

Bulb (B) The Bulb setting allows for unlimited time exposures lasting seconds, minutes, hours, or for the life of the camera battery.

Burst size The maximum number of frames that a digital camera can shoot before its buffer becomes full.

Cable release A device used to trigger the shutter of a tripod-mounted camera at a distance to avoid camera shake.

Calibrator A device used to measure the output of digital imaging equipment. A profile will then be created that can be used by other equipment to ensure consistent color.

Camera shake The movement of the camera during an exposure that can lead to blurred images, particularly at slow shutter speeds. Often caused by an unsteady support or when handholding the camera.

CCD (Charged-Coupled Device) A type of image sensor incorporated in some digital cameras.

Center-weighted metering A way of determining the exposure of a photograph that places importance on the lightmeter reading at the center of the frame.

Chromatic aberration The inability of a lens to bring spectrum colors into focus at one point.

Circle of confusion The size of an area of the image at which light rays cease to focus to a point and instead come together as a small circle. In human terms, this is the largest area that our eyes still perceive as a point.

Clipping The loss of detail in highlights or shadows.

CMOS (Complementary Metal Oxide Semiconductor) The most common type of image sensor used in today's digital cameras.

CMYK Shortened form of Cyan, Magenta, Yellow, and Key (black), the four colors commonly used in printing.

Coated paper Paper that has a coating to improve reflectivity or increase the ability to hold ink. A common substance used for coating is clay.

Codec A piece of software that is able to interpret and decode a digital file such as Raw.

Color cast Unwanted color tinting either in a digital image or on a print.

Color gamut The range of hues a digital device such as a monitor or printer can reproduce.

Color saturation The depth of intensity of colors in an image.

Color space Computers, cameras, and printing systems identify and interpret color information, known as color space, according to various systems—typically sRGB or Adobe RGB (Red, Green, Blue). Commercial printing uses the CMYK color space.

Color temperature The color of a light source expressed in degrees Kelvin (K).

Composition The way in which elements of a scene are arranged within the image.

Compression The process by which digital files are reduced in size.

Contrast The range between the highlight and shadow areas of a photograph, or a marked difference in illumination between colors or adjacent areas.

Converging The effect, either real or implied, of lines coming closer together in an image.

Crop To trim an image, either to reduce it in size proportionally or to reshape it for esthetic reasons.

Crop factor The number by which the field of view of a full-frame lens must be divided when used on a camera with a sensor smaller than 24 x 36mm (full frame), because the maximum area of the image projected by the lens is not covered by the smaller sensor.

Crop marks Marks added to a print or document to indicate where the paper should be trimmed after printing.

Deckle edge Ragged edge on paper instead of a clean cut. Often used for art prints.

Depth of field (DOF) The amount of a photograph that appears acceptably sharp. This is controlled primarily by the aperture (the smaller the aperture, the greater the depth of field), but is also affected by the camera-to-subject distance and focal length.

Differential focus The practice of teaming wide apertures (resulting in shallow depth of field) with a small, precisely controlled area of focus.

Diffraction The loss of image resolution when a very small aperture setting is used.

Direct flash Using the flash with no modifiers, such as a plastic diffuser, umbrella, or softbox, for direct hard light.

Distortion Typically, when straight lines are not rendered straight in a photograph. Barrel and pincushion distortion are examples of types of lens distortion.

Diopter Unit expressing the power of a lens.

dpi (dots per inch) Measure of the resolution of a printer or scanner. The more dots per inch, the higher the resolution.

DPOF Digital Print Order Format.

Dynamic range The ability of the camera's sensor to capture a full range of shadows and highlights.

Elements The individual pieces of glass that form the overall optical construction of a lens.

Evaluative metering A metering system whereby light reflected from several subject areas is calculated based on algorithms. Also known as Matrix or Multi-segment.

Exposure The amount of light allowed to hit the digital sensor, controlled by aperture, shutter speed, and ISO. Also, the act of taking a photograph, as in "making an exposure."

Exposure compensation A control that allows intentional over- or underexposure.

Exposure value A numerical system for measuring the intensity of light, typically in the range 0–20.

Extension tubes Hollow spacers that fit between the camera body and lens, typically used for close-up work. The tubes increase the focal length of the lens and magnify the subject.

Fill-in flash Flash combined with daylight in an exposure. Used with naturally backlit or harshly side-lit or top-lit subjects to prevent silhouettes forming, or to add extra light to the shadow areas of a well-lit scene.

Filter A piece of colored, or coated, glass or plastic placed in front of the lens.

Finish Description of the surface of paper. Paper can be glossy, matte, and so on.

Fisheye A type of lens with an extremely wide angle of view, typically 180 degrees.

Flare Stray light that enters the lens causing soft images and highlights. Modern lens coatings combat this phenomenon, but it can be used for creative effect.

Flash exposure compensation Increasing or decreasing the output of a flash to get either a creative effect or to override what the camera has chosen as "correct."

Focal length The distance, usually in millimeters, from the optical center point of a lens element to its focal point.

Focus The act of adjusting the lens, manually or using autofocus, so that the subject appears sharp.

Focusing distance Term used to describe the distance between the focal plane (the sensor/film) and the subject.

Four-color process printing Describes a printing method that simulates a full range of colors by mixing cyan, magenta, yellow, and black ink (CMYK) in varying amounts.

fps (frames per second) A measure of the time needed for a digital camera to process one photograph and be ready to shoot the next.

Front curtain synchronization With this setting the flash fires at the beginning of the exposure.

Front light Light that falls on the front of your subject.

f-stop Number assigned to a particular lens aperture. Wide apertures are denoted by small numbers such as f/2; and small apertures by large numbers such as f/22.

Full frame A term used to denote a digital camera that has a sensor with the same area as the negative of a 35mm film camera (24 x 36mm).

Gel A blend of polycarbonate and polyester resin, gels are attached to the front of the flash for color correction or color enhancement of the flash.

Grammage The weight of paper measured in grams per square meter (GSM).

Grid Cylinder or rectangular shaped attachment with a honeycomb pattern that severely limits light spread over a small area.

HDMI High Definition Multimedia Interface.

HDR (High Dynamic Range) A technique to increase the tonal range of a photograph by merging several images shot with different exposure settings.

High key A term associated with the overall look of an image. High-key images are usually bright in overall tone and have a white or very bright background.

HSS (High Speed Synchronization) The ability to use a higher-than-normal shutter speed to capture an image when using flash. The flash gives off multiple pulses of light before the exposure starts and ends after the shutter closes instead of one direct flash of light, eliminating the black line associated with using shutter speeds beyond the camera's maximum synchronization speed.

Highlights The brightest tones in an image.

Histogram A graph used to represent the distribution of tones in a photograph.

Hotshoe An accessory shoe with electrical contacts that allows synchronization between the camera and a flash.

Hotspot A light area with a loss of detail in the highlights. This is a common problem in flash photography.

Hue A specific color, such as red or blue.

Hyperfocal distance The closest point of focus at which infinity falls within the depth of field. This is the distance at which to focus to ensure that everything from that point to infinity is in focus, along with a significant zone in front of it.

Image stabilization A mechanism built into either a lens or a camera that senses and reduces camera shake, typically providing an effect equal to using a shutter speed between 2 and 5 stops faster.

Incident-light reading Meter reading based on the light falling on the subject.

Increment The difference between exposure settings, typically in ⅓, ½, or whole stops.

Interpolation A way of increasing the file size of a digital image by adding pixels, thereby increasing its resolution.

Inverse Square Law Property of light that states where the intensity decreases in proportion to the square of the distance from its source.

ISO (International Organization for Standardization) The sensitivity of the digital sensor measured in terms equivalent to the ISO rating of a film.

Joiner The technique of creating an image from a large number of smaller images.

JPEG (Joint Photographic Experts Group) A file type that uses lossy compression to reduce the file size of a digital image. JPEG compression can reduce file sizes to about 5% of their original size.

Laminate A coating—usually plastic—applied to a print to protect the surface.

Landscape Orientation of an image where the width is greater than the height. Also referred to as horizontal.

LCD (Liquid Crystal Display) The flat screen on a digital camera that allows the user to preview digital photographs.

Leading line A line, either real or implied, that helps to direct a viewer's gaze through a picture.

Lens The eye of the camera, which projects the image onto the sensor.

Lossless compression Method used to reduce the size of a digital image file without losing any data.

Lossy compression Method used to reduce the size of a JPEG file. As part of the compression process some data is irretrievably lost.

Low key A term associated with the overall look of an image. Low-key images are usually dark in overall tone or have a black background.

Macro A term used to describe close-focusing and the close-focusing ability of a lens.

Manual exposure An exposure mode in which the user selects both the aperture and shutter speed independently.

Manual focus When focusing is achieved through manual rotation of the lens's focusing ring.

Megapixel One million pixels equals one megapixel.

Memory card A removable storage device used to save digital photographs in-camera.

Metering Using either the camera's built-in meter or a separate handheld lightmeter to measure the ambient (or flash) light in order to determine the exposure.

Metering pattern (see **Center-weighted metering**, **Evaluative metering**, **Partial metering**, and **Spot metering**)

Midtone A tone that is half way between the deepest shadow and the brightest highlight.

Mirror lockup A function that allows the reflex mirror of an SLR to be raised and held in the "up" position before an exposure is made. Typically used to reduce the possibility of camera shake.

Multiplication factor (see **Crop factor**)

Neutral gray Gray that has no color tint.

Noise Interference caused by non-image-forming electrical signals.

Open-source Software created by unpaid volunteers that is often free to use.

Overexposure The act of exposing the film or sensor to too much light, rendering the image far brighter than it should be and causing highlights to burn out.

Partial metering A reflected metering pattern that measures a relatively small area at the center of the frame, but not as small an area as with spot metering.

PC socket Industry standard electrical connection used to attach flashes to cameras and radio triggers.

Perspective The way in which objects appear to the eye depending on their spatial attributes, or their dimensions and the position of the eye relative to the objects.

PictBridge The industry standard for sending information directly from a camera to a printer, without having to connect to a computer.

Pixel Short for "picture element"—the smallest bits of information in a digital photograph.

Placement The position of the main subject or subjects within the image space.

Portrait Orientation of an image where the height is greater than the width. Less confusingly referred to as vertical.

Postproduction Adjusting an image after shooting using software such as Photoshop or Lightroom.

Predictive autofocus An autofocus system that can continually track a moving subject.

Prime lens A lens with a single, fixed focal length.

Program mode An exposure mode in which the camera automatically selects a combination of both aperture and shutter speed, but allows the user to change this combination without changing the overall exposure.

Program shift The term sometimes used for the process of changing the combination of aperture and shutter speed in Program mode.

Proof Print made to test the accuracy of colors, density, and so on, before a final print is made.

Raw The file format in which the raw data from the sensor is stored without permanent alteration being made.

Rear curtain synchronization In this setting, the flash fires at the end of the exposure.

Red-eye reduction A system that causes the pupils of a subject's eyes to shrink, prior to taking a flash picture.

Reflected light The light reflected by the scene being photographed, for the purpose of metering.

Reproduction ratio A term used to describe the relationship between the size of your subject in real life, and the size it is recorded on the sensor/film. For example, a reproduction ratio of 1:2 means that the subject will appear at half its actual size on the sensor or film.

Resolution The number of pixels used to capture or display a photograph.

RGB (red, green, blue) Computers and other digital devices understand color information as combinations of red, green, and blue.

Rim lighting When the light comes from the rear, silhouetting your subject.

Ring flash Lighting system that uses a circular flash tube or some modification of a small flash unit to create flat, shadowless light.

Rule of thirds A rule of thumb that places the key elements of a picture at points along imagined lines that divide the frame into thirds.

Scene modes Camera modes designed to simplify the setting procedure for the user by naming each scene mode with the purpose for which it is intended (for example, Portrait, Landscape, Sports, Close-up) and automatically selecting the settings.

Selective focusing (see **Differential focus**)

Shading The effect of light striking a sensor at anything other than right angles incurring a loss of resolution.

Shutter A mechanism that opens and closes to determine the time that light is allowed to reach the imaging sensor.

Shutter priority An exposure mode in which the user sets the shutter speed and the camera adjusts the aperture to suit the light conditions and selected ISO setting.

Shutter speed The amount of time that light is permitted to reach the film or sensor, usually measured in fractions of a second, but also in whole seconds or even minutes.

Shutter synchronization The maximum shutter speed that can be used with flash before a black line is seen in the image. Most cameras typically synchronize with flash at 1/125–1/250 sec., depending on the model of the camera used.

Side light Light that falls on the side of your subject.

SLR (single lens reflex) A type of camera that allows the user to view the scene through the lens, using a reflex mirror.

Snoot Conical attachment that creates a small shaft of light.

Soft-proofing Using software to mimic on screen how an image will look once output to another imaging device; typically this will be a printer.

Spot metering A metering system that places importance on the intensity of light reflected by a very small portion of the scene.

Standard lens A focal length similar to the vision of the human eye—typically 50mm is considered a standard lens on a full-frame camera.

Stop A single EV (Exposure Value) step. Differs from f/stop as it applies to the shutter speed and ISO, as well as the aperture.

Subtractive color Color produced by light reflecting from a surface.

Teleconverter A lens that is inserted between the camera body and the main lens, increasing the effective focal length.

Telephoto A lens with a large focal length and a narrow angle of view.

TIFF (Tagged Image File Format) A universal file format supported by virtually all relevant software applications. TIFFs are uncompressed digital files.

Top light Light that falls on the top of your subject.

TTL (through the lens) metering A metering system built into the camera that measures light passing through the lens at the time of shooting.

Underexposure The act of exposing the film or sensor to less light than is required, rendering the image far darker than it should be and potentially causing shadow areas to lose detail.

USB (Universal Serial Bus) A data transfer standard, used by most cameras when connecting to a computer.

Viewfinder An optical or electronic system used for composing the subject.

Vignette The darkening at the corners of an image. Can be caused by the construction of the lens (optical vignetting) or something physically blocking the light, such as the incorrect lens hood or stacked filters (mechanical vignetting). Can also be added during postproduction to help draw attention to the center of the frame.

White balance A function that allows the correct color balance to be recorded for any given lighting situation.

Wide-angle lens A lens with a short focal length and consequently a wide angle of view.

Working distance The distance between the front surface of the lens and the point on the subject where the lens is focused. Longer focal lengths will typically have longer working distances.

Zoom lens A lens that covers a range of focal lengths.

Useful Web Sites

Equipment

Cameras

Canon www.canon.com

Fujifilm www.fujifilm.com

Leica www.leica-camera.com

Nikon www.nikon.com

Olympus www.olympus-global.com

Panasonic www.panasonic.com

Pentax www.ricoh-imaging.com

Ricoh www.ricoh-imaging.com

Samsung www.samsung.com

Sony www.sony.com

Lenses

Canon www.canon.com

Cosina www.cosina.co.jp

Fujifilm www.fujifilm.com

Leica www.leica-camera.com

Lensbaby www.lensbaby.com

Nikon www.nikon.com

Olympus www.olympus-global.com

Panasonic www.panasonic.com

Pentax www.ricoh-imaging.com

Samyang www.syopt.com

Schneider Kreuznach www.schneideroptics.com

Sigma www.sigmaphoto.com

Tamron www.tamron.com

Tokina www.tokinalens.com

Zeiss www.zeiss.com

Printers

Brother www.brother.com

Canon www.canon.com

Epson www.epson.com

HP www.hp.com

Kodak www.kodak.com

Lexmark www.lexmark.com

Printer Supplies

Ilford www.ilford.com

Lyson www.lyson.com

Marrutt www.marrutt.com

Paper Manufacturers

Canson www.canson-infinity.com

Fotospeed www.fotospeed.com

Fujifilm www.fujifilm.com

Hahnemühle www.hahnemuehle.com

Harman www.harman-inkjet.com

Hawk Mountain www.hawkmtnartpapers.com

Ilford www.ilford.com

Innova www.innovaart.com

Moab www.moabpaper.com

Museo Fine Art www.museofineart.com

PermaJet www.permajet.com

St Cuthberts Mill www.stcuthbertsmill.com

Filters

Cokin www.cokin.com

Hitech www.formatt-hitech.com

Hoya www.hoyafilter.com

Lee Filters www.leefilters.com

Tiffen www.tiffen.com

Tripods

3 Legged Thing www.3leggedthing.com

Benbo www.patersonphotographic.com

Bogen www.bogenimaging.co.uk

Joby Gorrillapod www.joby.com

Lowepro www.lowepro.com

Giottos www.giottos.com

Gitzo www.gitzo.com

Manfrotto www.manfrotto.com

Novoflex www.novoflex.com

Velbon www.velbon.biz

Wimberley www.tripodhead.com

Software

Adobe www.adobe.com

Alien Skin www.alienskin.com

Apple www.apple.com

Corel www.corel.com

DxO www.dxo.com

FDRTools www.fdrtools.com

GIMP www.gimp.org

NIK Software www.google.com/nikcollection

PaintShop Pro www.corel.com

Phase One www.phaseone.com

Photomatix Pro www.hdrsoft.com

Photoscape www.photoscape.org

PTLens www.epaperpress.com/ptlens

Pixlr www.pixlr.com

Sumopaint www.sumopaint.com

Qimage www.ddisoftware.com

Photography Publications

Black & White Photography magazine / Outdoor Photography magazine www.thegmcgroup.com

Photography books & Expanded Camera Guides www.ammonitepress.com

Index

A

aberration
 chromatic 66, 71, 78, 79
 spherical 66
abstracts 287, 288–289
acceptable sharpness, zone of 114
accessories 10, 14, 106–109
actions
 and batches 352–353
 palette 352
Active D-Lighting 156
active space 260
adjustment layers 350
Adobe
 Camera Raw (ACR) 328, 329, 339,
 340–343, 353
 CC (Creative Cloud) 328
 Lightroom 23, 160, 324, 329, 336,
 340
 Photoshop 23, 24, 28, 135, 298,
 324, 328, 339, 340, 352, 360,
 362, 426
 Black & White adjustment tool
 380
 Clone Stamp tool 346, 364
 Crop tool 256
 Elements 24, 329, 428–429
 Healing Brush tool 346
 layers 348–351
 Photomerge function 368
 Print dialog 426
 Transform tool 358
 RGB color space 28
AF-area modes 73
AF-focus modes 73
AF/MF switch 34
AF sensors 73
aging photos 390–391
alley 433
ambient light 109, 224, 225
analogous color harmonies 314
analogous colors 314–317
angle of view 36, 42, 46, 50, 60
angles, converging 55
ANSI paper sizes 420, 421
aperture 6, 13, 14, 32, 36, 80, 92,
 113, 114, 116, 118, 132, 140, 146,
 176, 284
 fixed 71
 ring 34
 settings 112
Aperture Priority (A or Av) mode 132
Apple
 Aperture 329
 App store 324
 iMac 324, 325

iPad 325
Mac 324
OSX operating system 324, 329,
 330, 332, 335
Time Machine 335
APS-C (Advanced Photo System, Type
 C) sensor 18, 19, 20, 39, 46, 56
aspect ratio 20
asymmetrical balance 262
atmosphere and light 190
Auto
 Exposure Bracketing (AEB) 150, 151
 Flash Off mode 138
 Lighting Optimizer 156
 mode 138
autofocus (AF) systems 15, 72
autofocus lock 73
autofocusing 72, 73
automated shooting modes 15
automatic white balance (AWB) 192
axial chromatic aberration 78

B

backing up images 334
backlighting 176, 177, 180
balance 245, 262–265
 asymmetrical 262
 symmetrical 262
batches 353
batteries 107
battery 107
 grip 10
 packs 14
Bayer sensors 22
bayonet mount system 36, 84
beam splitter 72
beanbag 82, 102
bellows 67
binding 433
bit 22
 depth 22
black & white 372–407
 adjustment tool 380
 beyond 382–383
 film 98
 shooting in 376–377
bleed 433
blower 84
Blu-ray player 326
blurring
 background 140
 motion 120
bokeh 71
bounce
 card 216
 flash 232

bounced light 188, 216
bouncing light 109, 235
bridge cameras 13
budget, deciding on 10
built-in flash 214–215, 220
Bulb mode 107, 112, 164, 166, 208,
 279
burning to CD or DVD 334
byte 22

C

cable releases 104
Catcus radio transmitter 228
camera
 bags 106
 choosing a 6
 digital 10
 features 10
 Holga film 10
 interchangeable lens 10
 orientation 246
 quality 10
 shake 82, 104
 supports 100–105
 -to-subject distance 48, 114
 toy 10
 type, deciding on 10
cameras 8–29
 APS-C 134
 bridge 13, 14
 cell phone 10, 14
 compact 12
 system (CSCs) 10, 16, 84, 136
 digital single lens reflex (DSLRs) 10,
 14, 84
 DSLR 10, 14, 84, 136
 pro-spec 15
 top-end 15
 fixed-lens 12–13
 full-frame 56
 Micro Four Thirds 134
 mirrorless 16
 point-and-shoot compact 10, 214
 professional system 10
 single lens reflex (SLR) 6, 10, 14
 SLR (single lens reflex) 6, 10, 14
 system 14–16
canvas, printing on 416
card reader 106
catadioptric optical system 71
CCD (Charge Coupled Device) sensors
 18
cell phone 12
center-weighted metering 97, 144
Channel Mixer 379
chroma noise 134

chromatic aberration 66, 71, 78, 79, 330
 axial 78
 transverse 78
citizen journalism 12
 cameras 10
cleaning a lens 84
clipped histogram 148
clipping 156
Clone Stamp tool 346, 364
close-up
 lenses 66
 photography 64, 219
Close-up mode 138
Cloud computing 335
clouds, reflecting light 196
CMOS (Complementary Metal Oxide
 Semiconductor) sensors 18
CMYK (cyan, magenta, yellow, black) 413
color 288, 292–319
 balance 363
 calibration 326, 327
 combinations 23, 294
 desaturated 298
 harmony 296, 304
 square 319
 tetradic 319
 triadic 318
 impact of 294
 filters 98, 99
 manipulation 235
 of light 247
 perception (table) 299
 qualities of 298
 recording 302
 scheme, monochromatic 318
 seeing 298–301
 space 28–29
 spectrum 296
 splash of (on black & white image)
 396–397
 subtracting 397
 temperature 190, 235
 value 298
 wheel, the 296–297
colors
 analogous 314–317
 complementary 310–313, 314
 split- 310
 cool 308, 309
 primary 296
 progressive 300
 range of 28
 recessive 300
 relationships between 296
 saturated 298
 secondary 297

tertiary 297
warm 304–306
color to black & white 378–381
compact
cameras 12, 14
system cameras (CSCs) 10, 14, 16
composition 6, 242–291
rules of 254–261
symmetrical 264, 265
compresssion
lossless 26
computer
hard drive 325
hardware 324–327
performance 325
software 328–333
context 282–283
Continuous AF mode 73
Continuous Ink System (CIS) 414, 415
contrast 154, 156, 157, 363
measurement 79
convergence 70
converging angles 55
Corel PaintShop Pro 330
CPU (Central Processing Unit) 325
Creative Auto mode 140
creative options 6
crop factor 18, 19, 46–47
cropped sensor range 50, 54, 56, 60, 62
cropped-type DSLRs 76, 80
cropping 290–291, 354–356
in Photoshop 356
Crop Tool 256
curves 272–275, 362–363
C- 272, 273
implied 272
S- 272
cyanotypes 394–395

D
digital asset management (DAM)
dark frame 135
dawn light 194
dead space 260
demosaicing 23
depth of field 10, 57, 70, 76, 114–119,
140, 234, 278
extensive 118
preview button 114
shallow 116
desaturate 378
diagonal lines 267, 268, 269
diaphragm, lens 36
diffraction 80
diffusers 188
bounce 232
flash 232
digital
imaging chip 22
sensors 6, 12, 13, 36

single lens reflex cameras (DSLRs) 10
directional elements 246
direction of light 174–181, 247
distance scale 34
distortion 330
dithering 413
DNG format 27
dots per inch (dpi) 410
dragging the shutter 225
D-Range Optimizer 156
drive modes 15
DSLR cameras 10, 14, 136, 220, 222,
248
DxO Optix Pro 330
dye 414
dynamic
performance 6
range 18, 144, 156–157
high 158–163

E
Edgerton, Harold 212, 222
electromagnetic
radiation 78
spectrum 172
electronic
flash tube 212
remote release 107
viewfinder (EVF) 16
element
group 36
of lens 36
emotional response 294
Enfuse plug-in
entry-level DSLRs 15
Evaluative metering 144
Exchangeable Information File Format
(EXIF) data 338
exhibition, hosting an 436
exposing to the right (ETTR)
154–155
exposure 93, 110–167, 170
adjustment 150–153
blending 160
bracketing 150, 158
compensation 150
control 12
making the "perfect" 6
metering mode 6, 15
modes 120
settings at ISO 100, table 146
values 146–147
Exposure Fusion 160
extenders 62
extension tubes 66
external
flash 13, 216–219
hard drive 334
extreme ND filter 92, 93
exposure compensation table 93

F
facial recognition 329
field of view 36
fill flash 214, 215, 226–227
film
grain 386–387
speed 6
file
formats 24
management 322–323
naming 335, 336
size 13
filling the frame 280–281
filter
adapter ring 88
holder 88, 90
step-up rings 88
thread 34
UV/skylight 85, 98
filters 13, 88–99, 147, 156
& accessories 86–109
color 98, 99
hard or soft 96
metering with ND grad 97
neutral density (ND) 92, 284
extreme 92, 93
graduated 88, 96, 156
polarizing 90
screw-in 88, 90, 92, 96
soft-focus 98
starburst 98
UV & skylight 85, 98
fireworks 164–165
firework scene mode 165
first (or front) curtain sync 224
fisheye lens 41, 50
fixed-lens cameras 12–13
flare 176
Flare Buster 196
flash 10, 14, 210–241
anatomy of a 217
and blur 120, 224
bounce 232
diffuser 232
built-in 214–215, 220
slave mode 216
diffusers 232
effective distances (table) 215
exposure 220
external 13, 216–219
fill 214, 215, 226–227
first (or front) curtain sync 224
guide numbers (GN) 215
head 235
tilting/swiveling/rotating 216
high-speed sync 225
hotshoe 216
icons 212
modifiers 216
modifying 232–237

off-camera 214, 216, 228–231
pop-up 216, 220
range 215
ring 219
second (or rear) curtain sync 224
slave cell 216
slow sync 128, 213, 224, 225, 229
softbox 232, 234
studio strobe 216, 221
sync 222–225
trigger 216
TTL control 220, 221, 226
twin 219
umbrella 233
wireless 228
zoom 216
Flash Exposure
Bracketing (FEB) 226
Compensation (FEC) 220, 226
f-number 80, 114
focal
length 19, 34, 35, 36, 42, 43, 62,
114, 116, 118, 278, 280
fixed 37
short 48
plane 36, 42, 67
shutter 222
focus 36, 72
points 72
selective 32
focusing 6, 15, 72–75
distance, minimum 37
points 6
ring 34
foreshortening 60
frame-filling pictures 60
frame rate 15
framing 276–277
prints 436
shots 6
freeware 324
freezing motion 120, 122
shutter speeds for 122
frontal lighting 174, 232
front-to-back sharpness 80
f-stop 80
f-stops 112, 114
full-frame
camera 46, 76
sensor 15, 18, 20
range 50, 54, 56, 60, 62
Fuzzy logic 142

G
gamut 28, 29
gels, colored 235, 236, 237
giclée 413
Gigabytes (GB) 106
GIMP (GNU Image Manipulation
Program) 332

global adjustment tool 346
gloss surfaces 173
Golden Hour, the 204
golden ratio 256
golden
 rectangle 256
 section 256
 triangle 256, 257
GPS metadata 329
graduated neutral density filters 88, 96, 156
grain, adding digital 386–387
Greek letter Phi 256
greetings cards 434
grid overlay, LCD screen 254, 355
guide numbers (GN) 215, 219
gum bichromate 402–405
gutter 433
gyroscopic sensors 82

H
HDMI/DVI ports 326
HDR (High Dynamic Range) 144, 158–163
 image 157
 creator 330
 shooting for 158
 software 158
HDRSoft Photomatix 330
HD TV 20
Healing Brush tool 346
Herschel, Sir John 394
high-key images 150, 230
highlights 156, 219, 246
high-speed sync 225
histogram 142, 154
 assessing a 149
 clipped 148
 distribution of pixels in 149
histograms 148–149
Holga film camera 10
horizontal lines 268
hot pixels 134
hotshoe 108, 228
 flash 216
 -mounted spirit level 108
hue 298
hyperfocal distance 75, 76–77
 tables 77
hyperreal images 160, 161
hyperzoom lens 41

I
ICC profiles 421
image
 adjustment 26
 editing software 328, 329, 378
 noise 18
 quality 12, 14, 18, 410
 size 422

stabilization 82
Image Adjustment Tabs 340
images
 high-key 150
 importing 334–337
 low-key 150
importing images 334–337
incident light readings 142
infinity focus 36
infrared (IR) 400–401
ink 414–415
 droplets of 413
 receptor coating (IRC) 418
 replacement cartridges 410
inkjet
 -compatible transparent film 417
 technology 412–413
interchangeable lens camera 10
International Press Telecommunications Council (IPTC) format 338
ISBN 433
ISO 13, 14, 22, 92, 113, 130–135, 164, 386
 /aperture/shutter speed reciprocal relationship 136
 Auto 132
 comparison 130
 range 18
 sensitivity 15, 215
ISO 216 paper sizes 420

J
JPEG
 compression 12, 24, 25
 files 12, 20, 24, 106, 138, 154, 192, 302, 322, 332, 349, 354, 376, 382
 images 28

K
Kelvin
 scale 190
 value 192
keywording 329, 334
keywords 339

L
laminate 433
Landscape mode 138
landscape orientation 252
laptop 325
Lastolite Ezybox Hotshoe 234
layers 348–351
 adjustment 350
 opacity 349
 panel guide 349
L-card crops 355
LCD
 monitor screen 326
 screen 16, 104, 148, 220, 248, 250, 254

articulated 108
 grid overlay 254
Lee Filters 235
lens
 anatomy 34
 cap 85
 care 84–85
 choosing a 6, 38–39
 cleaning 84
 fluid 84
 cloth, microfiber 84
 coatings 84
 diaphragm 36
 distortion 78
 barrel 78
 pincushion 78
 elements 36, 84
 extreme telephoto 42
 flare 176
 avoiding 196
 hood 107
 independent brands 39
 kit 32
 long telephoto 64
 macro 64
 mount 32, 34, 36, 84
 /contacts 34, 84
 mounting 84
 mark 84
 operation, theory of 32
 perspective control 70
 prime 37, 56, 113
 problems 78–81
 short-telephoto 64
 standard 37, 42, 56
 zoom 56
 storage 84, 85
 technology 36–37
 telephoto 37, 42, 45, 46, 48, 60
 ultra wide-angle 42, 44
 wide-angle 37, 42
 zoom 37
 zoom 13, 113
lenses 30–87
 close-up 66
 digital-specific 39
 extreme telephoto 62
 for cropped sensors 39
 macro 15, 64
 mirror 71
 prime vs. zoom 40
 reflex 71
 single-element close-up attachment 66
 telephoto 15, 60
 tilt-and-shift lenses 70
 ultra wide-angle 50–51
 super wide angle 15
 wide-angle 46, 54, 55, 128
Lens Pen 85
levels 360–361

panel 360
light
 ambient 109, 224, 225
 and color temperature 190
 and texture 173
 and the atmosphere 190
 artificial 182
 bounced 188
 bouncing 109
 color of 190–193, 247
 controlling the 6
 dawn 194
 detector 216
 diffusers 188
 direction of 174–181, 182, 247
 hard 182, 186
 intensity of 182
 meter 142
 midday 198
 night 208
 oblique 174
 quality of 182–189, 194
 readings
 incident 142
 reflective 142
 reflectors 188
 refracted 294
 soft/softening 182, 188
 sunrise 196
 sunset 200
 temperature of 194
 twilight 204
 visible 172
light & lighting 168–209
lightening & darkening images 362
lighting
 frontal 174, 232
 side 174
 studio 188
 top 175
lines 268–271
 diagonal 267, 268, 269
 directional
 implied 246
 real 246
 horizontal 268
 vertical 267, 268
lith printing 406–407
live view 10, 16, 248
Live View 82, 104, 107
Long Exposure Noise Reduction 107, 135, 164, 166
long telephoto lens 64
lossless compression 26
low-key images 150, 231
low-light performance 12, 131
luminance
 levels 156
 noise 134
Luminquest diffusers 232

M

macro 64–69, 114
Magic Moment, the 200
magnification, increasing 67
manual focus (MF) 62, 74
Manual (M) mode 132, 140, 141, 150
Massachusetts Institute of Technology 212
Matrix metering 144
memory cards 106, 322
metadata 334, 338–339
metering 15, 142–144
 center-weighted 97, 144
 Evaluative 144
 Matrix 144
 multi-area 144
 Multipattern 144
 partial 144
 patterns 144
 spot 97, 144
 systems 13
 TTL (through-the-lens) 62, 90
 with ND grad filters 97
MF/AF switch 74
MF (manual focus) 62
Micro Four Thirds
 cameras 134
 sensor 18
 system 32
microfiber lens cloth 84
microns 413
microprocessor 73
Microsoft Word 324
midday light 198
mid-gray tones 148
Miller, Lee 392
minimum focusing distance 57
mirror
 lenses 71
 lockup (MLU) 104
 slap 104
mirrorless cameras 16
mode
 Aperture Priority (A or Av) 132
 Auto Flash Off 138
 Bulb 112, 166, 208
 Close-up 138
 Creative Auto 140
 Full Auto 138
 Landscape 138
 Manual (M) 132, 141, 150
 Portrait 138
 Program (P) 132
 Shutter Priority (S or Tv) 132
 Sports 138
modes
 drive 15
 exposure 120
 scene 15, 138
 shooting 6, 15, 138–141

modifying flash 232–237
monitor
 color calibration 326, 327
 HDCP compliant 326
 resolution 326
monitors 326
monochromatic color scheme 318
monopod 82
Mooii Tech software 332
moonlight 208
motion
 blurring 120, 128, 225
 freezing 120, 128
movement 120–129
 blurring 124
 freezing 122
multi-area metering 144
Multipattern metering 144
multipliers 62

N

nature photographers 62
neutral density (ND) filters 92, 284
neutral density graduated filters 88, 96
 metering with 97
Newton, Sir Isaac 294, 296
night light 208
nodal point 36
noise 18, 132, 134, 166, 208
 chroma 134
 luminance 134
Noise Ninja 135

O

oblique light 174
off-camera flash 214, 216, 228–231
open-source software 332
optical
 density figure 92
 image stabilization 82
 viewfinder 16
 zoom range 13
orientation of camera 246, 252–253
 horizontal 252
 vertical 253
orphan works 338
overexposing 142
overexposure 148
 correcting 150

P

painting with light 238–241
 flash 238, 240
 flashlight 238, 241
panning 120, 128
panoramic images 368–371
paper 416–417
 gloss 418
 jam 431
 matte 418

 semigloss 418
 sizes 420
 texture 420
partial metering 144
patterns
 in nature 279
 repetitive 279
PC (personal computer) 324
 connection socket 228
PDF (Portable Document Format) 433
pentaprism 19
perception of color 299
perspective 48–49, 51, 54, 60
 compression 60, 62
 control lens 70
 correction 358–359
phase-detection AF 72
Phase One, Capture One workflow package 330
photobook, making a 432
photographic brush 84
Photomatix Pro 160
Photomerge function 368
photons of light 18, 22
photosensitive strips 72
photosites 22
PhotoScape software 332
Picasa DAM software 336
Pictorialism 402
piezoelectric printing 412
pigment 414
pixels 18, 23, 73, 148, 326
 per inch (ppi) 422
Pixlr web-based photo editor 333
plug-ins 328, 330
PocketWizard radio transmitter 228
point-and-shoot compact cameras 10, 214, 220
polarizing filters 90
pop-up flash 216, 220
Portrait mode 138
portrait orientation 252
posterization 22, 23
post-processing 14
postproduction 18, 135, 148, 154, 158, 344–371
pre-flash strobe 219
previsualization 247
primary colors 296, 297
prime lens 37, 56, 113
printer
 inkjet 410
 speed 410
printing 6, 408–437
 paper 412, 413, 414, 416, 417, 420
 jam 431
 photographic 418
 piezoelectric 412
 terms 433
 thermal 412

print
 heads 412
 media 416–417
 settings 428, 429
 size 410
 test strip 430
processor, multi-core 325
professional system cameras 10
Program (P) mode 132
progressive colors 300
proof copy 433
proofing 424–425
 soft 424
PSD format 349
publicity 437

Q

qualities of color 298
quality of light 182–189

R

radio transmitter 228
RAID (Redundant Array of Inexpensive Disks) back-up drive 334, 335
rainbows 294
RAM (Random Access Memory) 325
range of colors 28
Raw
 conversion software 135, 328, 330, 332, 336
 file editing 329
 files 13, 14, 24, 25, 26, 27, 106, 135, 154, 158, 192, 302, 322, 328, 336, 340, 354, 376, 382
 workflow 323
Ray, Man 392
recessive colors 300
reciprocal relationship (between ISO/aperture/shutter speed) 136
reciprocity law failure 166
red-eye 214
reflected light 173
reflective light readings 142
reflectors 109, 188, 189
reflex
 lenses 71
 mirror 72
refracted light 294
remote release 10, 104, 107
 electronic 107
repetition 278–279
reproduction ratio 64
resizing 357
resolution 422–423
retouching 364–365
reversing rings 67
RGB (red, green, blue) 22
 model 297
right-angle finder 108
ring flash 219

Rogue Universal Gel Kit 235
Rosco Filters 235
rule of
 odds 258–259
 space 260–261
 thirds 249, 254
rules of composition 254–261

S
saturation, of color 298
scene mode, firework 165
scene modes 15, 132
secondary colors 297
Secondary Image Registration (SIR) TTL
 passive phase detection 72
second (or rear) curtain sync 224
selective focus 32
self-timer 104
sensitivity of sensor 130
sensor 113, 190
 APS-C (Advanced Photo System,
 Type C) 18, 19, 20, 46
 full-frame 15, 18
 Micro Four Thirds 18, 19, 20, 46
 sensitivity 130
 shift stabilization 82
 size 10, 14, 18, 19, 36, 46
sensors
 Bayer 22
 CCD (Charge Coupled Device) 18
 CMOS (Complementary Metal Oxide
Semiconductor) 18
 comparative sizes of 19
 digital 6, 12, 13, 18–23
 gyroscopic 82
 through-the-lens optical AF 72
shadows 156, 219, 227, 229
shake reduction 82–83
shape 288
shareware 324
sharpening 366–367
sharpness, front-to-back 80
shooting modes 6, 138–141
 automated 15
shoot-through umbrella 233
short-telephoto lens 64
Shutter Priority (S or Tv) mode 120, 132
shutter 112
 speed 6, 13, 14, 92, 112, 113, 120,
 122, 124, 128, 130, 132, 146,
 164, 222, 224, 225, 284
 synchronization 222
sidecar file 339
side lighting 174
silhouettes 180
silica gel 85
simplification 284–287
single-element close-up attachment
 lenses 66
single lens reflex (SLR) 6, 14

Single-shot AF mode 73
slave
 cell 216
 mode 216
slow sync flash 128, 213, 223, 224,
 229
SLR (single lens reflex) 6, 14
snoot 234
softbox 232, 234
soft focus 384–385
soft-focus filters 98
soft proofing 424
software, computer 328–333
 commercial 328
 open-source 332
solarization 392–393
spherical aberration 66
spirit level, hotshoe-mounted 108
split-complementary colors 310
split toning 398–399
Sports mode 138
sports photography
spot metering 97, 144
square color harmony 319
sRGB color space 28
stabilized lenses 82
stacked elements (of image) 45, 61, 62
standard
 lens 37, 42, 56–59
 zoom lens 56
starburst filters 98
star trails 166–167, 208
stitching software 368
Sto-Fen diffusers 232
stop 112
stops, increasing/decreasing 150, 151
studio strobe flash 216
subject, placing in image frame 246
subject-to-camera distance 114
Sunny 16 rule 136, 137, 146
sunrise 196
sunset 200
superzoom lens 13, 41
symmetry
 mirror 262
 radial 262
SumoPaint web-based photo editor 333
sync speed 224
system cameras 14–16

T
tablet devices 325
teleconverters 62
telephoto 60–61
 extreme 62–63
 lenses 62
 lens 37, 42, 46, 48
 lenses 60
 zoom lens 41
telling a story 282

tertiary colors 297
tetradic color harmony 319
texture 173, 288
 and light 173
thermal printing 412
Thomson, William 190
through-the-lens optical AF sensors 72
TIFF files 24, 25, 349, 354
tilt and shift 70
tilt-and-shift lenses 70
time of day 194–209
tonal adjustments 341
tone mapping 160
tones, spread of 156
toning 388–389
top lighting 175
tracking moving subjects 73
transverse chromatic aberration 78
triadic color harmony 318
tripod 82, 100, 124, 208
 ball head 102
 heads 101, 102
 quick-release 102
 inverting central column 101
 leg locking mechanism 101
 maximum working height 100
 minimum working height 101
 setting up a 102
 technique 102
 three-way head 102
 weight and rigidity 100, 102
troubleshooting (printing) 430–431
TTL (through-the-lens)
 flash control 220–221
 metering 62, 90
 on-camera 220
twilight 204
twin flash 219

U
ultraviolet (UV) light 98, 394
ultra wide-angle 50–53
 lens 42
 lenses 50–51
 zoom lens 41
umbrella 233
underexposing 142
underexposure 148
 correcting 150
UFRAW (Unidenfied Flying RAW) plug-
in 332
UNIX operating system 332
Unsharp Mask (USM) 366
USB reader 334
UV & skylight filters 85, 98

V
value, of color 298
vertical lines 267, 268
viewer's gaze 246

viewfinder 144, 248–249, 254
 electronic (EVF) 16, 248, 249
 optical 16, 248
 right-angle 108
viewpoint 244, 245, 250–251
vignetting 80
virtual memory 325
visualizing 247
visual
 clutter 284
 notebook 13
 weight 266–267, 282

W
water
 freezing movement of 122
wavelengths of light 172, 173, 190, 296
weatherproofing seals 15
web-based editing 333
white balance 13, 14, 192–193, 236,
 302, 303, 340
 automatic (AWB) 192
 settings (Daylight, Shade, Cloudy,
 Incandescent) 192
 symbols 192
white space 261
wide-angle
 lens 37, 42, 46, 128
 lenses 54–55
Windows
 PC 324, 325
 operating system 324, 329, 330,
 332
wireless
 flash 228
 releases 104
working distance 228
workflow 320–343
 package 330
working distance 66
writing with light 112

X
Xenon gas 212
XMP file 339
X-sync speed 224

Z
zone
 of acceptable sharpness 76, 114
 options 6
zoom 280
 burst 223
 flash 216
 lens 13, 37, 41, 113
 fisheye 41
 range, optical 13
 ring 34
 telephoto 41
 ultra wide-angle 41

Picture Credits

Tracy Hallett

30–31, 51 (top left), 57 (bottom right), 61 (bottom), 65 (left, top right), 67, 106, 113, 120, 139, 149 (bottom left, bottom right), 151, 172, 175 (top right), 176, 179, 183 (left), 185, 188, 189, 192, 193, 215, 227 (top right), 258 (bottom right), 268, 278 (right), 282, 287, 289 (top left), 295 (top left), 296, 298, 305 (top right), 308, 312, 317, 361, 429.

Robert Harrington

210–211, 214, 218, 219, 221, 222, 224 (left), 225, 226, 228, 229 (top), 230, 231, 232 (top right, bottom right), 233–235 (bottom left), 236, 237, 260 (top).

Ross Hoddinott

14, 18, 33–37 (left), 39, 41, 43, 47, 49, 52, 53, 55 (right), 57 top left, top right), 58, 59, 61 (top left), 63, 65 (bottom right), 66, 68, 69, 70, 71, 72, 73, 74, 79, 80, 81, 83, 86–87, 89, 103, 114–115, 123 (bottom), 125 (top right), 255 (top left), 258 (bottom left), 260 (bottom left), 265, 271, 288, 309 (right), 332, 356, 358, 359, 423.

Andy Stansfield

110–111, 116 (bottom left, bottom right), 134, 138, 140, 156, 355 (top left), 377.

David Taylor

2, 4, 8, 11–13, 15, 17, 20 (top), 21, 23, 24, 26, 27, 29, 37 (right), 40 (left), 44–46, 50, 51 (bottom, top right), 54, 55 (left), 57 (bottom left), 61 (top right), 75, 76, 78, 85, 91 (right), 92 (left), 93–96 (top), 97–100 (left), 101, 102 (right), 104, 109 (top), 112, 115, 116 (top left), 118 (top), 119, 122, 124, 125 (left), 126–129, 133, 135, 141 (left), 142, 145 (bottom), 147 (bottom), 149 (top), 152, 153, 155, 157–167, 173, 174, 175 (top left), 177 (bottom right), 178, 180, 181, 183 (right), 184, 186, 187, 191, 194, 201 (bottom), 203, 206–208, 212, 213, 220, 223, 224 (right), 227 (top left, bottom), 229 (bottom left, bottom right), 232 (bottom left), 235 (top right), 239–254, 255 (bottom left, right), 256, 257 (bottom), 259, 260 (bottom right), 261–264, 266, 267, 269, 272–278 (left), 279 (top left, bottom left, bottom right), 280 (right), 281, 283–286, 289 (top right, bottom), 295 (bottom), 299–303 (top left, right), 304, 307, 309 (left), 311 (top left, bottom left), 313–315 (top), 316, 318, 319, 322, 324, 331, 333–354, 362–365, 367, 369, 372–376, 378–407, 411–421 (left), 422, 424–427, 430–437.

Steve Watkins

16, 20 (bottom), 25, 90, 91 (left), 92 (right), 96 (bottom), 100 (right), 105, 116 (top right), 117, 118 (bottom left, bottom right), 121, 123 (top left, top right), 125 (bottom right), 131, 136, 137, 141 (right), 143, 145 (top), 147 (top), 154, 168–171, 175 (bottom), 177 (top, bottom left), 182, 195–201 (top), 202, 204, 205, 209, 258 (top), 270, 279 (top right), 280 (left), 290–294, 295 (top right), 305 (left, bottom), 306, 311 (top right, bottom right), 315 (bottom), 320–321, 327, 355 (right), 370–371, 408–409.

Product photography

Apple Inc.: 325 (panel), 326; Canon: 12 (top right), 14 (center), 32, 38, 41 (top right), 56 (top), 60 (left), 62 (top), 64 (top), 217, 412 (bottom); Dell Inc.: 325 (top, center); JYC Technology 107 (top right); Kingston Technology: 334 (top right); Nikon: 14 (right, top, center, bottom), 54 (top right), 64 (bottom), 70 (top right, bottom right), 107 (top left), 108 (top right, bottom right), 216; Olympus: 14 (panel), 16 (left, 2nd from top), 84 (panel); Panasonic: 12 (bottom right), 13 (top right), 16 (left, 4th from top), 40 (bottom right); Samsung: 12 (bottom left), 16 (left, 3rd from top); SanDisk: 106 (right, 2nd and 3rd from top); Sigma: 40 (top right), 41 (right center), 50 (top right, bottom right), 60 (right), 62 (bottom), 218; Sony: 36, 41 (bottom right), 56 (bottom); LaCie: 304, 334 (bottom); Lastolite: 109 (bottom); Xrite Inc.: 326 (bottom); GIMP.org: 302 (left); Mooi Tech: 302 (right); Seiko-Epson: 412 (top right),414 (bottom right).

AMMONITE
PRESS